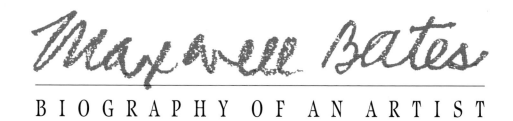

BIOGRAPHY OF AN ARTIST

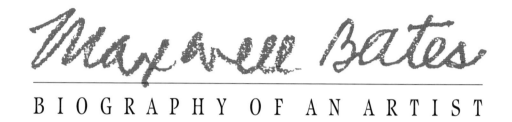

BIOGRAPHY OF AN ARTIST

by

KATHLEEN M. SNOW

UNIVERSITY OF CALGARY PRESS

University of Calgary Press
2500 University Drive N.W.
Calgary, Alberta, Canada T2N 1N4

Canadian Cataloguing in Publication Data

Snow, Kathleen M., 1918–
 Maxwell Bates

 Includes bibliographical references and index.
 ISBN 1-895176-25-5. —ISBN 1-895176-45-X

 1. Bates, Maxwell, 1906–1980. 2. Artists—Canada—Biography.
I. Bates, Maxwell, 1906–1980. II. Title.
ND 249.B32S68 1993 759.11 C93-091698-0

Financial support provided by the Alberta Foundation for the Arts, a beneficiary of the Lottery Fund of the Government of Alberta, and the Canada Council

Book design by Cliff Kadatz, Department of Communications Media, The University of Calgary

Printed in Canada by DWFriesen

∞ This book is printed on acid-free paper.

For my John Snow

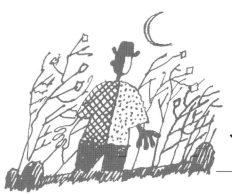

Table of Contents

 # Preface

Maxwell Bennett Bates (1906–1980), C.M., LL.D., RCA, MRAIC, artist, architect, author—this is an account of his life: twenty-five years in Calgary, ten years in England, five a prisoner in Thuringia, sixteen years in Calgary, and eighteen in Victoria. The recollections of his friends and colleagues together with Max's own records provided much of the material for this book. John Snow had also kept records from their thirty-four years of friendship and collaboration. Charlotte Bates gave the Snows permission to use Max's works and to transfer Max's files and some of his books to the Special Collections of the MacKimmie Library of the University of Calgary.

The background of Max's life was familiar to me. I, too, was born in Calgary of British parentage, went to the same schools as Max, knew some of the same families, devoured British magazines, and burrowed in the same books at the public library. By the time I became acquainted with the Bates family, Max had gone to England, but I was aware of his artistic career and the fact that he was a prisoner in Germany. When he returned, we met at the Allied Arts Centre and the public

library. Each of the Snows, though at the time unacquainted, bought a painting from Max's early exhibition at the Canadian Art Galleries, and these works still hang on our walls. In spite of the Snows' many years of friendship with Max, we never felt we grasped the elusive essential of this complicated man. His protective walls were strong and I am conscious that in this account I have not been able to penetrate them.

Max was a faithful keeper of notes and journals, and these were of immense help as an indication of his thinking. The emotional life of this very reticent man could best be reached through his poetry and painting. My academic studies do not cover the area of art criticism, and as a layman, I have not ventured a critical appraisal of Bates's work. My extensive quotes from the criticisms of his many exhibitions and of his architecture are intended to show the published reaction to his work contemporaneously and later.

His years in London were most difficult to research, as the records were scanty and his work had been dispersed or lost during the war. In his record of the sales of his paintings

in London, the name Brinsley Ford struck a note; the London telephone directory yielded his address; *Who's Who* furnished the details of his distinguished career. On the receipt of our letter, Sir Brinsley invited us for a drink at his home in the Marylebone area; he was most anxious to talk about Max and his work. His large flat was filled with art, some of it inherited and some acquired by him. Over the fireplace was an original Michelangelo drawing and on one wall a beautiful Toulouse-Lautrec. It was this latter purchase that Max celebrated in his portrait of Sir Brinsley, with the letters "*T*" and "*L*" just showing on the cover of the book he held in the portrait. He also showed us Max's watercolour sketches of the three young friends who admired Bates's work—Ford, Villiers David and Marcus Cheke.

Information about Bates's years in the prison camp came at an opportune time in a strangely roundabout way. Susan Maxine Davey, the daughter of George White, who occupied the upper bunk while Max was in the lower in the prison camp, happened to glance at her daughter's list of penpals and saw the address "Calgary." On an impulse, she wrote to the mother of the penpal to ask news of Maxwell Bates, her godfather. After a long series of phone calls, her correspondent in Calgary located John Snow. Once this connection was made, on a visit to England, we were able to interview George White in Bristol, Robert Cameron Macdonald in Harrow, and Leo Keys, who had been the interpreter at the camp. These men supplemented Max's restrained account of the five years of their war.

Bates's work is unique and unmistakable. Those of us who knew him regarded him with affection and respect and marvelled at his accomplishments in the face of setbacks and misfortune. Helpful to others, he was a quiet leader through the force of his personality and his integrity, an integrity which was the solid core of his art, his architecture and his writing.

Acknowledgements

Many of Bates's friends were willing to be interviewed or wrote accounts of his friendship with them. Especially helpful were Bill and Gisela Bates and P.K. Page. The book could not have been written at all without the help and knowledge of John H. Snow.

I am grateful to the following individuals for their contribution: Cynthia Bates Aikenhead, John Aikenhead, Gail Anderson, Douglas Andrews, Tom Baines, Ruth Barker, Iain Baxter, Daisy Benbow, Robert and Evelyn Black, David Blackwood, Peter Burgener, Steven Bury, Derek and Barbara Bwint, Azelie Clark, James Cook, Kate Craig, Marian and Peter Daglish, Susan Davey, Leonard Dolgoy, Quenten and Joyce Doolittle, Diane Douglas, Mrs. D. Rae Fisher, Sir Brinsley Ford, Nita Forrest, Della Foster, Alan Fraser, Fred Fraser, Clifford H. Fryers, John M. Gareau, Norma Gibson, Peter and Christine Gifford, Harold J. Gleusteen, Ted Godwin, Hugh and Pat Gordon, Colin Graham, Saul Green, Frances Plaunt Hall, Bertha Hanson, Lynette Harpham, Virginia Lewis Harrop, Donald Harvey, Philomena Hauck, Margaret Perkins Hess, Xisa Huang, Michael Isman, Beverley Jarenko, Yolande and Maclean Jones, Flemming Jorgensen, Mark Joslin, Tom Joyce, Lewis Kaplan, Illingworth Kerr, Margery Key, Leo Keys, Steve Kiss, Harry Kiyooka, Roy Kiyooka, Helen Knight, Christine Lamarsh, John D. Lamarsh, Luke Lindoe, Fay Loeb, Robert MacDonald, Glen MacDougall, Helen and James Mackie, Nicholas Macklem, Edwina Maier, Pat Martin-Bates, Kenneth W. Mason, Elza Mayhew, Lillian McKimm, Eric Metcalfe, Ivy Michelson, Jean and George Mihalcheon, Janet Mitchell, Allan Mogridge, Michael Morris, Rita Morris, Suzanne North, Frank Nowosad, Frank Palmer, Myfanwy Pavelic, William Payne, Kathleen Perry, Caterina Pizanias, Margaret E. Price, Mrs. George Prieur, Shirley and Peter Savage, Gerard Schlup, Jane Seaborne, Faye Settler, Ada Severson, Herbert Siebner, Robin and Sylvia Skelton, Barbara Harcourt Smith, Ronald Spickett, Janice Starko, Joseph Starko, D. Joanne Steinmann, Neil and Sheila Stewart, Kenneth and Frances Sturdy, Judy Tilley, Nancy Townshend, William A. Trow, Grace Turner, John Twyman, George White, Margaret C. Williams,

and Kathleen Worrall.

The appraisals of Bates's work were drawn from books, the periodical press and from catalogues. The most recent of the last, those by Ian M. Thom and Nancy Townshend, were especially valuable in the surveys of his work from the beginning of his career to the end.

The resources of the following institutions were generously made available on request: Special Collections, MacKimmie Library, University of Calgary; Calgary Public Library; the Glenbow-Alberta Institute; Canadian Art Galleries; St. Martin's Anglican Church; St. Mary's Cathedral; the Edmonton Art Gallery; the Alberta Foundation; the Art Gallery of Greater Victoria; the Vancouver Art Gallery; the Vancouver Public Library; the Canada Council Art Bank; the Tate Gallery; the Library of the Victoria and Albert Museum; the Westminster Reference Library; the Library of the Royal Institute of British Architects; the Towner Art Gallery, Eastbourne; and the Auckland City Art Gallery.

I am grateful to Dr. Morton Ross for his skilful and sympathetic editing of the first draft of the manuscript. I wish to thank Beth Duthie and John King for their meticulous final editing, John Dean for his photography, and Cliff Kadatz for his design abilities. John V. Snow was of immense help in the final preparation of the manuscript.

I wish to thank James Mackie, Q.C., for his interest in and generous support of the project. NeWest Institute for Western Canadian Studies, Inc., and Canadian Art Galleries were generous in their support. The Alberta Foundation for the Literary Arts and the Canada Council provided additional financial support.

Foreword

I first discovered the artist Maxwell Bates while I was a third-year student of drawing and painting at the Ontario College of Art in Toronto. There were few commercial galleries in the city at this time and only one or two seriously interested in contemporary Canadian art. As students we had a regular routine of visiting the galleries on Saturday mornings and were excited about the Bates exhibition at the Here and Now Gallery in February of 1962.

Every member of the class had studied with Jock Macdonald (1897–1960), the great teacher of painting at OCA. Apart from teaching at the college, Macdonald was very involved with his own work and preparations for major exhibitions of his paintings. This wonderful sense of involvement with art was passed on to his students. He made us aware of what his artist friends were thinking and doing. Those friends included, among others, the American painter Hans Hofmann and Maxwell Bates.

German expressionism was a big influence in the Drawing and Painting Department at OCA. We learned from Macdonald that Bates had studied with the German modern master

Max Beckmann. A few of us remembered everything that Macdonald ever said and went to see the Bates show. I remember we shared an enthusiasm for the content, directness, the simplicity and intensity of the Bates paintings. Word spread rapidly about the exhibition, and there were many return visits. A great deal was to be learned from seeing it.

Alan Jarvis, former director of the National Gallery of Canada, was present at the uncrating of Max's paintings in Toronto and was very impressed with the work. The exhibition, however, was not a commercial success. At the end of the show, Max received a disappointing letter from Dorothy Cameron, owner of the Here and Now Gallery. She suggested that they terminate their business relationship at the end of the season. The Toronto experience had a lasting effect on the artist and his view of future exhibitions in eastern Canada.

Cameron's attitude (which might have been different had there been sales!) reflected the times in Toronto, a city full of itself and desperately seeking glamour and sophistication. There was a growing demand for fashionably

large and loud decorative abstraction. Toronto artists, it seemed, were busy thumbing through glossy American art magazines and producing slick, second-class versions of what was the rage in New York. The Art Gallery of Toronto Volunteer Women's Committee was very busy fundraising to purchase this new "international" sophistication for the Permanent Collection. The late Harold Town was the darling *enfant terrible* of the Toronto social and cultural establishment, frowning for the camera and strutting about ... full of sound and fury. A media star!

This was the Toronto that received the Maxwell Bates exhibition in February 1962. It was a very strong and honest exhibition, full of substance. But in such a superficial atmosphere, it would have been described as "not very exciting," "without flair," and definitely "not nice." It was ahead of its time. The social content of Max's work was more in tune with a later period. It foreshadowed a generation of social commentary painters working in the 1980s. The Bates exhibition of 1962 would have been at home in Toronto 1993.

In 1968 the curator of the Memorial University Art Gallery, the artist Peter Bell, was tremendously impressed by Max's paintings. He considered Bates one of Canada's best painters, as he expressed it, "miles ahead of anything in Toronto." It was in this atmosphere of enthusiasm for Max's work that I purchased my first Bates painting, a 1967 watercolour titled *The Concert*.

The Toronto graphics dealer Doris Pascal had a great appreciation for Max's prints and drawings. She felt that he represented something very special and unique in Canadian art. There was always a selection of his work at the Gallery Pascal, and this led to further additions to my collection, in particular a series of richly textured monotypes.

While visiting Vancouver in 1974, I was able to catch the end of a Bates exhibition at the Galerie Allen. The show had sold out except for three "difficult" paintings, works that were exceptional but tough! I was able to take all three back to Toronto, including one for the collection of the University of Toronto, where I was artist-in-residence.

The Vancouver visit resulted in arrangements for an exhibition at the Erindale College of Art in October 1974. The purpose of this university art gallery was to expose the academic and local community to what was happening in the visual arts across Canada. The exhibition was well-received, with great interest and debate surrounding the subject matter, the artist's painting method, and his place in Canadian art. But things had not changed much since 1962. There was one piece of work sold and one prominent member of the curatorial fraternity confronted me with the question: "Do you really like his work?"

It is easy to understand why fellow artists have always appreciated Maxwell Bates. It is equally understandable why the curatorial academic often can't "see" it. They "read" content of a social and political nature but are unable to respond to the physical surface of the work, the feeling that you get from actual experience in the act of drawing and painting: making art. The curatorial world seems obsessed with verbal definition. For the artist it's

the visual experience that is important. Bates's
acceptance outside the museum field, by the
general public in western and eastern Canada,
has a great deal to do with his closeness to
both the land and the reality of life.

Max was first and foremost a painter, but
like that earlier artist, Giotto, he was also an
architect. St. Mary's Cathedral in Calgary
stands as his monument. This building and his
oeuvre as a painter underline the gothic nature
of this great Canadian artist. When I think of
Maxwell Bates, I am reminded of the unknown
builders, carvers and glass-makers who
camped around the great medieval cathedrals
of Europe. He would have been happy to join
them. They were considered rough and unso-
phisticated in comparison with the products of
later European academies. But they still reach
out across the centuries and touch us with
their humanity.

David Blackwood
Port Hope
December 1992

Illustrations

LE CHATEAU DES CARTES

Early Years in Calgary, 1906–31

"I am a product of the period of Art Nouveau, pared down by the prairie wind,"[1] explained Maxwell Bates of his cultural heritage as the son of an English architect. He was born in Calgary in 1906. Two years earlier, his parents, William Stanley Bates and Marion Montford Thomasson, known as May Bates, had arrived in the raw young city between the prairie and the foothills. The Bateses were members of a civilized, even sophisticated group of British immigrants who brought with them their skills, code of conduct, and a way of life which had a dominant influence on the developing city. They had come from Bedford, England, at the invitation of the architect Gilbert Hodgson, with whom Bates set up the firm Hodgson and Bates.[2] It was an opportune time for the young architects as Calgary was growing rapidly; between 1904 and 1912, the population increased from an estimated 10,543 to 73,759.[3] The city was prosperous, the transportation centre of a vigorous ranching and meat packing industry, dominated by two men, William Roper Hull and Patrick Burns.

When Hull approached Hodgson and Bates to build a large office building, the Grain Exchange Building, its construction turned out to be "an event not only in terms of Calgary's commercial expansion but also in terms of architectural development."[4] Bates's reinforced concrete frame technique was new in Great Britain and the United States, and the result was "the first truly modern business block in Calgary."[5] Six stories in height, classical in design, it was executed with excellent craftsmanship and through the years continued to be a dominant building on a main artery of the city's business district.

William Bates's skills were soon in demand, and Patrick Burns, the meat packing tycoon, commissioned the Burns Building. Six stories high, it was sheathed in white terracotta and styled "in the Edwardian classical manner. A distinctive feature of the elegant building was the large wrought iron and glass canopy which extended around the east and north sides."[6] Bates also designed hotels, banks, apartments, houses and churches and was the principal architect for the Roman Catholic Diocese. A

charter member of the Alberta Association of Architects,[7] he set high standards of proportion, harmony and rhythm. His work has proved enduring, for a number of his buildings, including the Grain Exchange and the Burns Building, are now preserved as heritage buildings.

Bates built his own home on Thirteenth Avenue Southwest, then the most prestigious area of the city; along the avenue would be built the homes of Senator James Lougheed, Burns and Hull. The Ranchmen's Club, the meeting place of the city's elite, was built just east of the Bates residence, and Bates became a member. The house itself was spacious—two stories, to which a third was added in 1912—and bore out William Bates's belief that "Comfort and good taste should not be regarded as unnecessary frills, nor should they be equated with extravagant expense. An artistic home is an education in itself."[8] The strong influence of William Morris and the art nouveau movement was further evident when the young architect went on to write that a badly planned house leads to the "degradation of the artistic sense and the loss of satisfaction which comes from the ownership of something good."[9]

Max was surrounded from birth with beautiful objects and furnishings in well-proportioned rooms. In summer the long front verandah was lined with flowers. The back garden could be seen through the casement windows of the living room,[10] "a riot of flower colours—delphiniums, peonies, phlox, white daisies. Or, in winter, soft and white as marshmallows, the mounded snow."[11] Max remembered how he enjoyed playing in the garden,

crawling among the shrubs and the tall delphiniums and looking up the stalks. He said, "It seemed like a jungle. They seemed to tower above my head and I was right down with the ants—very interesting. You seem to see much more at that age."[12] He enjoyed the scent of the mignonette and the sweet peas, but even in the beauty of the garden, he was strangely aware of danger in the world. In spite of his great affection for the birds, he would frighten them, "robins in particular, as they hopped about on the lawn ... to make them wary in a cruel world and less likely to be caught by cats or people."[13] He was conscious of the possibility of death, aware of it as a "presence and it would come to him at ordinary moments such as when playing croquet in the garden."[14] Though he was "extremely shy and afraid to speak to people," he said, "I had tremendous confidence in myself since I was about three or four."[15]

Within the house was beauty and colour, from the deep blue carpet in the long living room, with its border of a Greek key design,[16] to the rich furnishings which reflected the influence of art nouveau. P.K. Page, a friend from those early years, described the rooms:

> The furniture—dark oak—intricately carved, in many cases by the Bateses themselves, and innumerable "objets d'art"—fashioned of silver or ivory—covered the occasional tables: perfect little elephants, photos in silver frames, snuff boxes, patch boxes.[17]

Page often saw in Bates's paintings in later years reflections of the furnishings: the strong colours, the patterning and the beautiful objects.[18] The beauty and even richness of the

culture of his home in contrast to the relative rawness of the growing city on the prairie must have set up a creative tension in the child. From a very early age he knew he would be an artist, and his early consciousness of the polarities inherent in human existence would be with him all his life.

An only child until he was eight, quiet and inward looking, Max was often lonely in a not always understanding adult world. He was most often with his mother, sometimes accompanying her on shopping expeditions. He remembered in later years how she stood with her elbow on the store counter while the salesgirl carefully fitted her tight kid gloves;[19] how he waited, observant, while she tried on the large, elaborately decorated hats. His continuing fascination with headgear had its roots in these early shopping trips. On occasion he went to the theatre with his parents, and he retained cloudy memories of Pavlova, Bernhardt, and a production of *H.M.S. Pinafore*.[20] As a change from the stark, open spaces of the prairie, the family often spent their holidays in Victoria. Max loved the seashore and thought the sea marvellous. He was "mad on boats"[21] and remembered building sandcastles. Often he heard his mother say that she wished they lived in Victoria, because the sea reminded her of the home she had left.[22]

In 1912, when Max was six, the family returned to Bedford, taking the long journey across Canada and the Atlantic Ocean. It was from his memory of the many hotels in which they stayed that Bates later derived his celebrated series of monoprints, *Secrets of the Grand Hotel*.[23] The drama must have seemed so mysterious to the very observant six-year-old who sat in the lobby watching the sleek ladies and mustachioed men move among the potted palms. In one of the prints he has portrayed himself, a small square figure in a trim suit and short pants standing at the window looking out. His early experience of meeting his uncles and aunts in Bedford and visiting his parents' first homes helped to reinforce those aspects of his character which can be thought of as typically English: reticence, a certain formality, a respect for convention in daily life while at the same time tolerating and even welcoming what seem to others to be outrageous ideas or eccentricity.

On their return to Calgary, Max was enroled in the small, square Haultain school, four blocks from his house.[24] Walking along the tree-lined avenue, he would pass the luxurious houses in various stages of construction and the newly erected Carnegie Public Library. This building in the classical style, with its acanthus leaf trim, sat in a formal park which had, at one end, a bandstand for summer evening concerts. To climb the steps and enter the silence of the mahogany interior was awesome for the young Max. As he left through the main door, clutching his books, he faced enormous framed photographs of Michelangelo's *David* (with a fig leaf) and *Moses* with his mysterious horn-like rays, both figures of wonder. Max's lifelong passion for reading began in these years.

At home he pored over the reproductions in the *Studio* magazine to which his father subscribed. "I began to look at these at the age of

five and continued for ten or twelve years, making copies with pencil, pen and ink and watercolor."[25] He also drew steamships with smoking funnels, railway trains and street cars.

> I climbed fences in back lanes and read Chums and B.O.P. (*Boys' Own Paper*). My mother grew lilies in flat bowls full of stones smelling rather interesting and a little decayed. The entire civilization of China was there. My mother had tea parties on the first Thursday of the month. I enjoyed these because ladies gave me pieces of cake they didn't want but thought it polite to accept.[26]

Bates, Sr. was witty in a rather dry, sarcastic way, and far from encouraging his son's drawing, he made fun of him and only tolerated the activity because it kept Max quiet.[27] The atmosphere in the home was reserved, and there was little display of emotion.

Max's principal friend during these years was Glen MacDougall, who had come to the city to go to school and lived nearby. They played on their tricycles up and down the slight slope by the Hull house. The confidence Max felt in himself made him the leader in their exploits. With the coming of the First World War, the talk of their elders led them into playing war games. Once they quarrelled as they were playing soldiers in a hole on a vacant lot. Max would only resume the game if MacDougall would answer two questions: "Is a battle the same as a war?" and "How many men on the crew of a sixty-pounder gun?" The answer chosen to the latter question was "eight" and the play was resumed.[28] In con-

trast to Max's relatively short stature, MacDougall was growing to be quite tall, and the two were dubbed "Mutt and Jeff" after the comic strip characters.[29]

Bates's status as an only child changed with the birth of a brother, Newton, in 1914. Two other children were born in the decade: a sister, Cynthia, and a younger brother, William, known as Bill. The children did not provide much companionship because of the gap in age; in fact, because of the attention given to the younger children, Max inevitably received less from his parents. However, the family was extended by the arrival of Max's grandmother, Charlotte Thomasson. His aunt Katherine Shaw, known as Aunt Kit, was widowed by the war, and when she settled in Calgary, she and Mrs. Thomasson moved into a small, attractive house, one of three that William Bates, Sr. had built nearby as an investment.[30]

Max's days were filled with the schooling available to all children attending public schools. The curriculum was rigid, heavy on the basics and with little room for such subjects as art, music or drama. The content of history, geography and literature was dominated by the British experience, and what Canadian material there was seemed dull by comparison. As a result, for those children whose parents came from elsewhere, the country in which they lived had only a partial reality. At Central High School, the curriculum was a strenuous one, with a full complement of science, mathematics, literature, history, geography, French and Latin. There was little in this curriculum to appeal to Max. Intro-

verted and thoughtful, with a passion for reading and a cultivated background, he had little in common with his fellow students. A schoolmate, Della Scott, whose father taught Max chemistry, remembers Max in grade eleven as very quiet and unsmiling; his fellow students regarded him as a loner and cynic.[31] No doubt this perception masked a difficult adolescence. Max was unusually short, painfully shy with girls, took no part in sports, and was naturally reticent. Though he was successful in completing high school, he was not considered an outstanding scholar.

He found refuge from the difficult realities of this period in his life in books, and his real education was gained at the public library. In later years he wrote, "I read a great deal at the library to satisfy an insatiable curiosity and I owe it an incalculable debt. Had I spent less time in these studies and more on my school work I should have a better academic record."[32] He was more intensely involved with what he found in books of his own choosing and in his struggles to become an artist. The books he found at home were those his father enjoyed, works by Ruskin, Dickens, Lamb and de Quincey, in addition to the volumes of architecture and art magazines.[33]

Of great importance to Max at this time was the sympathetic understanding and encouragement of Rose Page, the wife of Lieutenant Colonel Lionel Page, who was stationed at Calgary with the Lord Strathcona Horse.[34] Their daughter, Patricia Kathleen, later became the renowned Canadian poet and artist, P.K. Page. The Pages emigrated to Canada after the war and met the Bates family in Calgary. Max

remembered the meeting in 1921 at the Pages' apartment, where, a shy boy, he perched on the warm radiator, fortunately without damage.[35] The Page family subsequently moved into one of the Bates's houses, and the adults frequently gathered to pursue the art of woodcarving—designs on tables, cupboards and other pieces of furniture—or to play mahjong.[36] The children, Patricia with Cynthia and Newton and sometimes Max, would be gathered in the den. They looked at books or drew

under the hanging Tiffany lamp ... in our own little island of light, above the deep reds and blues of the Turkish carpet. Inset on either side of the fireplace were bookcases with leaded glass art nouveau doors, containing the latest copies of the *Studio*. Newton ... began all figures with the feet. ... Under his pencil, which moved at fantastic speed, pages of comic-strip characters sprang upward from their shoes. ... [Max drew] intricate mediaeval forts, each stone carefully delineated, pennants and flags flying.[37]

Reminded of these later, Max said, "all those forts and castles had to be self contained with cows so they could drink milk and great stores of grain in case there was a siege ... somewhere safe from the encroaching terror of the outside world."[38] In spite of this early apprehension of a hostile world, Max had an interest in "the unusual, the strange or foreign, sometimes the bizarre."[39] These two aspects of his nature remained constant all his life.

By the time he was fifteen, Max had produced skilful and arresting ink drawings of working people, linemen up poles and cooks in

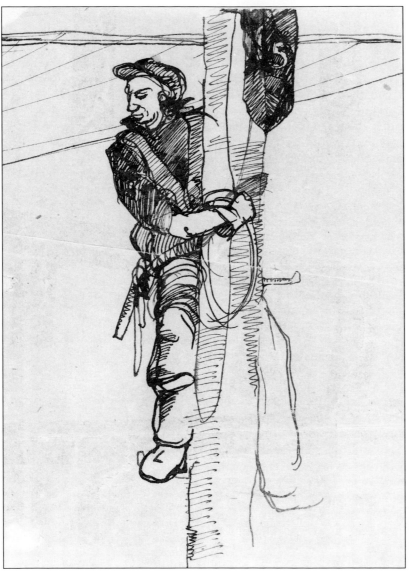

Lineman (ca.1921). Ink drawing, 18 × 13.4 cm sheet.
Photo courtesy of Destrubé Photography, Victoria. Private collection.

cafés. In the drawing, *In the Kitchen* are four burly men, cooks and butchers. Two of them are seated at a table, a knife in front of one, and behind them a companion brandishes a bottle. Each figure has a distinctive personality, and despite the jovial rotundity of the figures, there is a hint of menace and dramatic confrontation in the picture. Mrs. Page, who was very interested in Max, sent some of his work to an artist friend in England for his assessment. He wrote back, "If this boy has never seen Daumier, he is a genius."[40] Max had, of course, seen Daumier; a volume of his caricatures was in the family library, and the powerful draughtsmanship portraying the human drama exerted a lasting influence.

In those early years, P.K. Page remembers Max as shy but alert and curious about everything. He tried to play the violin, which was distressing to his listeners, but he said he liked the look of it and the sound, too, even the sound he made.[41] She recalled that her mother and Mrs. Bates were very "mod," with their hair shingled and flapper dresses. She later wrote this description of them:

> Seated in the bow window, they often had tea.
> "Auntie May" had a face like a white pansy,
> her dark hair grew in a widow's peak. Auntie
> Kit, her sister, was cheerfully sharp-featured
> with bright blue eyes. ... The green light from
> the garden dappled the three of them, ... and
> the two voluptuous white Persian cats that
> moved to their own slow music.[42]

It was fashionable at that time to read teacups and play with the Ouija board or Tarot cards in a half-serious effort to catch a glimpse into the

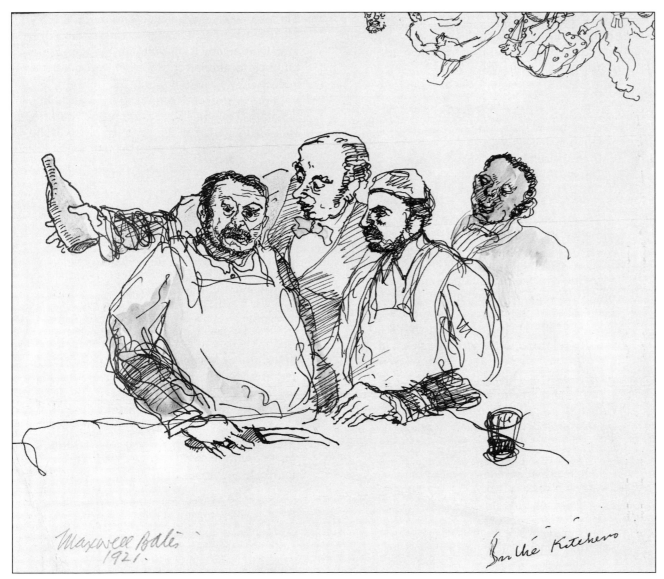

In the Kitchen (1921). Ink wash on paper, 17.6 × 16.2 cm.
Glenbow Collection, Calgary, Alberta, 72.18.4.

future. In later years Max pursued a serious study of astrology, and the look of the mysterious cards lying on a table became a stimulus to his art.

In his teens Max began to write poetry:

WAKING IN THE MORNING

Through my window
In the morning
The city murmurs:
Bird's clustered song,
Faint sound of hammer
And distant bark chide me,
And up I spring.[43]

He also tried his hand at a play in three acts, "Sky Flowers," set in a village in China. A romantic drama of disappointed love, the plot was slight but the language poetic, and as Max directed in his notes, the action would be visually colourful. The heroine lives with her father in the village and is destined to marry a wealthy official. She hopes for the return of her young lover and signals to him along the river with coloured kites, the "sky flowers." The play opens with the voice of Hao Kong, a river god.

I am the river god, Hao Kong.
I stretch from the snowy peaks to the sea
And with voices all along my length
Laugh at the men in the rice fields,
The pleasant moon at night
And ho! ho! at the august Imperial Governor
In his summer palace near my shores.
The maiden, living in the village
With her father is destined to marry
Though she waits for her true love.[44]

The play was read one evening by the Little Theatre Group which met at the public library. Max kept a copy of the play in his papers and planned to publish it.

Kite flying was a popular pastime in Calgary, with its surrounding hills and almost constantly moving air. In his poem *The Kite*, Bates anticipated W. O. Mitchell's use of the kite as an emblem for prairie boyhood.

WAKING IN THE MORNING

See the kite!
See it dive and struggle, terribly alive.
How its tormentors scream
With delight.
Look! it feels the air, the cool play
Of the wind. Now the boys are left behind,
Insignificant. It is serene
In its flight.
The string is blessed; bondage has no sting
At that height.[45]

One summer Max camped out on the prairie with the Page family, and P.K. Page has written of that time: "I remember him as short, stocky, sandy-haired, with bright blue eyes and a voice rather like an angry bee. Under the boundless summer sky there was nothing to do and everything to do." They swam in the nearby Elbow River:

... winding its way icily beneath us at the foot of a steep embankment; we could sing around a bonfire at night; search for puffballs in the prairie grasses, happy in the illusion that the Rockies were within walking distance; explore a nearby dump. Marvellous the objects which can be found if you are not too fastidious. My mother, Max and I collected pieces of col-

oured glass—gorgeous colours—rich peaty brown, 'eye-glass' blue, deep amber yellow, blood red, green; and the opaque white or patterned bits of broken pottery. With these as our tesserae, and clay from the river-bed spread on unused shingles as our ground, we made mosaics. Max's, as I remember, were bizarre figures, forerunners of his beggar kings—brightly-coloured, antic and beautiful—but because of the nature of the materials, as impermanent as flowers.[46]

Nancy Townshend, in her study of Bates's work, saw this experience as a valuable lesson in helping "him 'to see' the formal potential of large coloured shapes relating with one another."[47]

Along with this development in his art, he was reading the works of the great European novelists. The first librarian, Alexander Calhoun, an intellectual and social activist, made the library a partner in all the cultural developments in the city. He built a collection of books of high quality, which served serious readers well, and mounted exhibits of fine art in the building. From the library Max was able to borrow Hugo, Zola, Conrad and Kipling; but it was with the Russian novelists, Tolstoy, Turgenev and especially Dostoevsky that he was most deeply involved. He felt that the works of the Russians were "very apropos of my life somehow ... they seemed to be right, the sort of thing I liked."[48] Fortunately there was also a considerable selection of books on art and art criticism, many of them well illustrated. He was impressed by Roger Fry's *Vision and Design*, and Clive Bell's *Since Cézanne* and *Civilization*. He read Ruskin's work on drawing

with close attention and for a time followed its precepts slavishly, practising that "discipline and attention to detail upon which Ruskin had insisted."[49] He "became most interested in the drawings of Michelangelo, Rembrandt, Goya, Daumier and Forain and the paintings of the last three along with Degas and the Post-Impressionists."[50] At the same time, he read works on literary criticism, philosophy and psychology. Thus Max became steeped in European culture and was able to satisfy his hunger for visual and intellectual stimulation.

Another young man determined to become an artist, William Lewy Leroy Stevenson, habitually browsed along the library shelves, and one evening the two met. In Max's own words:

> It was my habit, in about 1925–26 to walk the four blocks to the Public Library on one or two evenings a week. I was a voracious reader of several kinds of books. One of these categories was painting and art generally. The Library possessed about sixty books on those subjects, all of which I should read, I had decided. Many of them were of value to me as a student teaching himself to become an artist, and deserved re-reading several times. Not having the sense and resolution to go to a good school of art and support myself by a spare-time job in some city less peripheral than Calgary, Alberta, I decided to learn by myself at all costs. ... I was unaware of other artists, and students of art. So I was not unsurprised when, one evening, a man who had been looking in the art section introduced himself to me as the secretary of the Calgary Art Club. It appeared in due course that he would like to recruit another

member. He introduced me to another man looking at art books, William Leroy Stevenson, who was to be a good friend until his death in 1966.[51]

The two young men did indeed join the Calgary Art Club, but they got much, if not more, benefit out of their own discussions, which began that very evening as they sat and smoked in the park.[52] While Max was learning the basics of architecture in his father's firm, Stevenson was employed by the Alberta Wheat Pool. Both young men were "loners," and both were determined to pursue their own paths. At their next meeting Stevenson showed Max some of his watercolours, one of which he propped up under a street lamp on their way to the nearby café which was operated by a rather stout Greek man. Paintings were propped up in booths for discussion.[53] "Although rather unwilling, the mystified Greek proprietor was the only supporter of modern art in the city."[54] Max often brought numbers of art magazines, *The Studio*, *Apollo* or *The Connoisseur* for them to study and discuss. They must have seen and talked about some Gauguins, because the secretary of the Calgary Art Club, the lively Harry Hunt, teased them about being followers of "Googan."[55] In later years Bates described this time as the most important of his life: "That period when I used to meet Stevenson and go down to the library ... I was developing my ideas about art and literature at that time and I haven't changed them. ... They've grown perhaps but not changed."[56] Their fortunate association, intense discussion, and mutual support undoubtedly stimulated and reinforced

their emerging convictions. In his notes Bates wrote: "Everything happened to me in the mid-twenties. I painted seriously and after; I was given to smoking and night walking in the uninteresting streets; sat in desolate cafés; saw the dawn, the time of reality, anti-dream time."[57]

Max and Roy took advantage of a life drawing group, organized by Hunt, which met in a basement room of the library once a week, but the group had to find new quarters when an irate taxpayer accused them of using nude models.[58] Of a pencil drawing of a nude male figure executed at one of these sessions, Ian Thom, curator of the retrospective of 1982, has written: "The figure has both a psychological and physical presence which is all the more remarkable when one considers that Bates was essentially untrained."[59] Max also worked in lino cut, and in an early one, *Siesta*, his enduring interest in and sympathy with the labourer is evident. The carpenter is seated on a ledge with his lunch pail behind him and his saw resting on the ground. In the background, partially obscured, is a circus wheel. The relaxation of the hands and feet is emphasized.

Bates and Stevenson undertook their own education, painting and comparing their work, reading about and looking at art. The library frequently housed travelling exhibitions and advertised occasional speakers. Max remembered such exhibitions as that of the work of Le Moyne Fitzgerald, the oil sketches of the Group of Seven, and the pastels of Leonard Richmond,[60] whose instructive book was in the library collection. Reproductions of the work of the great moderns—Picasso, Matisse, Derain,

Léger and Rousseau—appeared more frequently in the art magazines, and the young men studied them carefully. Of the older masters, Max "particularly admired Daumier, Degas, Vermeer and Velasquez." Max also bought books on art. One was especially important to them, *The Art and Craft of Drawing* by Vernon Blake; Max considered it the "best book on drawing ever published."[61] Gifted with an acute visual memory, Max set out to train it further and, as a result, was able to paint from memory or small scribbled sketches.[62]

There were no professional painters in Calgary at that time, so the conversation of a visiting English artist, Anthony Tyrrell-John, stimulated and encouraged the young artists. They liked his oils, which hung in an exhibition at Jack Booth's picture framing shop. Trained at the Chelsea School of Art, Tyrrell-John painted in a free, open style with simplified forms.[63] It was at this time that Max became engrossed in the modern movement, and he began "to paint Fauvist paintings of figures and groups of figures," a development which was much "resented at the Art Club." In Tyrrell-John, "who was powerfully built and took no nonsense from anybody," Bates and Stevenson found a staunch supporter.[64] The three of them formed a distinct group in the artistic community. When Bates went to London in the early 1930s, Tyrrell-John helped him with an introduction to the art world.

Also of great importance to the development of the young artists was the arrival of Lars Haukaness from Chicago. Born in Norway to a poor family, Haukaness had shown such talent that he was sent to the art school in Oslo, where he studied under the painter Fritz Thaulow, brother-in-law to Paul Gauguin and a leader of the avant-garde movement of the time. Haukaness emigrated to Chicago with his brother and painted and exhibited there. He taught for a brief time at the Winnipeg School of Art and in 1926 came west to paint in the mountains. He exhibited some of this work in a store in Calgary and as a result was contacted by the ever alert Harry Hunt, who introduced him to W.C. Carpenter, the principal of the Provincial Institute of Technology. A series of evening classes was organized, and Bates and Stevenson immediately joined. The new art school was launched with Haukaness as the head.[65]

Bates wrote of the experience of learning to draw from plaster casts of great sculptures:

The old man was a hard task-master. One of our first subjects was the head of Moses by Michelangelo. We made satisfactory drawings of this at least, (I mean Stevenson and myself) and were promoted to the *Discus Thrower* of Myron. I believe it was the end of the school year when the old man approved the drawings Stevenson and I made of it. In the autumn of 1927 we enroled again for another year. Haukaness gave us the difficult task of drawing the *Venus of Milo*, a model of which had arrived from the United States. These two years comprised the only formal training Roy Stevenson was to have. For the most part, both of us were self-taught, although many years later I was to go to art school in Brooklyn. The two years of drawing under Haukaness were beneficial to both of us. We learned that the apparent curves of

the human figure are really made up of straight lines. This Haukaness showed us. We managed, although it was extraordinarily difficult to draw the marvellously poised Venus. ... I think he [Haukaness] was the first artist to bring a professional attitude to Calgary where painting was not a life-work, but a hobby for some people ... a little foolish like yogi exercises standing on one's head.[66]

Because of the prevailing philistinism, which the young men discussed and tried to analyze as they sat in Central Park smoking in the evening, they decided that they would have to leave Calgary.[67] Perhaps in the hope of raising some money, they held a small exhibition of their work in a house, probably Stevenson's, to which they invited their friends and served jam sandwiches.[68] They did go to Vancouver for their holidays and stayed in a room near English Bay. At the Vancouver Public Library they found books on art they had not already read.[69] They sketched and painted, and one of Max's watercolours, *Beach Scene*, was done at English Bay. It features six dark-skinned figures standing on the beach with their baskets. As Townshend has pointed out:

> Like the Post-Impressionists, Bates employed coloured shapes for forms of the pants, woman's bonnet and the sea. However, even at this early date, two of Bates's attributes as an artist can be noticed: his superb colour sense, here, balancing warm and cool colours and the tension he achieved between contrasting modelled and flat forms.[70]

In Victoria they sketched every day in Beacon Hill Park, all the while discussing theories of

art, especially those concerned with rhythm. "Rhythm was of immense importance to us,"[71] as it was to the moderns who sought fluidity and movement in their composition. In an oil, **Woman with Dog**,* painted in the same period, one sees again how Bates composed with coloured shapes. The posed, seated figure holding the black dog is framed in the straight lines of windows, chair and porch. Warm, late summer colours suffuse the painting. The yellows are subtly differentiated, and the brick red of the hat echoes the red of the floor. The composition with the repeated darks is confident and satisfying.

A greater tension is evident in Bates's 1929 portrait of his mother **(Untitled**, *1929)*, Marion Thomasson Bates. A decorative figure in her brick red dress, she is seated in a white wooden chair, looking directly at the viewer with one arm forward, the hand drooping with a cigarette in it. Her short, dark hair with its widow's peak frames her pale face, and the shadow on her eyelids matches the grey-green scarf round her neck. She sits forward, half-turned away from the back of the chair as though listening to someone speaking to her. Behind her is a window draped in yellow, and forming a pattern against the drape and the grey-blue of the sky through the window are the large green leaves of a plant. The bold, well-defined shapes and the flat colour show the influence of Gauguin and the Fauves whose work Bates admired and whose original paintings he was to see the next year.

*****Bold italic** type indicates presence of colour plate in this volume.

In the winter of 1928, Bates and Stevenson submitted four paintings each to an Art Club exhibition that Harry Hunt had organized in downtown Calgary. Max wrote:

One of mine, entitled male and female forms was the first abstract painting to be exhibited in the City, possibly in Canada. Both Calgary newspapers printed letters to the Editor, recommending that I be confined to an asylum. Stevenson's paintings were less extreme, but annoyed many people; some of whom made some effort to prevent us exhibiting again in Calgary, and certainly not in a public building. Really, it was good to have reached these people, but we did not appreciate this at the time.[72]

It is very hard to see from the surviving sketch of the offending work what all the fuss was about, but that rejection certainly hardened Max's determination to leave Calgary. It was some consolation that shortly after this, two of Max's works were accepted out of 400 pieces submitted to a New York competition conducted by the Opportunity Gallery.[73]

The next year Stevenson and Bates travelled to Chicago for their holidays, probably influenced by what Haukaness had told them of the treasures of the Art Institute. There they hurried past the old masters[74] to the post-impressionists, Cézanne's famous apples lying on a folded cloth, *La corbeille des pommes*, Rousseau's *La cascade*, with its exuberant jungle and figures of black men and deer.[75] Stevenson looked intently, "with the sharp discriminating eye of a boy," at a still-life by Dunoyer de Segonzac.[76] Stevenson was ob-

sessed all his life with de Segonzac and Cézanne, and his work showed their strong influence. The young artists admired the works by Degas and a Tahitian painting by Gauguin of a female figure with a beneficent deity in the background. Van Gogh's *La chambre à Arles* was there, as well as *La berceuse*, a still life with melon, fish and jar and a view of Montmartre. Seurat's brilliant *Un dimanche à la grande-jatte* must have been a revelation to them. There were two still-lifes and a very beautiful landscape by Derain. They saw *Femme au divan rose* and *Femme devant un aquarium* by Matisse and an emaciated figure in *Le guitariste* by Picasso.[77] Bates and Stevenson had already spent hours studying reproductions of the great works of these artists and now could see the originals in their proper scale, study the painted surfaces, the brush strokes, the wonderful reality of the paintings.

The excitement and scale of the big city affected them also and Bates wrote of this in his poem "Night Mutter," with its strong sexual symbolism. The moon, in words and visual imagery, continued to appear at intervals in Bates's work.

NIGHT MUTTER

Chicago at night,
Above the green lake....
Mutter no lies.

Young sky-scraper,
Verge into the big, she-moon;
Tall moon-raper.
Croon

With night cries,
Windows in flight.....
Over a green lake
Full of sighs.
Shake,
White reflections;
Hang in shimmering green.
Poignant sections
Cut by lights arcing
The green lake.
Care......You are marking
Time's Book.[78]

This journey was undoubtedly a most important one for the young artists because it confirmed them in their artistic beliefs and inclinations. Both young men were at odds with their society, and this resulted in an inwardness and intensity which they expressed in their work through strong colours, simplification and distortion of the natural form. Their romantic dispositions, their pursuit of the intrinsic and individual, together with their intensive study and analysis of modern works, resulted in an expressionist mode of painting. Bates regarded himself and Stevenson as pioneer expressionists in Canada.[79] He later wrote:

> As a self-taught painter, I have moved in directions that seem interesting to me, however absurd other people, not artists, may think it is. My father, an architect, was often horrified. Strangely enough that seemed to me reason to feel encouraged. ... In painting I have always sought after intensity.[80]

Two poems written at that time reflected in words that intensity, human drama, and mystery which imbue his works. In the first is the melancholy of the autumn and that sense of danger which he had from childhood.

OCTOBER EVENING

Bluish air
Hangs coldly this evening;
Trembling brown leaves
Hang over the doorways,
And triangular
House-roofs are darkening
Below the orange ring of the moon.
Now timid rays of light
Switch on in a kitchen;
The sudden shadow of the bulb
Sways large.
Footfalls
From the street, a laugh and swish of leaves:
Quick, stifled jets of sound.
A man stands in the kitchen;
The window fills with shadow
And overflows
In broken pattern on the glowing ground.
He seems a janitor
Moving around in the apartments of evil.[81]

"Bricks and Leaves" was inspired by Brickburn, a small abandoned settlement west of Calgary on the railroad. The poet Robin Skelton wrote of this poem that "one finds both his fascination with colour and his interest in the worn and soiled world of human labour and human decay."[82]

BRICKS AND LEAVES

The railway tracks
By the brick-kilns poke through bricks:
Reds, yellow, browns and blacks.

Smoke stacks
Once smudged the sky;
They stand like trees
Naked over their leaves:
Reds, yellows, browns and blacks.
Workmen's shacks,
Vacant and wooden, squat to watch
The white-crossed cemetery,
Where set in the dull, rich clay
Those other products of the kiln,
Yellows, browns and blacks
Moulder and decay.[83]

Three works painted after his experience in Chicago show Bates experimenting with different styles. **Washerwoman**, with its brilliant colours, simplified forms and vitality, expresses the exhilaration of youth and the discovery of a freedom in paint. In *Painter's Bedroom and Studio*, crowded with furniture and his easel, Bates tried a cubistic manipulation of planes. Of a third painting, *Family with Pears*, Ian Thom has written:

> An astonishing tour de force. Three figures are arranged frieze-like across a narrow space. Each holds a pear and each inhabits a discrete psychological space, none of the figures communicate directly with the viewer or each other. The whole is unsettling and this feeling is reinforced by the tight, theatrical space, direct application of paint and apparently crude drawing.[84]

Max continued to work in his father's architectural firm while painting in the morning and late at night. The First World War and the subsequent depression had put an end to Calgary's building boom, but Bates, Sr., who was now on his own, was one of the city's few remaining architects who was able to keep his firm going.[85] During these years, the Roman Catholic Church was the firm's chief client, and when additions to the Holy Cross Hospital were commissioned, the Bates firm designed a beautiful chapel.[86] His busy father welcomed Max's tracing and draughting help in the office, and Max learned a good deal of the basics of architecture while absorbing his father's belief and insistence in practice that buildings should conform to the best of human needs and aspirations.[87] Max was genuinely interested in architecture and had sometimes amused himself making house designs. True to form, Max read all the books he could find on modern developments in the profession. In later years, though, Max confessed that he found it difficult to work with his father.[88] This situation reinforced his intense desire to get away from Calgary.

Little encouragement for the young artists was offered by Alfred Crocker Leighton, appointed as head of the Provincial Institute of Technology after the death of Haukaness in 1929. Leighton was familiar with Canada, as he had been commissioned to paint landscapes for the Canadian Pacific Railway. An accomplished artist and superb watercolourist, he was steeped in the English tradition; to some degree, he saw the Canadian landscape through European eyes. An exhibition of his works had been held at the Calgary Public Library in 1927,[89] and Bates and Stevenson had undoubtedly seen it. Of their meeting Max wrote, "Leighton seemed to avoid John, Stevenson and myself from the time of his

Family with Pears (1929). Oil on panel, 50 × 40 cm. Photo from Maxwell Bates fonds, Special Collections, University of Calgary Libraries. Private collection.

arrival in Calgary. ... I was introduced to Leighton at a lecture at the Public Library but I could not get him to say anything."[90] This was a disappointment, for Stevenson and Bates had hoped to find him attuned to their views of art.

Bates's account of the founding of the Alberta Society of Artists is illuminating and, though written years later than the actual 1931 event, betrays the bitterness he continued to feel at the rejection of his and Stevenson's views in the Calgary of the time. His version was based on what he had been told by Stevenson and other artists. Leighton, who had initiated the movement to form the Alberta Society of Artists,[91] was joined by Walter J. Phillips and Vancouver artist Charles Scott. The three men began selecting the society's members in the company of John Booth, who was notorious for his drinking and powerful brews. Bates wrote:

> I had left Calgary by the time the first members were chosen, but Roy Stevenson was here and remembers some of the circumstances. He submitted three fairly large canvases but he was turned down by Leighton who told him that he should have submitted some of his small watercolours. Stevenson said he preferred the paintings he had submitted. It appears that when Scott and Phillips arrived to choose, with Leighton, the members of the society, they fell into the hands of a picture-framer called Booth. Booth had done much to retard the progress of art in the city by protesting every time an exhibition came to the Public Library, and by pretending to a knowledge of art. ... The visiting artists were entertained by this man, first in one or two beer-parlours and later in

the day at the rear of his establishment. The story goes that when the jury met to choose the original members of the A.S.A., anything Leighton said was agreed to by the other two who felt very genial and happy indeed. The members of the new society could congratulate themselves on being members of a very homogeneous club under the influence of the British School.[92]

This influence was remarkably strong, and as a teacher, Leighton perpetuated it, tending to encourage those who adhered to his methods and style. Bates knew that he, like Stevenson, would have been refused membership in the society; but he did not have to face the rejection as Stevenson did, since by that time he had left Calgary.

The lack of encouragement Bates suffered was mitigated to some degree when his oil *Family with Pears*—listed in the catalogue as *Family with Tears*[93]—was selected for a representative exhibition of Canadian painting in Ottawa's National Gallery. His work was also shown at an exhibition at the Art Centre in New York.[94] This recognition undoubtedly spurred him on in his desire to strike out into the larger world. He had managed to save one hundred dollars and had decided to go to England.[95] His younger brother Newton, now in his late teens, was still at school in British Columbia, and Cynthia and Bill were at home. Neither Max nor his family suspected he would be gone for fifteen years. He took with him a few of his paintings, among them **Washerwoman** and **Woman with Dog**, and travelled by the classic Depression route—cattle train and boat.[96] His job was to feed and tend the

cattle on the train and in the hold of the ship, *The Salacia*. It carried a very rough crew, and conditions were so bad that some of the crew, Bates among them, confronted the captain, who threatened to put them in irons.[97] The threat was not carried out, and young Bates returned to his job with the cattle. Lying in his bunk, he could hear through the ventilator "the intermittent snore of the sea." As they approached Liverpool, "to leeward lay Ireland in full sunshine. Even above the harsh call of gulls and the hiss and rumble of the steam winch could be sensed the soundless fall of the waves upon its beaches seen oddly now and then between bale and bale of hay."[98]

From Liverpool he travelled to Bedford to visit the relatives he had met nineteen years earlier. While there he had the opportunity to paint again, and an excursion to Hunstanton-on-the-Wash resulted in three watercolours: one of the lighthouse, the second of the merry-go-round at the fair, and a third with the interesting title *Actress (dressing room)*.[99] After a short stay, Max made his way to London.

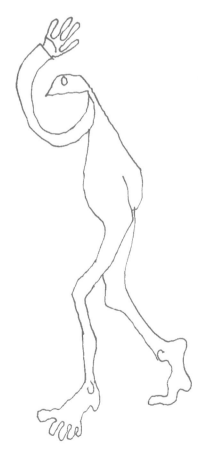

Londou, 1931-40

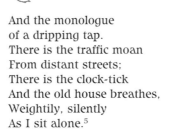

At 88 Holland Road, in London, Max found a bed-sitting room where he could paint, and managed to get a job selling Hoover vacuum cleaners and water softeners from door to door.[1] The genial, chatty approach necessary for door to door selling must have been excruciating for the reserved, even taciturn young man. His energy was drained, and the pay was minimal. As he most succinctly put it: "From 1931 to 1934 I mainly starved."[2] In his unpublished manuscript "Vermicelli" he wrote, "After six hours 'On the knocker' in the respectable wastes of Ealing, I didn't always feel like walking three miles there and three miles back" to the Chelsea Studio Club.[3] But his misery had some company there. He "had a number of painter friends also living on the starvation level—one of them (a very good painter) lived on bread and butter and took shelter in hallways and the studios of friends."[4] Even so, the loneliness he felt during this period is evoked most poignantly in his poem, "Sounds:"

> The old house is vacant
> And I sit alone;
> Alone with the conversation of cisterns

And the monologue
of a dripping tap.
There is the traffic moan
From distant streets;
There is the clock-tick
And the old house breathes,
Weightily, silently
As I sit alone.[5]

But loneliness was accompanied by a new freedom, and Max was determined to paint. He recalled that "With what money he could manage he bought poor-quality powdered paint and applied it to any flat surface he could find."[6] He lost no time in approaching the galleries to persuade them to take his work, some of which he had brought from Canada. In the fall of that first year, Max showed four watercolours at the prestigious Redfern Gallery.[7] He was also invited to join an exhibition of the work of five others, one being Anthony Tyrell-John. The exhibition at the Bloomsbury Gallery was an important one and was opened by John Skeaping, painter and sculptor.[8] The eminent art critics R.H. Wilenski and Clive Bell saw the exhibition and gave Max some welcome criticism: Wilenski said Max "really

Alone with the Conversations of Cisterns
~~And of but a dripping~~
and the monologue
of a dripping tap.

Sounds

The old house is {vacant / ~~empty~~}
And I am at alone;
Alone with the Conversations of Cisterns
And the monologue
of a dripping tap.
There is the traffic moan
~~Into distance~~
From distant streets;
~~Clock-tick.~~
There is the Clock-tick
And the old house breathes,
~~Heavily~~
Weightily, insilently
As I sit alone.

Poem written in London (ca. 1932). Maxwell Bates Papers, Special Collections, University of Calgary Libraries

painted at times, at others merely filled in patches of colour,"[9] and Max recorded in his notebook that Bell took the trouble to send him a postcard from Rome.[10] The attention from these critics, whose works he had read and whose opinions he valued, may have helped compensate for the Hoovers and poverty, making him feel nearer to the centre of the art world.

After the exhibition Max was invited to join the famous "Twenties Group" sponsored by Lucy Wertheim,[11] whose wealthy husband indulged her encouragement of young British artists in their twenties. "There was no subscription and I charged no fee for exhibiting," she wrote. "Soon I was inundated by requests to look at work and I made it my job to interview every applicant personally. Artists came to see me from all parts of the British Isles, from the Continent and from the Colonies."[12] Her gallery in the entresol of the Burlington Gardens was inviting, quietly elegant.[13] Max recalled, "I rarely missed exhibition openings at the gallery of my dealer in Burlington Gardens, where there were cocktails and new people to meet." But if Wertheim's gallery was elegant, this was Depression London—and there were other invitations along the way. Max continued:

> This meant walking from PICCADILLY past numerous women lurking in shop entrances.
> A typical encounter started with: COME TO MY ROOM, DEAR. My move was simply an admission of having no money. ... Little did she know I would have liked to give out six or seven five-pound notes along the way, had I had some to spare. Some of these dames had

good legs, as far as I could see. And a five-pound note would have been for no services rendered, just to show my good intentions, in fact.[14]

That first year the Wertheim Gallery held seven of Max's watercolours and ten oils, most of them small, measuring twelve by fourteen inches.[15] Many of the young artists associated with the Gallery are now well-known, among them Christopher Wood, William Townsend, David Gommon, Matthew Smith, Victor Pasmore, Barbara Hepworth and Anthony John.[16] Two of the already established artists who showed at the gallery were Phelan Gibb and Frances Hodgkins, both of whom had instructed the young Emily Carr.[17] There is, however, no indication that Max was ever aware of this link with another Canadian artist.

In order to promote her artists as widely as possible, Wertheim formed a loan collection of oils and watercolours which she circulated throughout England at no charge except for transport and insurance. The works of thirty-six artists, some established and some new, were in the collection. The most prominent of the established were Phelan Gibb, Frances Hodgkins and Walter Sickert. She chose the work of five of the seventy-four members of the "Twenties Group," and Max was represented by both oils and watercolours.[18] Thus the works of the twenty-seven-year-old Bates hung in comparison with atmospheric interiors by Sickert, Gibb's Matisse-like figures, and Matthew Smith's vibrant compositions full of daring colour. Wertheim wrote of the group:

In the year 1933 these names were practically unknown to the public and the greater proportion of visitors had never seen a 'modern' painting before. Again and again I was told, sometimes jeeringly, that the crowds who visited the exhibition were only doing so out of curiosity.[19]

That Max was in the forefront of the "Twenties Group" is further suggested by his invitation to submit an article to a quarterly magazine, *Phoebus Calling*,[20] launched by Lucy Wertheim, but lasting only two issues. He chose to write "On Naïve Painting," which he termed a "section of Post-Impressionism" and which had interested him since his early admiration of the work of Henri Rousseau.[21] He defined his subject:

> Naïve painting is more emotional than painting built on a theory or method invented by the intellect, and this lack of an accepted method or theory has the virtue of allowing it to be intensely individual; full of the personality of the painter. ... In the subjects chosen we see an absorbing interest in people and all those things commonly used by them. ... The naïve painter is a Humanist; making plastic comments on the residue of daily life.[22]

Chosen to illustrate his article were works by "Twenties Group" artists, including one of his own, *Woman with Fowls*,[23] which he had painted at Hunstanton. Ian Thom has described it as

> a paradigm of naïve painting—a simple, almost stylised figure, does washing in a tub and then turns to hang it on a line. The

woman ... is made faceless and the work retains some of the hieratic quality of *Family with Pears*. ... The extremely shallow space, which becomes a characteristic of much of Bates' figural painting, is derived from his study of Matisse and to a lesser extent Picasso.[24]

In January of 1934, Wertheim nominated Bates for election to the National Society of Painters, listing his name among three she was asked to submit from her gallery. She also arranged a one-man show for him in Manchester,[25] and she continued to purchase his work, though at what seems now a very low price, usually one pound. In later years Max spoke bitterly of this: "I got miserable prices, absolutely miserable. It makes me cringe to think of it. Beautiful paintings I used to do in those days and sell them for fifteen shillings each."[26] In the economic and artistic climate of the time, Bates was fortunate to enjoy Wertheim's steady sponsorship, and she purchased over sixty of his works during this period.[27]

With what time he had free from Hoover selling and painting, Bates explored London. In a poem written in 1932, he captured one familiar street scene:

STREET MUSIC

From the side of a street
Where stand two clowns
Wavers the sound of a melancholy trumpet,
Under the traffic sounds, between brief winds
That cause a rush of leaves
To drown
And sanctify the bathos of their lives.

Dark tinkles
Intermittently unreal
Vary the falling blare, the uncouth echo
Of their frowns.
Then the clatter of the hat,
Dance of copper, which seems to them
A brief sparkle of music.[28]

He loved the feeling of history all around him, the evidence of human drama through the generations. He attended the major exhibitions of French paintings, renewing his acquaintance with the works of Cézanne, Lautrec, Pissaro, Degas and Van Gogh. He prowled Charing Cross Road, haunting the book stores and print shops, where he especially admired the Japanese printmakers. He wrote:

There are two distinct qualities expressed in Japanese art: one, endless patience in execution of minute detail; two, a momentary conception of some fleeting idea boldly and freely carried out; profuse complexity and extreme simplicity, apparently inconsistent qualities. People of the West marvel at the former and are fascinated by the latter.[29]

Despite his penury, he was able to assemble a small collection of the prints.

Max also pursued his interest in astrology. "I used to go down to Cecil Court just off Charing Cross Road where there was an astrological bookshop and I used to buy books there. ..." Max recalled. "I studied late into the night reading astrological books, doing charts and things. ... I used to do all my friends' horoscopes." In the bookshop Max met a man he characterized as one of the great amateurs

of the nineteenth century in astrology. "I used to dine with him every Friday night for years. We used to go to the same place and have dinner and he used to talk about astrology a great deal and I used to ask him a lot of questions." Presumably it was this friend who so impressed him with the accuracy with which he described Max's circumstances and future, even before he cast his horoscope. The experience convinced Bates that "there is definitely something in it. ... It's not just a lot of nonsense."[30] Max's interest in the occult had been aroused in his childhood and continued all his life, an element in his constant desire to reach beyond the world of appearance. Something of these interests can be glimpsed in this poem written in 1934:

JOURNEY TO A LITTLE BEYOND THE WORLD

I ventured into the world
And a little beyond.
I left behind me
The iron eyes in pulpy faces;
Left behind
Were aberrant youth
And folly grown old.
I left behind
The Millionaires in Phrygian caps:
Became a vagabond
In empty spaces
Without benefit of maps,
Using the compass of the mind:
The needle of attention
Pointing always
To what I had not been told
And explained.

I came upon a building's skeleton
Standing alone, the ribs of timber
Silvered by rain and sun,
Dry grass about the walls of mottled stone.

I wandered in desolate places
Where the wind rages
At the resistance of columns,
And I remained alone
Where the sunset fought the evening
In a lingering battle.

I came upon a book thrown on the grass;
Lying open, the forlorn pages
Yellowed by age and damp,
Of ancient ink remaining but a trace.

I wandered reading in the ancient book
Deciphering a little
About aberrant youth
And folly grown old;
And returned
Wondering, to the Market Place.[31]

Max communicated his enthusiasm for London life to his young friend P.K. Page, who arrived in London in 1933. She wrote:

He introduced me to the Wertheim Gallery. ... And he told me the painters worth watching for in London, the galleries worth going to. Perhaps he directed me to Stanley Spencer, with whose work I fell so madly in love. Certainly he gave me another window on painting in London in 1933. And as we parted at the tube station ... we stopped first at a locker from which he removed some canvases and propped them up against a wall for me to see. Small, brilliantly coloured oils, vibrantly alive in the grey of the underground.[32]

Max also spoke to Page of his admiration for Paul Nash, the English artist whose work had been influenced by Cézanne and the cubism of Picasso and Gris.[33] Like Lucy Wertheim, Nash was concerned with revitalizing British art, and in 1933 he had helped form "a new group of English artists—painters, sculptors and architects—which adopted the name "UNIT ONE."[34] Max, who read as voraciously as ever, was alert to the turmoil of London's intellectual life and followed the fortunes of "Unit One." Earlier he had been stimulated by the Vorticism movement under Wyndham Lewis and Ezra Pound, the effects of which were still evident in art and literature. Their publication, *Blast*, was widely influential, despite the fact that only two issues appeared.

Bates's discernment in focusing on the work of Spencer, Lewis and Nash was confirmed fifty years later in an essay by Robert Hughes, the art critic, in which he singled out their work as most significant in English art in the twentieth century.[35]

He kept abreast of contemporary events in Europe, the Spanish Civil War and the rise of Fascism, but he was also reading widely about less contemporary issues. He not only used the Kensington Library near his flat but got a reader's ticket for the British Museum. He sat in the "gods" at the Old Vic theatre. He came to love ballet, attending the Sadler's Wells company, along with such imports as Colonel de Basil's Russian company.[36]

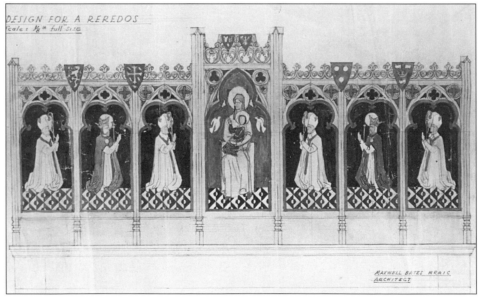

Design for reredos (ca. 1938). Watercolour, 30.6 × 43.7 cm. Photo from Maxwell Bates fonds, Special Collections, University of Calgary Libraries. Private collection.

Bates's life took a new turn in 1934 when he joined the architectural firm of J. Harold Gibbons, whose wife, Constance, was his mother's cousin.[37] It is possible that Max could have joined the firm earlier but for a stubborn determination to make his way as an artist. Having achieved a measure of success there, his decision to work with Gibbons enabled him to develop the second career which he had begun with his father. Gibbons was a Fellow of the Royal Institute of British Architects, a specialist in ecclesiastical architecture and considered an expert on Westminster Abbey.[38] Though distinguished in his profession, Gibbons was also an eccentric. He suffered from extreme swings of mood, and his wife came to rely on Max, who often visited them at their home, 16 Crooked Usage,[39] to prevent Gibbons from doing anything too outrageous. Gibbons was fond of music, played the violin, and in an attempt to organize a small orchestra, advertised for office boys who could play instruments. On one occasion Gibbons and Max passed a street violinist, and Gibbons tossed the man some money, took up his violin and played it.[40] Another time Gibbons's wife had to retrieve him from the police station. The police had found him covering the windows of his house with treacle and paper to prevent them from shattering and had mistaken him for a burglar. He seemed to be affected by the full moon. During one such phase he disappeared but finally contacted the family with the news that he had bought a white horse and was riding it to London from York.[41]

Gibbons's eccentricities seldom interfered with his work, and Max, who always relished the unusual, would regard them tolerantly. Gibbons furthered Max's education by taking him as a guest to the meetings of the Art Workers' Guild, whose members were architects, sculptors and painters. Gibbons' firm used "a good deal" of sculpture in their work and at the Guild meetings Max learned more about the practical aspects of architectural sculpture.[42] The firm not only designed and built churches, but specialized in their restoration and decoration. Max's design for a reredos still exists as a watercolour sketch. The image of the Virgin and Child in the centre panel is angular, and the Child is plainly a small boy rather than a baby. On either side kneel three saintly figures, bishops with their staffs and two crowned kings. The diaper pattern of the base ties the panels together. Max clearly liked that aspect of ecclesiastical architecture which involved the use of symbols and colour in the church, though not from a religious point of view. "I have always had an interest in religion, but my ideas on it are unorthodox and mystical," he wrote. "For me, religion and philosophy are the same: a search for the real and the valuable."[43]

The new stability in Max's circumstances allowed him to do more travelling. He had returned in 1934 to Bedfordshire and Hunstanton, where he did a number of paintings[44] and wrote the following romantic poem, which he dated "Hunstanton, Norfolk, 1935."

BEACH

A maid lay on the long slope of the beach
And love lay lonely in the ribboning wind.
As I walked on the straightening curve of
 reach,
Her face was hidden by the space between
Where the whitening verge of the sea slid up
 the stones
And love lay lonely in the ribboning wind.
That broke white domes of fountainous beads
Into the moving marble of the frayed wave-
 edges.
And love lay lonely in the ribboning wind,
She lay below the long beach ledges,
Under the sky's majestic level-headedness,
The grey and blue of marching summer
 cloud.
I, striding on the long curve of the beach,
Came level with the straightening of the
 wind;
Her face was Helen's and her soul was
 mine.[45]

Following this happy change in his fortunes came new friendships of considerable importance to Bates. At an exhibit at the Chelsea Studio Club, Max showed two oils, one of which was the **Washerwoman** he had brought from Canada.[46] Attending the exhibition was a young collector, Villiers David, who made Max's acquaintance, and through him, Max also met two other young men, Marcus Cheke and Brinsley Ford. All three had an interest in art and frequented the galleries, especially the Wertheim, where they had seen and been impressed with Max's work. As well as being a wealthy collector, Villiers David was a gifted amateur artist with a studio in King's Road. Like Max, he was enthusiastic about Japanese art.[47] His friend, Brinsley Ford, later Sir Brinsley, was the possessor of a magnificent collection of art that his family had been assembling since the eighteenth century. In his subsequent career, Sir Brinsley became an expert on collections and a trustee of the National Gallery. The third member of the group, Marcus Cheke, was a young diplomat, at that time stationed in the British Embassy in Brussels. As Sir Marcus he later became British ambassador to the Vatican.[48]

An entry in Bates's notebook shows that on 29 January 1936 Villiers David purchased *Washerwoman* and that the next day he took a chalk drawing, *At the Piano*, paying ten shillings for each of them.[49] The beginning of the next month, on 11 February, Villiers David and Brinsley Ford visited Max's ground floor "bedsit" on Holland Road in Kensington. The young men were approximately the same age as Max and had, as Sir Brinsley said, "great admiration for his work."[50] Ford bought an oil, *Sunday Evening*, and a watercolour, *Youth and Pear by Window*, and for each he paid a pound. That day David bought another Canadian oil, *Park*, for which he again paid ten shillings.[51] Throughout February and March the two young men bought a total of fourteen paintings. David then commissioned Bates to do a portrait of him "in two positions," for which he paid Max three pounds. Brinsley Ford was much more generous, paying ten pounds for his fourteen by sixteen portrait on straw board.[52] The price of a good suit in those years was twelve pounds.

In the portrait of Ford, the subject is set against a faintly pink-grey background; on the

right is a drape of a darker blue-grey with light brown stripes. Ford is seated on a couch with a lozenge pattern, and he is facing full forward. His face is in grey tones; his hair brown with white highlights. The shirt he wears is a pale pink with grey-green stripes, his suit is a grey-blue, and his tie is brown. Two letters can be discerned on the cover of the book he is holding—a "*T*" and an "*L.*" When the portrait was painted, Ford was still excited about his purchase of the previous year, a beautiful Toulouse-Lautrec,[55] and Max cunningly offered a clue to this enthusiasm. The characteristic use of colour, the composition, and the direct approach typical of Bates's mature work were all evident in this early portrait;[54] and as Sir Brinsley noted, it was executed in a very painterly way.[55] Max was always as interested in paint and colour as he was in the subject.

Sir Brinsley kept two of Max's watercolour sketches showing the three friends together. They were, he said, "not meant to be likenesses, they are what you might call hierarchical"[56] and were probably designs for a screen. They seem a celebration of what was to be a lifelong friendship. The sketches were executed in David's studio,[57] and in one, the young men sit on the seat along the window through which you can glimpse the brick coloured chimney pots. The colour scheme is a green-blue with a peach background. David sits in the middle, looking intellectual and rather "owly," while Cheke unaccountably seems to be holding a tawny lion cub, possibly a quirky reference to his status as a British diplomat. Brinsley Ford appears as the expansive one, wearing a deep green-blue suit. The three are flanked by classical statues, and the whole effect is one of a frieze. In the second work, David is garbed in a black, kimono-like robe, looking very Japanese as he works at a canvas. Cheke stands in the background, while Brinsley Ford is again the active figure. The overall impression is of three charming, urbane and intelligent young men eager to experience the best of their age. Bates must have enjoyed their company and their admiration of his work, for they became friends as well as patrons.

A chance for Max to visit Brussels and the Belgian coast came in 1936, when he was invited to stay with an aunt who had taken an apartment in Le Zoute in Belgium. "I got leave of absence to visit her there during the summer," he wrote. "This proved to be a very valuable sketching trip mostly in the coast towns, but extending, on occasion to Ostend, Bruges and Brussels, and Wallcheren in Holland."[58] He sketched old buildings at the seaside resort of Knokke, and at Le Zoute he wrote a strange poem, "Evening of an Actress."[59]

EVENING OF AN ACTRESS

Those fluttering, delightful birds are dead
 now
In an empty hollow of the hills.
The drawnout summer stare of the sun has
 ended
And the moon moves up the evening:
Calm echoes of a trumpet note remain
Receding in the stillness of her brain.
Her purple eyelids tremble, she is tired.
She is tired of the evening emptiness;

Of the dark noise of a crow in the rafters.
She is tired of tumult. Plebeian obsequies
Have killed the birds that sang of victory
Under the monumental arching of the trees.[60]

This same dark intimation of the passing of triumph and glory into tumult and decay was, according to the critic Herbert Read, a strong element in the *International Surrealist Exhibition* held at the New Burlington Galleries in London in 1936. In his introduction to the catalogue, Read wrote: "It is not just another amusing stunt. It is defiant—the desperate act of men too profoundly convinced of the rottenness of our civilisation to want to save a shred of its respectability."[61] Richard Cork, writing on the anniversary of the exhibition, commented that:

> Read's critical endorsement had not been heard in British art since Vorticism burst upon London 22 years before. And as his reference to "rottenness" implied, the artists who contributed to this huge survey at the New Burlington Galleries were acutely aware of the social unrest mounting in turbulence as the Thirties proceeded.[62]

Surrealism had begun in France early in the century as a literary movement in revolt against bourgeois conformity and rigid rationalism. Under the influence of Sigmund Freud, the writers sought a new path to truth and a new, better way of life through the unconscious by means of dreams and automatic writing. Their ideas almost immediately spread into the world of visual art and were taken up by such artists as Francis Picabia, Man Ray,

Marcel Duchamp, Max Ernst and Salvador Dali. It took some time before this mode of thought affected British art, though from the beginning Wyndham Lewis had proclaimed his enthusiasm for the work of Giorgio di Chirico.[63] English artists such as Paul Nash, Roland Penrose, Edward Burra, Henry Moore and Grace Pailthorpe gathered under the banner and were included in the Exhibition.[64] The last, a psychiatrist as well as an artist, visited Vancouver some years later and introduced Max's good friend Jock Macdonald to the technique of automatic painting.[65]

Bates undoubtedly visited the New Burlington Galleries several times and read Herbert Read's statements in the catalogue. His reaction was to write a letter to the *Listener* "deploring the movement,"[66] though he admired the work of Nash and Edward Burra. Nash exhibited a painting of a pair of wooden glove stretchers transformed into a forest, and Burra was represented by a painting called *Hostesses*, "a fanciful compound of low-life observation and Hollywood extravagance."[67] Some of the images were nightmarish and presaged the horrors of war to come. Several years later Bates elaborated on his feelings about the movement in his notebook he kept in the prison camp. Under the heading "Contemporary painting" he wrote:

> Let us gather under the pillars: the principles of organization and elements of art borne out of our conception and comprehension of rhythmic vitality will endure. They are the pillars that support all art in all times and places. ... Surrealism, while using rhythmic vitality and thus taking shelter under the

pillars has as its aim the destruction of the temple. Its purpose is to destroy all existing values and it uses the powerful forces of art as an instrument, a crowbar of destruction. It is not a normal revolt such as the many that have occurred in the centuries.[68]

Some of Max's own work subsequently showed the influence of surrealism and years later was included in an exhibition of Canadian surrealism.[69] In 1936, however, it was an echo of Matisse which was evident in *Study for Odalisque*, a watercolour and pencil piece which he considered one of his most important works.[70] The female figure patterned in blue, red and yellow sits forward in the painting, framed by her chair. With no perspective, the green carpet rises to the window and door in the background. It is a bold, strong work full of confidence. Max's mood during this period may perhaps be gauged from one of his most haunting poems:

SONG OF THE EARTH

The lovely sun watches us, he is a brilliant
 fruit
Of an universal tree, dark leaves I and the
 moon.
I sing of you, of you and I when we were one,
And the distant stars shone down,
Set in the black olympian stillness.
Then torn into the crystal areas of space,
From my womb flew, child of the lovely sun,
The winged moon, a lesser sun of night;
To sing the song of loneliness alone
On her autumnal wanderings
A cold, embarrassed replica of earth.
By wish of God. And so the men

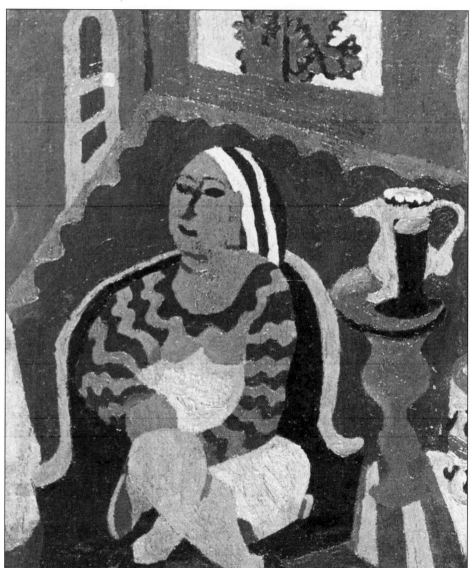

Odalisque (1936). Watercolour, pencil, 24.7 × 19 cm. Photo from Maxwell Bates fonds, Special Collections, University of Calgary Libraries. Private collection.

Who came for sadness and to rejoice
When the low torrid moon of August showed
A harvest in, or when clouds, enormous
 speckled fish
In the skies pool, moved to fields in spring.
Came, loved, and taking the dark crown of
 sorrow
Went. And still the lovely sun piercing the sky
Makes me motley and my moon
But doesn't warm her cold meanderings.
My own sweet moon.[71]

Bates turned thirty that December and thus, technically speaking, was no longer a member of the "Twenties Group." Though his works were still shown at the Wertheim Gallery, he was now free to show them in other London galleries. He left his oils at the Redfern, the Storran, and the Reid and Lefevre Gallery.[72] David and Ford continued to buy Max's work directly from his studio in Holland Road, and Lucy Wertheim planned his one-man show for her gallery in November of 1937.[73] Max submitted his work to the selection committee of the *Artists' Congress and Exhibition, 1937*, which was sponsored by the Artists' International Association meeting in London. Two of his works were selected to be hung in the company of paintings by such artists as Picasso and Matisse.[74] All this is evidence that, at the age of thirty, Calgary-born Maxwell Bates was well on his way to a successful career as an artist. He had accomplished the very difficult task of breaking into the London art world, and his work was being shown in the best galleries. He was now ready for Paris.

It is probable that Max made the easy crossing to the Continent from Guernsey, where he was holidaying.[75] Max was attracted to islands, protected and isolated like the forts of his youth. With its craggy cliffs and smugglers' coves, its old Norman language and ancient customs, Guernsey was most appealing. Sketches of "St. Peter Port ... a town of fine gables, piled roofs and chimneys, of stone steps to different levels, of passage ways and alleys and long views" soon filled his book. Guernsey was also the inspiration for two short stories, "The Cider" and "Chronicles of a Forgotten House."[76] In the second story the young hero, holidaying on the island and lodging in a rather bleak boarding house, visits the house in which Victor Hugo lived for his twenty years in exile. Bates described the study where Hugo stood to write some of his masterpieces. The young man is deeply affected by the atmosphere of the house and thinks of Hugo

> able to look through his upper windows on a fine day, at the coast of France. In that house, just off his glassed-in study, is the library as he left it, book-lined small, in size nothing, but in a way magnificent. Hardly more than a book-lined passage as it is, I had fled the richness of an atmosphere that was heavy, almost, with romance.[77]

The bustle and excitement of Paris, with the 1937 World Fair in full swing, met all of Max's expectations. He recorded his reactions to the city in his manuscript, *Vermicelli*:

> After walking all day, either in the Exposition or in different parts of the city making pencil drawings of the streets I needed a rest. I

observed other people at tables in a discreet way, fascinated by everything during this first visit to the city; a visit toward which my whole life ... seemed to have led; so much so that I did not feel like a stranger, particularly.[78]

At the Fair, he saw Picasso's *Guernica*, a powerful symbol of all the horror to come, and "found it a revelation."[79] Making sketches in preparation for his November show, he savoured the life of the Paris streets, explored the art galleries, searched for books along the Seine, and looked for prints in the art shops.

In an amusing story written about the Paris experiences called "The Dentist of the Rue Mahomet," he recounted in the first person an episode of a young man meeting a palmist:

> A minute or two later I was aware of the cheap perfume, and I felt Mme Palmi very close to me in the narrow passage. Her gloved hand was on my arm. The slight pressure was at the same time very pleasing and very slightly alarming. ... The perfume was quite strong. I did not find it objectionable; but many ladies would, I knew, and many men would think it in bad taste. Her heavily made-up face would be in bad taste too,—to many people. I am neutral in such matters and, in fact, I am more inclined to find heavy make-up rather fascinating.[80]

Though his intention was to visit the dentist in the same building, the young man is lured to her apartment, with its hanging corsets and stockings. The story continues:

> In an incredibly short space of time, Mme Palmi minus her black dress, proceeded from the cover of the screen and lay down on the quilted pink coverlet of the bed. She crossed her legs and held me with her dark, lustrous eyes. Then occurred one of the great surprises of my life. She said very distinctly: "Put the twenty francs on the table, hon, and come over here...."
>
> I was in a room of Magritte, but without his taste. The effect was disturbing. I thought: This is real-life surrealism.

While Mme Palmi uses the chamber pot behind the screen, the hero escapes to the dentist chair in the rooms across the hall.[81] One immediately thinks of Bates's **Odalisque**, painted in 1970. The oversize woman with her large dark eyes, holding a card as she reclines on the bed, dominates the small figure of man seated with his back to the viewer. The man's settled stillness would suggest paralysed fascination. The demi-monde, one of society's fringes, was always interesting to Max.

Bates returned to London with his sketches and worked them up into paintings for his one-man exhibition at the Wertheim Gallery. He also had his paintings at the Redfern and Storran galleries.[82] Of his work at that time, Max wrote:

> I began to find that, for me, carefully planned and considered work involves haunting doubt, the anguish of deciding between alternatives—a painful process not necessarily superior in the result from the relatively hasty and careless adventure of spontaneous creation.[83]

His one-man exhibition opened on 25 November 1937 with fifteen oils and one drawing, ranging in price from seven to twenty guineas.

Among the most expensive were two from his Paris trip, *Rue Jules César* and *Rue Clovis*.[84] The only record of a sale is that to the Preston City Art Gallery,[85] but in 1939, *Rue Jules César* was hung in the Royal Academy show.[86]

Paris drew Max back in 1938, but he seemed to see the city in a different light, shadowed by the threat of coming war.[87]

PARIS 1938

They call that city gay;
It is not so to me,
Unless the exaltation
Before the storm breaks
Is gaiety.
The faubourgs' silver grey
And wood-smoke acrid smell
Permeates the day
With light melancholy.
The noises of the night,
Rumours of the dark,
Tell the dangers of tomorrow.
Assassins in a doorway,
And under the high wall
Stained by decay,
Wait expectantly
Until the tragic city
Is lighted by opal fire.[88]

Bates's forebodings were shared by many of the artists whose works were shown in the *Exhibition of 20th Century German Art* that opened in July at the New Burlington Art Galleries.[89] It is possible that the experience of seeing for the first time a large number of the works of German expressionists had an impact on Max's subsequent development as an artist. The exhibition of course included the work of Max Beckmann,[90] with whom Bates was

destined to study. Herbert Read, who was active in organizing the exhibition, had interested himself in the plight of European artists threatened by the coming storm of war. Included in the exhibition were paintings by Paul Klee, a ruthless and satiric café scene by George Grosz, work by Kathe Kollwitz, and Lionel Feininger's serene, cubist study of boats on calm water.[91] Even if Bates did not hear the opening address by Max Beckmann, he would have been able to read some of the translation in the periodical press. Beckmann had said,

> What I want to show in my work is the idea which hides itself behind the so-called reality. I am seeking for the bridge which leads from the visible to the invisible, like the famous cabbalist who said once: "If you wish to get hold of the invisible, you must penetrate as deeply as possible into the visible."[92]

Thus Beckmann made it clear that his work was not like the abstract expressionism of Klee or Kandinsky, stating that,

> The individual representation of the object, treated sympathetically or antipathetically, is highly necessary, and is an enrichment to the world of form. The elimination of the human relationship in artistic representation causes the vacuum which makes all of us suffer in various degrees. Human sympathy, and understanding, must be reinstated.[93]

This aspect of expressionism appealed to Bates. He no doubt paid particular attention to Beckmann's work in the exhibition.

Beckmann had endured severe deprivation in the First World War and seen terrible suffer-

ing during his service in the medical corps.[94] His work in the exhibition showed his passionate sensitivity to the tragic implications of contemporary events in Europe. *The King* depicts a crowned, commanding figure whose arms are resting on the hilt of a sword. He sits impassively, a beautiful young woman resting against his thigh as they await the approach of the catastrophe which a dark, hooded figure in the background is attempting to ward off with a gesture of the hand. The colours are strong, the figures are outlined in black, and the whole conveys a sense of the inevitable destruction of majesty and beauty. The main figures bear a resemblance to Beckmann himself and his wife Mathilde.[95] *The Temptation*, a triptych, was completed in 1937 and was inspired by the artist's repeated readings of Flaubert's *The Temptations of St. Anthony*, as well as by his own explorations in Gnostic literature.[96] Full of the symbolism connected with these sources, the seductive women are held captive by grotesque figures. In the centre panel a shackled artist sits gazing before the image of a modern Venus. Even without understanding the symbolism, the viewer's imagination is assailed and stimulated by strong suggestions of dark and brutal power in contrast to beauty rendered passive.

Though Bates could have no intimation that he would eventually study with Beckmann, he could identify with the aims and methods of German expressionism. Its roots lay in the Gothic art of northern Europe and the art nouveau movement. As Beckmann said of his own work, the expressionist rejects concrete reality and uses rhythmic distortion to get at the essence beneath surface appearance. The artist aims at an intensity derived from his own vision and feeling.[97] Such art requires the active participation of the viewer, and it is doubtful if more than a few individuals in the large crowds who came to the exhibition could, at that time, fully appreciate the works of the artists.[98] Most came to see the art banned by the Nazis.

For Lucy Wertheim "the political situation had become acute."[99] Because her clients and artists were preoccupied with the growing dangers, she agreed to rent the Gallery to the Society of Refugee Artists. In that exhibition, the works of Kokoshka, Max Ernst and others were shown. On 3 September 1939, war was declared, and two days later, the authorities took over the Gallery for an air raid shelter.[100] Wertheim asked her artists to pick up their work, and she dispersed her own collection to galleries in Britain, South Africa, New Zealand and Australia. Four of Bates's works remain in the collection of the Auckland City Art Gallery in New Zealand.[101] The whereabouts of many of Max's works remained a mystery until he discovered many years later that the mansion in which they had been stored was blitzed.[102] Lucy Wertheim's pioneering work in bringing young British artists to the notice of the public was ended by the Second World War, but time has confirmed her insights and her artistic judgment. Many of her "Twenties Group" made their mark as they matured. To nourish young talent in a period of economic recession, she weathered financial difficulties as well as an often indifferent, sometimes scornful public. She gave to Bates and others her steady sup-

port, providing an outlet for their work at a time when the cultural climate was hostile to their art. It would be difficult to overestimate her contribution.

For Max, the struggling, triumphant years in London were coming to an end. He had lived through poverty, loneliness and uncongenial work, and had determinedly pursued his art. His training in architecture provided him with another source of income and opportunity for achievement. He wrote:

> My outlook had not altered in any decided way since my arrival in England in 1931. In my ten years in London I saw nearly all the exhibitions, in dealers' galleries and otherwise, probably about 2,000 in number. The paintings that I thought the best confirmed my ideas, without giving me any reason to alter them. I particularly liked some early Utrillos showing in London at various times, Lautrec, Pascin, Soutine, Sickert, Tchilechew. … The artists who have helped me most, perhaps, are: Michelangelo, Rembrandt, Goya, Daumier, Degas and Toulouse-Lautrec, Gauguin, Van Gogh, Cézanne, Picasso, Vlaminck, Utrillo, Modigliani, Soutine, Kokoschka, Beckmann … yes, include Rouault.[103]

He thoroughly enjoyed London and meant to make his home there, but fate decreed otherwise.

Bates's name was put forward as an English war artist,[104] but when the assignment came through he was already in the army. He had volunteered for the Middlesex regiment, recruited in Kensington, and he was put in the Princess Louise Machine Gun Battalion. He learned to "strip down and reassemble ma-

chine guns."[105] For a short time Bates was posted to Ilminster for further training. Two former students of the Royal College of Art were in his company and they sketched together.[106] When the Company Commander found Max drawing, he expressed his disapproval and suggested he give it up. He said "I went through an Arty Period myself when I was at Oxford, but it passed off!"[107] Just before they were to leave for the Continent the Company Sergeant Major said, "Bates, I don't know what to do with you, so I've put you down as a Butcher's Assistant" and thus Max went to war.[108]

Prisoner of War in Germany, 1940–45

In his book *A Wilderness of Days*, published in 1978, Bates characterized the years of his life from the beginning of the Second World War to its end as "a wilderness of days."[1] Those days were spent as a prisoner of war in Germany. Only his stubborn determination and his mature, philosophic outlook enabled him to survive two lengthy forced marches and hard labour at a Thuringian salt mine. The account of this experience is remarkably free of bitterness or hatred of the enemy. In the notebook he managed to keep in the camp, he wrote:

> My hatred of those years began in a loss of personal freedom unavoidable to any unit drawn into a great war; my profound dislike of war in itself and, consequent on the first, the break amounting to years in my work and other activities natural to me.[2]

Bates's machine gun battalion, hastily assembled and inadequately equipped, was rushed to the front to bolster the French, who were giving way under the German assault.[3] Preparing for departure, Bates naïvely filled several sacks with books. The Regimental Sergeant Major found the large sacks during an inspec-

tion of a truck holding the men's kit bags, and he was rendered speechless when he saw their contents. "I was paraded to the company commander, who expressed his amazement," said Bates. "He told me to distribute the books among the men, but I didn't. In the end the Germans got them or they were destroyed by bombs."[4] The battalion was part of the 51st Highland Division, which was fighting the enemy at Abbeville but suffering heavy losses as the Germans advanced. Unaware that there were now no more boats for the Dunkirk evacuation,[5] Bates's company hoped to make its way to the coast and escape over the Channel. Amid great confusion and with no reliable information, the men were ordered to leave their kits in the trucks so as not to overload the boats; they carried only their guns. The French, more resigned to surrender, kept all their personal equipment.[6] Bates's company

> ... occupied a dozen towns and villages during the period of withdrawal. During the most peaceful hours, such as a day in the inland village of St. Maxent billeted in an evacuated cottage among half-open drawers, torn letters, old petticoats, a fly buzzing in

the window; watching the leisurely movements of a cow in the sunny pasture (she was milked by a soldier) there was edginess caused by extreme boredom and a sense of approaching disaster.[7]

In some verses of the poem "Before the Deluge, April 1940," which he wrote in London in 1945, Bates recalled this experience:

'Château Lorraine',
A song's refrain
That has no end
Turns over and over in my brain,
Like recurring sounds of a bombing plane.

White stars in an indigo sky
And everywhere black woods;
All night the French go by
Coming out of the line
Which we shall occupy.
With clanking sounds they come
On bicycles and horse-drawn carts.

. . .

The creak of the moaning pump,
The horrible sweet stench of the ground
Behind the plaster houses at Neudorf
Come to mind.
The white, deserted houses
Full of furniture, red eiderdowns
And old letters.

. . .

German patrols
With blackened faces call to each other
With the Cuckoo's notes,
Past Dampont Farm and Beckerholz.[8]

. . .

When General Rommel's tanks caught up with them at St. Valéry, the battalion surrendered. Facing an unknown future, each man looked to what he could carry for survival. Bates decided against a great coat because of its weight, but he managed to keep a haversack and a shaving kit, which he used for the next five years. The march to captivity began. At first it was every man for himself, each struggling for the little food and water available. The exception for Max was a friend, Jim Brown, who offered him part of a tin of herrings with the mutual assurance of a good dinner in London when the war was over.[9] Then, prodded by the German guards, they marched, often by moonlight and in the rain. Bates fell forward on his face at one point, but he soon regained consciousness.[10] As the march dragged on, the prisoners began to form groups for sharing what they could salvage and for the mutual protection of their belongings. In the camp these groups became known as combines or syndicates.[11] Often the French civilians came out of their houses with food and drink, sometimes getting knocked down by the rush of hungry and desperate prisoners. Eventually Bates could hardly summon the energy to reach for a piece of bread. The march went on, and their captors became more brutal, often shooting prisoners who left the column for food.[12]

A respite came in the middle of June at Doumont, where they sat on a hillside for three days.[13] Here Bates read Virginia Woolf's *The Common Reader*, one of the few books he retained, and he was given a New Testament by a Scotsman who found it too heavy to carry. In his account of the march, he provides both a word picture of the bedraggled column and a drawing of the weary prisoners in their knotted

handkerchiefs, berets, tarbooshes and old felt hats.[14] Even in his fatigue, Max retained his fascination with headgear. Crossing into Belgium, they arrived at Lokeren, and on the grounds of a technical school, the Germans took names and numbers. That night Bates slept in the attic of the school, where he found himself surrounded by plaster casts of Greek sculpture which must have reminded him of his classes with Haukaness. He had torn up his sketchbook when he was captured, so he was glad to find another abandoned in the attic; unfortunately it was later confiscated in Germany.[15]

At Walsorden on the Scheldt, the prisoners were crowded onto long coal barges with decks which sloped upward to a ridge. The coal dust in the hold was full of lice, and Bates preferred to stay outside even in the rain, reading his New Testament and carefully rationing the single loaf of bread issued to last him the four days until they reached Germany.[16] When they disembarked at Emmerich, the town was celebrating with flags and parades, and many people wore swastika arm bands. Bates's account notes the dramatic contrast between the wretched prisoners and the gold-braided officers; and he points to the irony of this gaiety, for later in the war, the city was reduced to ruins. Weakened by hunger and cold, the prisoners were herded into cattle cars where there was barely room to stand. After sixteen hours they reached the transit camp at Ziegenhain.[17] French prisoners were assigned the task of washing and de-lousing the men and their clothes. Bates notes that the French were unnecessarily rough shaving heads, but

he understood their considerable resentment towards the English for continuing the war after they had surrendered.[18] The aftermath of this grooming session Bates described as "Rows of naked, hairless men sitting on forms (some were gaunt and all had lost considerable weight) looked like a Martian parliament in session."[19]

Assigned to a crowded tent, Bates turned his eye to the mass of prisoners wandering the camp. The French "noirs" from Senegal and the Moroccans stood out for him. Max tried to buy a tarboosh from one Moroccan but the man refused, saying "C'est mon bébé." In his book Max has drawn from memory a lively scene of three figures gambling with cards for their major possessions. Despite this circus-like atmosphere, the situation was brutal, with prisoners struggling to get a drink of water from the one pipe,[20] or balancing on the rail surrounding the huge cesspit in order to relieve themselves. One unfortunate fell into this horror and could not be rescued.[21] Food was scarce, and in one instance, a cart pulled by a horse was loaded with "les noirs" and driven a distance away. A shot was heard, and the cart returned, this time with the prisoners pulling the cart with the dead horse in it. The animal was cooked, the meat divided up, and the English prisoners were presented with the inedible hooves.[22]

The prisoners in Max's group were again loaded onto cattle cars for the next part of the journey to the administration centre at Bad Sulza.[23] Behind Bates's unemotional, laconic prose one can sense the humiliations suffered by these men. Weak with hunger, they were

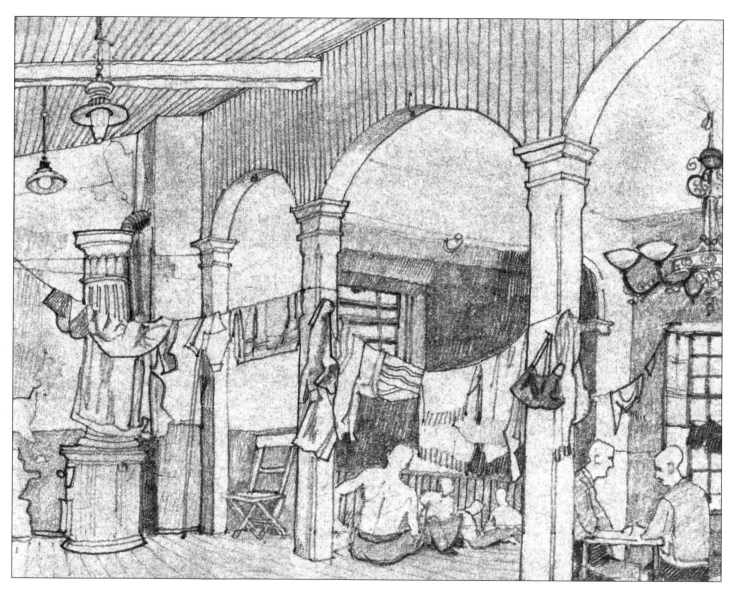

Untitled (Hell's kitchen, Germany, 1942). Pencil, 12.6 × 20.3 cm sheet. Private collection.

stripped of every outward vestige of individuality, clothes, possessions, even their hair. They were rendered both physically and psychologically vulnerable, forced to struggle with their comrades for food and water. Max's stubborn inner strength helped him survive. Bob MacDonald, who later became one of Max's mates in the camp, reported that Bates, older than most of the prisoners, emerged as a quiet leader.[24]

At Bad Sulza, Bates was assigned his prisoner number for the rest of the war, and his books and most of his remaining possessions were taken from him. He was billeted in a former dance hall, Hotel Eichenbaum, which soon became known as "Hell's kitchen."[25] In spite of the filth and the lice, Max enjoyed sitting on the grass, filching vegetables from the nearby gardens, and listening to the calliope organ in the neighbouring village.[26] He sketched the arched dance hall with its pillars and chandeliers and washing hanging above the sitting men.[27] Ian Thom wrote of this sketch, "while obviously executed quickly, the placement of figures, the low viewpoint of the arches and the careful distribution of elements bespeak the touch of a master draughtsman."[28]

Finally, at the end of July, Bates was assigned to a work camp. He hoped his school French would assure him a clerical job, but there was no work of that kind in a salt mine. One hundred of the prisoners left in a cattle car and arrived late at night at Unterbreizbach, a quaint old town on the Ulster River. They were marched a mile to the wooden barracks of the camp Arbeits Kommando 137, their lodging place for the next five years.[29] Each hut

was furnished with double bunks and wooden cupboards for eighteen men. There was electric light, a central stove and tables, and the huts were new and clean. George White was the first to enter Bates's hut; he flung his coat on the nearest lower bunk and left. When he returned to his bunk he found Max stretched out there and asked him to move. The dispute must have been settled amicably, because George White quickly became Max's "mucker," his special pal. For the rest of the war they provided support for each other.[30]

The following day, the prisoner of the highest military rank became the "man of confidence," the negotiator with the camp commandant. He was Bob Doyle, a bandmaster remembered by one of Max's fellow prisoners as "a great man, extremely well-read and a good companion."[31] He was paired with Leo Keys, a lively interpreter of Russian and Jewish descent, who also had been captured at St. Valéry. Keys called himself "Leonard" to help disguise his Jewish origins, and the men were careful never to betray him. "The tall, dignified Bandmaster," Max wrote,

> ... always erect and neatly dressed ... appeared very different from our Jewish interpreter, short, vivacious, never still, dressed often in underwear shorts with his shirt half out. They were a formidable team, the Bandmaster extremely firm, courteous, confident: the interpreter quick-witted and aggressive.[32]

The German commanders were frequently changed, especially if they showed sympathy with the prisoners and tried to uphold the

Untitled (view from the prison camp, Germany, ca. 1942). Pencil, 20 × 29.4 cm sheet. Photo by John Dean. Private collection.

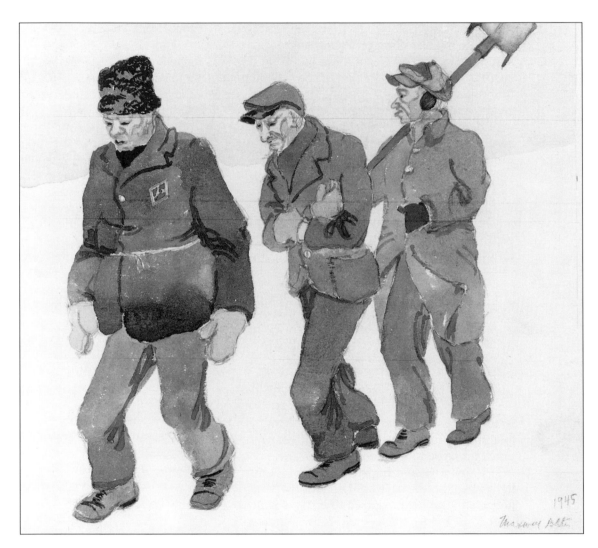

Untitled (work party in the prison camp, Germany, 1946). Watercolour and pencil, 27.5 × 27.5 cm sheet. Photo by John Dean. Private collection.

Geneva Convention.[33] There was continual pressure to increase production from the civilian employees and control officer of the salt mine.[34] The two negotiators had little success in improving the diet of the prisoners: four slices of bread a day, sometimes sausages, and endless cabbage or turnip soup with caraway seeds.[35] Klotzbach, the provision contractor, was thoroughly hated for profiting from short rations.[36]

The morning shift to which Bates was assigned began at 3:15 A.M., and after a breakfast of heavy bread, ersatz jam and coffee, the men marched to the salt mine.[37] Max often enjoyed the beauty of the dawn and described it in his notebook:

> Sometimes the pink light called by the Germans "Morgenrot," sometimes the bars of cool, pale gold that are not seen at any other time, appeared in the sky. At the mine I often looked at the rounded, fir-tree covered mountain called Oechsenberg where, on clear days, other British prisoners could be seen tipping wagons from a shelf in the mountain side. It was a stone quarry.[38]

Bates was assigned to the transport gang, loading and unloading bricks, coal, heavy pipes or oxygen and acetylene containers. At first Bates was so exhausted after the eight-hour shift that he could only lie on the straw mattress.[39] As he grew used to it, he was glad to stay on the transport gang rather than work inside the mine, because the work at least offered variety and the enormous man Gobel, who was in charge, was "genial in a rough way."[40] Max has included in his book a drawing of the prisoners loading canisters, with

himself standing beside the truck, cigarette in hand.[41]

Max advised the men in his team to work as slowly as possible to save their strength and as a form of sabotage. At first the prisoners used the excuse "don't understand,"[42] but soon they set up a system where lots were chosen to organize sabotage, and the seven huts vied with one another in the ingenuity of their plots.[43] The Gestapo was everywhere and escape was almost impossible, as the camp was isolated from any safe borders. But one prisoner, an American nicknamed "Alabama," found another way of getting out. Caught with the Canadians at Dieppe,[44] he had been sent to Camp 137 and assigned to Gobel's gang. Feigning madness, he would pull a large empty box around by a string and borrow Bob MacDonald's tin whistle, holding out his hat for contributions.[45] He was successful in his ruse and was sent to hospital.

The official publication *Prisoner of War* reported that conditions in Camp 137 were very "unsatisfactory."[46]—a considerable understatement. The food was poor, the men were overworked, and some had to travel miles underground. They cleaned out the cesspits, dumping the fertilizer on Klotzbach's cabbages, or washed out the great soup kettles in which his mistress cooked the cabbage. Klotzbach was so hated that when the camp was evacuated towards the end of the war, the Poles did not leave before they drowned him in the Ulster.[47]

Conditions improved when the Red Cross parcels began to come in March of 1941, and the men took their soup and bread into their

own hut, where they were able to cook on the stove.[48] The parcels were locked in a huge storage room, and twice a week the guard allowed the prisoners to take what they wanted from the parcels.[49] In his sketch Bates has given the "Klim" tin prominence,[50] for both the tin and its dried milk contents from Canada were much valued. Testing his culinary skills, Bob MacDonald once asked George White, "How do you know when it's done?" White replied, "When it's brown, and when it's black it will be overdone." To which Max added, "I could do with some carbon!"[51] Canadians also received generous amounts of cigarettes, and these were used as bribes to exchange for eggs, flour and sometimes mushrooms gathered by the guards. Each man saved and hid a portion of his parcel, so that a cache of food, clothing and cigarettes was available for those who attempted escape.[52] Occasionally the prisoners were offered limburger cheese and sometimes buttermilk. Although good for their diet, this was not popular fare. Working prisoners did, however, find refreshment in the peppermint tea that they could fill their flasks with in the morning.[53]

Christmas meals were as elaborate as the prisoners could make them from the parcels. They had a try at making a Christmas pudding, wrapping the mixture in a shirt and cooking it in the boiler in the wash-house. Because the boiler was only free for two hours, the pudding was removed and hidden on a top beam in the hut. In the night, they heard the pudding plopping onto the floor. Boiled thereafter at intervals, it ended up being sliced and fried. They also contrived a home brew from the parcels' yeast tablets, the prunes and apples, siphoning it off with a hollow casing from the mine.

The men in Bates's hut, Stube 5, were very compatible and known as the "5 pound a week boys," for they were considered the camp's intellectuals. Bates's companions found him reticent, rather serious but with a sense of fun. He was not soldierly in his dress or bearing and seemed to be absorbed in a world of his own.[54] Though beards were forbidden, Max grew a moustache and sometimes in the winter it would be hung with frost. Leo Keys thought that Max looked like "Old Bill," the comic common soldier from the First World War cartoons.[55] Bates was becoming competent at coping with the strains of daily living in the camp, especially in procuring food for his syndicate. His opinions and other capabilities were greatly respected and his friend Bob MacDonald later said, "I'd get in the same trench with him anytime, but he was no soldier."[56]

Though Max says little in his book about his part in the camp entertainments, his mates appreciated his major contribution. He painted posters and created backdrops for the skits, some of them written by George White.[57] One of the backdrops depicting the white cliffs of Dover can be seen in the group photograph of the men in Stube 5 with Max, expressionless, seated left on the floor. Max designed the costumes for their performance of *Twelfth Night* and gave each player a coloured sketch of the character they were to represent. He played the part of the Duke and Bob MacDonald was the Clown. Max also designed Punch

Maxwell Bates and fellow prisoners (ca. 1942). In this group photograph of the inhabitants of Stube 5, Bates is seated to the left on the floor. Bob MacDonald is at the other end of the first row, and George White is standing to the right in the last row. Maxwell Bates fonds, Special Collections, University of Calgary Libraries.

and Judy puppets on seven pieces of four-inch square wood—Punch, Judy, the baby, the dog, the hangman, the crocodile and the policeman. One of the prisoners was a remarkably skilful carver, and the puppets emerged as works of art. The show was such a success it had to be repeated, and the guards asked for and were given the puppets.[58] In Bates's art of the postwar years, puppets became a favourite subject, symbols of helpless humanity. For himself, Max carved chess pieces similar in shape to checker counters but with the proper symbols on them. He lost the first few times he played with George White, but he soon became the consistent winner.[59]

The men used the little money they earned to buy saxophones, trumpets and a violin, which Max insisted on trying to play even though he met with as little success as he had when he was a child in Calgary. He was more in his realm in the art class he organized, which was held in the cramped cobbler's room. Bob MacDonald felt that "Max had a wonderful way of pulling our work to pieces but assuring us that 'if the War should result in us being there (say) 10 years he felt he could do something with us.'" MacDonald retorted that if the War should last that time, Max might master the violin.[60] Max made a few sketches of his fellow prisoners, and as he later told his friend, Margaret Hess, mentally he painted every day, continually creating compositions from what he saw around him.[61] With the aid of George White's eight-scale rule, which the Germans had not confiscated, Bates set himself to design a cathedral, the genesis of the actual cathedral he was to create in the fu-

ture.[62] Max was faithful in sending his family the correspondence allowed, a card on the fifth of the month, a letter on the fifteenth, and another card on the twenty-fifth.[63] He regularly received news from his family, including the sad report of his bedridden mother's death on the twenty-third of March, 1945.[64]

It is doubtful if Max took part in any of the physical games, one of which he portrays in a lively drawing of the men playing volleyball.[65] Nor did he indulge in the rough language the prisoners used, especially when within earshot of their captors. At one point, when a public relations officer complained about the insulting remarks of the prisoners, Leo Keys told him that the only way to put an end to the blasphemous language was to stop them talking altogether.[66] Much of the talk among the prisoners was about women, but Max gave no indication to his friends of any romantic attachment. He spoke very little about his own life, even to George White, though he regaled him with accounts of the eccentricities of his former employer, J. Harold Gibbons. He also told him about his architect father, and about the Alberta Hotel in Calgary, designed by Bates, Sr., and famous for the longest bar in the West. He mentioned that on his mother's side he was related to Sir Isaac Newton, after whom his brother was named. Of his artistic life in London he spoke very little to White, except to say he was interested in cubism. He said he walked a great deal in England, no doubt partly out of necessity, and he explained to his friend that walking in Canada was not popular because there was nowhere to walk to. In England you could walk from village to

village, but in Alberta, when you got to the edge of town there was nothing but the prairie. White got the impression that Max preferred living in Europe.

Max did talk at some length about his fascination with astrology. He could not work at it in the camp because he lacked a ship's almanac which would give him the position of the stars. However, on the night of 19 July 1944 White called out "Anyone going to the bog?" before they were locked in the hut. Max accompanied him, and as they walked, he looked up at the stars and saw an interesting conjunction and remarked "If Hitler is alive tomorrow I will be a surprised man."[67] The next day Max heard from an elderly civilian of the attempted assassination of Hitler.[68] The old man muttered bitterly about the failure of the attack, for he hated the regime.[69]

From his conversations with Max, White understood that Max believed in the influence of the stars but maintained that the influence was not absolute and could be modified by the exercise of free will.[70] Exploring the question of predetermination and free will in his camp notebook, Max wrote:

> The generic lines or principles controlling the universe remain ever the same, are predetermined, but among the minutiae or small branches there is a kind of movement caused by incomplete predetermination of lesser events. ... As applied to art, certain principles may not be disregarded which may be likened to the roots, trunk and main branches of a tree, but the lesser branches and foliage which may be likened to the results of the unique temperament and imagination of the

artist are not predetermined—here free will has some play.[71]

Though Bates's everyday life was now stripped down to monotonous essentials, he compensated for the deprivation by concentrated study and thought. In the closely written pages of his notebook is the record of his struggle with some profound philosophical puzzles. On the initial page he wrote:

Maxwell Bates

> British P.O.W. No. 1697 Kdo 137
> Stalag 1Xc
> notes and original material written at Arbeits Kommando 137, Germany and after. Writing not followed by the name of its author is original material,—much of it notes for an essay on the philosophy of art.[72]

Random pages of this remarkable work are imprinted with the stamp of the camp, which ensured that it would not be confiscated. The writing is small, neat and regular with very few corrections. There are no lists of the books Bates read, but the notes themselves give us indications of what he must have obtained from the Red Cross circulating collections. He quotes André Gide and Spinoza and copied excerpts from *The Unquiet Grave* by Cyril Connolly as "Pausanias," and John Dewey's *Art as Experience*. Several pages were devoted to P. D. Ouspensky's *A New Model of the Universe*,[73] and George White remembered him reading a massive history of architecture by Bannister Fletcher.[74] He read Carlo Levi's *Christ Stopped at Eboli* and the letters of Rainer Maria Rilke

in translation.[75] He must also have obtained a volume of Rilke's poetry, for in 1943 he tried his hand at translating one of the poems from German into English.

ON THE LITTLE SIDE
A Prague poem by Rainer Maria Rilke

Old houses steeply gabled,
High towers full of ringing.
In the narrow courts
There lingers
Only a tiny patch of heaven.

And on every newel post
With languid smiles—little cupids;
Rose-chains hang about the baroque
Vases upon the roofs above.

Spider-webbed is the gate yonder,
And with stealth the sun alone
Can read the secret words under
Our Lady's figure carved in stone.[76]

In one passage in the notebook he explains its purpose:

Several years ago when I began to contemplate developing an explanation of the purpose and nature of art I realised that no satisfactory explanation could be given without introducing moral and philosophical ideas. Analysis alone, as a method, is insufficient. ... Synthesis is necessary ... and will inevitably draw general philosophy and especially ethics into the explanation. ... Generally, writers on the nature of art have not even thought it necessary to roughly sketch the framework of the Universe of which art is a part. ... My approach is personal.[77]

Frequently he noted the importance of rhythm, a concern which had interested him from his earliest discussions with Stevenson. Indeed he headed one whole section of the notes "The Rhythmic Universe," and he referred to the book *Symmetry in Motion* by Willard Huntington Wright. Bates related rhythm to polarity and synthesis: "Synthesis implies polarity. Synthesis is part of the rhythmic process."[78]—a process which was central to expressionism.

An initial section of the notes was headed "Towards Good or Evil," and in the confines and stress of the camp, Bates must have pondered on the place of evil in the world. Considering evil in the context of the underlying unity of the universe, he saw it as being "fundamental to the particular as opposed to the Universal."[79] A poem which he wrote in the camp also deals with good and evil.

BEHOLD THE FLOWERS

A shifting serenity of light
Is present;
Even in the darkened places
Shadowed by combatants:
The march of Alexander's army,
Progress of Caesar,
In the confusion of war.

Through the night flux
Moves a waste of white stars.
The dark profundity of death
Is ambient with new points of life.

Francis, he of Assisi,
Pondering
The mysterious motivations of the soul

In the mazes of evil;
Wrote his 'Little Flowers'.
Even 'Les Fleurs du Mal'
Are of those gardens;
Both having their beauty.
In a stagnant pool
Grow the cool lotus petals.

Massed gatherings of flowers
Are trodden
To drops of scent,
Even as the arrogant diamond
Is compressed of coal;
As a Hero springs
From ultimate generations
Of primeval life.

Remember the Analects
Confucius raised
Out of the conflict of men and women;
Thinking in a mountain pavilion
Full of the conversation of philosophers
Sipping their wine,
And a lute's music.
Wedges of flying geese
Cross the moon;
Things of purpose and order
Like the Analects.

Behold the flowers
That grow from a chaos
Of earth unredeemed;
They gather and blossom
In the Canticles of the Just.[80]

Some of the notes, especially one section titled "Personality and Consciousness," are cast in the form of a conversational of three voices: a philosopher, "Alpha," displaying synthetic power of mind (de Quincey's quotation); "Beta," a critic whose function it was to ana-

lyze; and an artist, "Gamma," displaying sensibility. They discuss the value of the Greek ideal of moderation and then move on to the topic of motion, space and time. In moments of crisis or extreme concentration, a person may experience a "dilation" in time, an experience Bates compared with looking at a section under a microscope so that the normal is greatly enlarged. He wrote:

> The dilation of the present occurs in the states of mind more or less rarely reached by those who apprehend a reality underlying the reality of sense impressions and ideas; ... Perhaps sometimes by every man, woman and child of high mental quality. These are the well born souls of Montaigne.[81]

In the persona of Alpha, Bates maintained that in the state of expanded consciousness, the mind "has almost become a part of the timeless, spaceless underlying unity ... which is the universal purpose of all consciousness to reach." In the same vein, he visualized the sum of all things in the image of a sphere and considered the material world in which man exists as being the perimeter. Only occasionally can man glimpse incompletely what may be called "God," the great reality at the centre. He wrote:

> The desire for unity with another which we call "love" is the impulse behind the desire to fuse with the eternal. ... I do not think it possible to reach any understanding of the ultimate nature of God, force, matter, etc., except symbolically. The symbol is necessary to thought concerning the unknowable and it becomes of the highest value because we are

led to the conclusion that the entire process of things, as displayed in the aggregate of the visible universe is analogous to the entire process of things, as displayed in the smallest aggregates.[82]

These perceptions underlay Max's art. His desire to get behind mere appearance was intense, and he sought with colour and shape to bring opposites together to create a sudden synthesis, an expanded moment. In the section headed "Art," he wrote, "Beyond the Self and Space and Time is the goal of man's spirit. To reach this state is the ultimate purpose of artistic and moral development."[83]

The monotonous days of labour in the camp were occasionally relieved by breaks in the routine, good or bad. In 1942 Max's transport gang was forced to work hours of overtime to pack the valuable libraries and paintings from the Liechtenstein collection into the salt mine. (Years later Max read that the National Gallery in Canada had bought some of these treasures, including a Rubens and two Chardins.[84]) Sick leave gave the prisoners another break, though when they reported sick, they had to walk the mile to the village to see the local doctor. The physician never betrayed in words how he felt but, he was sympathetic to the men and usually gave them two days of sick leave. The prisoners drew up a roster and everyone took as much sick leave as possible.[85] If a prisoner was seriously ill, he was sent to one of the nearby hospitals.

In 1942 Bates had severe gastric trouble and was taken to the private asylum at Hildburghausen, where British doctors were allowed to work under the command of a German doctor. He took his possessions with him on the train journey, since it was possible he might not return to the camp. As usual, he had collected a rather large number of books, so his kitbag was heavy. Most often civilians ignored the prisoners, while the latter, their morale always high, felt themselves superior to the Germans, who were victimized by their leaders. If the train carried local country people, the sympathy was sometimes tangible, with the passengers giving up their seats to the uniformed men.[86] At the Karolinenburg hospital there was good food, rest and care, but the presence of the prisoners obviously disturbed the mental patients, who shook their fists at the intruders. One morning Bates saw Polish prisoners being marched to watch the hanging of a number of Poles in reprisal for the killing of a German policeman. The experience was disturbing for Max, who wrote, "We liked the Poles, knowing which side they were on."[87]

It was at Karolinenburg that Max met Chopanov, an engaging rogue whose portrait he sketched.[88] After the war, he painted a superb work of the cocky Serb: from his twin-peaked cap to his upturned moustache he is the very picture of a colourful survivor.

The prisoners obviously wished to stay in the hospital as long as possible, and Bates compared their state of mind with the attitude of the patients in one of his favourite books, *The Magic Mountain* by Thomas Mann. They dreaded the return to their former life with its "worries, exertion and responsibility."[89] Bates's reprieve lasted five weeks, and he was sent back to Arbeits Kommando 137 in better health. But his stomach trouble persisted

because of the rough food, and eventually he was assigned to lighter work such as laundry fatigue.[90]

Laundry detail involved making a trip to nearby Vacha and staying in the house of the old woman who did the laundry. She had an ancient talking parrot, and her parlour was decorated with fierce engravings depicting the fate awaiting sinners. This rather Gothic scene was appealing to Max. Besides, he wrote, "We felt for an hour like free men."[91]

When the war began to go badly for the Germans, they tightened security and announced on a poster that escaping had ceased to be a joke and that attempts would be severely punished.[92] They also electrified the wire around the camp, which explains the drawing of the wire with a butterfly that Bates used for the dust jacket of his book, *A Wilderness of Days*. The drawing complements the poem which Max wrote in 1943:

BARBED WIRE

A strong wind sings in the barbed wire:
 I hear
The menace of their interplay.
 The wire
That tears the flesh away
Yet cannot stay a fragile butterfly,
Or hold man's weak spirit, stronger yet than
 clay.
And the poet in his eternal dream
Knows but a wandering zephyr in le fil
barbelé.[93]

In February of 1945, the bombing of Dresden began,[94] and an American flyer returning from the raid bailed out of his plane. He had been wounded in the arm, and the blood spurting out from the wound froze in the intensely cold upper air. At the sight of this macabre figure descending with his wing of frozen blood, the guards opened the gates, and the prisoners rushed out to rescue him. They removed all his identification and carried him to the sick bay. He was then taken to a hospital, where doctors had to amputate his leg.[95] A month later, as the allied bombing got nearer, the prisoners were forced into two shelters, but fortunately the Kommandant changed his mind and marched them into a nearby wood before the Americans bombed the shelters and the camp. The men were carrying their heavy kitbags and whatever food they could manage. They all wished to take their chances and wait where they were for the Americans,[96] but orders had come from the highest command that they must be moved. The insane purpose was to gather all the prisoners into Bavaria, where the Nazis planned a last stand using the mass of prisoners as a bargaining chip. Bates thought the orders came from Himmler,[97] but Leo Keys understood the command came from Hitler himself.[98] Though the elderly guards accompanying the marching column were lenient, the fanatic S.S. roaming the countryside were still to be feared, so there were few escape attempts. As luck would have it, the Kommandant was lame and marched with a stick, so he allowed hourly rest periods; at one point he had to be wheeled along in a baby carriage.[99]

This march was so gruelling that even the guard dogs suffered: the pads on the feet of the Alsatians became completely worn down. The

men ate whatever they could find—dandelion leaves, nettles and potatoes. One time they found a store of wheat, and Max helped his syndicate grind up one hundred pounds in a mill. As a result, the whole company had porridge.[100] Any food they could scrounge, they willingly carried, in spite of the heavy weight of their knapsacks, greatcoats and kitbags.[101] American bombers were constantly overhead, and the prisoners were in some danger from them, especially after they entered the dense Thuringian Forest, where they could not be distinguished as prisoners of war.[102] At times the fleeing German troops tried to march with them for safety, but the prisoners halted and forced them to go ahead on their own.[103]

They met other British prisoners, Russians and even Americans on their way to the southeast, but it was the meeting with the civilian survivors of the terrible camps that was most memorable. Bates wrote:

> Wearing large, wooden shoes the column did not march, it shuffled slowly, wearily, over the cobblestones, eyes on the road, shoulders bent. The movement of the column had a horrible, staggering, halting rhythm. The column was like a multitude of puppets in ordered movement, but each awkward and badly made. Hardly a word was spoken. At intervals the sickening musty smell enveloped us.[104]

Their S.S. guards were brutal, shooting any stragglers, and throughout the four days they followed these tragic marchers, the men found bodies stacked in bundles by the side of the road.[105] The company caught up with them again one rainy evening, and as they approached, "a strange noise like a loud murmur" grew greater and greater. In a dense grove of trees below the road were the civilian prisoners, milling round in the darkness, shouting for their companions. Bates described the haunting experience: "a medley of sound which yet, at the same time, held a note of fury and of haunting desperation ... the sinister grove of voices was the last place we came across the political prisoners."[106]

The brutality of this tragic and despairing scene was in stark contrast to the enduring beauty of the Bavarian countryside Bates described:

> Its white, winding roads and dark patches of forest look like illustrations of a fairy tale. Old crones carrying faggot, and the ox-drawn carts seemed medieval, yet brightly coloured and cheerful, and one thought again of old myths and tales.[107]

After they crossed the Danube, they met up with a steady stream of German convoys, all of them leaving the towns which waited to surrender to the advancing Americans. The American forces freed Max's company at Palling, then invited the rescued men to help themselves to the food and wine left by the departing Germans. Some of these Germans were rounded up as prisoners, and Max noted the spectacle of a Pole on horseback carrying a whip delightedly herding a group of them.[108] The Americans very efficiently transported the British prisoners to the large clearing camp at Mannheim.[109] There they met fighting men from many different countries, including

Russia. The Russians kept strictly to themselves, and when Max tried to exchange something for one of their colourful berets, he was met with silence.[110] Bates enjoyed the week at Mannheim, stimulated by the exotic mixture of people. He was especially intrigued by a South African who, like Bernard Shaw's Henry Higgins, could discern from an individual's speech his place of origin. All he could say about Max was "You're a colonial."[111]

Bates was flown back to England in the fuselage of a bomber. "For five years I had looked forward to the day of freedom," he wrote. "But on that day I felt nothing, neither joy or much relief. It was another day in the wilderness of days."[112] He returned from that wilderness with a somewhat weakened heart, but with his resolution, his sense of fairness, and his compassion strengthened. He harboured no resentment against the German people, even those who were Nazis, but from certain passages in his account, one can sense his feeling against collaborators.

Once in England, each man was tested to assess his physical and mental fitness and granted nine weeks' leave on double rations.[113] Max's father had asked him to return and join him in the architectural firm, so Bates contacted the Canadian authorities and prepared to leave for Canada later in the year. Fortunately Max was able to retrieve some of the belongings he had left five years before at his old address in Holland Road. He obtained permission from the Board of Trade to take back with him a number of his paintings, both oil and watercolour, a collection of Japanese prints and French engravings, some sketches and sketchbooks. There were designs for two churches and two crematoria and a coloured rendering of the design for the reredos.[114]

It was difficult to obtain passage to Canada, and he was forced to go to Glasgow to board ship. There he met up with two friends from the camp, young men from the Gorbals, the violent area of Glasgow where knife-wielding "slashers" held sway. Under his friends' protection he explored that underworld,[115] the raw, darker aspects of society that held a continuing fascination for him. Ironically, his homeward bound ship was the same one in which he had left Canada, the *Salacia*, this time carrying a cargo of whisky which enabled the crew and the passengers to celebrate the Christmas season.[116]

Though Bates lost contact with most of his fellow prisoners, he continued to keep in touch with his "mucker," George White. When White wrote to say he was engaged to a young woman, he asked Max to cast her horoscope. In reply he received a three page-letter outlining their future life with remarkable accuracy and including the information that the bride had been previously married, which was true. When the Whites' daughter was born, they named her Maxine in honour of her godfather, Bates, and she was christened in Kenton in St. Mary the Virgin Church, which was designed by Gibbons.[117] In time, though, the two friends lost touch, and they did not see each other again.

Return to Calgary, 1946–49

On a January day in 1946, a short, square, sad-faced man of thirty-nine years, stepped off the C.N.R. train at Calgary's old sandstone station next to St. Mary's Cathedral. After fifteen years, Max Bates was home—and there to welcome him were his father and his younger brother, Bill.[1] In many respects, Bates was a changed man, and the family that had anticipated his return since 1931 had changed as well. With his mother gone, his aunt Kit Shaw was now in charge of the household. His brothers Newton and Bill, teenagers when he had left, had both enlisted in the forces and were now studying art: Newton at the Vancouver School of Art and Bill at Calgary's Provincial Institute of Technology and Art. His sister, Cynthia, was living in eastern Canada with her husband, Dr. John Aikenhead.

Because of his long absence, his triumphs and his trials, Max was somewhat of a legend to his brothers and sister. But his pleasure at being home must have been mixed with misgivings at the thought of re-integrating himself into the Calgary community and tempered by considerable doubts about how his art would be received. There had been plenty of time to think about the future on the journey by train across the country. The bleak wilderness of northern Ontario and the wintry expanse of the prairie were in desolate contrast to the familiar landscape of Europe, dense with layers of history and human occupation.

The Calgary to which Max returned had also changed, in part as the result of the war. Because of the spacious Alberta skies, the city had become an important centre for Commonwealth pilot training. While the trainees had enriched the city's social life, their presence had also underscored Calgarians' sense of loss and sacrifice as these young men, too, went off to war. Max's attitude toward his post-war city and its inhabitants is perhaps best hinted at by the passages he copied from *Prisoners of War*, published by the New Zealand government:

> Many repatriates from Europe speak of restlessness and inability to settle, impaired power of concentration and memory ... a feeling of awkwardness in meeting strangers, a strong dislike of crowds and queues, and an overpowering desire to be quiet and alone. ... Most of these men had been away for four or five years.

On their return to the real world they found that

> The average civilian seemed "self-centred" and "out for himself": this came as a shock after years in prison camp communities. ... A number were depressed by what they saw of the civilian attitude to work; by a tendency for each civilian "to give as little as possible" and "to take as much as he can"; and by what they saw as a "disinclination to accept responsibility." Some felt that the moral fibre of the civilian community had deteriorated during the war years, and, according to their temperament, they felt "amused" at what they found; or "disillusioned" or "irritated" or "disgusted."

To this excerpt, Max added a few phrases of his own, "waste of food, complacency—self-satisfaction" and "taking too much for granted—the high standard of living."[2]

Bates's own feelings may be further gauged from this poem he wrote in 1947:

CALGARY

City of the Plain,
City of the wind—a place in the wind
Fed by grain.
I complain
Of Beer Parlours and City Fathers;
The nonsense
Expressed in an ideology
Of commercialism:
Private gain and public pain.
And yet
I have come back again.

City of the Plain,
No worse than others;

Better than many;
Different from any.
A city is its people.
Its people; their thoughts
And feelings
Solidified.
Permanent and unashamed.
Solidified in
Blocks of salt
From looking back
In the Spirit
While the body moves forward.
Solidified
Like the badlands.[3]

The post-war housing shortage in the city gave Bates little choice but to settle back into the family home. He was bitterly disappointed to find that so little of his pre-war self remained there; many of his sketches and notes had simply disappeared. He renewed his friendship with his boyhood friend Glen MacDougall, who had fought overseas in the Canadian army and was now employed in the insurance business. The two met after work and on long walks reminisced about their war experiences.[4] Roy Stevenson, the other friend of his youth, was in Vancouver, and it was the next spring before the two met again. Max set up an easel in his bedroom, plunged into his painting, and resumed his career as an architect. Though he had been registered as an architect in Britain during the war, he was not licensed to practice on his own in Canada until 1951.[5] William Bates, Sr., now seventy-two, had kept the firm going, and it was working on plans for two schools, two churches in Calgary, and the town offices of Rocky Mountain House.[6] It was apparently not easy for Max to work with his

father, but the firm needed his help: Calgary was set on a post-war building boom.

Max found the public library much the same, except that the books were more worn and mended because of wartime scarcities. Alexander Calhoun had continued the high level of services and, though retired, was still a vigorous leader of Calgary's artistic community. The newly formed Confederation of Canadian Artists had sent Lawren Harris on a cross-country tour to stimulate regional thinking about the development of art in the nation. His visit to Calgary resulted in the formation of a civic committee embracing nine arts and crafts groups. Calhoun, already serving as president of the Alberta Society of Artists, headed the committee, and his first task was to find an appropriate centre. He managed to secure the Coste House, which was used by the art school during its wartime displacement from the Provincial Institute of Technology and Art. This wonderful old mansion was built in 1913 by Eugene Coste, a geological engineer. Volunteer labour lovingly restored its twenty-eight rooms, thirteen fireplaces, five bathrooms, and the beautiful conservatory overlooking the lawns.[7] Max attended the opening in September of 1946 and saw the exhibition of work from the newly organized Western Canada Art Circuit. The Coste House became the common centre not only for the whole range of visual, tactile and decorative arts, but for music, drama and film as well. Max especially appreciated the exhibitions organized by the picture loan committee, where works by recognized artists from across Canada could be rented for a nominal fee. The sale and rental

evenings had a party atmosphere, a celebration of contemporary Canadian art. Although fiercely independent, Max clearly understood the artist's need for a community of those who would collect his pictures.

Max spent a great deal of his spare time at the Coste House, where he found a refuge from the raw commercialism of a booming Calgary and a congenial group of friends aware of his achievements. One of these friends was Janet Mitchell, who balanced her work at the Income Tax office with her painting, developing her unique, whimsical style. Another was Margaret Perkins Hess, known as "Marmie" and long a friend of the Bates family, who became an early and discriminating collector of Bates's work. There Max met Lettie and Henry B. Hill, who became his intimate friends. Lettie, a librarian and poet, loved to talk to Bates but disliked his portrait of her, although her friends assured her that Max had captured her essential character. Her husband balanced the rigours of finance—he was an investment specialist—with a lively interest in art. Handicapped by severe deafness, he had an engaging, humorous personality and was affectionately known as "Hilly." Max spent many hours in their house and visited their summer home in Salmon Arm, B.C.

Through the Coste House he also became acquainted with the artists Marion and Jim Nicoll. A native Calgarian, Marion was an instructor at the art school, while Jim, who came from nearby Fort Macleod, was an engineer by training. Their partnership was stimulating to them and their friends, and their home was a gathering place for artists.

After a lecture or other occasion at the Coste House, a group would meet at the Nicolls' and discuss art and literature until the small hours of the morning.[8] In contrast to Max, Jim was a witty and brilliant conversationalist but on occasion, after a convivial drink, Max would talk at length.

J.W.G. Macdonald, known as "Jock," and his wife, Barbara, were welcomed into this group on their arrival in Calgary in September of 1946, when he became head of the art school at the Provincial Institute. He and Max had much in common: both were sons of architects and both had survived a war, Macdonald the First World War[9] and Max the Second. Macdonald, like Bates, sought to express in art the spiritual reality behind surface appearance, using symbols to express that reality.[10] Barbara was very interested in theosophy,[11] and they had been at the centre of the group in Vancouver interested in metaphysics. Macdonald and Bates had both read *Tertium Organum* by P.D. Ouspensky, "whose vision brought together the spiritual, philosophic, and artistic concerns of the era."[12] Macdonald's warm friendship and intelligent interest provided Bates with a refreshment badly needed after the arid years behind him. He helped Max release himself from the events of the past, a healing process,[13] and they remained friends to the end of Macdonald's life.

In the hope of finding a way to express inner truth, Macdonald was in the process of working out the techniques of automatic painting under the influence of surrealist painter Grace Pailthorpe. As a result, as Joyce Zemans points out,

Within a few months, Macdonald's artistic vocabulary altered radically ... Macdonald's discovery of automatism is the key to all of his future painting. For him, nature's hidden laws emerged from internal sources; they were no longer interpreted objectively from outside subjects.[14]

As a teacher, Macdonald was eager to convert others and succeeded with Marion Nicoll, his colleague at the art school.[15] Bates, however, never "formally agreed with the automatic school or theory; instead he quoted Picasso on the uninhibited imagination."[16] He wrote:

Automatism in painting as in poetry can be no more than an incantatory technique and not creative expression. The verbal flow of the poet and the kaleidoscopic flow of the painter emancipated in automatism are nothing but raw material and it is the great merit of surrealism to have taught us that it is this and not the exterior world that is the true raw material of the poet and painter. The poet often combines words in hitherto unknown groups to express fine shades of meaning and which no one had thought of placing together and which may evoke strikingly original effects. In surrealism the painter placed hitherto unrelated objects together.[17]

On the other hand, Bates once told his young friend Ted Godwin that his palettes were his true paintings. At times he would take two pieces of masonite, use one as a palette and the other as the painting, and perhaps half way through he would change the boards and convert the palette to a painting. He felt that

on the palette the colour achieved a total automatic quality.[18]

Jock Macdonald soon left Calgary for the position as head of the Ontario College of Art, glad to escape Calgary's "isolation, the lack of understanding about art in general; and the environment of the Technical School itself."[19] Before he left, he organized the "Calgary Group," artists "whom he felt represented the new and modern spirit of Alberta."[20] Among those chosen were H.B. Hill, Vivian and Luke Lindoe, Janet Mitchell, the Nicolls, Roy Stevenson and Max.[21] Writing about the group in *Canadian Art*, Macdonald stressed their freedom and contemporaneity of expression. He quoted Bates at some length:

> every picture must have a visual motif, its origin is an image, not an idea in words. Whether the visual image is found first in the mind or in the chaos of the visual world is immaterial. It must be extricated from the tangle of nature, intensified and brought into relief so that it can be seen by everyone. Every new picture is an adventure and should push back the limits of our experience.[22]

Macdonald continued to keep in close touch with Bates and helped the Calgary Group arrange for exhibitions in British Columbia and in Ontario.

Max's first Calgary exhibition was held at the Canadian Art Galleries, recently opened by Jack and Grace Turner in a second-storey space in the centre of the city. The Turners were committed to showing a high standard of Canadian work and, through their friendships with H.G. Glyde, A.Y. Jackson and Walter Phillips, were able to assemble a good initial collection.[23] They also sold art supplies, framed pictures, and were the first in the city to carry Penguin Books. Not only did they offer to the artists of Calgary a reputable gallery in which to show their work, they actively helped Calgarians develop a taste for the best Canadian painting.

At Bates's invitation Turner, himself an artist, visited him in his studio and offered him a one-man show beginning in January of 1947. Their meeting led to a long friendship and business relationship. Max's directness of approach and sure touch impressed both the Turners. In their view, he seemed to know exactly what he wanted but rarely revealed his inner thoughts, though Grace detected in him a "remote sadness."[24] There were eighteen oils and twenty-one watercolours in the exhibition at the Canadian Galleries. Some of the subjects, such as *Bavaria—1945* and *Chopanov— A Serbian Prisoner of War*, reflected his experiences in Germany. There were also musicians, beer drinkers, and several depicting Calgary buildings.[25] In *Old Farmhouse* the sagging barn is surrounded by debris, a familiar sight in the country around Calgary, but the colouring and light project a European landscape, as though Max's eye had not yet adjusted to the prairies. He sold several watercolours and at least one oil, and there were a number of sales after the showing.

Several of the works in the exhibition were night scenes of East Calgary, where Max and his brother Bill went prowling at night, observing men and women in seedy cafés and bootlegging houses. Bill remembered one of these

dives where a bed comforter crawling with flies covered the window to conceal the suspicious activities within.[26] Another notorious and colourful haunt, familiarly called, "Chicken Charlie's,"[27] was described by a policeman:

> It was a typical bootlegging joint. There was dining, music and drinking. They had good food, though. I remember they cooked chicken in a big pot on an old stove, with flames shooting out of it ... there were some prostitutes and pimps hanging around and the odd stabbing did take place.[28]

Max habitually sought material in the haunts of the common man and the exposed fringes of society. Most nights, however, he was painting into the small hours after a long day at the office. He kept up with his reading by devoting an hour to it in the early morning. Besides rereading his favourites, *The Idiot* by Dostoevsky or Thomas Mann's *Magic Mountain*, he read, among others, works by Henri de Montherlant, Franz Kafka, Albert Camus and Louise Vilmorin. He subscribed to many periodicals dealing with art and literature, including the *Listener*, which he had read in England. Reading was indispensable to him and fed the sources of his own thought and creativity.

Bates was invited to exhibit at the Vancouver Art Gallery in April–May of 1947, and he and Glen MacDougall drove through the States to the coast.[29] At the time Newton Bates was studying at the Vancouver School of Art under Illingworth Kerr, and he was eager for Max to meet him. The Saskatchewan-born Kerr had drawn and sketched as a boy, then managed to save enough to get to the Ontario College of Art, where he was taught by Arthur Lismer, J.E.H. Macdonald and Frederick Varley and thus came under the influence of the Group of Seven. Kerr weathered the Great Depression, supporting himself in England working in film and writing short stories which were published in *Blackwood's* magazine. At the outbreak of war, he and his wife, Mary, settled in Vancouver. Kerr remembered the moment clearly when Max smilingly put out his hand and they chatted about the exhibition.[30]

Roy Stevenson was also in Vancouver, and the two friends were able to meet again after their long separation. The reception to Bates's work is indicated by a quotation printed in the *Vancouver Daily Province* from the caretaker of the Gallery: "He's all right, this Bates. He paints good stuff. Folks in places like New York would go crazy about him."[31] Mildred Valley Thornton, a critic writing in the *Vancouver Sun*, drew attention to his direct method of applying paint, his use of figures and repeated patterns and line. She described his colour harmony as low in tone but rich and subtle.[32]

On the way back to Calgary, MacDougall and Bates stopped in Spokane, and as they were having a drink at a hotel, they saw two girls "eyeing" them. Glen, who knew Max to be very shy, dared him to ask them to dinner; Max did, but without success.[33] For five years, Bates had been denied the company of women, and he had not yet found a focus for his undoubted interest in them, as these poems of 1947 reveal.

TO A LADY NEVER MET

Is it poetry or troubled prose I write
In the night silence
When I think of you?
Sometimes your voice fails
And your face
Is no face.
But somewhere
You are doing something,
Or nothing;
Moving or being still.
Wherever you are
You are not dead.......
Yet.
You are a bud that will never open
To my eyes.[34]

This second poem expresses the ambivalence of the attraction:

WOMAN

I would not have you jealous
I would not have you free of heart
I could not bear from you to part.

I must go and I must stay
See you I must without delay
But I would be alone today.[35]

Also testifying to his interest are several figurative works Max executed at this time of women wearing elaborate hats sitting alone in cafés.[36] Max used headgear over and over again to suggest a role and to reinforce the psychological impact of the figure. "With her padded shoulders, she is the picture of the correct Miss," Ian Thom wrote of one of these paintings, *Girl with Cake*, "An illusion gently destroyed by the highly improbable floral spray protruding from her head."[37]

Max's brief meeting with Kerr in Vancouver was the beginning of a long friendship that grew when Illingworth Kerr was chosen to replace Macdonald as the head of the art school at the Provincial Institute of Technology and Art. Max immediately renewed his acquaintance with "Buck," as he was known, responding to the Kerrs' straightforward, unpretentiousness and passionate concern about art and literature. The friends' admiration for each other's work did not inhibit their critical powers, and at times they were in vigorous disagreement. In these early years, Bates often visited the Kerrs in the evening and would talk about books and art until the small hours of the morning, unmindful of the fact that his host had to appear in a few hours for class.[38]

By this time, Bates had become somewhat adjusted to his new life and was beginning to make his contribution, apart from his painting, to the cultural and intellectual fabric of the city and the province. That he was able to do so was, to a degree, the result of his years of isolation and thought. He spoke little, but what he said was direct and relevant. Even his silent presence exerted a power. His opinions were greatly respected by his fellow artists, though sometimes they were delivered after an intimidating silence. He had no small talk and simply shut off if he detected insincerity or posturing. Most of his friends remember him with a slight smile on his face. Kerr wrote,

> Max had a way of expressing himself very positively." He sometimes growled it out for emphasis. He carried on his arguments with a tight lipped grin so that you were always

drawn into a very personal orbit. Always there was a sense of sharing. I always had a terrific sense of closeness to Max in this give and take. We were never opponents: we were investigators!, and his ironic, impudent grin will be forever with me. What he so often wore was an air of triumph. Or so it seemed in that broad grin. It was this, his air of certainty, that impressed the layman audience at the Art Centre when we had round table discussions on various topics. I was not happy to meet him in public debate. Max never allowed a "discussion" to become milktoast.[39]

Max became a member of the Canadian Society of Graphic Art and the Alberta Society of Artists and frequently contributed to the latter's journal, *Highlights*, of which Jim Nicoll was the vigorous editor. One of Max's first pieces stressed the importance of the graphic arts, which he felt were especially suited to figurative work, an alternative to the prevalent landscapes in oil and watercolour.[40] The dominance of landscape painting to which he referred was a legacy from the strong influence of Leighton and Phillips. When Kerr asked Max to teach figure drawing and painting in evening classes at the school and to conduct children's classes on Saturday morning, he accepted.[41]

John H. Snow joined that first evening class. He had always wanted to be an artist, but the economics of the Great Depression decreed that he pursue his other career, banking. He had returned to the Royal Bank of Canada after his years of war service as a navigator with the Royal Air Force. Snow found Bates to be an enlightening and sympathetic teacher who explained himself clearly. Like Bates, Snow was naturally reticent, but a deep bond of unspoken understanding developed between them.

Frank Palmer, who was in the class with Snow, remembered Max talking about art in a philosophical vein and making suggestions about a student's work without trying to change it or to demonstrate.[42] On occasions when the class was using a female nude model, Max would seek out Janet Mitchell, who was often working in the cast room or elsewhere in the art school, and ask her to join the all-male class so that the model would feel more comfortable.[43] In the class and in conversations Bates stressed the importance of hands and feet as the instruments of action in figure drawing. A fashion-type of hand or foot weakened the picture. He taught that it was the repeated line, shape and colour and their variations which resulted in a good piece of work, and Snow was able to relate this to his own understanding of the structure of music. Max told Snow that he often started out with "terrible raw colour," then made it right with other colours beside it. He warned that dead black in a painting killed it because it left no room for further movement. If, however, the black was mixed with yellow or brown, a resonance resulted which offered possibilities.[44] Kerr noted that Bates did not have an academic vocabulary and had no patience with colour theory. In spite of that, in Kerr's opinion, Bates's colour was compelling, and though he often went against all the rules of pictorial composition, his work was outstandingly successful.[45]

Max's thoughts on the creativity and teaching of children were set down in a paper published in *Highlights* of May, 1948.[46] The classes were for children aged eight to fifteen, and Bates taught one of the four sections of twenty-five. He made the following comments on the two schools of thought on how to teach children:

> From the opinion that the child up to fourteen years of age should be allowed complete freedom to draw from its imagination and receive no adverse criticism, there is a wide range to the opinion of the academic instructor who would set the child to copy, as exactly as possible, some object. Advocates of the first look with pious horror at any attempt at guidance; those of the second treat with contempt the beautiful self-invented forms of the creative child, so that it develops a feeling of inferiority about its own creativeness. There is no doubt that frustration of this kind tends in later years to psychological ills. Of the two attitudes the academic is positively harmful, and the completely free method, though harmless in itself, and often productive of good in children who have no scope for self expression in their home, is negative, and causes a lesser frustration of its own—the denial of enough guidance to satisfy the young child's desire to learn. ... The balance is found when the child is subjected to certain rather strict disciplines.

In brief, these consisted of ensuring that the pupil did not copy work in order to avoid the effort of expressing their own imaginative images; insisting on careful, unhurried execution; limiting colours and subject matter to force the child to creative solutions; and finally, introducing the older child to perspective and technical instruction. He summed up with a quote: "Art is when forms of our own spiritual conception occur," and concluded with the statement, "The one aim of the instructor is to obtain such forms from every child."[47] When Kerr asked him, "What do you tell them?" Max said, "I tell them to make good shapes."[48]

Max was especially helpful to the younger artists who met him at the Coste House, heard him speak, and saw his work. Kathleen Perry, who was teaching at the centre, was impressed by Bates's readiness to look at a young artist's work and offer advice.[49] Ted Godwin, just beginning his career, consulted Max about the difficulty he was having with watercolour, and Max said, "Just add water—no problem!"[50] Roy Kiyooka remembered going with Bill Bates to visit Max in his studio in the family home, which Roy described as "splendid." Dimly lit, it was full of beautiful objects, books and magazines and "very English." He was especially struck by Max's manner with young, aspiring artists: he spoke to them as equals and on a very human level.[51] Other visitors to the studio were Ron Spickett, George Mihalcheon and Greg Arnold, all of whom benefited from Bates's advice and inspiration.

The young artists frequently gathered round the etching press in the basement of the house, where Bates and Snow worked on prints. They had been producing woodcuts and lino-cuts, some of which they exhibited. Bates sent one of the latter, *Two Figures*, to the Western Canadian Art Circuit. His skilful pairing of the two

Two Figures (ca. 1948). Linocut, 16 × 13 cm.
Photo by John Dean. Private collection.

figures—one classical and one abstract—resulted in a striking work. Bates and Snow had a chance to expand their printmaking when, with the help of fellow artist Wesley Irwin, they managed to get an etching press, which they installed with great difficulty in the basement of the Coste House. Bert Earle, a skilled engraver, got them started on the etching process.

Bates and Snow were also very interested in modern films and were active in starting a flourishing film society. It grew from a small group John Snow had gathered together to see unusual films. The initial experiment was so successful that a meeting was held at the Coste House to formalize the organization. It was attended by Alexander Calhoun, sitting on a window seat smoking his pipe, Bates, quiet in a corner, and Mary Kerr, among others. After Bates mischievously nominated him as first president, Snow found himself responsible for finding accommodation for a rush of membership of approximately two hundred. The group met Sunday afternoons above a dance hall in a room draped with blackout curtains. Films such as *Battleship Potemkin*, *The Cabinet of Dr. Caligari*, *Les Enfants du Paradis*, *Choreography for Film*, and *At Land* were shown in the early years of the organization, which lasted for forty years.

In spite of these activities at the Coste House, his teaching and practice of architecture, most of Bates's energy went into his art. When asked in later years how the war had affected his art, he replied, "I don't think it had any effect except to intensify it when I got out because I had been thinking so much about it

all the time."[52] Certainly he seemed to accomplish an enormous amount the first two years after his return, as though all that had been repressed was bursting out. He prepared a one-man show for the Saskatoon Art Centre of twenty-eight oils and watercolours. The forced economies of his youth and war years had made habitual his search for bargains in materials and unconventional painting surfaces. Max got his wood for framing and packing from the lumber yards—though frequently it was green—and he was tireless in making crates for shipping his work east and west.[53]

Response to the Saskatoon exhibition was encouraging; the reviewer in the *Saskatoon Star-Phoenix* quoted some of the viewers:

> Here then, is certainly something decidedly new in Canadian art, which fact inspired one spectator to herald it as the "beginning of the revolution" and another called him "the greatest artist now in Western Canada."

The reviewer also noted that the show stimulated unusual interest "because there has never been a show of its style displayed here before. The majority of the pictures are concerned with the human figure."[54] At the top of the column was a reproduction of *Beer Drinkers*, two men relaxed over a table with several empty glasses, one figure in work clothes and the other in shirt and tie, which was probably an image from one of his visits to East Calgary.

At the end of 1947, members of the Calgary Group exhibited at the Vancouver Art Gallery.[55] Max sent eight works, including the stark prairie paintings depicting farm people. G.H.

Tyler, the curator, wrote Bates to tell him that over 10,000 people had seen the exhibition and that more would see it at the University of British Columbia. "It was extremely gratifying to find a group of Alberta painters finally released from the influences of the past in the province, namely, Phillips, Glyde, Leighton, which is a most healthy sign and undoubtedly will bear fruit."[56] This view vindicated Bates's and Stevenson's early rejection of that influence. The show went to Saskatoon in the fall, and the reviewer was enthusiastic about Max's **Prairie Life**,[57] which depicted a man and wife standing in front of a fence, he with a pitchfork and she holding a pan from which she has fed the chickens. She looks stoically forward, her hair blown by the dry wind, and nothing disturbs the straight, uncompromising line of the horizon. *Prairie with People* is even more disturbing in that there seems to be no bond remaining between the woman with her blowing blue skirt in the foreground, the standing male figure at a distance, and the figure resting on the ground. Again the horizon is absolutely flat, and the clouds are a mockery of the parched land. One cloud is curiously shaped, like a bone, perhaps another example of his impulse to incorporate what he laughingly called a "bone of contention" in his composition.[58] One saw such "bones" in the puzzling lion held by Marcus Cheke and the tantalizing lettering on Brinsley Ford's book.

As Kerr once said, Max had never been on a farm,[59] but he perceived the effect of the treeless space and aridity of the prairies on the human form and spirit. He also understood very well the harsh discipline of manual

labour. The intensity of the shock Max experienced on his return to the expanse of the prairies is in his famous painting, ***Prairie Woman***. The worn, desiccated figure stands under the bright, relentless sky, lifting her gnarled hand as she moves towards us. The colours are pale, washed out by the sunlight and the dry wind. Commenting on this work Ian Thom wrote:

> The image . . . is notable for formal, as well as iconographic reasons. A deliberately crude painting, it avoids painterly tricks in order to be as blunt as possible. ... It is in paintings such as *Prairie Woman* that Bates' expressionist tendencies are first evident. It is clear, however, that it is not the expressionism of the German expressionists but rather of the naïve or primitive Rousseau and the emotional tenor of Gauguin.[60]

While Bates saw the prairies as pitiless, Kerr, who knew them intimately, painted the beauty of the space, the sky and the animals which roamed them. Kerr's prairie landscapes rarely, if ever, contained human figures, for they become totally insignificant in that vastness. Bates, on the other hand, saw the effects of this landscape on the lives of its inhabitants, a subject he dealt with in his 1948 article "Some problems of the environment."[61] In this piece for *Highlights*, Bates expressed his sense of the cultural aridity of the prairies and dismissed the plea that the struggles of the pioneer left no time for aesthetic considerations. He wrote:

> Of the two compensating activities of the spirit—religion and art—religion has been entirely dominant. Without doubting for a moment the necessity of religion to a people, the fact is that conventional religion, especially those creeds that are fundamentalist and ultra-protestant, has tended to destroy the aesthetic reaction to life with which every man and woman is born, and without the development of which no full and rich life can be achieved. For underlying the extreme Protestant creeds is the belief that life is evil; that all beauty is vanity—a thing of flesh and therefore, in this distorted view, of the devil. A sterile puritanism is not ground in which the arts can grow. Only materialism can flourish, as has been amply proved by history even if, as must be admitted, it has sometimes a mitigating humanitarian tinge.

He went on to point out that prairie immigrants are offered only this materialism in place of the culture they have left. He concluded that "A great opportunity exists for the artist, whatever his medium, to make an art that embodies and is informed by those qualities which differentiate the Prairie Provinces from any other region in the World." Some years later, in the introduction to a catalogue, he was able to write of his friend Kerr, "He has made some of the most successful interpretations of prairie landscape ever achieved—often translating the Prairie into contemporary idioms."[62] Bates's poem, "Prairie from a Train Window," is another expression of his reaction to the landscape.

PRAIRIE FROM A TRAIN WINDOW

Reticulations
In a world of tiny dimensions
Like tear stains on window panes
Of trains

Hurrying in the prairie dust,
Sliding beyond bone-tawny prairie
And distant tree shapes.

Wind channelled faces
All that reminds us
Of thought tracks in the dust
In the same tracks
Backwards, forwards, across.

A few planks,
Sun blistered........
Cows
Remotely listless,
Motionless.[65]

Bates preferred to paint the landscape of the foothills west of Calgary. **Farm near Bragg Creek** was painted after a spring sketching expedition with John Snow. Bates made a rapid sketch on a piece of cardboard and returned to his studio to realise the painting.[64] The blue of the sky, the tender green of the field, and the puddle in the road, which he had shifted beyond the fence, all betoken the season. "Back in Calgary I became more interested in landscape than before," he wrote. "There is a danger that nature (thought of as a world apart from man) is being drowned in man and his works. I never thought of this in earlier days or of a kind of nature mysticism I now find attractive."[65] Most of his landscapes show traces of human occupation, shacks, roads, planted trees. "There has to be a trace of man," he explained. "I like to have a shack or a fence or something, otherwise I don't relate to it somehow."[66]

Max sometimes went sketching with Kerr, who thoroughly enjoyed painting and sketch-

Prairie from a Train Window (poem, 1950). *Maxwell Bates Papers, Special Collections, University of Calgary Libraries.*

ing in the outdoors. Kerr said that Max's sketches were not good—he would just indicate colour—but his visual memory was so acute that the resulting work was "wonderful." "For a sketch he would make a quick scribble and then you would see a sixteen by twenty very soon afterwards in his studio." Max once remarked to Kerr, "What can you do with a fir tree—it's green and they are all the same."[67] Kerr tried to entice Bates to the Calgary Zoo, where he frequently sketched animals, but Max was not interested.[68]

In the spring of 1948, Max sent some of his poems to *Canadian Poetry*, which published "Behold the Flowers" in its June issue.[69] Aroused by the article "Modern Art and the Dignity of Man" that appeared in the *Atlantic Monthly*, Max wrote a vigorous letter to the editor defending the modernist movement. The author of the article had termed modern art "incomprehensible to the ordinary man," and in his letter Max pointed out that the "masses have never assumed supreme control in the arts," but that over a period of time, appreciation is achieved at different stages. He countered the accusation of "sterility" by stating that modern art has "been very productive of new forms and has been more daring and venturesome and grappled with fundamentals more mightily than in any previous age."[70] It was a theme on which he had expended considerable thought.

For *Highlights* he wrote an article, "Art and snobbery,"[71] discussing the design of furniture and common useful articles. Max had long ago read Herbert Read's *Art and Industry*,[72] in which the author called for new aesthetic values that could relate to the products of the machine age. In Read's opinion, abstract art offered the best possibility of replacing the aesthetics of Morris and Ruskin, but his call for industry to pay attention to abstract art had largely gone unheeded. In his article, Max placed a large part of the blame on the public for the pretentious designs turned out by the manufacturers. He said that the effort to make articles look expensive was directed at the customer who wanted his household furnishings to proclaim his material success. Those designers who stress showy excess instead of intrinsic beauty of design are snobs about household articles. Their snobbery denies that domestic forms of art are art of any kind. Bates wrote:

> The problem in Canada is how to raise standards of taste of people who already have standards of a low order. ... The all-important quality of a people is its sense of values. To a greater extent than is realized its sense of values is conditioned by high standards of taste.[73]

Subscribers to *Highlights* received with each number a print by one of the members of the Alberta Society of Artists. Max contributed two commercially printed lithographs, *Central Park, Calgary* and *Theatre*. In the former, men are sitting on the park benches where Max and Roy Stevenson had once talked so animatedly about art. But the figures in the print do not communicate; rather, they sit lonely and defeated under the trees. Bente Roed Cochran wrote of this work that:

Bates's images conclusively demonstrated that he was one of the strongest artists of the group who contributed to the bulletin. ... *Central Park, Calgary* relied on economy of line and simple tactile qualities that resulted in a visually powerful work.[74]

Bates's industry was such that he had a sufficient body of work ready for an exhibition that July at the Canadian Art Galleries, a mixture of landscape and figurative work. Two pieces were notable for their contrasting subjects and moods. The figure in **Poet** is a young man seated at a table with paper before him. He wears a green coat with a pink flower in the button hole and a blue tie, colours of hope and spring. His head is raised against the open window, and he seems to be listening to unseen music or voices. The colours, the pose, indeed the whole composition convey a sublime tranquillity. **Puppet Woman**, on the other hand, is one of the first of Bates's many paintings and drawings incorporating hapless creatures doomed to be manipulated by an all-powerful hand. Some think the gypsy with her crossed eyes and hanging puppets is "malevolent,"[75] but she, too, has her prescribed role and accepts it. These two works can be seen as an example of the polarities Max perceived in life. The exhibition was memorable for the quality of the work and successful in that a considerable number of pieces sold.

There was no question, however, of Max's living on the proceeds of his painting. The practice of architecture was a satisfactory solution for him. He and his father were working on plans for St. Edmund's Church in Bowness,[76] a suburb of Calgary, and the

Ursuline nuns had asked for a design of an outdoor swimming pool for their pupils. Max designed the pool as requested, but pointed out to the nuns that at the time of year the pool would be most useful, the pupils would be on holiday. It would have been a good commission, but Max's good sense prevailed: the project was abandoned.[77] Later he designed a shrine for the nuns in the garden of the convent.

Max's architectural career was soon brought to a temporary halt. Both his father and his aunt Kit were ailing, and they died within a month of each other in early 1949.[78] Though this double bereavement was sad for him, it also freed him of some responsibility and gave him the opportunity to go to New York to study with Max Beckmann. In a statement, "Plans for Work," probably drafted as an application for funds to assist him in the project, Max wrote:

> As I am primarily interested in drawing and painting figures, I need to spend a year in a large centre, preferably New York, where there is a strong interest in figure painting, as apart from landscape and other forms of subject matter. My project is to develop my ability to express a personal approach in painting all types and kinds of people in their daily life. ... My wish has always been to reveal underlying universal qualities in the topical and particular. ... I find that for me, continuous drawing from the figure itself is a necessary discipline however experimental my work may be. ... My ultimate purpose as an artist is to paint the people of Canada,—more especially those engaged in common occupations,—trainmen, workers in the building

trades, farmers and the people of the towns and cities. I have become interested in painting the people of certain Canadian minority groups such as the Ukrainians, and I believe I am the first artist who has given particular attention to this subject.[79]

Max also explained his need to be in a large centre so that he could study contemporary trends and new currents of thought in order to catch up on the years he had lost during the war. He wanted to go to exhibitions and talk to other artists. He spoke of his projected work on the philosophy of art and his need to be near good reference sources. He expanded on this, writing that:

A secondary project is to have access to books on aesthetics, psychology and philosophy which I cannot obtain at present. I believe I have several contributions to make to the Philosophy of Art, partly as a development of Gestalt Psychology and partly from quite original sources. ... I have made a long search for the fundamental meaning of rhythm in order to help the artist and his public to a closer understanding of the arts. I believe my reading of the subject has been wide enough to exclude the possibility of my own ideas having been worked out already by someone else. Original material has been written over a period of fifteen years; much of it was thought out while detained in Germany as a prisoner of war. Gestalt Psychology drew my attention to new theories of perception which seemed to point to a fundamental simplification of the philosophy of art.[80]

As it turned out, circumstances prevented his work on the philosophy of art from coming to fruition; however, his experience with Beckmann was fruitful and his figurative work increased in range and intensity. The year also proved to be a turning point for his emotional life.

New York, Calgary, 1950-54

It must have seemed remarkably fortuitous to Bates that his circumstances should have changed so dramatically in 1949, the year that Max Beckmann was teaching at the Brooklyn Museum Art School.[1] Beckmann, whose work Bates had long admired, and whose career and outlook had so many parallels with his own, had come to the United States in 1947. In 1949 he taught one year at the Brooklyn Museum Arts School before his death in 1950.[2] Bates made plans to go to New York in the fall of 1949 and spent the early months of the year settling his father's affairs and closing the office.

Max's last months in Calgary were enlivened by his new friendship with May Watson. On holiday from New York, May had come into Canadian Art Galleries and seen a small painting of a woman wearing a decorative hat. Intrigued, she told Grace Turner that she would like to meet the artist.[3] An entry in Max's notebook states that *Girl with a White Cap* was purchased in September. Beside the entry he wrote "May."[4]

The daughter of Niels Nielsen, a prosperous rancher in the Priddis area of the foothills west of Calgary,[5] May was born in 1902. The family maintained a home in Calgary, and May attended school in the city, graduating from Central High School.[6] She left Calgary to begin her nursing career at the Vancouver General Hospital. After her graduation in 1926, she worked for a time as a nursing supervisor in Columbus, Ohio,[7] then left to attend Columbia University, where she married a fellow Calgarian, Harold Watson.[8] Though the marriage was cut short by Watson's death, May made a life for herself in New York, lecturing at New York University and serving as health advisor for schools in New Jersey and New York.[9] She also travelled and studied in Europe.

Max and May soon discovered they had much in common. Intellectually she was the equal of Max, not only because of her B.A., B.Sc. and M.A. from Columbia University, but because of the quality and range of her mind and the interest she shared with Max in psychology. When Max's brother Bill heard of their sudden engagement, he suggested that, with three degrees, she would suit Max.[10] His friends agreed that May's outgoing personal-

Max and May Bates. Maxwell Bates fonds, Special Collections, University of Calgary Libraries.

ity, physical attractiveness, and incisive mind, together with her appreciation of his work, were just what it took to break through Max's formidable shell, built as a result of the emotional and sexual restraints imposed by poverty and prison. George White, his "mucker" of the prison camps, remembers a letter from Max telling of his pleasure in his forthcoming marriage to a woman older than himself.[11] May returned to New York, and Bates joined her there when he began his courses at the Brooklyn Museum. They were married on October 15th in the Little Church Round the Corner in Manhattan.[12]

At the Brooklyn Museum Art School, Max took some rewarding classes in analysis and art criticism with Abraham Rattner,[13] noted American modernist, but his principal teacher was Max Beckmann, whose style of teaching was very different from that of Max, who rarely touched a student's canvas.[14] One of Beckmann's students wrote of him that

> With as few as six strokes of the brush he would reorganize a student's weak composition into a coherent and meaningful whole. ... He used black paint or charcoal on the student's work and urged them to use more colour and more paint.[15]

Beckmann's charming wife, Mathilde, was usually in the class with him to help with translation, but Beckmann dominated the classroom. One of his students provided the following description:

> At the Brooklyn Museum School he occasionally wore his hat as he criticized; it was an

impressive sight, for the hat with the brim usually up-turned in the front ... came to be Max Beckmann's expression of his attitudes about the world: a jaunty defiance of the commonplace and a strong assertion of his presence.

Through his wife he made pronouncements such as:

If you want to reproduce an object, two elements are required: first the identification with the object must be perfect, and second it should contain, in addition, something quite different. ... In fact it is this element of our own self that we are all in search of.

Beckmann also stressed "the importance of large movements in the composition" and the need to respect "the two-dimensional reality of the canvas."[16]

As Max did with his young friends, Beckmann was continually recommending reading to his students, "Stendhal, Flaubert, Dos Passos, Steinbeck and others who saw duality as a factor in the lives of all men."[17] The concept of duality was of continual interest to Max. He had written in his prison notebook:

For instance, belief that the spirit and matter are incompatible and opposite, is, although untrue, very close to the truth. They are opposites or polarities and therefore merge or fuse. As polarities they are related to each other according to an as yet, unformulated "law of polarities." The synthesis of the merging moment unites them and there is unity.[18]

Max was "disturbed to discover that only those students who imitated the Beckmann style received very much attention."[19] The elements of Max's own style were largely in place, and he felt later "that he had profited more from coming into contact with Beckmann's personality and thought."[20] The two artists were, in many ways, remarkably similar. Their sufferings in wartime intensified their sensitivity to the "*condition humaine* which transcends the established social order and unites all men in a common fate."[21] Sarah O'Brien-Gwohig, in her essay "Beckmann and the city,"[22] drew attention to the underlying despair of café society as portrayed by Beckmann. This sadness and essential loneliness can be seen also in Max's own café scenes, his drawings of solitary figures sitting in windows, or in the gaiety of cocktail parties. Like Beckmann, Bates was "fascinated by the involuntary movements of self-revelation within the relative anonymity of social bustle and noise."[23] In the works of both are found the performers, the clowns, the beggars who "like the artist exist on the fringes of society."[24]

Past exposure to the grimmest aspects of reality made both artists impatient with superficialities and pretence; like Bates, Beckmann had no interest in small talk because "he could not think small."[25] Beckmann, too, was drawn to an art "which gives direct access to the frightful, vulgar, spectacular, ordinary grotesquely banal in life: an art that can always be immediately present to us where life is most real."[26] Though Bates saw the use of symbols as a way of expressing the reality behind the habitual daily round, he did not use

Lower East Side, New York (1949). Ink and watercolour, 50 × 40 cm.
Photo from Maxwell Bates fonds, Special Collections,
University of Calgary Libraries.

them in the same forceful, complicated way as Beckmann. Interest in spiritual truth led both men to the works of Helena Blavatsky, and Beckmann became very interested in the study of theosophy and gnosticism.[27] Bates's long-held belief in the validity of astrology and the implied fatalism paralleled Beckmann's "metaphysical predestination."[28] Bates would agree with Beckmann's statement that "The greatest danger which threatens mankind is collectivism. Everywhere attempts are being made to lower the happiness and the way of living of mankind, to the level of termites."[29] In his notes Bates favoured the term "social individualism" to describe an opposition to collectivity and added "The responsibility of the individual is the only aristocratic way of life."[30] Finally, neither man was willing to discuss the meaning of his works, wanting most of all, as Beckmann's son said of him, "to preserve the spontaneity of the subjective impression of the viewer."[31] When a viewer would venture an interpretation of a work, Bates would reply, "If you see it that way."[32]

Because of the similarities in the outlooks of the two men, the degree to which Beckmann directly influenced Max's work is debatable, and it is unclear whether that influence was any stronger than that of Daumier, Rouault, Picasso or Matisse. Bates's technique, on the other hand, was, by his own admission, strongly influenced by the work of Paul Klee, whose expressionism, abstract and poetic, was not that of Beckmann. Max saw the large exhibition of Klee's work mounted in 1950 by the Museum of Modern Art[33] and studied it carefully. "He was the greatest man for tech-

niques," he said of Klee. "I've learned more from him than from anybody else, I think almost."[34] Max was very much intrigued by some of Klee's early works, which he thought were produced by the technique of the monoprint. Max explained,

> I think it's the only way you can get that crumbling look in the line. There was one called *The Twittering Machine*. If you look at the line, it's not very definite, crumbling all over the place.[35]

Max decided to try his hand at it and got "a bit of glass and rolled ink on it and then put paper on it and drew on the back of a sheet. There was this nice line. ... I find it's a very good basis for working on afterwards with pen and ink and water colour and so on, once it dries." Max liked drawing with ink on wet paper for "the ink shot out in all directions like a thread gone mad,"[36] and by this method he produced many of his most distinctive works.

Max found time to paint and sketch the New York scene, prowling the streets as he had done in London. *Lower East Side, New York* is typical of the work in ink and wash he completed there. The tall buildings crowd in on the bulky figure of a woman with a baby carriage waiting to cross the road. She seems a vigorous life force enclosed in the rigidity of the buildings. Bates produced other similar works from his New York sketches. Illingworth Kerr wrote of these:

> Returning from New York in the fifties, Max made some astounding watercolors. Because he was an architect he could turn his scrib-

bles into remarkable structures—remarkable, too, for their eccentric character ... the buildings of that city interested him as much as had those of Europe. His architect's eye retains the image of a building as clearly as a horse-trader pictures an individual nag.[37]

His watercolour *14th St. N.Y. City*, in tones of orange, brown and grey, shows a group of buildings viewed from a height. From the variety and richness of the shapes, he produced a composition that is striking in its beauty, mystery and even humour.

Bates continued his habit of exploring the galleries and soon began showing his work. He exhibited six large watercolours in the Harry Salpeter Gallery on Fifty-Sixth Street and some more at the American and British Art Centre, but none sold.[38] He contributed *Street Scene* in ink and watercolour to a show, "Directions for 1950," mounted at the Laurel Gallery by the instructors and students of the Brooklyn Museum Art School.[39] Invited to give a one-man show at Queen's University, Max was able to send fifteen watercolours.[40] Further news from Canada came when Jock Macdonald wrote to say that he was off to France and complained that a recent Montreal show "black-balled practically everyone west of Montreal."[41] This was an intimation of what J. Russell Harper called "the anglophone revolt in the fifties,"[42] with which Jock Macdonald was closely associated. He was also involved with the group, "Painters Eleven," young artists with experimental ideas who banded together to promote their work.[43] Macdonald and Max often expressed their concern about the uneven exposure of the work of Canadian artists.

On their return to Calgary, Max and May renovated one of the smaller houses that Bates, Sr. had built. They did much of the work themselves and stayed in the home of Lettie and Henry Hill while they were on holiday.[44] At the same time, they took on the task of clearing and selling the Bates's family home. May, who as one friend said "was the smartest woman I ever knew"[45] and knowledgeable about real estate,[46] was of tremendous assistance. She was anxious to provide Max with the financial means to devote himself to his art full-time and looked forward to their enjoying a year or two in Paris while he worked there. She encouraged him in his writing, especially the comprehensive work on aesthetics he was planning.[47] She had been warmly welcomed into Max's circle of friends, who saw that he was genuinely in love, so much happier, less "glum and distant,"[48] and certainly more approachable. The couple entertained frequently, and May was "kind, hospitable and welcoming."[49] She and Mary Kerr struck up a firm friendship, took long walks together, and studied ceramics at the Institute of Technology and Art.

Max resumed his architectural career in partnership with Alfred W. Hodges, who had practised in Hong Kong and survived internment by the Japanese. He was an expert on construction and the handling of concrete, while Max concentrated on design.[50] Allan Mogridge, a young architect, also worked in the firm and was impressed by the fierce attention Max gave to everything he did. At times, though, Max was so uncommunicative that it seemed to Mogridge that the "darkness of the mine had entered Max's soul."[51] The firm was very busy with new schools being built in the area and the design of new churches, for which Bates's London experience with Gibbons provided special expertise. In some random notes headed "Restlessness in Modern Architecture," Max commented on the "Use of too many different materials to allow unity or dignity or repose." This was especially true of churches, where serenity is necessary. "Every opinion, every belief, every inarticulate certainty, every thought and memory is responsible for the architect's conception," he wrote. "Slickness, meanness, triviality result from the calibre of the architect as a man, more than from his training at this or that university, or this or that office."[52]

In his *Self-Portrait of 1950*, one sees the same brooding thoughtfulness as in the 1945 watercolour he painted in England just after his release, but the face is younger looking and framed by a canvas against a decorated background. His palette and brush are held in front of him. In Ian Thom's opinion,

> We are drawn again and again to the face and more particularly the eyes. We, the viewers, are regarded with a mixture of understanding of and a slightly sardonic resignation to our foibles. The artist is at once accessible and aloof. The work has a compelling ambiguity.[53]

Another oil of that year, *Evening Matrix*, is a mysterious composition in which an owl sits in a tree stump, a night bird flies low on the canvas, and to the right stands a sinister figure near a closed door. Reaching behind to the edge of the painting is a brick wall that in

a strange way draws the viewer back to normality. There is a certain feeling of Beckmann about the work.

Bates's still life of a lamp on a bracket (**Untitled**, 1951) is one of many such rich compositions he painted through the years. Though the objects are recognizable, they are actually beautiful shapes which came with the colours as a "free flow from his subconscious."[54] In reality, the lighted lamp on the art nouveau bracket would fall and the drape would slip from behind the vase with the flower, but here the tension is sustained. The painting works as a whole. Kerr was intrigued by Bates's still-lifes and wrote:

> To my knowledge he never set up still-life as Cézanne would do or I would do for a class. ... Bates is a colourist. Yet having little use for colour theory, he relies on a sensory response which heightens the individuality of his work. The strangeness and surprise of his colours is almost unfailing in canvas after canvas, large and small.[55]

Bates himself wrote that

> The world is revealed to us as a kaleidoscope of colours, sound, smell, feelings which continually changes into new patterns, surprising completed arrangements. Perhaps we will see, smell, touch one combination again and again over a period of years.

This he conceived of as being in "individual rhythm," with childhood patterns remaining the richest.[56]

Max frequently sketched the landscape west of Calgary where Bill Bates had taken up ten acres. When A.Y. Jackson occasionally made visits to Calgary, Max went sketching with him.[57] Jackson later donated one of Max's paintings, *Alberta Road*, to the Art Gallery of Ontario.[58] Nancy Townshend, curator of an exhibition of Bates's landscapes, described Max's experiments with landscape in this period as a "painful exploration of potentially conflicting visual concerns such as local color, naturalistic light and fairly abstract, flattened rather than naturalistic space."[59] Bates occasionally went with Frank Palmer to the coal mining town of Canmore to sketch working people. The two also sketched at the Stampede that summer, visiting Gypsy Rose Lee and her artist husband Julio de Diego in their own railway car. They found her an entertaining conversationalist.[60] Bates's eye was captivated by the garish midway, the dancing girls, barkers, the acrobats. In notes he made later, he recalled one enticement to come "where the monsters are."[61]

The summer Stampede and fair, a Calgary institution since 1912, was one of the few aspects of life in the city that had remained relatively unchanged in the post-war years. The enormous Leduc oil field, opened in 1947, was a magnet to the large international oil companies, and Calgary found itself flooded with their employees, most of them from the United States. Until then the social climate had retained strong traces of the original British inheritance, tempered by a growing Canadianism, but suddenly the pace of life quickened, salaries went up, divorces went up, buildings went up, and the aggressive materialism that Bates abhorred became the ostentatious norm. Business over lunch, noisy cock-

Line drawing from a sketch book, n.d. Maxwell Bates Papers, Special collections, University of Calgary Libraries.

tail parties and dining out replaced the unpretentious gatherings in family homes, occasions that were rarely motivated by considerations of commerce. Like many native Calgarians, Bates looked on with a jaundiced eye. In spite of the influx of wealth, the arts did not benefit particularly in these early years; the newcomers were often only superficially interested in Calgary. When one attractive newcomer driving her Jaguar was asked, "Do you like Calgary?" she replied, "No, honey, but this is where the money is."

Undoubtedly it was this climate which prompted Bates to copy out a passage from Lewis Mumford's *Technics and Civilization*, which explored the reaction against the prevalence of commercialism and dominance of technology, a reaction which formed one root of expressionism. Mumford had written:

> A new type of personality had emerged, a walking abstraction, the economic man. Living man imitated the penny in the slot automaton, this creature of bare rationalism. These new economic men sacrificed their digestion, the interests of parenthood, their sexual life, their health, most of the normal pleasures and delights of civilized existence to the untrammelled pursuit of power and money. Nothing retarded them; nothing diverted them. ... Outside the industrial system, the economic man was in a state of neurotic maladjustment. These successful neurotics looked upon the arts as unmanly forms of escape from work and business: but what was their one-sided, maniacal concentration on work but a much more disastrous escape from life itself.[62]

Despite the prevailing climate in Calgary, Bates was leading a full, satisfying life, practising his architecture, reading, writing and painting late at night. He and May were active in Coste House. On one occasion, May chaired a symposium on the state of the various arts in Alberta. The speakers included Kathleen Perry, John Snow, Wes Irwin and the colourful Madame Valda, a ballet teacher who used her petite foot to demonstrate a point and threaten her fellow panelists, to the great amusement of the audience. On behalf of the Allied Arts Council, Max composed a letter to the federal government asking them to implement the recommendations of the Royal Commission on National Development in the Arts, Letters and Science, familiarly known as the "Massey Commission."[63] Always concerned for the welfare of young artists, he helped organize an exhibit of works by George Mihalcheon, Ron Spickett, Roy Kiyooka and Greg Arnold and arranged for it to travel to Toronto and be shown at Hart House.[64]

Max's own work, along with that of Walter Phillips, represented Alberta in an exhibition of western Canadian art that was organized by the Dominion Gallery, Montreal.[65] Two of Max's prairie oils were noted in a rather dismissive manner by the critic Robert Ayre, who thought them "amateurish in execution" but representative of the reality of the prairies.[66] Bates's watercolours appeared in the exhibition of the Canadian Society of Painters in Watercolour, to which he had been elected, and two sold.[67] Paul Duval chose *The Graceful and the Disgraceful Child* to represent Max's work in his book *Canadian Drawings and Prints*.[68] In the monotype with wash, two children are in a carpeted room with their backs to the viewer. An untidy boy with tousled hair and stretched limbs holds up a puppet-like doll against the wall, his figure sturdy and forceful. The girl with her long hair and butterfly bow, reminiscent of the 1920s, watches him expectantly. For his subsequent book on Canadian watercolour painting Duval chose Max's *Early Morning*,[69] a haunting work in which a lonely, drooping figure is dwarfed by the silent, lowering buildings lining the deserted streets.

This sad figure may well have been Max himself, for his life was abruptly darkened by May's failing heart. For months she lay in the hospital, struggling to live. As his friend Kathleen Perry said, "It seemed as if he was being tried."[70] He expressed some of his anguish in "The Tiger," which he wrote at that time.

THE TIGER

Suddenly the tiger springs:
No one had thought of hidden things.

Watching the sunlit path
No one had thought
Black and yellow malevolence
Hid behind the fence.

No one had thought of hidden things;
No one had seen
The tiger that follows the steps of kings:
The smouldering fire of hate in things.[71]

The strain went on until June of 1952, when May Bates died.[72] In his grief, Max wandered

alone at night through the streets he had so often walked in his youth.

NEON CITY

The great, human stain of the city:
The dark edges of sin, black soot on the
 stones,
The simple faces of the great,
Unknown, but seen.
I belong to those streets.
And tears at the surface of grief
Tears for what has been,
Knowing what should have been.
Tears like neonplay
Against the great violet night sky
That will not return quite the same again,
Although the neon winks and shimmers
Exactly as tomorrow.[73]

His second poem of that year is even more poignant:

PAIN

Pain the monolith,
The monument
That may not be done away with;
That must not be done away with;
That must remain.
The imprisoning pain
That presses down and presses down
Like stone, like stone feet
Pressing the wine of the spirit
From the grapes of remembrance
In the gutters of the deserted street:
A disappearance
To the lower end of nothing,
To the level of flat despair.
Only to return from there,
Apprehensive, unquiet, seeking,

Agitated in limbo,
To be crushed again
With sheer weight of pain.[74]

As Roy Kiyooka said, "She was the love of his life."[75] And though his friends tried to rally round, Max retreated to his shell and spoke little of his feelings. He spent Christmas with Azelie Clark and her husband, George, the physician who had looked after May in her illness.[76] One of the few paintings Max did soon after May's death came from a poignant remembrance of the past. ***Two Women*** is a memory painting in shadowed blue and grey of his mother and Aunt Kit as they looked and dressed at the time of the First World War, the years of his childhood. Their characters are clearly differentiated: his mother dominant, reserved and speculative; his aunt, warm and sympathetic. They offer a contrast to the troubled face in ***Head of a Woman***, which Max had painted during May's illness.

Max's brother Bill provided him with understanding and companionship, and Max's visits to the Snow house increased. He and Snow now experimented with making wood-block prints using the end of apple boxes or plywood and rubbing the paper with the back of spoons. During one of these sessions, Max expressed the wish that they could incorporate colour into the prints. On holiday in Seattle that spring, Snow visited the art department of the University of Washington and showed some of his work to the artist Glen Alps, who suggested that Snow would find lithography a good medium for colour. Encouraged by Alps, Snow was determined to find a press, and on his return he visited all the printing firms. His

persistence paid off when Western Printing and Lithography told him they had just thrown out two for scrap. Snow hurried to the snowy machinery dump and carefully gathered the parts of two presses to the last nut and bolt. There were also lithograph stones, some still showing the last traces of their use in printing butter wrappers or corporate bonds. Snow initially moved one press to his basement and the other went to Max's house, but both ended up in the Snow's basement. With a book from the public library, they began working first in black and white. Additional help arrived in the person of Laurie Duff, a customer of John Snow's at the Royal Bank, who had worked on the Western Printing presses as a boy. The next summer Snow again visited Alps's studio to perfect his technique. Though Bates and Snow had relatively little time to work on the presses, they experimented in the evenings or at the weekends and slowly mastered the process.

Gradually Max took up his life without May. He and Bill often dropped in to the Canadian Art Galleries to chat with the Turners and look at the paintings and books. They helped celebrate the wedding of two young artist friends, George Mihalcheon and Jean Lapointe, a talented ceramicist. When the Royal Winnipeg Ballet came on their first visit to Calgary, Bill and Max attended. They invited two of the dancers to Bates's home after the performance.[77]

Max was ready to express his views publicly when he and Luke Lindoe were asked by Dushan Bresky, a columnist, for their opinions on the general appearance of the city. Under the headline, "Stronger civic pride advocated by artists," Bates deplored the proliferation of tasteless billboards. He called for a project to bury the tangle of telephone wires and emphasized that the appearance of streets and squares was as important as that of houses. He advocated the use of murals and sculpture and strong colours, which were more effective on the prairies where the brilliant sunlight and clear air had a tendency to wash out pastels. He and Lindoe deplored the fact that even if sculpture was commissioned for a building, it was too often not integrated into the design but added as an afterthought.[78]

In two of Max's poems of that year, there is a certain acceptance of the tragic loss of May and also what Kerr called "the mystic element that charges Bates' work."[79]

INTIMATIONS

Upon the houses
Black and beautiful,
Light of the moon
Shadowed dim silver;
And in my soul,
Feelings of some scarcely perceptible
Great beauty,
Some words of God,
Not quite invisible.[80]

VISION

For in the Beginning is the End
In the drop of water is the ocean found
By he who sees Christ standing
In the small, red eye of a bear.[81]

Max was cheered when his good friend Jock Macdonald came to Banff to teach for the

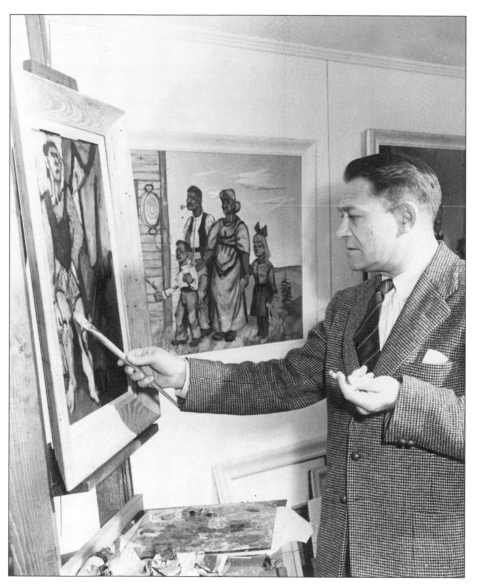

Maxwell Bates (1953). Photo from Maxwell Bates fonds, Special collections, University of Calgary Libraries.

summer, and together they acted as judges for the art show at the Calgary Stampede. Max's experience in teaching children, and the fact that he was designing a great many schools at that time, gave him a special interest in children's art.[82] Macdonald's Calgary friends gathered at the home of Marion and Jim Nicoll. On one occasion they eagerly discussed Aldous Huxley's recently published *Doors of Perception*,[83] and Max later wrote about the book:

> If reality (or existence) is too strong to allow the prosaic business of living, and the mind is a filter that regulates the amount perceived, then the artist tries to increase the amount of reality filtering through the mind.[84]

The possibility of a clearer, more intense vision induced by hallucinatory drugs was very tempting to some—but not to Max.

The British artist William Scott was also instructing at Banff, and Max invited him to stay at his house when he visited Calgary. Max brought Scott and Macdonald to Snow's basement to see the lithography, and Scott urged them to begin producing editions. Scott was intensely interested in contemporary art, and he had brought with him from England recent lithographs by British artists, including some by Graham Sutherland. Macdonald tried his hand on a stone and produced his only lithograph, *Polynesian Night*, for which Snow pulled twenty prints. Originally the print was called *Polynesian Morning*, but Macdonald changed the title. It was reproduced in Joyce Zemans's study of Macdonald, and she noted the influence of Sutherland on the print.[85]

Bates and Snow continued to work with the press, gradually moving from black and white to colour.

At Christmas of 1953, fate took another turn for Max when he met Charlotte Kintzle at a friend's home.[86] She was petite, cheerful and attractive, and Max offered to drive her home in his old green Studebaker. With Bill's encouragement, Max invited her to a New Year's Eve party at Bill's country place. This first date turned out to be rather embarrassing for Max when, because of the deep snow and his less than expert driving, he had to rely on Bill to lead the way back to the city.[87] Max pursued Charlotte with such vigour that she wondered at his importunity and kept putting him off. She finally gave in to him and they were married on the thirty-first of March, 1954. The wedding took place in the Anglican cathedral, over the objections of the clergy because it was Lent. Max was insistent about the date, since the horoscopes were favourable.[88]

The marriage was a fortunate one for both Charlotte and Max. Though she was not at first particularly interested in art or literature, she found Max's circle stimulating. A good hostess, she enjoyed entertaining friends in their comfortable home, which had some of the same subdued richness and quiet beauty of the old Bates's house. The household was completed with the distinctive personality of their cat, Spike. Their enduring relationship developed slowly, time and events proving the worth of Charlotte's quiet patience and kindness. Through the years she was especially helpful to Max in dealing with his extensive correspondence and typing his manuscripts.

One of his most important manuscripts, "The flight from meaning in painting," was published in *Canadian Art*.[89] In it he discussed what he saw as the contemporary artist's continuing preoccupation with new processes and techniques to the detriment of communicating his personal vision and sense of values. Bates suspected that the use of many of these technical means "for the sake of visual interest" was a form of escape from the artist's duty to confront our unstable world with "new values" and to break up those "that are no longer valid and have become obstructive." Max went on to state that, in an age of conflict, the artist

> may choose to turn to an unreal but more satisfying world of his own, or to an unreal neutral world. On the other hand he may try, in his small way, to stabilize our culture by remaining fully conscious of those values that are truly contemporary.[90]

In his poem of that year, "Talent," he expressed his own vision of the artist as a favoured son who, as in the Biblical story of Joseph, must fulfil his destiny in spite of his brothers.

TALENT

Who has talent
Must know it is given
Like a coat of many colours.
He may wear it
Woven by generations before him
Or by God.
He must keep it bright, untorn,
And he may be attacked by his brothers.[91]

Max and Roy Stevenson had withstood such an attack in the twenties from the members of the Calgary Art Club and the public and had successfully maintained their own vision. When Stevenson returned to Calgary in the fall of 1954, the two men resumed their long association. Stevenson was introduced to John Snow and the presses and sometimes joined the printing sessions in the Snow basement.

The art community also profited by the arrival of Kenneth Sturdy, who came to teach at the Provincial Institute of Technology and Art. He had studied at the Chelsea School of Art before he emigrated to Canada and had taught in Toronto for the summer.[92] He was impressed with the artistic climate in Calgary at the time and later called this period "the golden age." He found the artists in the city to be a "homogeneous and cooperative group ... showing generosity of spirit and easy tolerance." Sturdy enjoyed the formal and informal gatherings at the Coste House and was amazed at the quality of *Highlights*, the journal of the Alberta Society of Artists.

Sturdy met Max soon after he arrived, and he remembered one of their first evenings at the Bates's house, with Max taking evident pleasure in *The Goon Show* he was watching on television and Charlotte serving coffee. Initially Sturdy found Max "rather grim," but they talked until late and then Max went off to paint, probably until dawn. Max was the first person in Calgary with whom Sturdy could discuss such authors as Samuel Beckett, Karel Capek, or Bertolt Brecht. As a newcomer to Calgary who was familiar with a larger art world, Sturdy was able to evaluate Max's work

with intelligent objectivity. He perceived that Bates was very "strong intellectually" and because of his qualities of character "he was a sort of Messiah. People came to him. In his pictures you could find the insight which he drew from his own resources." In discussing Max's view of women as represented by his works, Sturdy maintained:

> his attitude to women was revealed in his paintings where, quite apart from content, his use of paint was sensuous; which would indicate that he was interested in sex. ... He drew in a very physical way also ... and was a "stage-door Johnny" in the way he painted the chorus girls.

Sturdy was impressed that Bates had a "great sense of the truth of light, as had Vermeer"; and he compared this quality with the gift of "true pitch in a musician." Some of Max's work reminded him of Beckmann's, "which represented a form of visual protest," and like Beckmann, Max had a "passion for justice and an acute sense of injustice. In the presence of sham he would turn away."[93]

By the end of 1954, Max's life had entered a new period of stability. He was a leader in his own community, and his art was becoming recognized both nationally and internationally. His sales were no longer confined to Calgary but ranged from Vancouver to Montreal. The church he had designed for a Chinese congregation was completed, and he turned with enthusiasm to a new project. The Roman Catholic authorities had decided to erect a new cathedral building on the original cathedral site where the missionary priests had settled on the banks of the Elbow River to minister to the Blackfoot.[94] Discussion with Bates, Sr. about the cathedral had taken place in 1937, and it is interesting that Max, aware of the project, took to making his own design for it in the prison camp.[95] When the final decision was made by the Roman Catholic authorities and the project awarded to the firm of Hodges and Bates, Alfred Hodges generously offered Max the chance to design the cathedral.[96] This task was to occupy him architecturally for the next three years.

Art and Architecture in Calgary, 1954–56

For the next six years, Bates's life was stable and productive. Though his activities in art, architecture and writing were diverse, they were united by his over-arching interest in man's essential being, the mystery of his place in the universe, and his role in society. For some time he had been working on a book entitled "Vermicelli,"[1] which he translated as "little worms." Speaking about it to P.K. Page in 1973 he said, "It's mostly experimental, a sort of mosaic. No story line or narrative—jumps about from one thing to another and nothing at all conventional about it."[2] Among the poems, plays, stories, quips and phrases is "Parrot's Gold," a nicely ironic short story about a certain Miss Parnell and her greed for the wealth of her brother, a London bird fancier. Mr. Parnell, who has managed to teach his pet macaw, Oscar, only the phrase "parrot's gold," makes the bird his sole heir. After Parnell's death, his sister plots to dispatch the winged usurper, at one point with a plan for poisoned peanuts. Fate seems to turn the contest her way when Oscar escapes his keepers, but finally, as she sits in the solicitors' offices sure of her triumph, there comes through the window the raucous cry of "parrot's gold." The effective contrast between the pinched, acid and hypocritical woman and the exotic and wayward beautiful bird makes the story a moral comment turned almost pictorial.

A short fragment from "Vermicelli" titled "A Young Girl in a Parisian Twilight" evokes Max's continuing fascination with hotels as settings for human drama. This fascination is apparent as young Ninette anticipates her evening:

> And now Ninette's thoughts of the Dining Room and the Opera to follow were of an indistinct brightness of hanging crystal lights, in which elegant and enigmatic people moved toward ends of pleasure or business inexpressively fascinating; yet for Ninette, unknowable and secret.

Another piece suggests Max's own frequently paralysing shyness with women. It recounts the agonies of Al, who as he sits in a Calgary café:

> He could feel the blonde in the red coat looking at him now and then and he felt

peculiarly exposed and tense. His brain wouldn't work at all so there wasn't any use even trying to think of some way of speaking to her. ... He couldn't master the heights of casualness necessary. ... Then she stubbed her cigarette in the ashtray and touched his sleeve and said "Pardon me" and Al murmured something inaudible."

Selecting a new record from the jukebox as she leaves, her departure was accompanied by its mocking refrain:

> Love somebody, yes I do.
> Love somebody, yes I do
> Love somebody
> But I won't say who ...
> I
> Don't know why
> He acts so shy.

The song intensifies Al's humiliation and frustration, and he leaves the café for a beer parlour, the scene of Chapter Two of the proposed work. We never discover what happens to Al. Max wrote in his notes, "Is it not strange that, in a novel or even a short story I suppose, a beginning and an ending are considered necessary parts. In real life, events seem to have no end but cease to be in focus because some other matter holds the stage."[5]

Bates's manuscript pages have notes scribbled on them at all angles; tags, phrases, quotes he wishes to remember. They are written on bits of paper, cigarette boxes, notices of shows, anything at hand. He copied out Guy de Maupassant's advice to his admirer, Gustave Flaubert:

The very least object contains a little of the unknown. Let us look for it ... this method forced me to express in a few sentences a being or an object in a way that particularized it exactly, that distinguished it from all other beings of the same race or species.[4]

Max tried to follow this advice in his writings; certainly he did so in his paintings. One group

Maxwell Bates and John H. Snow with lithograph press (1955). Private collection.

of notes is headed "Little Worms" and includes items such as "somehow incongruous like picture of a naked bishop"; "That colossal inconstant woman, the future"; and "A poem should be as full of thoughts as a candelabra is of candles, all of them lighted to dispel the surrounding gloom." Next to a list of possible titles such as "Twisted Streets," "Kings and Castles," "The Knave," "Recoil," "Fair Wind," "Shy House," "Piccadilly Roof," "Beggars Can Be Choosers," he wrote:

> The true aristocracy is all those who have something of grandeur in them; whether it is the genius of the creative artist or the hero-ism of an obscure person, it is the corpus of those who do great things for no reward or to whom a reward is of least importance. It is, in the last analysis, an altruistic company for it believes that the divine in man is the best in man. It is moral.

On the verso of the page are two notes: "In this matter he acted rather better than was expected of him and rather worse than decency re-quired"; and "The Facetted eyes of a Fly. Each of our minds is like one facet in the eye of a fly. God's mind is like the whole eye, composed of all our minds and comprehends everything at once and as a whole."[5] In Max's busy life these notes, products of a constantly active mind, were simply filed for future use.

Max and John Snow continued to experiment on the lithographic press. After the tragic loss of his wife in 1954, Snow had submerged his grief in the care of his young son and work on the press. His strangely fortuitous recovery of the presses and limestone slabs fuelled his

Canal Street, New York (1955). Lithograph, 38 × 28 cm. Photo by John Dean. Private collection.

Settlers (1955). Lithograph, 25 × 18 cm. Photo by John Dean. Private collection.

determination to master them completely. Max, always interested in new techniques, was an eager participant, and they were establishing themselves as the "first lithographers in the west."[6] Three of Max's early lithographs, produced in 1955, were black and white. *Canal Street, New York*, drawn directly on the stone, shows a "lonely crowd" moving in various directions beneath the city's signs, and high above them, washing hangs fluttering from iron balconies. In *Settlers* two immigrants in clothing suggestive of their eastern European origins stand looking at the viewer with calm contentment. Behind them is their wooden dwelling, surrounded by fir trees and vigorous flowers. It is a very satisfying composition and projects none of the usual strain and aridity of his prairie families. The subject must have pleased Max, for he also painted a large oil **Prairie Settlers**, of such a couple against a background of ripened grain. *Nurse and Child*, in black and white and shades of grey, is a strange, rather disturbing work. The nurse, wearing an ugly, bucket-like hat, gazes sombrely downwards, oblivious to the child in her lap. For one of his first lithographs with colour, *Cock and Hen*, Max drew with a soft line on a yellow-ochre background. In **Ballet** he started off with magenta, and by using yellow over it, produced an orange, so that the costumes of the four figures are patterned in magenta, yellow, white and black. All but the black dancer wear fantastic headgear.

Of his experiments in lithography Bates wrote:

Perhaps greater subtlety and delicacy are

possible than in any other print medium. This medium imposes no discipline and, because of its flexibility, great breadth of expression is possible. ... The result of the process itself is visible and recognizable in the woodcut, engraving, etching and silk-screen. By them a subject may be transformed by the process (and thus formalized) without a creative, imaginative act of the artist. ... Like the painter, the lithographer must make his own limitations. Of course discipline is necessary in all media whether forced or self-imposed. I believe it is more difficult to impose it oneself.[7]

Max maintained in this account that the artist benefits by doing the printing himself, but because of Max's weakened heart, Snow did most of the press work with the heavy stones. The two artists started by using a different stone for each colour; later they used the same stone right to the uneven edge. For the next colour, the image would be ground off the stone and a new image and colour used. Max felt that the medium encouraged experimentation. "I don't think lithography leads the artist in any particular direction except one: a decided image," he wrote. "One remembers Daumier's saying that artists should return to the clarity of figures on playing cards. ... I don't find that lithography influences my painting. The two media follow separate but parallel paths,—parallel because they both reflect a singular outlook."[8]

In Bates's papers one finds a variety of short statements and notes relating to his painting. Many of these entries are cryptic, fragmentary, or merely the suggestion of an idea, but the note headed "Method of Painting"

is complete.

Method of Painting

1. Lay out masses and shapes in charcoal.

2. Lay in flat shapes to form an abstract pattern without many small or slight indentations, etc. The picture is very simple at this stage as to tone, colour and shape. This stage is not finished until a fairly abstract painting is achieved that is satisfactory as such. Tone is used to make contrasts, connected light and dark areas as big and simple as possible. Colour is limited to four or five colours at most, one colour dominant. Not more than one colour is of anything like full chrome or intensity, and this one occupies small areas only, it is never the colour occupying the most space that sets the colour-mood of the painting. This stage sets the framework or skeleton of the painting. Paint is rather thin and may be allowed to dry before the next stage is started. Really it is the simplified map of local colour and general tonality.

3. Any detail now begins to appear. Large areas are enriched with calligraphic brush-work close-toned to the area it is painted on, or enriched with texture also close-toned.[9]

In another note Bates warned of the dangers of conceiving of the sketch as a small version of a finished work. The quality of intent as the artist sketches is very important. As he explained,

> The practice of working from small sketches seems to me to be bad in painting. Too often the picture, many times larger than the

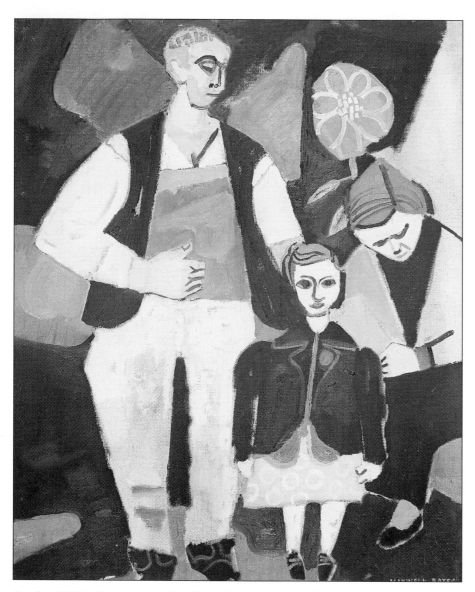

Family (1956). Oil on canvas, 75 × 60 cm. Photo from Maxwell Bates fonds, Special Collections, University of Calgary Libraries.

preliminary sketch looks empty, weak, diluted. It is more practical and less wasteful to work out the beginning of an idea to a small scale and I do not suggest making tentative designs on huge pieces of paper; but it is possible to work on a sketch as if it represented a picture several times the size of the actual canvas to be used. In this way the final painting is reduced from the sketch instead of being enlarged from the sketch. The painting gains in volume and force and may achieve the monumental.

Other of these notes are on colour—for example, "bright, warm brown most reassuring, comforting colour" or "Red—exciting, danger. Green relaxing macabre effect. Magenta subduing. Lavender wistful." He also pondered technical questions such as, "If its complementary enhances a colour, then is it possible that the correct combination of colour and shape would allow negative shapes to have correct colour? e.g. Yellow for a long pointed pale form in a blue field."[10]

During 1955–56 Bates was painting a number of large still-lifes and figurative works with angular, stiff figures. In the still-lifes are elements which appear over and over again in his work: the deal table with a drawer, a vase or jug with leaves or grasses, the cut loaf of bread, the child's drum, and the striped lines of a radiator or table cloth. *Still-Life with Table* was purchased by the National Gallery, and in his notebook Bates described it as "jar on table with wisps of straw, tumbler, dark blues, magenta, orange reds."[11] In figurative work such as *Family*, Bates centered the attention on a child figure, startlingly fresh and inno-

cent in contrast to the worn, bent adults who stand protectively over her. This young, bright face, in one guise or another, became a feature in many of his future works.

Bates and Stevenson were asked to submit to the first Biennial of Canadian Painting organized by the National Gallery. Max sent an oil, *Children*, and Stevenson submitted *Bouquet on Chair*.[12] For the exhibition organized by the Allied Arts Centre to celebrate Alberta's Jubilee year, Bates chose only one of his recent paintings. The others were very early works, *Beacon Hill Park* of 1928 and *Family with Pears*, thus signifying his claim to be a pioneer Alberta artist. He also exhibited his early lithograph of 1954, *Cock and Hen*.[13] In recognition of the Jubilee, Bates was asked to write an article on Alberta art for *Canadian Art*, and this was published in the Autumn number. In it he again referred to the materialism and puritanism of the prairies, so inimical to the artist, but he also commented on the work of those individuals who "show in their work that they have taken some creative and personal direction."[14] Of the Jubilee Exhibition itself he said, "The quality was uneven and paintings of mountains were numerous. Mountains and Indians, having what there is in Alberta of the picturesque, have received most attention from artists over the years."[15]

Bates continued to sketch in the foothill country west of Calgary, and like Beckmann, who believed in learning the forms of nature by heart, Max said,

> I do a great deal of painting from nature following its forms. It's a way like those of Monet and Thoreau by their ponds savouring particularities. I also paint from my inward nature following the various laws of contrast and the growth of free invention, truly a more radical exploration.[16]

In Townshend's judgement, "Bates saw nature simply, consisting of individualized and generalized forms. He enjoyed composing his paintings with contrasts between these two forms. ... By the mid-to late 1950's, Bates had full control of his medium. Paintings such as *Summer Trees ... Northern Landscape ...* and *Storm, circa* 1955 reflect total confidence ... and a looser and more painterly style."[17]

Maxwell Bates and Leroy Stevenson with presses (1955). Private collection.

Describing the essential elements of the dramatic "Storm" series of this period, Townshend wrote:

> a prominent white, angular cloud shape against dark clouds contrasts sharply with highly reduced, simplified dark forms on the horizon. The flatness and directness of the dark shapes on the horizon against the white sky declare the picture surface with a new immediacy. This contrast establishes the "insistent duality of earth and sky" that Bates noted as a characteristic of the prairies.[18]

Bates himself wrote of the transformation by the artist of the landscape he actually saw:

> It seems that the transposition of nature to a medium of art at once gives it a value it did not have before. The result can be quite simplified and the "beauty" almost lost in the process without losing its value. This "beauty loss" occurs in any painting of landscape. Something very important must be added. What is it? Expression? It seems to have to do with transposition, changing from purpose to purposefulness, to something to be admired for itself. A fine landscape never looks as good as what is painted, yet gains value when away from what is painted.[19]

Most of Bates's landscape sketches were done in Stevenson's company in the spring and fall. During the summer Roy worked at the Banff Springs Hotel as a timekeeper, and in a local bar, he met, by chance, a young Englishman, Peter Daglish, who was also working at the hotel. Daglish wrote of the meeting that

> He [Stevenson] went on to tell me about his experience as a painter ... how he and Max had made a trip to Chicago to see "real" paintings. ... Totally marvellous—transposed my latent interest in painting ... into one of action. That was it! Roy wrote down what colours he felt would be useful and what to paint on and I made a start! Meeting Max and Jack followed. From their example I realised not only was it possible to accommodate interests other than painting into one's activity as a creative individual e.g. plays, music poetry etc. but that one should encourage and give voice to the various facets which make up one's personality. From Jack I learnt about lithography which remains one of my most loved means of capturing and recording images and ideas.[20]

That summer Daglish visited Calgary as often as possible and worked on the presses. In the fall he went to Montreal and entered the École des Beaux Arts, and his distinguished career was launched. The friendships thus begun lasted through the years.

Friends were always welcome at the Bates's house, and young John Snow, aged four, frequently visited them and found there a cache of children's picture books for his amusement. Max would draw him animals, cats and long, sausage-like dogs. It was about this time that the young artist Iain Baxter introduced himself to Max. He felt that Max enjoyed "unusual people who struck out for themselves."[21] Baxter qualified in this regard because, despite lack of formal training, he had sent his work to all the exhibitions he could. His few meetings with Max were intense, and Baxter remembers Max as "a wellspring of inspiration and strength for young people."[22] Max heard frequently from Jock

Macdonald, who was working in France on a grant from the Royal Society of Canada.[25] With those individuals he liked, Max was relaxed and often talkative, though, as Illingworth Kerr noted, he could be "glum and distant, abrupt, even repelling."[24] Even so, Max clearly valued his friends, and he transcribed in his notes the following quote from Jean-Jacques Rousseau: "Nothing shows the true inclinations of a man better than the character of those he loves."[25]

Max took on a new role when he agreed to be the judge for a 1955 exhibition organized for the Winnipeg Art Gallery and sponsored by the University of Manitoba's Art Students' Club. He recognized that "Artists are often poor critics and sometimes the best judges of art have never attempted plastic creation." He cited Van Gogh, Cézanne and Gauguin and said the last, alone of the three, was the best judge.[26] The exhibition was to be "a representative show of some of the up-to-date work being done in Canada."[27] Bates's fellow judge was Jean-René Ostiguy of the National Gallery, and the two men became friends. They chose 111 out of 400 submissions and divided the first prize between R.P. Dubois of Winnipeg, for his *Three Figures*, and Jean-Paul Mousseau of Montreal, for his *La Marseillaise*.[28] Because of pressing work on the cathedral, Max had to return to Calgary before the show was hung, so he was not on the spot when the storm broke concerning the overwhelmingly modernist cast of the exhibition. Ostiguy simply said the show "had a slight tendency to non-representational art simply because more good non-representational paintings were submitted."[29]

Bates was more blunt. "Some people want paintings that are some sort of a pretty picture post card," he said. "People who are interested in art don't want to see that sort of thing."[30] The leader of the attack on the show, the formidable wife of the Dean of Arts and Science at the University, threatened to withdraw her support from the Art Gallery. She described one of the prize-winning paintings as "things with blobs of red white and blue all over them ... which a kid can do" and which she found "nauseating."[31] But in an editorial in the *Winnipeg Tribune* under the heading "The Winnipeg show's new look," George Swinton pointed out that because the reputation of the judges assured the quality of the show, a larger number of artists than in previous years had submitted their work from all across Canada.[32] Pictures of the judges appeared in both the *Winnipeg Free Press* and the *Winnipeg Tribune*.[33] The *Saskatoon Star-Phoenix* published Bates's remarks:

> beautiful sunsets over the Rocky mountain peaks make an artist's job too easy ... half the artist's work is done for him before he picks up his brush. He ought to be able to see something ordinary, even something ugly, and from that create a work of art. ... It is too bad to rely on lovely scenery too much. ... Prairie scenery is not such a temptation to a lazy artist because it must be treated with imagination to make a picture.[34]

The stir created by this exhibition certainly enhanced Bates's reputation as a leading modernist.

An exhibition of Max's own work was hung at the university's School of Art gallery, and

the headline in the *Winnipeg Tribune* read "Art squabble judge shows his paintings." The short notice reassured the public that his work was "figural and fairly representational" and also mentioned that he was writing a book on contemporary art.[35] His work was also shown in the Winnipeg Art Gallery in conjunction with the sculpture of Cecil Richards. George Swinton wrote of the exhibit:

> Both artists have a tendency to work in a small scale which further sets them apart from their contemporaries and current practices. ... Both artists, in concerning themselves with the human figure and feelings placed themselves outside the current trends and pursued their own vision.

Swinton was especially struck with Bates's monotypes.[36] That the controversy over the judging of the Winnipeg show had not troubled Max unduly is indicated by the fact that he went to Regina to act as judge with Raymond Obermayr of Idaho State College for the annual exhibition of Saskatchewan art at the Norman Mackenzie Art Gallery.[37] "Generally imagination, and originality have been preferred to the mere display of technical competence," the jurors wrote in a joint statement, "and naïve sincerity has been preferred to fashionable sophistication."[38]

The reference to "naïve sincerity" reflects Bates's continuing interest in what he called, in his earliest article, "Naïve painting." He offered more on the subject in an unpublished fragment, "Modern primitive art." There he maintained that he preferred the term "naïve" to "primitive," and that interest in this type of work is "decidedly limited to a predominantly romantic period such as our own." Max focused on the qualities linking such artists: their passion for detail and their obsession with order, though the order is of an elementary kind. In their effort to depict reality as they see it, the "parts are seen separately, rather than in relation to the whole." In his inability to create an ensemble, the average naïve painter differs from the great Rousseau "because, with the charm of naïve vision and a passion for precise delimitation, he had a feeling for coherent organization." Bates saw naïve painting as "a poor relation of Surrealism ... bound to flourish in a century that has produced Da Da and Surrealism, basically romantic movements."[39]

Bates was also setting down his thoughts on architecture in preparation for a seminar devoted to the architect and society. In a letter to the secretary of the Alberta Association of Architects, he wrote:

> Our much vaunted high standard of living on the North American continent is taken to mean a high standard of comfort and convenience. I am very doubtful if this is a good end in itself. It is grotesquely one-sided. A high standard of living includes much that is of the mind. Ultimately the often sub-conscious sense of well being that good design can give, harmony or variety controlled by a sense of unity of shapes, volumes, colours is more important than convenience. I cannot see that the number of steps a housewife takes from fridge to counter is of epic making importance in an age when perhaps the average person takes so little exercise. Root concerns are a sense of values.[40]

This statement carried echoes of convictions and principles that his father had enunciated so many years before. Bates elaborated on this theme in an expansion of his letter, stressing the need to consider art and architecture as "a social function and an integral part of living."[41] He deplored the fact that many architects were not sufficiently aware of "the arts of space" and continued that "Architecture, as an art of space and colour, is more closely related to painting, sculpture, ceramics, landscape design and any other visual art than to any other profession except engineering."[42]

In addition to his work on the cathedral, Max was busy with two other interesting projects. One was the design of a house for the big game hunter and author Colonel Harry Snyder, who wanted the house built of a special imported stone.[43] He also wanted a main room that was large enough to display his trophies. Snyder's tall tales and eccentricities intrigued Max. The other project was the design for a small theatre to sit on the grounds of the Coste House. Max drew up the plans, but the surrounding residents were opposed and the result of the dispute was that the Allied Arts eventually had to move out of the Coste House.

For a lecture series at the Coste House, Max prepared a paper with slides on contemporary Canadian painting. Illingworth Kerr had spoken on Canadian painting up to the Group of Seven, and Bates followed, bringing the subject up to date and stressing the international nature of contemporary art. He mentioned the rise of automatism in Quebec under Paul-Emile Borduas but made it clear that Jock Macdonald was painting automatic works in 1935. He noted the formation of the Painters Eleven and their subsequent success.[44] Illingworth Kerr celebrated Max's own art in "Maxwell Bates, dramatist," featured in the summer edition of *Canadian Art*. He saw that the tension in Bates's work came from the momentary resolution of psychological and spiritual conflict realized in colour and design. Of his handling of figures Kerr wrote, "It is intimate observation, but impersonal," and "they are not copied from sketches on a pad but are seen suddenly by him as part of an emotion 'recollected in tranquillity.'" He stressed the mystical and romantic aspect of Bates's vision: "the mystic element that charges Bates's work, whether landscape, still life, figure or abstraction. All to a degree are possessed. Possessed by their own inner spirit, invested with associations, overtones of other times or even other existences."[45]

Under the heading "Foreword," also in his papers, Max wrote of his own efforts to formulate a philosophy of art.

We can grasp some of the contours of Bates's thought through his notes. One of the most important statements is headed "Note on the Question of Value in Painting."[47] There Max reports that he had failed to find in any of his reading of Bell, Fry or Read a discussion of "why aesthetic qualities are considered so valuable to mankind and if ethical values are only then perfunctorily in any way concerned." Those artists who are "mystical by nature" come closer to the question of ultimate value. He believed that the work of some artists of the Byzantine, Romanesque, Gothic and Renais-

sance periods paralleled the mysticism of those ages. In the modern world, Kandinsky developed his "mysticism visually without the aid of illustration. Odilon Redon very nearly arrived at this position in the 19th century. Mondrian continued in this vein." Bates believed the question was important because of the confusion of our age. For him, the transcendent component was necessary to any worthwhile work of art. He wrote, "God is Being. Art is the worship of God by a concentration on the significance of existence or being. This concentration, brought about by selection and intensification is necessary because the mind ideates or abstracts or typifies everything."[48] From Aldous Huxley's *Doors of Perception*, he adopted the idea that the action of the mind blunts the intensity of being and that the role of the artist is to awaken that intensity.

Bates was drawn to books that ranged widely, books like Oswald Spengler's *Decline of the West*. He made numerous notes on Spengler, among them,

> All that is cosmic bears the hallmark of periodicity; it has beat, rhythm. All that is microcosmic possesses polarity. It possesses tension. Cosmic beat is everything that can be paraphrased in terms like direction, rhythm, time, destiny, longing. The speed of cosmic cycles goes on notwithstanding the freedom of the microcosmic.[49]

Volume I of Spengler's work *Form and Actuality*[50] was especially interesting to Bates, as it dealt with the concept of the soul and the symbols through which man expresses his deeper intuitions. He read Alfred North Whitehead's *Adventures of Ideas* and Henri Bergson's *Creative Evolution*. He appreciated the latter's emphasis on the importance of the intuition of poets and artists as a possible approach to the mystery of God and the universe; and the concept that the *élan vital*, the impulse to life, was more powerful than the intellect. From Olcott Paulham's *Laws of Feeling*, he drew the idea that artists who wait for inspiration may wait forever. The very act of working at their art arouses the necessary emotions and ideas. They must work for a time unproductively to get into the full swing of artistic creation, a parallel to Pascal's advice on the practice of religious devotion.[51] His reading also included more current publications, such as André Malraux's *The Walnut Trees of Altenburg*, Marshall McLuhan's *The Mechanical Bride*, Arnold Hauser's *The Social History of Art*, and the works of Arthur Koestler and Albert Camus.[52]

But Bates's time for reading and philosophical speculation was limited by work on the cathedral and his evenings of painting and lithography. He was offered a one-man exhibition in 1956 at the Greenwich Gallery, a Toronto gallery specializing in Canadian art, and he was present for the opening, which showed fifteen recent oils and seven watercolours.[53] Pearl McArthy wrote two short critical pieces in the *Globe and Mail* welcoming the show and praising Bates's ability to "amalgamate realism, abstract artistic qualities, and his own autographic impress." She considered **Two Women** to be the "gem" of the exhibit.[54] A small number of the works sold, one to his former co-juror, Jean-René Ostiguy. While in

Toronto, Max saw his friend Jock Macdonald, who suggested that he show one of his works in the forthcoming exhibition of the Canadian Group of Painters.[55] Max also met Graham Coughtry, Michael Snow, Gerald Scott and Robert Varvarande. A group photograph of the artists with the gallery owner, Avrom Isaacs, was published in the *Weekend Magazine*.[56]

Bates and Snow had the opportunity to show their lithographs at a graphic art exhibition at Stratford. Bates showed *Cock and Hen*, Snow entered *Blue Bowl*, and Jock Macdonald's *Polynesian Night* popped up again. The whole show was moved to Toronto under the auspices of *The Telegram*, and the National Gallery subsequently selected thirty-four works from the exhibition for a travelling collection.[57]

Although they often worked together, the prints that Bates and Snow produced were very different. Snow used "large simplified forms to construct the images of still-lifes" full of colour, while Bates's lithographs were notable for his line and drawing.[58] Bates had produced three works in red, yellow, white and black—**Ballet**, *Dancers* and *Rocking Horse*. The drawing in Bates's lithographs is full of what Illingworth Kerr termed the "whimsy" occasionally "revealed in his graphic art and his painting, where it affects his treatment of line and surface."[59] In *Dancers* a guitar makes up the fourth leg of the two figures, and the abstract *Rocking Horse* is a marvel of playful manipulation. The ballet dancers are muscular figures with Bates's trademark—fantastic headgear. Amused and intrigued by the very old furnace in the basement of the Snow

house, Bates made a black and white print of it, *John Snow's Furnace*. Bates had also been doing lino-cuts, and *Departure* shows his wit, whimsy and the same brilliant manipulation of line. The boat and its anchor, the cow, the sailors, and the mop and pail all recalled Bates's departure for England many years earlier.

Bates spent many hours supervising the construction of the cathedral. The site was a commanding one, "closing the vista at the end of a long and important street."[60] He had chosen a neo-Gothic design with a tall, slim spire. The nave was designed to seat 1,000 worshippers, all with a clear view of the altar. The Lady Chapel on the east side of the building was to hold ninety persons. In addition, there was a baptistry on the east side and four small chapels on the west. An exterior finish of biscuit coloured brick covered the steel and reinforced concrete.[61] Bates did not consider red brick suitable for the intense prairie light.[62] The exterior trim was pre-cast stone and included panels with symbols of the Virgin. Her lily, the fleur de lys, was also a reminder of the French-Canadian origins of the cathedral.

Max liked rich church interiors and enjoyed working on the designs. After hours of research on religious motifs and church symbolism in the reference room of the public library, he made over 400 drawings of the decorative details for the pulpit, the baptistry, and the heavy bronze doors, which were being cast in Florence, Italy.[63] On the panels of the main entrance doors, Bates placed the symbols of the four Evangelists, the Papal arms, and the

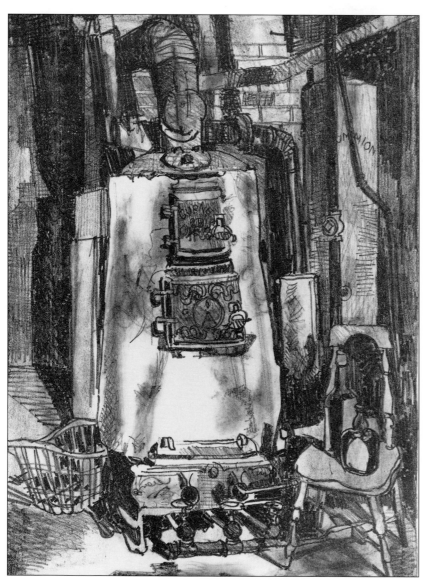

John Snow's Furnace (1956). Lithograph, 37 × 26 cm.
Photo by John Dean. Private collection.

arms of the Diocese. For the Baptistry, he designed glass and gilt bronze gates with grille work in which a wave design symbolized water. He ordered different colours of marble for the altars of the small chapels dedicated to St. Joseph, the Canadian Martyrs, St. Pius and St. Patrick, and for the main altar top he chose a single slab of Rosa Corallo marble.[64] Images of Christ and the prophets were carved on the five sides of the oak pulpit. Stained glass windows were ordered for the sanctuary, the Lady Chapel, and the baptistry.

Max often found it difficult and frustrating dealing with the building committee. One member tried to insist that there be no outside ledges where pigeons could roost.[65] The Bishop wanted a more solid-looking pinnacle for the tower than the one in Bates's design, which was open, graceful, and more suitable for a cathedral dedicated to the Virgin. Eventually, though, Bates had his way.[66] Because he was constrained financially, he decided to ensure that the exterior shape and construction conform to the highest standards. Any concessions that had to be made would be related to the interior, which could more easily be changed in the future.[67]

When Max approached his friend Luke O. Lindoe, an artist and sculptor, and showed him the drawings of the cathedral, it was obvious that the plans called for a sculpture over the doors. Lindoe offered to attempt the commission, and Max introduced him to the Very Reverend Monsignor John O'Brien C.S., who was supervising the construction. Lindoe wrote:

It was agreed ... that it would be a good idea for me to do a sketch model, still no formal arrangements. When the sketch was completed Max and Father O'Brien called in to see it; both seemed pleased. Max then asked what I thought of it. ... I can still see the grin growing on Max's face as I explained that the sketch served only to show me how much more was needed. The whole thing would have to become much more formal, particularly the Gothic line; all trace of the clay modeller would have to be erased, and it was still only an object, it didn't make a statement. The rest is history. Very few words were expressed in the whole process, I don't even remember the talk about money. There was no pressure, no anxious hovering around. Both Max and Father O'Brien called in fairly often as the work developed but they had very little to say. ... There must have been some anxiety for Max in trusting such an untried sculptor because when the scaffolding had been removed and we could see it for the first time he turned to me with that Max grin on his face and said "Yes, I am glad you did it."

In Lindoe's view, "The older it gets the better it looks."[68] Lindoe also made the moulds for the cast stone panels with the symbols of the Virgin.

Though he is not wearing the "Max grin" in the self-portrait with his familiar waistcoat (**_Self Portrait_**, ca. 1956), Bates's strength of character and quiet confidence are evident. He had suffered a great deal and endured, and his efforts both in his art and his architecture were fruitful. As Ian Thom has written of this self-portrait:

Bates' reputation as painter, architect and now print-maker was well-established and yet there is no hint of self-satisfaction. ... His strength is revealed in every aspect of the image, from the application of the broad strokes of paint to the piercing set of his eyes. The artist has truly reached his maturity.[69]

At Home and Abroad, 1957-59

Although Max's own career was continuing apace, the general tolerance for modernism remained low in Calgary. The 1957 sale of his painting *Girl with the Yellow Hair* to the committee of the Allied Arts Centre provoked considerable controversy and increased Bates's dissatisfaction with the artistic climate in Alberta. Writing in "Divided we fall," an article that appeared in *Highlights*, he bluntly criticized the Alberta Society of Artists for their ineffectiveness in raising the standards of art in the province. He saw that the society was divided and he wrote:

> I believe that the factions, instead of being basically traditional and modern, are (1) artists who think of painting as a serious form of expression and communication that has become a very important element in their lives, and (2) those who find it a way to relax, a pleasant pastime, or primarily a way to make money. These two factions represent legitimate points of view. Unfortunately they do not speak the same language and would be far happier separated into congenial groups.[1]

The Calgary City Council's rejection of his design for the Calgary airport mural fed Bates's scepticism about the prevailing artistic values.[2] The architect had commissioned the design for a wall of the main concourse. Max had incorporated the major aspects of Calgary's history into a skilful, witty design that featured natives, buffalo and Mounties on the left, churches, houses, railway, cowboys, miners and finally, oil workers on the right. In the background are the foothills and mountains. Ian Thom wrote of the design:

> The whole avoids business or distracting detail. Perhaps what is most notable is the fact that the figures are not just anonymous ciphers but real characters. We sense their vigour and determination despite the fact that they are not portraits or studies from life. The whole work has an energy, even to the stylised clouds, which reflects the growth and energy of Alberta. While of its time (1957), it remains a vital image today.[3]

By contrast, the work approved by the city seemed sentimental. It showed such figures as Father Lacombe and Colonel Macleod in soft

pastel shades, with rays of heavenly light shining upon them as they look to the city of the future. With the rejection still rankling after many years, Max told an interviewer that the artist was best known for his beer parlour murals in southern Alberta.[4]

Max's work was becoming better known in eastern Canada. Jock MacDonald had entered two of Max's pieces in the Canadian Group of Painters exhibition of 1956. This organization was a direct outgrowth of the Group of Seven, and over the years they added to their number those artists making a significant contribution to the art of Canada. They asked Bates to join the Group early in 1957 and hoped that he would have work ready for the exhibition scheduled to open in Montreal that November.[5] He was also elected to the Canadian Society of Painters in Watercolour and received an award for his watercolour, *Scarecrow*.[6] At the Montreal Spring Show his powerful painting *Puppets* received honourable mention and was reproduced in the *Montreal Star*.[7] The work carries overtones of Beckmann; the central female puppet, innocently beautiful, is surrounded by enigmatic, faintly threatening figures. The dwarf "Punch" puppet, with his huge nose, crowds in with two more male puppets, one with a permanently startled look on his painted face; the other frighteningly expressionless. Mysteriously, there is a glimpse of the face of a woman, perhaps the puppeteer, looking on from above.

In the spring of 1957, an exhibition of the work of five Calgary artists—Mitchell, Kiyooka, Stevenson, Spickett and Bates—opened at the Hélène de Champlain Hall, St. Helen's Island,

Montreal. Two Montreal newspapers published critical accounts. The tone of Robert Ayre's piece was unenthusiastic, even supercilious. He wrote, "Their work, so far, doesn't look significant as a contribution to Canadian painting, whatever it may be in their own community." However, he also saw "implications for growth" and commented that "Bates paints people and the still-life with blunt honesty."[8] R. de Repentigny's account of the forty-six paintings was more encouraging. He found Bates's work complex and preoccupied with plastic values. He wrote, "He [Bates] always has an intriguing ambiguity. The deformations that he introduced in several of his still-lifes make us think of different ways that you can view 'reality,' even the most banal." De Repentigny praised *Woman with Scarf*, saying "his precision, his economy of method make Bates among the best figurative painters."[9] Later issues of *La Presse* reproduced two of Max's works, one of his vigorous still-lifes and *Woman with Scarf*.[10]

At this time Bates had considerable correspondence with *Canadian Art*, under its editor, Donald Buchanan. The magazine had published a good humoured article by Earle Birney, "Poets and painters: Rivals or partners,"[11] and Max chose to respond. He pointed out that in Europe, especially, poets and painters understood each other. In France it was often the poets who, in their enthusiasm, called attention to the vital painting of their day, and the value of their interpretations was immense. For their part, artists such as Gauguin, Odilon Redon and Toulouse-Lautrec cared about good writing, while the American

poets William Carlos Williams and Kenneth Rexroth clearly appreciated the art of their day. Max continued that he felt poets often made good critics, but in Canada, poets and novelists are only occasionally interested.[12]

Max was also preparing an article for publication in *Canadian Art* on the work of Jock Macdonald, who was going through a period of discouragement. As Joyce Zemans wrote in her account of Macdonald, the artist had written in a letter that his colleagues at the Ontario College of Art "continued to damn modern painting and its exponents. They tore down the announcements he posted about contemporary exhibitions and about current events in the art world." And "it seemed as if Canadian critics were consciously undermining Painters Eleven's efforts and successes."[13] He was especially upset about the claim that "Borduas and the French-Canadians were the original founders of abstract art in Canada," when his own experiments in automatic painting had begun in 1935 in Vancouver."[14] Zemans points out,

> There was an interesting regional rivalry at work here. As a westerner, Macdonald had often felt he was on the periphery of the Canadian art movement. In Toronto he discovered that the pre-eminent role had been allocated to Quebec artists.[15]

In spite of delays and Macdonald's gloomy doubts, Max's article appeared in the summer issue of *Canadian Art*. Bates and Macdonald thought alike on many aspects of art—both, for example, felt the need to study and master the vocabulary of nature—but the article mainly dealt with Macdonald's pioneering of automatic and abstract painting in Canada. Commenting on Macdonald's style, Bates wrote, "his style is really a series of styles related by his personality, or more exactly by the mark of his inner being."[16] In one of his random notes he wrote, "Dealers don't like the lack of a fixed style—a continuously creative person blends many styles."[17] Macdonald was disappointed with the paucity of illustrations accompanying the article and their small format, and no doubt Max felt the same.[18]

Max began a personal "Journal" on 30 August 1957, writing in the "Foreword:"

> A journal is not a vehicle in which every entry is as interesting as every other. Like driving on a country road, the journey is uneven,— up and down; here a fine prospect and view, there a dull stretch. Now and then we pass through mysterious areas that may be of great interest, if only we saw behind this tall hedge, or that line of bushes and trees. Once or twice enough of a distant mountain or range of hills is seen to tempt one to penetrate to them; or an intriguing house is passed; the scene of who knows what bizarre story.[19]

In his first entry he noted that he burned eleven watercolours, describing it as "a salutary exercise for all artists ... the act of maintaining a standard. It has its symbolic value, and the artist seldom makes a mistake when the works are several years old. The reputations of painters suffer who die with a studio full of inferior stuff."[20] Several of these early entries relate his own feelings. He recorded his impatience with the sameness of North Ameri-

can life, a sameness without interest. Contrasting it to European life, he attributed the monotony to a lack of history.[21] In another note he observed that a sensitive human being is bound to be prey to feelings of anxiety, anguish and dread, "the future holding unthinkable possibilities for all of us."[22] In spite of his multiple activities, mental and physical—or perhaps because of them—in one entry he expressed a strange sense of alienation:

> I often have the unsatisfactory feeling that I am not really alive, but caught in some kind of time consuming trance in which I am not as aware of important events in the world as I should be. The idea of going through life in a daze is upsetting. I can't help feeling that nearly everyone lives improperly, in a way that wastes their lives. The difficulty is to clarify and explain this dissatisfaction.[23]

He deplored "the inefficiency of my brain, especially my memory prevents me from making more progress in the philosophy of art."[24] Max used the journal to comment on aspects of painting and architecture. He wrote that he could not understand why some painters do not respect the essential qualities of the watercolour, "transparency, delicacy, the running together of colours, the way the washes dry to give a unique edge, etc. Many contemporary watercolourists ... try to get the strength of oil paintings, the opaque quality of gouache."[25] Of the essential quality of an artist, he wrote, "The act of recognizing what can be used among passing events, sights, thoughts, accidental technical effects, etc., is the artistic creative act, perhaps basically the act of genius,—recognition."[26] And about the process of creating a painting he suggested, "The subject should be constructed and reconstructed, painted and repainted a score of times in the mind before being placed (thoroughly understood) irrevocably but spontaneously on the canvas. This painting in the mind is very hard work, it is easier to make a series of preliminary studies, which of course, is the classic method."[27] Bates had painted in his mind constantly in the prison camp, and he continued to do so. In his writings on architecture he commented,

> Architecture as a not very monumental solid without holes in it, corresponding to the stressed picture plane, or frontal design plane in painting. Use of textures is away from design in depth.
>
> A retreat from subject in painting corresponds to a lack of differentiation in buildings built to serve vastly different purposes. Perhaps it is a classic trend to force buildings of widely different use into one style.[28]

Max's cathedral in the Gothic style was approaching completion. His partner, Hodges, had decided to emigrate to Australia, and Max was left with the task of finishing the cathedral without his assistance. The impressive bronze doors were hung, and the sixteen-foot high Madonna and Child stood serenely above them. The critic Nancy Tousley later wrote this description:

> Designed to be seen from below, the Madonna leans forward as though to present the Christ Child she holds to people entering the church. As in representations of the Virgin in

medieval Gothic art, the Virgin wears the crown and mantle of a queen, over a long gown, which hangs in delicate folds. The niche designed by Lindoe ... also echoes elements of Gothic art in the canopy above the figure's head and the fluted plinth on which she stands. Architect and sculptor worked in precise harmony.[29]

Four bells from the original cathedral were hung in the tower.[30] Max was horrified when he saw the mosaic stations of the cross, which had been commissioned separately. His journal notes that "Mosaics have arrived at the Cathedral. They are worse, even, than I expected. ... Unfortunately the people will like them much better than the excellent stained glass windows."[31] Bates had worked out the decoration of the sanctuary in watercolour, gouache and pencil.[32] The plaster walls of the nave were ivory, and the side aisle walls blue. A deeper blue and burgundy were used for the sanctuary, and the coffered ceiling was decorated in blue and silver. To the left of the main entrance, the baptistry with its five slim stained glass windows piercing the walls, was jewel-like in its beauty.

The consecration of the Cathedral of the Immaculate Conception of the Blessed Virgin Mary took place on 11 December 1957.[33] Stephanie White, architectural critic for the *Herald*, writing some time later, found the interior to be "cool, quiet and very meditative." She thought it less impressive than the exterior, especially because of the scale and texture of the ceiling of the nave.[34] "One of the last churches in Calgary designed in the classic mode," White continued, "St. Mary's is beauti-

fully proportioned with additions on the sides creating a complex base to a solid and straightforward building."

She praised its "immense refinement" and found herself contrasting its "classic religious hopefulness" with what she considered the "disillusioned, cynical romanticism" of Max's paintings.[35] Apart from announcements of the consecration, the only contemporary notice appeared in the *Journal of the Royal Architectural Institute*, which published photographs of the finished cathedral and a reproduction of Bates's drawing of the choices for the design of the steeple.[36] The construction boom of the following years in Calgary produced little to rival the beauty of the strategically situated building. St. Mary's Cathedral remains one of the most artistically satisfying buildings in the city.

The end of 1957 also saw the first joint exhibition of Bates's and Snow's lithographs, for which they had assembled a considerable body of work. Snow had already shown at the Northwest Print Makers in Seattle and had been asked to send five works to the first Tokyo Biennial. His print *Theatre* won him his first Adrian Seguin Award at the Canadian Society of Graphic Art Exhibition of 1957, and he put the prize money toward two new rollers, which he bought from England.[37] Canadian printmakers were afforded opportunities to exhibit widely, thanks, in part, to the efforts of Kathleen Fenwick, curator of prints and drawings at the National Gallery. She was "an untiring and knowledgeable spokesperson for printmakers. ... a champion of print artists, and much credit is due her for her astute

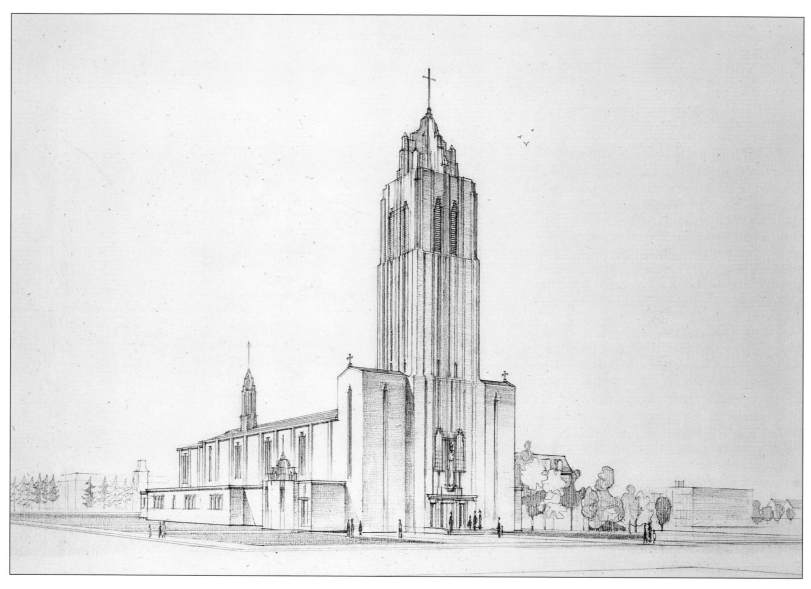

St. Mary's Cathedral (1957). Photo from Maxwell Bates fonds, Special Collections, University of Calgary Libraries.

judgement and unwavering support of the print medium."[38] She kept artists across Canada informed of forthcoming national and international exhibitions to which they could submit their works.

When the New Design Gallery in Vancouver suggested a joint exhibition of their prints, Bates and Snow were each able to submit twelve,[39] most of which were done in 1957. The *Vancouver Province* praised Snow's skill as a printer, saying his work had the "stamp of an outstanding craftsman and inspired artist." The reviewer also singled out Bates's *Angry Cock*, together with his largest print, **Show-girls**. The print, possibly inspired by a scene on the Stampede midway, was described in the review as "recalling in its lively spirit one of the French Impressionists."[40] The three show-girls pose before a curtain in their tight dresses and high heels. The black girl wearing a blue skirt stands in contrast to the two blondes, with their cropped yellow hair, and fleshy white thighs and arms, and predominantly magenta costumes. Disappearing behind the curtain and into the tent is another showgirl, her long hair in a ponytail. It is a vital, straightforward, sensuous work. In contrast, the two figures in his *Fortune Teller* inhabit an enclosed, complicated, mysterious milieu with a bird in a cage, a Corinthian column, and cards on the table. Bates said, "I don't know why I am fascinated with fortune tellers. I think it's the decorative look of the cards partly, I suppose, enough to get me started on a composition."[41] Bates did two runs of this lithograph—one in all grey and a second with yellow added. He later used the

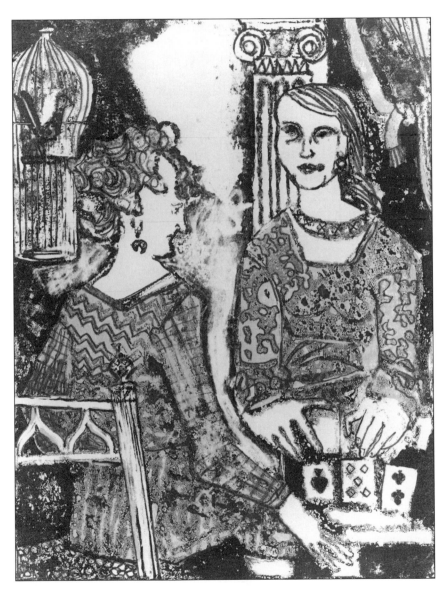

Fortune Teller (1957). Lithograph, 45.8 × 33.5 cm.
Photo by John Dean. Private collection.

same scene, slightly changed, in his painting *Ace of Hearts*. The women sit in different positions and are joined by a third who stands at the edge of the painting in place of the bird cage. It is interesting to see how the greyed colours, mauve, green and brown, impart a sense of the faded past, just as the patterns did in the lithograph.

The artistic and financial success of this first joint show represented a satisfactory culmination of their year-long work on the presses. Many of the same prints were sent to the lithographic show requested by the Norman Mackenzie Art Gallery in Regina,[42] and this exhibition subsequently travelled on the Western Ontario Art Circuit, opening in Brantford.[43] Bates and Snow were very encouraged when they were chosen as two of three Canadian artists to participate in the *Fifth International Biennial of Contemporary Color Lithography* in Cincinnati in 1958. Their work was shown in the company of the lithographs of such masters as Picasso, Tamayo, Miró and Henry Moore.[44]

Max sent two works to the third Biennial of Canadian Art, and one of them, an oil, *Figures on a Beach*, was purchased by the National Gallery for the Department of External Affairs.[45] For their first *Canadian Artists Series*, the National Gallery chose to exhibit works by Maxwell Bates and New Brunswick artist Jack W. Humphrey[46] in an obvious effort to counter the domination of central Canada in the art world. The travelling show consisted of ten representative paintings from each artist and was accompanied by a three-page publication with pictures of the artists at work and a

statement from each. Max is shown at his easel in his customary conservative business suit. He wrote in his statement for the exhibition,

> Experience gives me increased ability to transpose what I see. My intention is to transpose meaningfully. This amounts to expressionism, in my opinion. The meaning escapes description: it cannot be put in words. ... Good painting must offer something meaningful to the spectator but it may be enigmatic. Painter and spectator collaborate unconsciously. ... But collaboration must take place because, at bottom the aim is to convey something on one's own terms to the spectator who can respond.[47]

From the numerous notices in the newspapers of the smaller centres to which this show was sent, it is clear that this effort by the National Gallery to reach out to Canadians across the country was successful.

The *Brandon Daily Standard* reproduced one of Bates's most important and interesting works travelling with the exhibition, ***Interior with Figures***.[48] A couple stands stiffly behind a table on which can be seen the remains of their lunch, a slice of bread, a glass, and an open can. Through the window are the buildings of a factory, with a smoke stack, possibly the man's work place. While the faces of the young people are fresh and innocent, the hard, vertical lines of the factory and the stripes on his shirt and her apron convey a sense of imprisonment. It is as if the young couple is caught in the unnatural sterility and rigidity associated with urban industrialized society. For Bates, the bread represented the earlier,

simpler agrarian society; the can, contemporary technology. Bates thought so much of this subject that he painted another version, this time with a cat crouching in the foreground. Max was very fond of cats, and they appear frequently and sometimes disconcertingly in his paintings.

During the same time that these pieces were produced, Max was working on another church, St. Ann's, in an old section of Calgary that, like the cathedral's site, had French-Canadian connections.[49] Max's design for St. Ann's complemented the old, four-storey brick school building next to it. The arched doorway of the church was matched by the curved tops of the windows, and the brick detailing emphasized the decorative features. The square tower was surmounted by a metal cross. The subtle variations in the colour of the brick resulted in an overall rich reddish brown. The solidity, simplicity and quality of the building fitted well with the neighbouring structure. The cornerstone of the church was laid by the Bishop in September, but the construction proceeded in Bates's absence. Max and Charlotte had left their house and Spike, the cat, in the care of their young artist friend Greg Arnold and begun their long-planned trip to Europe.

The Bateses made the long train journey to Montreal and boarded the *Empress of France* on the thirtieth of September, 1959.[50] At this point Max began his travel journal, itemizing even small expenses, recording meals and hotels, and detailing their itinerary. The record of his impressions—people, places, buildings, weather, pictures—is especially vivid, and the tone is conversational. "I forgot to say. ...,"[51] he remarks often in the journal. After disembarking at Liverpool, Max and Charlotte travelled directly to Edinburgh, where the cleanliness of the streets and the beauty of the old houses along Queen Street impressed Max as evidence of the citizens' pride in their city.[52] Jock Macdonald had asked him to call on an old friend, and the man introduced Max to members of the drawing and painting department at Edinburgh College, where he spent an afternoon. He bought a sketchbook from the famous bookseller James Thin and used it throughout the trip.[53] He sketched the Old Calton Burial Ground and the Prince's Gardens with the Scott Monument in the background,[54] and despite his heart problem, he climbed the 200 feet of the monument to take in the view. On his visit to the galleries he saw an exhibition of Tachiste paintings, most of which were from Paris, and gave special note to Riopelle and Jean Dubuffet. From the catalogue, Max copied out a quotation from St. John of the Cross which pleased him. "In order to go where one knows not," it reads, "one must go by a way one knows not." After seeing an exhibition of Norwegian Art Treasures he wrote, "Nine hundred years of textiles, sculpture and silver ... were fresh to the modern eye. There is no progress in art—only change."[55]

In London they settled in a hotel in the Queen's Gate area, where Max made a number of detailed sketches that he later turned into paintings. He made note in his journal of the colours of the "drawing from the west pavement of the South Kensington Underground Station: ... gray brown brick (Chimneys etc.)

dirty white, black, cream, fawn and gray blue painted plaster."[56] They are the colours of the tall buildings, the wet sky, the striped crossway, all set off by the orange of the Belisha beacon in **South Kensington**. He returned to the astrological shop in Cecil Court and bought a 1959 *Astronomical Ephemeris*.[57] Max took Charlotte to the Gibbons's house in Crooked Usage and found that Mrs. Gibbons had moved north. In a rare expression of emotion, Max wrote of his sadness that he could not introduce Charlotte to either of them and that "we should enter the house after both of them had left it forever."[58]

Max made the rounds of the London galleries, seeing exhibitions of work by Harold Town, Paul-Émile Borduas and Kurt Schwitter as well as Clavé, the printmaker he so much admired.[59] He showed slides of his own work at several galleries but met with no success. One of the dealers he had known before the war told him that buyers were favouring abstract canvases over modern representational paintings of quality. Max reported:

He wasn't happy about a merely fashionable change. Much abstract work belongs to the new abstract academy with a decorative function in expensive flats. The abstract painter is no longer a rebel. The rebels are semi representational painters struggling with their conceptions of what is of ultimate value in art. Buyers have often moved to abstraction without having appreciated the quality of creative representational painting.[60]

They also took in the London theatre fare, and Max particularly enjoyed two plays by Samuel Beckett at the Royal Court Theatre,[61] *Endgame* and *Krapp's Last Tape*.[62] He greatly admired Beckett's work, and commentators on Max's beggar pictures have frequently connected them with Beckett.

Max and Charlotte left London for the south of England in a hired Mini-Minor, and Max, whose poor driving was legendary, was full of admiration for Charlotte's expertise as they made their way out of London to Guildford, Surrey.[63] On their visit to Guildford's unfinished cathedral, Max noted that the stained glass was not as fine as that in St. Mary's in Calgary.[64] They travelled widely throughout the southwestern counties, venturing as far as Land's End. Along the way they stayed at cosy hotels, where they enjoyed sherry in the lounge before supper and kippers for breakfast. At Ilminster, where Max had been posted before going overseas, they had cider at "Ye Olde Vine," a pub he had frequented.[65]

They wound their way back to London, where Max went to see the large Jackson Pollock retrospective at the Whitechapel Gallery. "I was interested but unimpressed," he wrote. "Elegance there was, of course. ... Some thirty very large works left me a little de-

pressed."[66] At the show he met William Scott, whom he remembered from Scott's time at the Banff School, and they arranged to meet again when the Bateses returned from the continent. Max had lost touch with his wartime "mucker," George White and seems to have made little effort to contact other ex-prisoners; however, one meeting was special. Although they usually dined at the Lyons Corner House in Piccadilly, Max chose an expensive restaurant to entertain his fellow prisoner of war Jim Brown and his wife.[67] Thus Max redeemed the promise made to Brown on their first forced march when, in exchange for a share in a tin of herrings, Max had promised Brown the best post-war dinner London could provide.

Max and Charlotte took the night train to Paris and settled in a hotel on the Left Bank.[68] Even through the rather pedestrian entries of his journal, one can sense Max's excitement at being back in Paris. London was familiar ground for him, but much of Paris still remained to be explored. That first evening they had coffee at the Café Deux Magots and dinner at the Vagenende, which was furnished in the "rather ornate style of the nineties."[69] Both places were haunted by the shadows of the artists and writers Max so much admired. In the mornings Max explored the city on foot and by métro, while Charlotte often chose to remain in the hotel resting or reading. He made a beautiful sketch of the ornate fireplace in their room, and on the mantel are pears, oranges and a long loaf of French bread they had bought.[70] Café de Flore was their favourite spot for lunch, and for coffee it was Deux Magots.

Max found much to sketch in his wanderings. He liked the yellow and black Dubonnet advertisements and the blue and white métro signs.[71] Walking down the Rue Edgar Quinet, he passed the entrance to the Cimetière Montparnasse. The row of tombs with their classic pediments reminded him of "sentry boxes. ... Sentry boxes at the gates of eternity."[72] Just as he stepped inside the gates to draw the tombs, a black *gendarme* came forward and informed him that entrance was forbidden. Tracing his footsteps from 1937, Max returned to the Place de la Bastille and the Rue Jules César but found the scenes much changed.[73] Several times he visited the Boulevard St. Martin and its canal, which attracted him, and he stood in a doorway out of the rain to make his sketches.[74]

Fresh from his own work with St. Mary's Cathedral, Bates was taken with a large display of Gothic art at the Trocadero[75] which featured excellent copies of stained glass and full size models of French Romanesque and Gothic architecture. He visited the great Cathedral of Notre Dame and wrote of it

Magnificent interior of the Cathedral. Windows glowing with jewel like colours. The Rose windows with sections of a beautiful purple. Intense blues and reds. Deep spiritual influence in a dim, cool light. ... Everything in the church well designed—staggering contrast to Notre Dame in Montreal![76]

There was, of course, a feast of exhibitions to explore. "In Paris I was anxious to see what was going on," he wrote in his journal.

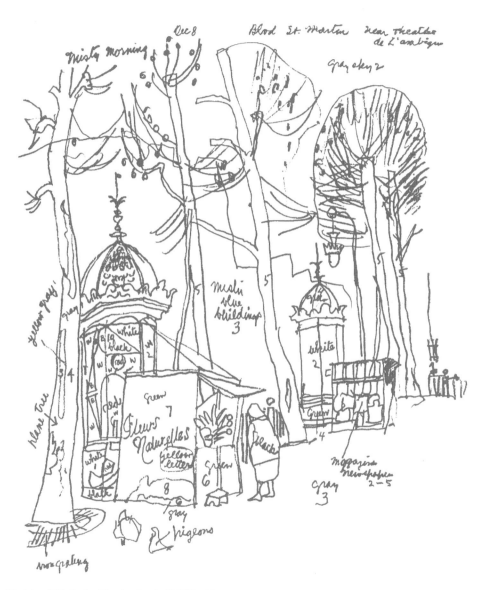

Sketch of Blvd. St. Martin, Paris (1958). 23 × 17 cm. From sketchbook. Maxwell Bates fonds, Special Collections, University of Calgary Libraries.

The Salon d'Automne in the Grand Palais had a retrospective of important work shown in the last fifty years, and one-man shows of Rouault, Marquet and Walch. Some fifteen hundred works were hung against rough, sand coloured sacking with many prominent French painters represented. It required two long visits in galleries where I could see my breath. ... This salon had a core of very good work, and much that was mediocre. I took a few notes and was approached by people who thought I was a critic and who wanted to engage my interest.[77]

They saw an exhibit of fifty landscapes by Vlaminck at the Galerie Charpentier and a show of French drawings from American collections at L'Orangerie, where they also saw the Nymphéas Room, which had been especially designed to house Monet's large water lily paintings. The latter left him a little disappointed. He made a small note in his journal, "By the way, a page written by Gauguin was in small neat handwriting which is in contrast to the disorder of his life."[78]

At the Musée Jeu de Paume, he especially admired *Blue Dancers*, by Degas, and was surprised at the small size of Cézanne's painting of the card players.[79]

I had the feeling that painting was marking time in Paris, and I looked for any movement that might be starting up. There are some hundred galleries fairly near our little hotel on the left bank. None of these gave me any intimations of a new direction, although I patrolled the quarter like a gendarme. Style, taste, purely formal qualities were demanded.

Abstractions predominated, but variety was considerable and there was a great range of quality. Paintings made up of the square slabs of paint originally introduced by de Staël are common. Some painters using this method are very good, Cottavoz for instance.[80]

Day after day, he looked for prints to buy. He bought a Dufy etching for less than ten dollars, but left a print by Rouault which he felt was too expensive. He was anxious to get hold of some prints by Clavé and he finally found two he liked, unsigned and reasonably priced. In addition, the proprietor of the shop gave him three posters announcing exhibitions.[81] Many of these posters were lithographs printed by the famous Fernand Mourlot, and Max sent Snow a magazine clipping that showed Mourlot with his stones piled high behind him. He knew Snow would appreciate the accompanying text:

> Later methods of printing caused a world-wide slump in lithography, but one French craftsman—Fernand Mourlot, ... kept it alive. He is the instrument of Matisse, Picasso, Dufy, Utrillo and others who, captivated by the medium, said of Mourlot, "With science destroying the soul, he is a ray of hope."[82]

The thought of the Rouault prints proved too tempting for Max, and he went back and purchased a Rouault etching, "one of the Misèrérè series published by Ambrose Vollard,"[83] which was later donated to the Art Gallery of Greater Victoria. The day before they left Paris, he succumbed again and bought two more Clavés. He was also interested in pur-

chasing some sculpture from Africa and one frosty, misty Monday morning finally bought one at a flea market.[84] He had seen some fine pieces at the Carrefour Vavin and decided to buy two, a Baoule Fétiche and an Antelope.[85]

The Bateses' explorations were not limited to the galleries. Conveniently located near their hotel were two cinemas showing interesting films such as a fantasy in colour by Jean Giono and *Mon Oncle*, Jacques Tati's witty and subtle satire on modern suburbia. They admired Alec Guinness's acting in the film version of Joyce Cary's *The Horse's Mouth* and thought John Bratby's paintings for the film were excellent, but Max had read Cary's trilogy and was disappointed in the film adaptation.[86] A visit to the Cirque Medrano[87] near the Place Pigalle yielded a drawing, which he made from notes taken at the circus, and this subject proved to be a fruitful source in the future. They also saw the Baglioni Circus at the Cirque d'Hiver and found it captivating.[88] They attended Marcel Marceau's performance at the Théâtre de l'Ambigu; Max made notes for a sketch on the inside of a cigarette package. On Max's fifty-second birthday, 14 December 1958, the couple went to the Café de Flore for coffee, tipped the wandering flautist, then made their way to the Place Pigalle and the Grand Guignol Theatre down an alley.[89]

After his years of constant activity, painting, writing and producing lithographs in addition to the hard work necessitated by the cathedral, Max was ready for the feast that Paris offered him. Something of what the city meant to him is revealed in the story "L'Hôtel du Carrefour Croix Rouge," written in the first person and

inspired by his travels on the métro. The narrator is sitting in the Tuileries Gardens sketching and thinking of his previous visit to Paris before the war:

> The great dark mass of the Louvre to my right hand was brownish purple, impressive and melancholy—a melancholy relieved briefly by two or three children in adjacent paths. The even, overall grey of the sky was not depressing, because my spirits had been lifted by the buildings of the Rue de Rivoli. I could accept this scene as Paris, a city not too far removed from the Paris of Daumier and Meryon. ... No city approached this, in wonder and magic and mystery. ... I drew some more chimney-pots, full of beauty in their military lines, disciplined, yet each so different from the others. The great street brought some names to my mind from the murky pool of my haphazard ignorance, names like Bazaine and Changarnier and more familiar Baudelaire, Manet, Gautier. There would be no end to this should I permit myself to continue, and, feeling colder I closed my sketch-book and walked in the direction of the river.[90]

The mysterious tale unfolds to an inconclusive end, but the sketch he made from the Tuileries Gardens became a major painting.

"If Paris is feminine," Max wrote in his travel journal, "Munich is masculine. Trees and arcades are set out like rows of soldiers. Museums hang paintings perfectly and keep them in condition, which cannot be said of French museums. Pictures of equal interest look better in Munich than in Paris."[91] Max's only indication of his memories of the war years in Germany was his reaction to the uniformed immigration officer on the train to Munich. Even then, he wrote only of the officer's "field grey uniform very like the German Army uniform I remembered with the peaked cap and front pushed up."[92] Munich had been in ruins when he saw it last,[93] and he and Charlotte were impressed with the rebuilt city, contrasting it favourably to Paris.

Max found the magnificent interiors of the Baroque churches spiritually moving. Describing one, he wrote,

> the fantastic elaboration is rigorously unified by the over-all white colour. Sun patches are broken up in a way calculated by the architect, the sources of light sometimes hidden in the Baroque manner. ... I felt the Baroque to have a correspondence with our time, as has the Byzantine style.[94]

He felt that if he were to design another large church, he would choose the style of simplified Baroque.[95]

In one gallery, the Haus der Kunst, he found a collection of "fine Monets, Vuillard, Bonnard, Utrillo, etc. Very fine small Daumier of lawyers."[96] During a second visit, on Christmas Eve, he saw "Pictures by Hodler, Munch, Beckmann, Kirchner, Marc—others by older painters such as Liebermann, Slevogt and Bocklin, Lenbach, etc."[97] At a gallery on the Königsplatz he found a collection of the Blauer Reiter school, "Marc, Klee, Kandinsky, Macke, etc." On Christmas Day, their last day in Munich, they went to the Krone Circus, where Max enjoyed, as always, the slapstick humour of the clowns who were acting as house painters.[98]

Travelling on to Vienna, the couple settled in the Hotel Austria.[99] The heavy rain there did not prevent Max from prowling round the galleries, which he found even more rewarding than those in Munich. At the Belvedere he looked at the nineteenth-century German paintings and thought, "why are Poussin, David, etc. so much better known and highly regarded?"[100] On a second visit to the Belvedere they saw the work of Klimt and portraits by Kokoschka, whom Bates considered might "be the best of all portrait painters—interesting colour."[101] He was clearly responsive to the remarkable psychological insight Kokoshka brought to his portraits. In Max's view, the

> Germanic countries are more concerned with content than is France, and less with taste, style and purely formal qualities. The room of great Kokoschkas at the upper Belvedere, and the large works by Egon Schiele and Gustav Klimt in the same gallery confirmed my opinion that these achievements are sadly under rated. Around 1905 Klimt was trying out some of the most recent directions in painting. Surely these early Kokoschka portraits are unsurpassed.[102]

Max did several sketches and was especially taken with a Czech church, Maria am Gestade, "which has a beautiful Gothic crown on the high side towers. Very original and beautiful Gothic."[103] Their final evening in Vienna was spent on the Nightlight Serenade Tour. At one stop there was a dancer "wearing only a triangular, black, diamond studded patch with two strings holding a black cloth on her behind and a scarf,"[104] details that suggest Max was

noting figures for future work. Their final stop was at a famous night club specializing in strip tease; Max thought the can-can the best, although he noted that the middle-aged woman in charge of the props looked disapproving at times. Max's final note was "A very interesting evening."[105]

They travelled overnight to Venice and in the rainy morning looked out on "flat country with small trees and rectangular, dilapidated buildings, reddish pink and ochre plaster."[106] Their first evening there Max ventured into the winding streets, lost his way, but managed to find the hotel again and make a sketch in the evening light. In the morning they visited Saint Mark's Basilica and the Ducal Palace where Max could see "better than in reproductions how the Venetians became known for their colour—especially Veronese."[107]

Saint Mark's Square was decorated with hangings and flags in preparation for the visit of the Archbishop of Venice to the Basilica. The whole city seemed like a museum to Max— "dirty pink, orange-red and pale violet … unique and fascinating."[108] Because the public rooms open to tourists were unheated, Max and Charlotte often took refuge from the cold in the opulent warmth of Florians, the famous café on the square. In spite of the expense, Max enjoyed the tea and the "elegant fin de siècle atmosphere, cream and gold wood panelling, red plush, antique gold framed mirrors, glass panels with Chinese subjects painted in them."[109] On a second visit they found themselves in a room with paintings of women and angels on clouds behind glass panels. Max obviously was indulging his

enjoyment in the café milieu, for he relished the opportunities to observe his favourite subject, people, in unguarded moments.

While Venice did not inspire many sketches, perhaps because of the cold, Florence was more fruitful. Their hotel window overlooking the Arno had "an exhilarating morning view in the Turneresque light."[110] In his sketch of the church Santa Maria del Carmine he indicated an orange dome, sand-coloured stone, red tiles and green grass.[111] Inside he found Masaccio's superb frescoes depicting scenes from the life of St. Peter and the expulsion from Eden. This last, with the anguished face of Eve, has been termed "one of the pages of expressionism—expressionism outside history."[112] The power of the artist's human figures, so enduring over the centuries, moved Max more than anything else he saw. He found in the frescoes "a strange spiritual power—a strength and simplicity—but the essence defies analysis."[113] It was exciting for him to see at the Academy Gallery the original of Michelangelo's colossal *David*, which was forever imprinted on his mind's eye from his frequent youthful visits to the library. Max was impressed with the amount of great sculpture in the city, and he was especially attracted to Benvenuto Cellini's *Perseus* which he went to see a second time.[114]

The Bateses took side trips to Fiesole and Pisa, and Max noted that the road to Pisa was disfigured by numerous signs which clashed with the old plaster farmhouses.[115] The landscape on the way from Florence to Rome was "the best I have ever seen, I think ... ideal for landscape painting. ... Old plaster farmhouses—dark accents of cypress trees—small

towns nestled on hilltops."[116] Near the Spanish Steps in Rome they found the eighteenth-century "Antico Caffé Greco ... one of the most interesting cafés we visited in Europe. It has dark red walls with prints and portraits of Italian literary figures of the nineteenth century."[117] Max and Charlotte, in frequent need of coffee and cigarettes, were becoming experts on café life.

At the Church of Saint Pietro in Vincolo, Max saw the second colossus of his youth—and the subject of his drawing lessons with Lars Haukaness—the *Moses* of Michelangelo.[118] When they returned to their hotel, they found Donald Buchanan, editor of *Canadian Art*, waiting for them, and he took them to the apartment of Alberta artist Roloff Beny, where Buchanan was staying. In the course of the evening, they phoned Ken Lochhead, another artist who was also living in Rome, and arranged to visit him. Both men were making photographic studies of the Roman scene. Lochhead showed them the painting and drawing he was doing in the city, "excellent sketches and water-colors—personal solution of cluttered townscape—very valuable work."[119] Max, too, tried his solution to the crowded buildings in two sketches he did from the hotel. The only exhibition he saw of note was a Braque retrospective on the sixth floor of the Villa Barberini.[120] On their last day, before taking the night train to Nice, Max and Charlotte visited Tivoli, the Villa d'Este and gardens, and Hadrian's Villa.[121]

They relaxed in Nice, strolled along the Promenade des Anglais, fed the pigeons, and enjoyed the cuisine. St. Jean-Cap-Ferrat was

their first stop in their exploration of the coast and the highlands above. At Cap-Ferrat, Max was much taken with the Chapelle de St. Hospice,[122] with its Virgin and Child made of copper sheets, and his sketch[123] shows the figures with their elaborate crowns. Jock Macdonald had written a great deal about Vence in letters, and Max was anxious to see the famous city that had harboured so many artists and writers. He admired but was not moved by the Matisse chapel, except for the drawing of the Madonna and Child on the white tile.[124] At Menton he and Charlotte were intrigued by Jean Cocteau's *La Salle de Mariage*, with its black marble floor, leopard or ocelot carpet, red chairs and murals with symbolic figures. It was, as Max wrote, "Rather like a night club." They saw more of Cocteau's work, the fishermen's chapel which he had decorated both inside and out, at Villefranche. At Antibes they saw a collection of Picasso's painting, sculpture and ceramics in the old Grimaldi castle turned into a museum.[125]

Bates had always been attracted to islands and he was very keen to visit Corsica. Their four days on the island inspired him to write an account of the expedition for *Highlights* on his return to Canada. The island was ringed by watch towers, and occasionally the couple caught a suggestion of the underlying primitive vendettas and violence that remained a part of the life of the people. They travelled over the island by bus, a journey that Max described as follows:

> This road is only eight feet wide in places. We pass donkeys whose riders dangle both legs on the same side. There is almond blossom

and whitish lilac. Square houses stand widely separated on the hill-sides. Beyond is a sea of green bush and mountains. The indigo sea breaks white on ochre rocks. The road winds interminably, often a narrow shelf on a mountain side. Our driver is small, adroit and competent, calling out names of interest without nonsense or forced humor. ... At the calanche of Piana are rocks, pink and brown, suggesting a heart, an eagle, an elephant, a bishop with his mitre and cross. I can hardly believe such tremendous vistas possible in an island only 114 miles north to south. They are more impressive than any I have seen in North America.[126]

Max offered a sugar lump to a donkey and nearly lost his thumb, which was sore for a week. They enjoyed the distinctive food on the island— a sausage of pork mixed with chestnut flour, good rosé wine, local cheese, nuts and figs, and even "a small bird with its legs up behind its head and beak—very tasty."[127] As they sat drinking coffee in the capital, Ajaccio, they looked out "at the statue of Napoleon on horseback, surrounded by his brothers on foot, all facing the sea from the great Place de Gaulle. I idly sketch the emblem of the Island—a Moor's head, his forehead bound with a ribbon."[128] They returned to Nice during carnival time, visited St. Tropez, La Turbie, Grasse, Fréjus and Cannes, then made their way back to England.[129]

During their last few days in London, Max and Charlotte indulged themselves with their remaining money, and Max bought a coloured lithograph by Juan Gris.[130] They attended a show of German modern art at the Institute of Contemporary Art, and Max remarked that

some paintings could almost be called sculpture, "with spiky projections up to six inches."[151] The Bratby show at the Beaux Arts excited him, and he wrote,

> Bratby's huge paintings were impressive; his smaller work much less so. Extraordinarily thick lines of paint from the tube are related to Van Gogh; in fact these paintings are Van Gogh brought up to date and blown up to seventeen feet with motor scooters, television sets, cornflake boxes, etc. Nevertheless, Bratby is important because of the amount of his creative energy.[152]

William Scott and his wife wangled them an invitation to the opening of an important American show at the Tate Gallery. Max wrote of his reaction:

> The exciting impact at first glance lessened after half an hour, except in the cases of de Kooning, Rothko, Gorky, and one canvas by Tomlin. ... The violence of some others, including Joan Michell, did not combine the necessary immediacy and authority. The exhibition is bound to be influential in Europe, in England perhaps mostly with students. The English character is not sympathetic to violent expressionism. Some restraint is preferred. This was revealed during Kokoschka's sojourn in London; he was nearly ignored. Of course restraint may be admirable when, as Quentin Bell said recently, "the artist really has something to restrain."[133]

On their return to England, Max had written in his journal, "I was relieved to land on British soil, and I remembered I always have been coming from a foreign country, even the U.S.,"[134] a note which suggests that however much he was intrigued by the exotic and the passionate in human experience, in his daily life he preferred moderation, civility and the relative security of the rule of law. He was ready to go home.

Final Years in Calgary, 1959–61

The six months of intellectual and visual stimulation built up in him an energy that found release in an explosion of exhibitions, experimentation and writing. In his absence his lithographs had been hanging in a joint show with Snow's in the new gallery of the art school at the Provincial Institute.[1] Max's friends were anxious to see his new work, and Illingworth Kerr immediately arranged for an exhibition in the same gallery. That April, Max was able to mount an exhibition of thirty-six oils and chalk drawings. While some of these works reflected his travels, others explored new paths. Kerr wrote of the exhibition that

> Gamblers and Circus in Town are both surrealist, a phase which Mr. Bates has not pursued to a great extent. The drama of pure form is best evidenced in paintings of still life in which Mr. Bates has found symbolism in commonplace objects.[2]

Tin cans was a large oil of ordinary cans piled one on the other, subject matter thus described by Max:

> symbols developed in the fifties are tin cans and bread. The first represents assembly line mechanical living, and the second what the industrial revolution has not yet destroyed of immemorial attitudes to life and nature.[3]

He had used the same symbols on the lunch table of the young couple in his *Interior with Figures* of 1958. With his early art nouveau background and his intense individuality, Max was extremely sensitive to the depersonalizing and alienating effects of modern technology. Part of Europe's attraction for him was that it had not yet succumbed to the mass production culture; it still presented a contrast to the North American experience.

More results of his explorations in Europe were shown in an exhibit in the new gallery of the Allied Arts Centre, which had moved from the Coste House to a restored warehouse in the centre of the city. There were nineteen large oils and three pastels, all devoted to what he had seen in Europe: the Tuileries Gardens, South Kensington, La Turbie, the Black Virgin of Cap-Ferrat, Corsica, the Cirque Medrano, Boulevard St. Germain, and the Arno in Florence. Of these works Ian Thom wrote:

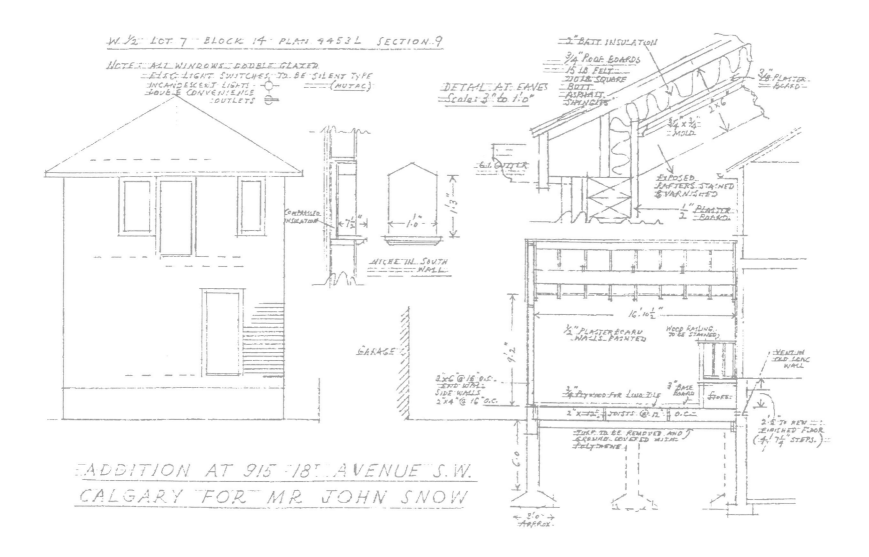

Bishop of Tours and the patron saint of France. St. Martin is also the patron of those who enjoy wine.[17]

Bates chose the red of St. Martin's cloak, a wine red, for the sanctuary. The altar is framed by a curved arch, and over it hangs a large cross painted grey, the colour of the sword. The walls are painted the yellow of the prairie fields[18] and "a pale aqua and turquoise ceiling floats brilliantly overhead."[19] Max presented the congregation with a painting of St. Martin cutting his cloak for the beggar **(St. Martin of Tours)**. In the background are thorny, barren trees and a stone fortress. Commenting some time later, Stephanie White, the architectural critic for the *Calgary Herald*, rightly picked this work as a clue to the whole structure. She wrote:

> The key to understanding what at first glance appears to be a rather stolid and plain building lies in a St. Martin painting by Bates which hangs on the back wall of the nave. It shows two unmistakably Batesian figures standing with ceremonial urgency in a hilly field. ... Framing this little scene is a dark red, semi gothic arch, some medallions and a harsh, bright blue and red geometric pattern in a strip along the bottom. ... The powerful little painting is very Gothic in feeling.[20]

White concluded that

> St. Martin's is a collection of paradoxes: It is mysterious yet familiar, clumsy in a way, but finely-tuned. It is heraldic in a cerebral way without being intellectual. What I find so fascinating is how one can see Bates experimenting three-dimensionally in architecture

with ideas so much more easily expressed in painting.[21]

The church was consecrated on St. Martin's Day, 11 November 1960.[22]

In an entry in his journal Bates wrote, "I shouldn't be writing; actually I have work to do,"[23] but he was writing a great deal. He wrote two pieces for *Highlights*: one on his impressions of art in Europe and the other on their trip to Corsica. He concluded the first article with the firm statement:

> A result of the trip was the pleasant conviction that the best Canadian painting compares much better than most Canadians realize, with what is being done in Europe. I think the art-conscious public too often forgets that the prominence of many famous artists is partly due to the unremitting publicity of dealers and critics. ... To say that some superb German and Austrian painting has suffered in this way is not to detract from the deserved, and thoroughly stressed, reputation of the School of Paris. In its turn, the best Canadian painting is neglected by Canadians.[24]

He also prepared a paper, "The Existential Direction in Painting,"[25] in which he related his study of that philosophy to the directions of modern art. In his notes he defined existentialism as a "philosophical doctrine which gives priority to existence over essence."[26] Given that a human being develops through experience, Max saw the "complete existential freedom of the individual"[27] as necessary for the person to attain his uniqueness. Society should impose itself only to ensure the rights and freedoms of each individual. Max made a

note on Jean-Jacques Rousseau's thesis that it was necessary for every person to re-discover the fundamental self and separate it from the acquired social self, a search which is conducted in solitude.[28] He saw that in modern art, the artists were attempting to reach new limits of romanticism, "a sense of heightened existence ... attained by tension wrought to the point of anguish." Max considered art as the worship of God, a concentration on the significance of being. He defended abstract art as "not man as seen from outside himself, but it is man and ... aspects of the Cosmos apprehended from within."[29]

However, Bates saw a reaction to the "extreme simplification of much abstract painting" in the experiments in photography conducted by some artists.[30] Max had seen the photographic work being done in Rome by Donald Buchanan and Ken Lochhead and wrote about it in "Visual art and photography,"[31] an article for *Canadian Art*. The article was illustrated by some of Buchanan's Rome photographs, two by Walter Drohan—*Ink Suspended in Water* and *Peeling Paint*—and Ron Bloore's *La Forêt Mécanique*. These last exposed the small, detailed patterns of everyday experience, and Max concluded that "the inner vision (inscape) is becoming exhausted and needs the raw material of new sense data." This material, he thought, would come from a minute examination of nature and from "Found Objects significant and mysterious."[32] He had decided to attempt to use the latter in his own work.

Bates found an example of the artist's struggle to penetrate reality close to home in the work of Ronald Spickett, a young Calgary artist with whose ideas he was in sympathy. Spickett later wrote:

> The keen interest Max had for ideas, for the search and for the process took him closer to friends than would mere affinity to vocation. In the early years of "Art in Calgary" (40's 50's) Max offered not only the basis of friendship but also creative affirmation to a new crop of gropers. To move through the world with knowing is the effort of the artist. Not simply the making of art forms. Max knew this and moved with knowing grace even when the movement was accompanied by pain. The larger route of Life itself was the larger insight that allied Max to others. He was touched and we were touched by him.[33]

After a visit to Spickett's studio, Max wrote his article, "Ronald Spickett: Symbols of the real" for *Canadian Art*, in which he described Spickett's recent works as "complexes of crossed lines, the character of each painting determined by prominent knots and skeins, and by color."[34] Spickett had explained that his aim was to make a symbol of reality, the whole painting being a symbol. He considered that non-objective painting was most valid for the modern artist and that naturalism or magic realism was "too clogged with appearances to penetrate to the reality he tries to find."[35]

By this time Bates's drawings and lithographs were being widely exhibited. *Canadian Art* also published a reproduction of Max's coloured lithograph *Children* in an article by Donald Buchanan entitled "Canadian graphic art abroad."[36] His lithograph *Character* won the Adrian Seguin Memorial Award at the

exhibition of the Canadian Society of Graphic Art.[37] He was asked to contribute to an exhibition organized by the American Federation of Arts, Canadian Watercolours and Graphics Today,[38] and was invited to send some work to the Second International Biennial Exhibition of Prints, held in Tokyo in 1960.[39] His work was also among that hung at the exhibition of Canadian Painting and Graphics, Mexico City and Guadalajara.[40] Both he and Snow exhibited in New Directions in Printmaking,[41] Chicago, and their lithographs appeared in a joint exhibition in the Art Gallery of Greater Victoria.[42]

Stimulated by what he had seen in Europe, Bates embarked on a period of experimentation in both prints and oils. Inspired by the sculpture of Edward Paolozzi,[43] he decided to incorporate real objects into his work, the throwaway waste of our civilization, such as razor blades, paper clips, coins, old keys. He considered: "Much of the immediacy of action painting; that is the break into reality, can be obtained by the impressions of real objects." He compared the modern artist's fascination with debris to the appeal and mystery of ruins in past ages. "I am using the new technique to advance farther than I could with my Scarecrow and Beggar series," he wrote. "All are related."[44] Bates and Snow experimented in their lithographs with plastic doilies and lace to enrich the surface. Bates described the process:

> The ground, whether paper or canvas, must be prepared with an arrangement of colour and tones because a background cannot be put on after the impression, etc. are made. I am not aware of any previous attempts to use these techniques exhaustively with oil paint on canvas, or even of their full exploitation on paper with pencil, crayon, etc.[45]

He did not use this technique with his oils for long but continued to experiment in his graphics.

More intensive was his foray into tachism,[46] in which he let the paint run in dribbles on the surface of the canvas. He thinned the paint with turpentine, let it run down the canvas in one direction, then quickly gave one turn in another direction so the running paint formed a sort of a grid.[47] He felt that the paintings related "to the Group of Seven in being tapestry-like and rather decorative Canadian landscapes."[48] Max showed four of them (*Blue Painting, Prairie, Forest Tapestry* and *Northern Painting*) for the first time at a Winnipeg Art Gallery exhibition that featured submissions from the judges and prize winners of the 1955 Winnipeg show.[49] Max also began experimenting with his faceted paintings. These pieces differed from the tachiste works in that there was, as he explained,

> no dependence on accident. The paintings are made of small geometric facets varied in tone and colour and painted with a small brush quite precisely. The space is shallow throughout the canvas. I shall probably introduce areas of deeper space in later paintings. These retain and may increase, the detail and complexity that I believe is desirable at the present time. ... These might be called "Facetism" (facetiously).[50]

In his journal he wrote, "My faceted paintings ... have a resemblance to a kind of song, usually American negro, that repeats the same words, few in number to the end with differences only in pitch, emphasis, etc."[51]

When examples of these experiments hung later that year in the Norman Mackenzie Art Gallery in Regina, Max enlarged upon what he was trying to do, and the account was published in the *Regina Leader-Post*:

Facets (1962). Oil on canvas, 50 × 60 cm. Photo from Maxwell Bates fonds, Special Collections, University of Calgary Libraries.

"This abstract expressionism is a disciplined movement," he said pointing to a painting titled *Facets three* which shows pyramids and hour glasses. "This is intellectual, while those," and here he pointed to some wavy abstractions of his in which the paint appears to have been dripped down the canvas, "are more emotional." Another painting titled *Facets 1* made up of red, blue, black and white geometric patterns, he described as the point of impact of a battle. One can see the red and blues meeting head-on the white and the blacks. "Many artists are flirting with chaos in their works and I want to move into order," he said. He predicted that in the future artists would veer away from chaotic paintings and he said he felt he was a pioneer in this new form, an art expression which he called a new form of cubism.[52]

In spite of his stated intentions, Bates found in these paintings not a new path to reality and intensity but a cul-de-sac. Moreover, as he told Ted Godwin, "Not one of the damn things sold."[53] Years later Bates said,

> There was a time in 1960 when I did a lot of abstract pictures, which you might call "tachiste." And then I went to the op, and from there I went back again to figurative work. But it was only a sort of diversion, that's all, a change. I like to change now and then, for a refreshment.[54]

These experiments with the abstract, "tachiste" paintings proved to be just that—experiments—but they were also fertile ground for Bates. Traces of them can be seen in subsequent works, and Max occasionally used the "tachiste" paintings as a base for later works, as in the **Unself Portrait** of 1978.

He had not, however, turned away from his puppets, beggars and scarecrows, for as he explained, "Puppets represent man as a victim of irresistible forces and scarecrows attempt to protect their heritage. Scarecrows are religious and at times become crucifixions."[55] He sent *Scarecrows Protect the Wheat and Grapes* to the 1959 exhibition of the Canadian Group of Painters, which hung in Toronto and Fredericton.[56] A powerful oil, *Midnight Crucifixion*, was bought by the Art Gallery of Windsor.[57] In his journal he had written,

> I am considering a picture of the Crucifixion 36"–48",—"The Midnight Crucifixion." Midnight because it is the Nadir (the sun is at its Nadir). Dawn might be the time of the Resurrection. It is winter, the low point of the year. Spring would be the time of the Resurrection. There will be a group of beggars foreground,—three crosses will be in the distance, or middle distance. The winter trees will have thorny, spiky branches and there will be snow on the ground.[58]

Max had been writing to Jock Macdonald about his experiments, and one of Macdonald's replies contained the news of a recently opened Toronto gallery, Dorothy Cameron's Here and Now Gallery, which specialized in Canadian art.[59] Macdonald had a successful show there early in 1960.[60] Further news was that Max had been elected vice-president of the International Society of Plastic Art. In February of 1960, Macdonald wrote that he was to have a retrospective at the Art Gallery of Toronto .[61] He "was flattered and thrilled, by the prospect, for never before had a living artist outside the Group of Seven been given such an honour."[62] He lived to see the exhibition before he died on 3 December 1960.[63] The loss of this warm, supportive and long-standing friendship was a blow to Max.

The Here and Now Gallery mounted a joint show of lithographs by Bates, Snow and Roloff Beny the same year, 1960.[64] Bates joined the gallery's stable after Cameron made a trip across Canada to the west coast, contacting artists whose work had not had the exposure in eastern Canada which she felt it deserved. Cameron, who had studied at the University of Toronto and at the Fogg Museum at Harvard University, was an intelligent and enthusiastic dealer, and her gallery made a notable contribution to the promotion of Canadian art. As a result of her western journey, she organized an exhibition of the work she had seen. In her introduction to the show, she described the "intense sun shapes" of Ronald Bloore, the calligraphy of Roy Kiyooka, the "grainy skeins" of Ronald Spickett, and the "luminous red space" of Maxwell Bates. "Each expresses some sense of the light and the lonely severity of the prairie experience."[65]

Bates's first retrospective opened at the Mackenzie Art Gallery in Regina in 1960,[66] which included seventy-two of his works, dating from 1921 to the tachiste paintings and the facets series. The non-objective pieces were hung separately in the Canadian Gallery upstairs, and in spite of—or perhaps because of—such titles as *Moses*, *Swamp* and *Sacred Text*, they were the source of considerable puzzlement to the public who came to look.[67] After the showing at the Mackenzie, the exhibi-

tion was booked for the Winnipeg Art Gallery and the Edmonton Art Gallery. The following lines appeared in a poem written as a preface to the catalogue by Bates's friend Roy Kiyooka:

He has painted and I have seen
 Droll, grotesque males with clay feet, dumb red hands
and songless, green-faced children buoyed to light as lead
with ochre passions pushing pregnant perambulators.
Daguerreotype families, sternly stiff-packed into chromeless
living rooms.
 He has painted
 Red pubescent girls and mute crowds on sunless,
funless, festive fairways. Clapboard houses in mindless
city suburbs and grey protesting cathedrals with ungothic spires.
He has painted black, truncated butterflies poised against
treeless umber horizons and Sunday parks with mundane
lovers, embracing speechless statues of wreath-bound unknown
soldiers. He continues to paint and to reveal that
Every artist's strictly illimitable country is himself.*
These paintings I suggest are for someone—no anonymous political
everybody is worth painting for.[68]

*E. E. Cummings. I-Six Non-Lectures 1958

In his introduction to the catalogue, Ronald Bloore, director of the Mackenzie Art Gallery and himself an artist, pointed out,

> This retrospective exhibition is not indicative of the end of a man's career, rather Bates, as these later compositions reveal, is even more aware of our contemporary situation than many of the younger artists.[69]

For a short account in *Canadian Art*, Bloore wrote, "Bates has been an expressionist painter, concerned with creating, in firmly constructed compositions, statements about Anyone."[70] Max attended the opening, and surrounded by his young artist friends and admirers—among them Kenneth Lochhead, Ronald Bloore, Douglas Morton and Ted Godwin, all of whom were based in Regina—he thoroughly enjoyed the occasion. J.Russell Harper described the interchanges between these artists as "a healthy mixture of Western robustness, intellectual searching, friendly rivalry and unspoken ambition."[71] Regina was a centre of intense activity, and Harper noted that "a new 'modernist' wave of the late fifties … spread out from Regina." He also pointed out that there was a period when Regina painting was better known in the New York art world than was the work from many larger American cities.[72]

Max made time to look at Godwin's latest work and mentioned that he wished he had done some larger paintings. He also told the young artist that, in his opinion, it was important that the artist get up and shave and "go to the office,"[73] a remark that perhaps reflected what he saw in the Regina art scene as manifestations of the "Sixties." It is certainly in tune with his own outward conformity, his discipline, and his dislike of any exhibitionist dress or behaviour. While in Regina, Bates became involved in a discussion with his friends about an artistic movement, a version of constructivism centred in Saskatoon around Eli Bornstein at the university there.[74] The group produced a magazine called *The Structurist* and was very critical—even fanatical, in Max's opinion—of the turbulence of the essentially romantic modern movement.

What he heard from the artists in Regina about the movement inspired Bates to look again at constructivism, and he drafted a statement on it. He began by tracing its western roots to Plato and the classical ideal and wrote: "Although the Platonic aesthetic and Pythagorean number are valid elements in art and always will be I don't believe that they are the only valid elements." Max pointed out that the Saskatoon group seemed excessively narrow, as they scorned even such artists as Ben Nicholson, Victor Pasmore and Mondrian. At any rate, he concluded, such a narrow view of visual art should not be prevalent at a university. Bates saw the boundaries of art in the twentieth century expanding rather than contracting and believed that "expression of feeling, mood and intangible aspiration and poetic vision are also valid elements in visual art."[75] Aspects of the classical and romantic are present in all art, and in Bates's own work the second continued to predominate. He had tried new techniques as a way of "liberating his art," but he was wary of the dangers of "bogus originality"[76] as a cover for lack of creativity and an ethical base.

Illness and Move to Victoria, 1961–63

Bates's interest in experimenting with the tachiste and facet paintings may have waned, but he did not stop his innovations with other forms. For his works on paper he continued to use graffiti, doilies and cheese-cloth in various combinations. In the spring of 1961, one of these experimental prints was reproduced in *Canadian Art* in a survey article that included the work of eighteen printmakers from across Canada. Max's colour lithograph *Man*[1] was a good example of his experimentation with a variety of materials; however, the full impact of his techniques was lost in the reduced black and white reproduction.

Bates was also experimenting with a technique of ink paintings. As he explained:

These paintings, which are not prints (there is only one of each) are the result of an interest in rich textures which I have had for about ten years. ... I realized that texture is the means by which decorative effects are achieved in the 20th century. This is most evident in architecture because the Modern Movement insisted on simplicity, and decorative carving, etc. became suspect, referred to by ambitious students as "gingerbread."

Work by some modern painters, Klee, Dubuffet, etc., showed me that the decorative value of texture applied just as much to painting. ... In October, 1961, I began to use lino ink (which resists water) filling in the spaces of white paper with washes of coloured inks. This had possibilities; and I found a plastic doily with a design I could use, at Woolworth's. (I found other designs later.) To use these on heavy white paper I rolled out lino ink on a sheet of glass and placed a doily face down, then applied pressure with a clean roller on the back. After lifting the doily (or peeling it off the glass) I placed it face down on my paper and applied pressure to the back with the roller. This left an imprint of the design, and I repeated this performance again and again, until the texture was rich enough, or I spotted a figure or some subject in the maze of lines. Then I applied washes of coloured inks, using up a large number of bottles in the process. ... If the paper is well pinned down it dries perfectly flat after the ink washes. ... I do not like to publicize techniques invented by myself (and have a large number of people copy me), but I do not believe techniques should be secret. It is not the technique, but how it is used that is important.[2]

Pursuing such innovations, he was also mulling over the idea of writing the framework and designing the decor for a ballet "about bees—with some satire,—also 'Le Monde Mécanique' revealing the battle of the individual with the regimented modern world." He was working out the plot of a play, "Mice in Dark Corners," and thinking of a novel "in which the author plays the principal role in commenting on the actions of the characters. The characters are rather like puppets playing out situations illustrating the point of view of the author,"[3] a scenario anticipating Alain Resnais's 1977 film *Providence*. Bates also thought about innovations in film. He conceived of the screen becoming

> a surface of planes at different angles relative to each other, or a curved surface. These changes of direction in the screen itself would break up the photographic reality of the projected film. The screen surface need not be static but could change as the film progresses—could even protrude considerably in places casting shadows on the surrounding areas. Anything in the visible world chosen as a subject would then be transformed by the movements in the screen itself.[4]

While he was pursuing these intriguing possibilities in his journal, Bates was painting until two and three o'clock in the morning. For a major one-man show at the Calgary Allied Arts Centre, he assembled thirty-one large oils, all of them executed since his return from Europe and twenty-five of them completed in 1960. The paintings represented three aspects of his work—figurative, tachiste and the facet experiments. Though the exhibition was impressive, only one reviewer ventured to comment on the non-objective works. Astrid Twardowski likened the tachiste works to "seeing life through a coarsely woven raffia screen"; and related the facet paintings to "Synchronism where the artist takes pure color and sets up a rhythmic design." She felt, however, that Bates had done himself a disservice "by putting himself within the harsh and rigid boundaries of geometrical abstractionism."[5] Respectful puzzlement characterized the general reaction to the non-objective works.

Bates sent *West Indian Puppets* and his 1961 painting *Puppet Clowns*[6] to the Canadian Group of Painters' Exhibition in Vancouver. The three mustachioed figures in *Puppet Clowns* call to mind the clowns Max enjoyed at the Krone Circus in Munich. Under the elaborately patterned clothes is the unyielding wood of which they are made, and this stiffness reinforces the sturdy, uncomprehending patience of the waiting figures. **Beggars and Scarecrows**, a superb work also painted in 1961, shows three men backed up against a brick wall. Chance has brought these strongly differentiated characters together; like the scarecrows in the background, they wait. Ian Thom wrote of this piece, "Fixedly immobile, they have a disturbing sense of ennui, coupled with an inability to act. We have entered the world of Vladimir and Estragon,"[7] Beckett's famous characters in *Waiting for Godot*.

Bates also resumed his work with Snow on lithographs. *Cats and Birds* was printed in two versions—black and white, and in blue with brown. The disturbing aspect of *Two Dolls* was

heightened in a second version, to which Bates had added red. In Bates's landscapes of this period, as Nancy Townshend explained, "he briefly investigated naturalistic prairie light" and "reduced his palette to browns, white and blue."[8] These are the colours of his powerful *Northern Landscape*. The paint is slashed on in vigorous strokes and though the piece is almost completely abstract, one sees the blue of a northern lake against the snow with the trees in the background under a lowering sky. A streak of orange below the trees joins with the rust at the bottom of the picture to focus the eye on the blue of the water. Another painting, *Trees, South Calgary*, is totally different in mood, feminine and delicate, with the leaves of the aspens fluttering above the pale trunks. An entry in his journal reveals his intense enjoyment of the sight as he wrote:

> the small, bright green leaves against the blue sky seemed as beautiful as anything can be—I thought the ivory of the branches necessary to the effect. I wondered how my impression of this could be isolated and presented as completely as possible in an abstract or semi-abstract canvas. I don't know how—but, vaguely I could apprehend something better and *happier* than I had yet seen in paint.
> Why is it so difficult to make *joyous* art.[9]

The landscape *Grove of Trees*, which he sent to the 82nd Annual Royal Canadian Academy Exhibition in Montreal, shared the abstract quality of *Northern Landscape*. In his review of the exhibition, Robert Ayre singled out Bates's entry "with its rust coloured field, its fence of

Cats and Birds (1961). Lithograph, 35.5 × 50 cm. Photo by John Dean. Private collection.

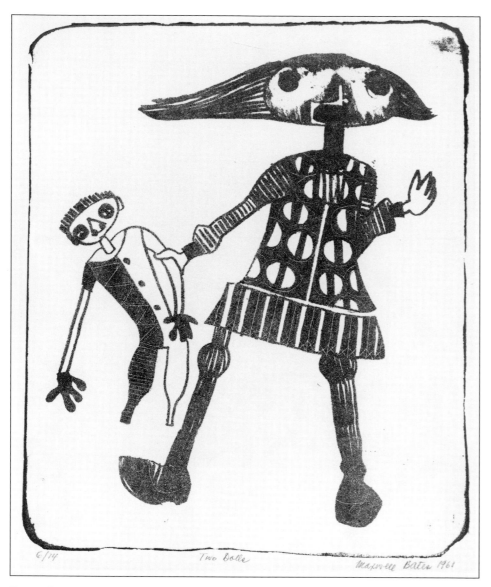

Two Dolls (1961). Lithograph, 30 × 25 cm. Photo by John Dean. Private collection.

trees and its narrow clouds … it has a quality that makes the pattern makers look perfunctory and uncouth."[10] Peter Daglish sent Max a clipping about the show and across the top he had written "Sum up the show in one word 'BANAL'."[11]

To celebrate a meeting of the Canada Council in September, the Calgary Allied Arts Council planned an exhibition of Alberta painters, all of them members of the Alberta Society of Artists. They asked Max to chair the jury, which was to consist of William Townsend of London, England, Colin Graham, director of the Victoria Art Gallery, and Professor Eric Dodd of the University of Calgary. Max seized this opportunity to reinforce his view that the members of the A.S.A. must adopt a professional attitude to their work and struggle to maintain a high standard. In the notice to members he wrote:

> In so far as the Canada Council is placing emphasis on professional standards in the arts, it is hoped that this exhibition will demonstrate that the A.S.A. is a major exhibiting society, and that its members are deserving of greater recognition.[12]

Out of 104 works submitted, the jury chose fifty-two, and the result, according to the *Albertan*'s reviewer, amply illustrated the benefit of a jury. It was, as she wrote, "a very fine show."[13]

Dorothy Cameron was planning a one-man show for Bates in 1962. In a letter to him in June of 1961, she told him not to be disheartened by the lack of sales in the previous year. "Toronto is a slow town to pick up an artist,"

she wrote, "and since you have not shown here to any great extent for so many years and are not known by the new crop of young curators, your position is virtually that of a new artist."[14] This explanation, though probably true, must have been galling for Max. He had received many awards in national exhibitions, had just been elected a fellow of the International Institute of Arts and Letters based in Switzerland, and had been made an Associate of the Royal Canadian Academy.[15]

As he had in the early fifties, Max was again reacting to the stark ambience of Calgary and the prairies. In an article with the quirky title "A private eye looks at a western," which he drafted at this time for possible publication in *Canadian Art*, he wrote:

> Perhaps the fanaticism that the great plains seem to encourage in politics and religion informs the visual arts also. Puritanism and a liking for austerity are regional effects that may characterize an abstract canvas at the same time they prevent many minds from encouraging art. To date some forty religious denominations and sects wax and wane but no "schools" of painting,—unless those artists who prosper from the sale of their postcard mountains with foreground water and fir trees form a "school." The creative painters are individualists.

He concluded on a somewhat less bitter note:

> No comparison can be made with the early days—say, the twenties. Primary interest in business, sport and religion and latent antagonism to the work of the intellect has shown signs of allowing some good-will and

respect to the creative individual working in the arts.[16]

He commented on these creative individuals in a letter about a second article for *Canadian Art*.[17] Paul Arthur, the magazine's managing editor, had asked Max to comment on five artists, and of the list submitted, Max chose Ronald Spickett, W.L. Stevenson, Illingworth Kerr, John H. Snow and Frank Palmer as artists who had worked in Alberta for many years. He wrote that Spickett was "perhaps closer to the avant-garde than any other painter in Alberta" and that he had done many fine drawings with a reed pen. Max maintained that the work of Stevenson, a self-taught artist who interpreted the foothill landscape in a "free and well-constructed style," had never been adequately appreciated. Bates characterized Kerr as a regional painter who "had made some of the most successful interpretations of prairie landscape ever achieved, often translating the prairie into contemporary idioms." Of John Snow he wrote that, largely self-taught, he was "one of the most personal painters on the Prairies ... in all his work, prints and paintings, he is an expressionist with great interest in color." Max thought that the vast prairie spaces gave man a kind of a pathos, and he saw that quality in the figures of Snow, "both in his lithography and in his expressionistic oils and watercolors."[18] He described Frank Palmer's "strong abstract framework" and his interest in "texture and subtle tonal quality." Max added additional paragraphs, commenting on the fine colour of the painter George Mihalcheon and mentioning the sculp-

ture of Luke Lindoe and Katie Ohe. He was convinced that Ohe was a sculptor who had a future, and time proved him right. He concluded his letter with the following comments:

> There are now very few painters doing good figurative work in the Province. Art students seem to believe that, if they are to become successful in exhibitions where figurative work no longer wins prizes, the future belongs to painters of abstractions. By no means all of the best painters believe this themselves, but those who still believe in figurative work are perhaps not the most influential.[19]

Bates's assessments, as ever, were sound, and his colleagues appreciated his critical abilities. But neither of these articles was published: they were displaced by a long article by Clement Greenberg, the noted (even notorious) New York art critic, who wrote about the art he had found in the prairie provinces.[20]

Max drafted another article, also unpublished, for *Canadian Art*. "The tough dollar: How the creative artist makes a living" begins with the pithy "The yellow pages don't list him" and continues in a bitter vein. The article is a condemnation of Canadian, if not North American, society for supporting "Kitsch" and fearing the truly creative artist who, as a consequence, must supplement his income with commercial art or teaching. If he is handled by a dealer, he must resist the pressure to increase the quantity of his work and "maintain continuation of the same kind of work which first brought sales." Max was especially critical of the church for failing artists and society:

> Our Christian churches and institutions appear materialistic to many artists because of their essentially anti-mystical nature, and their claims to a spiritual life which is merely humanitarian and co-operative rather than spiritual and which has no conception of spiritual insight, to whom Christian teaching is double-talk that does not take the teaching of the New Testament literally and seriously.

In spite of the fact that society resents him, the true artist must act "as the antennae of society, feeling its way into the future with all its as yet unknown changes...."[21]

For some time Max and Charlotte had been planning a move to Victoria. Max had many childhood memories of happy times spent there and of his mother's fondness for the city. He also wanted the stimulation of change, and he was attracted to the milder climate. With his damaged heart, Calgary winters had become increasingly difficult for him. In other ways, too, the time was right for a change. Max's two large architectural commissions were completed, and the income from his artistic work and his investments was now sufficient for them to make the move. In November 1961, Max and Charlotte chose a house in Saanich, outside Victoria, on Beaver Lake Road. But when they returned to Calgary before the end of the month, Max suffered a massive stroke. Their holiday in Europe had been more stimulating than restful and had come after his very strenuous three years of involvement with the cathedral. Since his return, Max had pushed himself to the limit, painting, writing and carrying on the architectural firm alone. He was constantly shipping

work to exhibitions and picture loans, making the crates himself, sometimes over 100 crates in one year, and smoking heavily. Charlotte had become increasingly apprehensive about her husband's health. Some time later she remarked to one excessively active young friend, "If you don't slow down, you'll be like Max."[22]

For weeks he lay in the Calgary General Hospital with Charlotte in constant attendance. Max began physiotherapy sessions at the hospital, and his left leg was fitted with a brace. His speech was affected to some degree, and he lost the use of his left arm. Once again fate seemed determined to crush him, but the excellent treatment and his own stubborn will restored him amazingly. When he came home, Charlotte began her long, devoted and understanding care of him. Cheerful and competent, she continued her role as secretary, took on some of the packing of his work, and even helped in the varnishing of his paintings. Max's accomplishments over the next fifteen productive years would not have been possible without her.

The one-man show at the Here and Now Gallery opened on 8 February 1962.[23] Cameron had written to tell Bates that Alan Jarvis, editor of *Canadian Art*, had been present at the unpacking and how impressed they had both been.[24] The show was not a commercial success, and Max wrote to Cameron: "I hope my show, though the results were disappointing, achieved the object of getting me better known in Toronto at least in part."[25] Her reply came as a blow to him. She explained that she had decided to broaden the focus of the gallery and limit the number of exhibitions of Canadian artists in favour of more international work. She added,

> In spite of my respect and admiration for your work, I have not, let's be frank, succeeded very well in creating public interest around it or selling it in Toronto. It is best for both of us to accept this situation and call a halt to our association at the end of this season.[26]

Max's work had been rejected before by a Montreal dealer who found it too "barbaric" for that market, and this second rejection from a reputable and knowledgeable dealer was hard for Bates to accept. His mood at this point can be guessed from his short poem:

LIFE WORK

> I am an artist, who, for forty years
> Has stood at the lake edge
> Throwing stones in the lake.
> Sometimes, very faintly,
> I hear a splash.[27]

Later that year Max's work received considerable exposure in an exhibition at the Stratford Festival, *Canada on Canvas*, featuring nine prairie artists. A photograph of him was published in the *London Evening Free Press* along with a reproduction of *Girl with Black Hair*, one of the five oils he had sent. According to the reviewer another of Max's paintings, *Autumn*, had

> The essence of a Canadian fall caught in the meshes of paint. ... Bates is a master of subtlety and of tonal richness in this exhibit

which provokes a viewer to demand far more of his work in order to study it and know this complex person called Maxwell Bates.[28]

Despite this compensating praise from the otherwise unreceptive East, Max and Charlotte had other matters on their mind, such as the move to their Beaver Lake home. By spring Max was well enough to travel to their house on the island. Charlotte remembers the trip as a "dreadful experience," four days getting Max—now using a cane but still unsteady— safely into and out of motels, and attending to Spike and his portable sand box.[29] The house was on a large rocky lot with fruit trees, and Charlotte looked forward to gardening. They planned the studio in the garage and had the driveway black-topped so that Max could make his way there safely. The garage, however, remained full of boxes of books until well into the summer.[30] In a letter to Jack Turner, who continued to represent Max in Calgary, Max said they missed their friends but had no regrets about moving to Victoria.[31]

That summer's letters to Turner reveal Max's anxiety about sales in Victoria; he had found no dealer and felt that sales there would be limited, if he were fortunate enough to sell anything at all. Turner was in the process of moving his gallery to a new location on Seventeenth Avenue and wanted to open it with a one-man show of Max's paintings and prints. "Please don't hesitate to alter prices of my work a bit if you can thereby get a sale," Max wrote to Turner. "My expenses have been rather high so I should be happy to sell some work and prospects seem dim here."[32] Twelve

of the forty-one works sold immediately and more went later, including the most highly priced one, the superb ***Two Men with a Bird***.[33] Joyce Zemans reviewed the show for *Canadian Art*, beginning with the statement that Bates "had come a long way since 1948," a somewhat strange remark considering that he had been a well-established artist in England. She wrote of the "conglomeration of artistic styles" and was doubtful about many of his figurative works. She found that

> Bates' real talent lies in his skill as a Western Canadian landscape artist. This is made poignantly evident in his attempts to render European landscapes. ... The figures in the "Tuileries Gardens" look like visiting Canadian school girls. And even the "View of Florence," bathed in the all-too-literary "warm glow of the Italian sun" could be almost any Canadian cityscape. ... But it is his "Northern Landscape," an almost abstract spatial composition of tonal values, which so characterizes the total starkness and frigidity of the Canadian North, that is in my opinion Bates' best work on display.[34]

Zemans seemed insistent on submerging Max into eastern stereotypes of western painters.

Zemans's article was illustrated with *Picnic*, an example of subject matter which, as Townshend later noted, Bates painted throughout his career, "large figures in a landscape setting.... Bates presented these workers of the land benignly," Townshend wrote, "as universals."[35] In *Picnic* the workman in his overalls relaxes with his wife and child in a quiet wooded area. The dark green, blue and black, relieved by soft pink, contribute to the

feeling of seclusion and peace in the painting. In another work, *Potato Pickers*, the blue-clad figures bend to the land under a Chinook arch. In these testimonies to the dignity of physical work, Townshend continued, there are overtones of Van Gogh and Millet.[36]

Max asked John Turner to show his work to Clement Greenberg, who was touring the West in order to write about what he found for *Canadian Art*.[37] Greenberg visited Canadian Art Galleries and saw the large exhibition of Max's work. While he praised John Turner's gallery in his article—the same article that was published in place of Max's two essays—he said little about Max's work. However, a reproduction of *Northern Landscape* did accompany the piece.[38] Tired from the move, frustrated with his physical limitations, and still smarting from his rejection in Toronto, Max became a bit testy about galleries and museum directors in general. He wrote Snow about lithographs they had sent to a gallery in Toronto which had subsequently gone broke without paying the artists. He was also upset that William Townsend, who had come to Victoria to make a selection for the next Biennial, had rejected his two submissions. However, he ended the letter on a positive note: "There are 15 good artists here now, at least. I only wish we had 15 good collectors."[39]

Two poems written at this time reflect his feelings:

CRITIC

The critic saunters on the exhibition floor
Late, after lunching with an editor of Vogue.
This guy is nothing, such work was done
In 1910, why repeat it now—absurd.

Now, this is elegant, a picket fence in marble
No one's done before—and this
A masterpiece,
Exact replica of a ten foot turd.[40]

AN INTERNATIONAL CONFERENCE OF THE ARTS

If some Foundation will supply the money
He goes and sits and farts
In an International Conference of the Arts,
And talks a lot of balls
To those imprisoned in the stalls.
To talk sense is unnecessary;
Who does?
It's obscure crap that goes,
Implying how much one does for art.
Looks as if he's on his toes
At a cocktail party
Or exhibition opening.
Becomes horribly knowing
In mentioning something
That no-one has heard.
Oozing false modesty
Like a cracked sewer.[41]

"I've always been rather ambitious in painting, you know," Max confessed. "I used to read so much about the Renaissance artists who were always such rivals—so ambitious ... they were all trying to get ahead of each other in Florence and Rome."[42] He believed competition made for better art and knew that he should have competed in New York or Paris, yet he had chosen to retreat to an island. Certainly he now enjoyed the special qualities that life on an island could offer. Victoria was quieter, less aggressive than Calgary; the university was relatively small and more involved with the community; and Victoria's buildings were

constructed on a human scale. Though he had made his decision to live in Victoria when he was in relatively good health, his illness now made it an even more fortunate choice.

Old friends from Calgary were already settled in Victoria. Jane and Ken Seaborne had been members of Lettie and Henry Hill's circle, and Ken had studied under Jock Macdonald. Virginia Harrop, daughter of the manager of the Alberta Hotel which was designed by Bates, Sr., had known Max since childhood and called him "Maxie." An accomplished artist, she exhibited frequently under the name "Lewis" with such artists as Alistair Bell and Molly and Bruno Bobak.[43] Long-time friends Laurie and Dorothy Wright also moved to Victoria, and the Bateses often played cards with them on the weekend. Friends from Calgary—Roy Stevenson, the Snows, Janet Mitchell or the Turners—made welcome visits. Max was also in constant correspondence with Turner, who continued to purchase materials for him and act as his agent in Calgary.

The artistic community in Victoria knew of his work and welcomed him as something of an elder statesman. The *Victoria Daily Times* greeted him with a short account of his life and career and concluded with the paragraph, "To have an artist of such calibre become a resident of this city is certainly our gain, and, as well as a hearty welcome, we wish Mr. Bates all success on his coming exhibits."[44] The published portrait showed him sitting in front of his easel. Colin Graham, director of the Art Gallery of Greater Victoria, contacted them almost immediately and offered Max a show at the gallery for November.[45] Donald

Harvey, who was teaching at the University of Victoria, was also familiar with Max's work. He had come to Canada from England in 1958, and as executive secretary to the Saskatchewan Arts Board, he had met Max and seen his retrospective at the Norman Mackenzie Art Gallery. As so many did, Harvey found Max taciturn and thought that he saw the world in a harsh light. It was also clear to Harvey that Max could not suffer fools gladly. He was impressed at the range of Max's reading and especially his grasp of new developments.[46] Roy Kiyooka, now teaching at the Vancouver School of Art, lost no time in calling on Max and Charlotte when he visited the island.[47]

Another early visitor was Rita Morris, a widow who had emigrated from England, where she had studied at the St. Martin's School of Art.[48] She later became a good friend of Max and Charlotte, and her son, Michael, an aspiring artist, was also a frequent visitor to the Bates home. "We shared a great love of books, journals, catalogues, essays, etc.," Michael wrote.

> He subscribed to many and I was always picking up new things on my travels. These afternoons followed a pattern. I'd arrive about 1 o'clock. Max and I would compare notes and talk till Charlotte would decide it was time for tea and then we would go to the studio and dissect the paintings and drawings until the sun was over the yardarm![49]

The Morrises introduced Max to Flemming Jorgensen, who had come to Canada from Denmark in 1958. Being familiar with German expressionism, Jorgensen was responsive to Max's work, but, as he said, "To get to know

Max himself was a different matter."[50] Later acquaintances in the community included artists Richard Ciccimarra, Herbert Siebner, Nita Forrest and sculptors, Elza Mayhew and Robert de Castro.

Their life settled into a pleasant routine. Max read in the early mornings, worked in his studio, or watched the life of the garden from his window. "I should like to be friendly with a gull standing on a decrepit pergola," he wrote.

> I look at it from my chair in the kitchen. The bird is wary and I don't blame it but I should be a good friend given a chance. The wind is fraying out breast feathers, very light against the dark green fir trees behind, tall and grave to the edge of my world here.[51]

In the afternoons they went driving, often stopping at Ivy's Book Shop in Oak Bay where Max browsed, chatted with other customers, and enjoyed the tea—sometimes wine or saki—served by the shop's owners, Ivy Michelson and Ada Severson.[52]

Max made an effort to get back to painting in his studio. Having only the use of his right arm and hand, he had to use his teeth to unscrew the tubes of paint. Stimulated by his new surroundings, he was painting landscapes of what he saw on his daily drives with Charlotte. One of these, **Mountains—Vancouver Island**, Ian Thom described as "A work of breadth and depth, it has a sureness of handling, a rigorous composition and a vitality which belies any suggestion of weakness."[53] For **Landscape Near Victoria**, Bates chose another aspect of the scenery, the semi-rural surroundings of the city. Max's show of fifty-

two works in a variety of media at the Art Gallery of Greater Victoria hung there for a month and introduced his work to a new public. Max also welcomed the invitation to mount a show of lithographs at the Parliament buildings, a show so successful they asked him to leave it another month.[54] As Richard Ciccimarra wrote in the *Victoria Daily Times*, the show was

> A wonderful small collection, which, apart from its excellence, is made particularly interesting by its almost exclusive preoccupation with the human figure—unfortunately a rarity these days.[55]

After Townsend rejected his submissions for the Fifth Biennial, Max was particularly pleased when J. Russell Harper, who was making the final arrangements for the exhibition, asked him to submit two oils.[56] The show was also exhibited in London, England, and after it was dispersed, the National Gallery purchased, Max's *Facets Eleven*.[57] To the exhibition Canada on Canvas at the Stratford Festival arranged by Alan Jarvis, Bates sent his *Northern Landscape*.[58] In addition to these exhibitions, he submitted to numerous group shows with other artists in the Pacific Northwest.[59]

Max had been given a more effective medication, and John Snow noticed the improvement in his letters. That he was fully recovered in spirit was signalled by his article published in the *Victoria Daily Times* under the provocative headline, "Fort Street's thunderbird mural is a turkey." There Max was in fighting trim, blasting amateur artists who resented criti-

cism, castigating public bodies responsible for mounting an inferior mural, and sharply rebuking the designer of the mural. "The mural itself," he chastized, "is a work that is hackneyed and full of cliches—where all is decorative, except the decoration."[60]

He also entered the fray over the design of a new Canadian flag, submitting his own design. "Several years ago I became convinced that Canada should have a flag of her own," he wrote. "At once the maple leaf came to my mind as the most immediate and well-known symbol of Canada." He felt that the three countries most involved in the history of Canada—Great Britain, France and the United States—should be represented by the colours red, white and blue, which would provide a valuable link with the past. In a second entry, he incorporated "a green maple leaf on a parti-coloured red and blue field. In this flag, the green reflects the comparative youth of Canada which is still in her springtime. ... In addition green symbolizes eternal life."[61] The designs were submitted to a special, all-party committee of the House of Commons, which spurned the artists' designs and, predictably, chose one that was safe, simple, and dull.[62]

Max continued his note-taking, sometimes making lists of words—"serenata, toccatina, maranatha, cloaca, vertebrata, errata."—which could be composed into a nonsense rhyme such as this one:

> Invited to a party—
> Bring your own inamorata hearty
> I forgot my errata
> Listening to a serenata.

He copied out "Song of the Crabs" twice,

> If we go forward we die
> If we go backward we die
> Let us go sideways and live.

and to the last line he added the note, "Most people."[63]

Some notes suggest plans for future use; often they were about books he was reading. "I am under the impression," he wrote, "that if Henry Miller leaves a note for his milkman the contents will one day be published." He also copied passages that had particular meaning for him.[64] For example: "The bourgeois mind is really the inability to rise above the absolute reality of time and space" (Kierkegaard) and "The fairest thing we can experience is the mysterious. It is the fundamental emotion that stands as the cradle of true art and true science. He who knows it not can no longer wonder, no longer feel amazement and is as good as dead, a snuffed out candle"[65] (Einstein). Interspersed with these are lies own reflections, among them "Mysticism which lays stress on the personal experience of God, direct contact with the creative spirit is what we call open religion." and "The best gift the gods have given me is that of finding myself interesting."[66]

Although he professed to feel well, in the late spring and summer of 1963, Bates produced a number of works whose intensity seems to have been fuelled by suffering and physical frustration. The figure hanging on the cross in *Crucifixion* is no longer a scarecrow but a human who bears a resemblance to Max himself. The eye he trained on his subjects was

a compassionate one. More and more, he was incorporating into his work not only human suffering and corruption but also the vitality and colour that are associated with it. In the *Girls at the Cafe Congo* the women wait stoically, while through the window the virginal moon, cool in the night sky, mocks their role and bizarre finery. Their fractured faces and the raw power of the work remind one immediately of Picasso's *Demoiselles d'Avignon*.

The figure in *Interior with Boy*, a work in oil and collage also painted at this time, carries nightmarish overtones. Bates has exaggerated the large, open eyes, the curled hair, and the splayed hand on the table, so that the boy becomes subtly menacing. The awareness of some indefinable menace had been with Bates since childhood. The same sense of menace is present in the figure of *The Beggar King*, with the glass of his spectacles obscuring one eye, while the other is startling in its intensity. The image evokes the nurse's broken eyeglass in Sergei Eisenstein's film masterpiece *Battleship Potemkin* and carries the overtones of violence. In this painting Bates again exploits his ability to create brilliant pattern without obscuring the force of the work. The symbolic figure of the beggar king is an expression of Bates's obsession with polarity. "You see, I've always been interested in contrasts, complete opposites," he said. "It seems to me that the beggar and the king are complete opposites. I've put them together, into one being."[67] In *Workmen*, another of his familiar subjects, Bates shows the five men, one Oriental, sitting apparently relaxed, but the overtones are not comfortable. Once again he used a device which increases

the ambiguity and extends the emotional range of the work. In *Girls at the Cafe Congo*, it was the moon at the edge of the picture; in *Workmen*, it is the back view of a waiting girl tucked in at the extreme right of the canvas. "Visual pathos," he wrote in a note, "(is) for me most often found in children, especially young girls, and in women. Very often viewed from their backs. Very often their hair, its disarrangement or disposition."[68]

Bates showed some of these new works at Ego Interiors, an interior decorator's establishment on Fort Street in Victoria. The shop sent out a striking notice of the show with a clown-like impression of Max's face in taupe on a black background.[69] Because their space could not take the full exhibition of twenty-seven paintings, it was arranged in two parts, figurative work and non-objective paintings. This division resulted in the headline "Nothing unusual about a two-way artist," under which the reporter wrote:

He still paints despite his illness, which forces him to use a cane. But in his brush there is tremendous virility which shows in the strong lines and expressions of his figurative characters and in the powerful design and color of his non-figurative work.[70]

The excellent picture of Max with his heavy brows and cigarette in his mouth shows him seated before a painting of workmen, *The Carpenters*.

Girls at the Cafe Congo (1963). Oil on canvas, 91.4 × 121.5 cm. Photo from Maxwell Bates fonds, Special Collections, University of Calgary Libraries.

Moncrieff Williamson, subsequently director of the Confederation Centre, Prince Edward Island, wrote at length about Max's work in that exhibition. His review provided an insightful and comprehensive account of what he saw as Bates's place in Canadian culture. He stressed that Bates's work demanded repeated viewing to get at its "hidden communication," As he explained:

> I think, perhaps, that this hidden communication is a quality which underlies the majority of prints and paintings by Maxwell Bates and which is why he has climbed to an almost incontestable position from a critic's viewpoint. ... Mr. Bates is himself a very complicated and dynamic personality. Poet, visionary, painter, lithographer and finally, an accomplished writer and architect. In his complicated way undoubtedly he is one of the most prominent and significant of living Canadians. ... As a colourist, Bates is a wizard. With almost slapdash casualness he works magic with colour, often discordant or unsettling within a given area, yet the total effect is just as it should be, neither overworked nor understated. In his recent works completed this summer there is a new liquid quality which somehow frees his painting of those tight, almost rigid forms which in some earlier canvases were both distracting and disturbing.[71]

A photograph of Max taken by Karl Spreitz, painter, photographer and filmmaker, accompanied another feature article in the *Victoria Daily Colonist*.[72] Spreitz had studied with Herbert Siebner, the painter and printmaker,[73] and was one of the congenial cluster of Victoria artists. "We had something in common—expressionism," Siebner wrote of his friendship with Bates. "Max studied in New York under Max Beckmann and I at the Berlin Academy under the direction of Carl Hofer and other German expressionists; so we visited each other's studios and talked, also compared works. Also we both did many graphics and may have influenced each other."[74] Max found more enjoyment in the company of the cosmopolitan Victoria group than had been possible for him in Calgary, perhaps because of his heavy work load there. The new freedom Williamson had noted in Max's work carried over into his personal life, and though Max could still be intimidating, his illness had mellowed him and he talked more freely. Visiting in the late summer, the Snows found him relaxed and jovial. Max even flirted with a pretty waitress at the Empress Hotel Garden Terrace, an exchange which would have been impossible for him in previous years. It was as if his obvious disabilities released him from his constrained shyness, especially with women—and this release marked another beginning.

Full-Time Artist, 1963–66

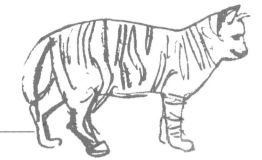

Encouraged by his friends, Max embarked on two important projects, his collection of poems, *Far-Away Flags*,[1] and his series of twenty-five monoprints, *Secrets of the Grand Hotel*.[2] He was assisted in the first project by Roy Kiyooka. Max rather dismissed the poems as unimportant, but Kiyooka assured him they were not the work of a mere hobbyist. He arranged the poems and produced a distinguished design for the book; Max paid for its publication in 1964 by Seymour Press of Vancouver.[3] The sixty-three poems, spanning fifty years and dedicated "with love" to Charlotte, provide a valuable insight into the deeper feelings that were only partially revealed in Max's prose and daily life.

The images of the *Secrets of the Grand Hotel* monoprints were inspired by his memories of the Bates family's trip to England in 1912.[4] These childhood impressions were still sharp, having been reinforced by the novels of Marcel Proust, Arnold Bennett and Vicki Baum, and Max speculated that his pleasure at living in Victoria may have helped to "bring memories to fruition."[5] To these vivid memories was added the fresh material of his recent trip.

"Some hotels are small, others large like the Château Frontenac in Quebec. A large one in Montreal where lived friends of my parents. Hotels in London and Liverpool and south coast resorts such as Eastbourne." In all hotels I was fascinated by the views from windows." To Max, hotels were the "crossways of the world with every kind of person represented, the great lady and the demi-mondaine—the friend of the family or the hustler in the lobby." He brought into his prints this multiplicity of figures, all of them playing their parts in the "strange dramas going on that you know nothing about. Like an infinite number of novels."[6] In his notes he paid tribute to his friend the painter Michael Morris, "without whose approval the series might not have been completed."[7]

Six of the monoprints have some colour, and there is a great variety of textures, for which Max frequently used plastic doilies or lace. In *Myself at the Window* both the interior and exterior of the hotel are shown behind the small figure in the angled frame of the window. At the top of the picture, there is a faint drawing of a woman in a bath holding a scrub

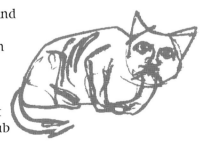

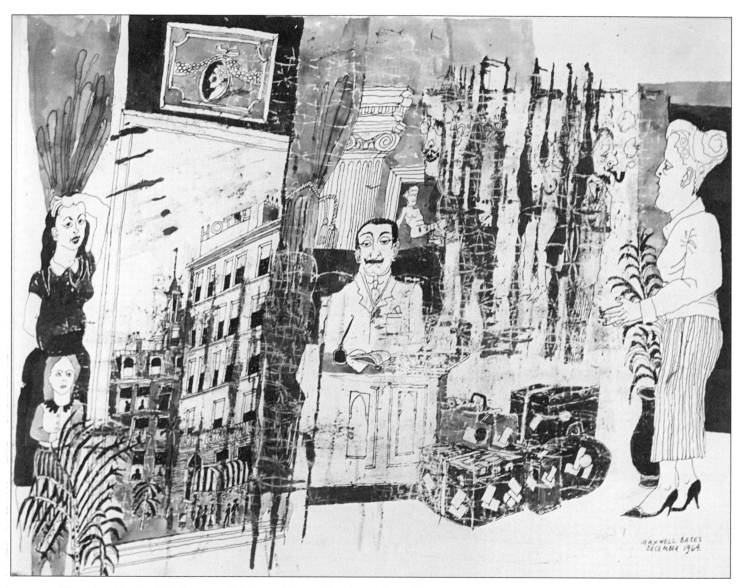

Luggage of Departing Guests (1964). Monoprint, 50 × 42.5 cm. Photo from Maxwell Bates fonds, Special Collections, University of Calgary Libraries. Collection of the Vancouver Art Gallery.

brush, and looming over all is a bearded man. To the right is an elegant matron with a black busboy. The central figure in *Luggage of Departing Guests* is the floor manager of the hotel, "always a supercilious man at the desk, with a black moustache."[8] The luggage sits by the desk and a stylish woman is approaching him. To the right, hidden behind a pipe-smoking male figure, can just be seen a female nude; to the left of the picture, again through an angled window, is the outside of the hotel. This clever manipulation of interior and exterior is rather like the use of mirrors, so that one sees simultaneously, in another print, a girlish figure standing outside the hotel and uncertainly in the lobby. The sexual ambience of the hotel is conveyed in another print in which a demi-mondaine stands smoking a cigarette with her back to the shadows, where the blue face of a rather menacing male figure can be seen. Max has again drawn himself in *Art Nouveau Reception*, this time seated in a chair with his cane. It is a work that foreshadows his later "cocktail parties," with their self-conscious participants in a social charade. The "strong considered forms, together with brilliant drawing and a compassion for humanity"[9] make the *Hotel* series endlessly fascinating.

In addition to working on the monoprints for the *Secrets of the Grand Hotel* series, Bates produced two other notable works on paper at this time, *Untitled* and *Duchess of Aquitaine*. In the first, Max used to the full his ability to manipulate shapes, colours and textures. The multicoloured image with its suggestion of a crowned head explodes on a bright green, lacy background. The **Duchess of Aquitaine** is an unforgettable work, puzzling in its detail and implications. Three figures with decayed faces and costumed in motley attend the yellow-haired duchess, whose features are coarse and her breasts protuberant. The foreground of the scene is full of strange growth, with spiky flowers and plants like crosses, and in the background can be seen towers and mansions. "The enormously busy surface is kept under control by constant shifts of form and colour," writes Ian Thom. "In the midst of this sea of pattern are the duchess and three attendants. They stand like the giant heads of Easter Island—awesome, immovable, mysterious."[10] The impulse behind Max's poem is just as mysterious:

GOD BLESS THE QUEEN OF AQUITAINE

God bless the Queen of Aquitaine
With fifteen dead-men in her train.
She cursed the slain;
Their corses piled in caves in Spain.

In all the bed-sheets I have lain
There is a stain
She cried:
They cry aloud unto the skies
And in the hollows of the stratosphere.
But never mind;
For we shall see the times unwind
And God is kind,
And notices my tears and pain.
God bless the Queen of Aquitaine.

With painted face, and heart of stone;
Hell will be to be alone;
To watch the Autumn mist and flying crane

The Gamblers (1952). Oil on canvas, 59.5 × 49.5 cm. Photo from Maxwell Bates fonds, Special Collections, University of Calgary Libraries. Collection of the Canada Council Art Bank.

On an island in the Spanish Main.
A Japanese intellectual hangs about:
Why should he shout,—and what about?
God bless the Queen of Aquitaine.[11]

Bates sent another striking and puzzling work, *The Gamblers*, painted over ten years earlier, to the 1964 exhibition, *Surrealism in Canadian Painting*, which was mounted by the London Public Library and Art Museum in London, Ontario.[12] At the base of the *Gamblers*, a man sits shaking the dice in a mean, dark room, oblivious to his surroundings. Above him, as though framed in a window, is a large painting of a glorious young woman, naked to the waist with long yellow hair. She dominates like a goddess, Diana striding along under her crescent moon. The dreamlike quality of the scene is reinforced by the night sky with flat clouds seen through one window, while through another is a daylight landscape. Though elements of the surreal occasionally appeared in Max's work, in *Gamblers* they are dominant.

During these years Max resumed work on his proposed book, "Vermicelli." His manuscript had been lost in the move from Calgary, and he tried to gather it together from his notes and memory. He drafted a "Foreword":

Too many years ago, it occurred to me to write a kind of book that I should like to read; not that there are not many such in existence already, but I come across these too seldom. ... Anyway, I began to keep scraps of notes towards writing such a work.

In any art I like what is foreign, what is far-removed; even to what is odd and bizarre.

This is a quirk (or fault) of my personality; going back to the genetic pattern of my ancestry. But it may explain (in part) my reluctance to pursue a single line of enquiry (like Morandi painting bottles, Samuel Beckett describing the contents of a beggar's pockets.) Rather, I am first exploring Africa with Speke; then raking the remains of Troy; or combing the hair of a Spartan woman. People will say all this is the result of lack of discipline; what people say has never disturbed me in a disturbing world. I am moved by the opinion of my peers when I find them; by no means often.[13]

"Vermicelli" is a compilation, a repository of his ideas, stories, fables, dramas: a collection which he termed "a Vaudeville in the Rococo style. Rococo because it may turn out to be a little over-decorated."[14] He planned to include the stories he had already written, poems, the descriptive accounts of Guernsey and Corsica, and some ironic fables. He wrote a curious chamber play reminiscent of Bernard Shaw's *Don Juan in Hell*. Queen Victoria, Julius Caesar, Brutus and Pizarro settle down for a picnic in the cool winter of Hell. Their conversation is punctuated by the cry of a crow and seriously interrupted when Caesar is called to a seance. Queen Victoria objects, as she feels it is beneath the dignity of royalty to oblige such gatherings. The conversation continues and ends with Pizarro, the man of action, throwing an orange at the crow.[15]

Interspersed with the prose in "Vermicelli" are short squibs such as,

> Love is a two-way street.
> Don't make U-turns so often!

and

> Where are the snows of yesteryear?
> I don't know, and I hope I never see
> the stuff again.[16]

On the back of catalogues he scribbled words and phrases such as "enjoy the romantic thighways," "lonely in the dipsomaniac night," or "couldn't show his film because he had no commercials." "See Sin without Sin at the Art Gallery" is a typical mixture of what Max was putting into "Vermicelli." He began with

> The grey gull no longer pays us a visit in the early mornings,—I don't expect to see it again until the winter months. However, pheasants still strut around, scratching for wheat. They are cocks and present a minor mystery,—they lack the brilliant white collars I have become used to seeing. Perhaps they are moulting.[17]

He then digressed into a discussion of architecture and a short complaint about being asked to explain paintings in a gallery:

> This was never satisfactory to either party. Most annoying to me was a woman who repeated my answers to her questions in a stentorian and penetrating voice that could be heard in every storage cupboard and lavatory of the Art Centre. I know this because a friend came up to me after one of these encounters. She had used the lavatory. That was rather good, she said, especially about having to dismiss all one knows of Euclidean Geometry from one's mind before one can understand Modern Art. It figures, of course,—I should make a note of it.[18]

grey gull who comes every morning and requires ¼ loaf. He has a mean eye.

Also included in the "Vermicelli" file is an analysis of pathos:

> It is now some days since the grey gull favoured us with his appearance. Winter is not yet here, so we can enjoy the melancholy beauty of autumn. This morning for instance, is mild and miserable.
>
> The anatomy of pathos is very complicated and, to me, just as interesting. This morning, in the early half-light, I saw our cat making his way slowly through long, dry grass and uneven ground in the field about one hundred and fifty yards away. His small figure had the essence of pathos. Really he is a large cat, but distance made him seem very small. At once I wondered how important is size to pathos; and whether the infinitely lesser quality of cuteness is involved. It would be interesting to speculate on the aesthetic quality of cuteness, which is prominent in North American values in my life-time. An elephant, or a rhinoceros would have no pathos if it stood in our drive-way; in the distance, I don't know. I think it might if it were a close friend like our cat but, in general, pathos is hard to associate with these enormous creatures. ... Old age is not conducive; but extreme youth often is; as with foals, lambs, calves, etc.,—helplessness being the lead into pathos. As for cuteness; I suppose a future Gibbon will trace this maggot of North American civilization. In my time I have heard it used to describe Kewpie dolls and dirty jokes."[19]

On the same page Max rails against what he has termed "HEMANISM," which he found to be prevalent in Calgary, the booming "oil capital." As he explained,

> This horrible symptom of disease; this chancre of American mores comes to light in the vogue for the tough guy; in the hatred of intellectualism and creative sensibility. ... Both hemanism and machismo are sexual complexes. I wish Dr. Freud had visited America for long enough to discover these vile and brutal neuroses and dissected them. ... Of course, Fascism involves hemanism, so perhaps he does mention it somewhere. ... I have been plagued by this two-fisted, he-man outlook for most of my North American life. However, since I have lived on the west coast I have been spared.[20]

The section concludes with another glimpse of the grey gull: "The grey gull has become a daily morning visitor again. ... I find its appearance reassuring,—an indication of an orderly universe that can be depended upon in certain small instances."[21]

Though much of "Vermicelli" was typed out, it was never properly edited. Circumstances prevented Bates from bringing the elements of this work together. They remain in two large

files labelled "Vermicelli" in the Special Collections of the MacKimmie Library, University of Calgary. In January, with the winter half over, the snowdrops up, and the tulips and daffodils showing, Max was already looking forward to spring and the deafening noise of the frogs.[22] He maintained his correspondence with Turner and also wrote to J. Russell Harper, who had just left his post at the National Gallery. Helped by Max's notes on western art, Harper was preparing his book, *Painting in Canada*.[23] He visited Max and Charlotte at the beginning of 1964 and in his letter thanking them wrote, "I was much impressed with your latest paintings of the figures—a type of solidity, vigour and colour that I like very much." He asked Bates to send the negatives of photographs that had been made of his paintings so that prints could be made and deposited in the recently organized "Archives of Canadian Art at the McCord Museum, McGill University." He also asked for Jock Macdonald's letters, which Max sent to him.[24] Harper was enthusiastic about Max's work. After seeing the contemporary British show at the National Gallery, he wrote to Max:

> I felt that it really does not stack up with what Canadians are doing. Your last two paintings which I saw in Victoria are much more exciting and significant than almost anything there—and I can say this without pouring it on.[25]

It is likely that Harper was referring to *Girls at the Cafe Congo*, which he mentioned in *Painting in Canada*.[26]

Harper's support must have cheered Max for he was disappointed that there had been no sales from the Ego Interiors exhibition. Moreover, he complained in a letter to John Snow, "we had nothing to drink at the opening. There seems to be general agreement wine or sherry is unnecessary, although before my show it was always a must."[27] In the meantime he and Snow were working on a joint show that was booked for March at the New Design Gallery. Snow intended to send a number of abstract works in liquitex on paper, mounted on masonite, and he thought that it might be a good idea for Max to include some of his abstract paintings.[28] On the back of his return letter, Max drew a picture of the grey gull "who comes every morning and requires 1/4 loaf. He has a mean eye."[29] They showed fifteen works each, paintings and lithographs.

During his visit to Vancouver for the show opening, Max saw an exhibition of Persian and Indian miniatures at the Vancouver Art Gallery.[30] This exhibition of paintings which were "both very skillfull and small in scale" prompted him to reflect that:

> Small scale did not prevent these artists from using the myths, religion and life of their time as subjects very successfully and with meaning. I can find no reason why, given sufficient competence, painters of today cannot produce successful and significant work on a small scale. In my own case it is a practical necessity to paint small paintings. Storage, shipping, packing and expensive materials make it necessary. Neither do I find any reason why the contemporary world cannot be adequately dealt with on a small

scale. An artist who shies away because considerable skill is required is not an artist who should command respect.[31]

Though Max had once remarked that he would have liked to paint large paintings,[32] he resisted the trend of seeking significance by means of large dimensions.

In this mid-sixties period, Max and Charlotte made new friends and became re-acquainted with an old one, P.K. Page. She and her husband, Arthur Irwin, settled in Victoria at the conclusion of Irwin's diplomatic service, during which he represented Canada in various countries. Irwin became publisher of the *Victoria Daily Times*.[33] P.K. later remembered her first meeting with Max after many years. "He was a travesty of his former self," she wrote.

> Locked into an iron support, he moved with what appeared to be excruciating difficulty. It was as if his body was a cage. His square, always determined-looking face was twisted into a grimace of even fiercer determination. But looking out of it, his eyes seemed more alive than the eyes of anyone I had ever seen. They reminded me of the eyes of a fox I had once stared into at short range—alert and fiercely innocent—taking everything in. Knowing it all.

Max sometimes went to visit his sympathetic friend from the past, P.K's mother Rose, who was now in a nursing home.

> Max would occasionally visit her, thumping down the hall to her room with his brace and stick—elderly, more the age of a brother than the son of a friend. They didn't have a great

deal to say to each other—Max was always inclined to monosyllables and Mother said little more than "Dear Max!" Sometimes I looked on, and as I remembered all the occasions on which I had seen them together, their joint presence conjured up for me the Bateses' living room in Calgary—but seen now as if at the end of a long tunnel—very small, and very brilliant, and about the size of a stamp.[34]

Another who sought Max out at this time was Pat Martin-Bates, a Maritimer and accomplished printmaker who had long admired Max's work and had become increasingly curious about him, in part because of their shared surname. A.Y. Jackson jokingly would ask her, "How is your uncle Maxwell?" She felt "subconsciously she was trying to catch up with Max," and when she finally met him, he too joked about their name. The Bateses picked her up on the university campus as she was hitching a ride home, and Max said, "So you're the one winning all these prizes. The papers have been chasing me." Martin-Bates explained that "Because of the similarity of names, Max sort of got it into his head that we were in some way related." She felt Max believed in "a sort of eternal pattern. Things were meant to be and he used to talk about re-incarnations—sort of half joking that we had been together in a past life."[35] Possibly Max also mused on the coincidence that his first wife, May, had the same name as his mother and that Charlotte bore the name of his grandmother.

Max's connections with the university through Don Harvey and Martin-Bates led to a

show of his work in the student union building in January of 1964.[36] Max had met Robin Skelton, chairman of the Department of Creative Writing at the university and editor of *The Malahat Review*. A poet and occasional art critic, Skelton practised witchcraft, which Max found to be an interesting element in their friendship. Max also met Myfanwy Spencer Pavelic, whom he considered the finest portrait painter in Canada.[37] She painted several perceptive portraits of Max and one of Charlotte. Some of these were sketched in Max's studio, where she watched him paint.[38] On occasion P.K. Page also watched him work, and as she wrote in a 1988 article:

> he was painting—slashing away with his good arm—great paintings, intricate drawings, landscapes, people, patterns, self-portraits. He was, perhaps, in his best period. It was as if by overcoming seemingly insuperable physical difficulties he had been given a new energy. He was like a laser. And Charlotte, gentle, loving, Charlotte looked after him.[39]

Max was always interested in young people and indulgent with them. Michael Morris had introduced him to Eric Metcalfe, who took to visiting the Bateses on Saturdays. At the time Max was at work on his *Grand Hotel Suite*, and Metcalfe was inspired to try some work in black and white. Max particularly admired his young friend's *Cafe*, offering to trade a painting for it, which gave him, Metcalfe recalls, "an enormous boost." Metcalfe found Bates to be "an incredible resource. He set me up with the basics. Max said very little but what he did say

was the essence." Through Max's influence Metcalfe received a scholarship to study art at the university.[40] Other students came to visit Max's studio—groups from Rita Morris's art gallery classes,[41] from Donald Harvey's classes at the university,[42] as well as students of Pat Martin-Bates. Although such sessions were tiring for him, he was responsive to the students; they, in turn, were impressed by him. Pat Martin-Bates felt she learned a great deal about teaching from Max—"not to say 'Don't do that' or 'This is wrong'... Max would say, 'You have a good sense of line' or 'You should look at....' He would point the way through for them—offer them pathways. He was encouraging. It was a very simple, sensitive approach."[43] Max's generosity also showed in his many recommendations for fellow artists to granting agencies and in his introductions for catalogues. Colin Graham summed up Max's generous spirit thus:

> He had a low level of tolerance for sham and insincerity. Yet ... there is no more generous-minded artist in Canada, nor one whose gruff exterior conceals a warmer heart. Anyone who serves with him on a jury soon finds him generous to a fault, especially if the artist judged is young and sincere."[44]

Because there was no commercial gallery in Victoria, Max must have been pleased to have his work taken up by Paul and Xisa Huang, who ran the Bau-Xi Gallery in Vancouver; in 1964 they mounted the first of his many one-man shows there.[45] His new work was also shown on the Western Canada Art Circuit and in Calgary, where it hung at the Alberta Col-

lege of Art. The latter show generated great interest, in part because many people were anxious to see what Bates was painting after his illness—and they were not disappointed. "We must be thankful we are still able to witness his work—" the *Calgary Herald* reviewer wrote, "the astonishing aspect is that, if anything, this bitterness seems to produce even more powerful expression."[46] Accompanying the article was a reproduction of *Crucifixion*. The show was received rather differently in Vernon, B.C., where it was hung in the Trinity United Church Hall. "There was a primitiveness about the work and one could almost recall similar pictures painted by children in school," read the review on the "Of Interest to Women" page in the *Vernon Daily News*. "Art teachers, escorting their charges through the show were hard put to explain the paintings, particularly since the artist had broken some of the rules being laid down to the children."[47] The review must have appealed to Max's wry humour, as he remembered his own experience teaching art to children.

What some saw as Max's "bitterness," others saw as courageous acceptance. "Maxwell Bates's contribution is challenging and disturbing," Robin Skelton wrote of Max's self-portrait of 1965, which was exhibited in the Canadian Group of Painters show that opened in Victoria in March.

> He has placed a self-portrait alongside an abstract composition made out of a thickly painted plastic table-mat and an impression made by the same mat. The portrait is painted with a distorting energy that seems partly self-flagellation and partly wry self-acceptance. The twisted body seems to mock all human pretension to beauty and dignity, but the lined face is filled with strength, and the eyes contain a vision. The abstract composition beside this figure seems to both reward and challenge it. The colors are as bold as the concept and the composition and the whole is passionately, absurdly, satirically, lyrically alive."[48]

The self-portrait is one of the works Ian Thom was referring to when he wrote that "Occasionally in an artist's life there is a period of exceptional productivity and exceptional success. For Bates this was 1965, the year was marked by a succession of works which reveal Bates at the height of his powers."[49] Thom continued:

> The *Self Portrait* of 1965 ... summarizes many of Bates' concerns in painting. His fondness for intense colour, direct application of paint, shallow space and a variety of texture are all used to advantage. ... Although the painting is satisfying from a formal point of view its power is in the emotional content. Bates represents himself as he is—a man of strength and character, a man not given to superciliousness. A man of compelling vision which is suggested by the rivetting eyes— eyes which fix one to the spot and yet not in a negative way but through a benevolent force of personality.[50]

In another painting from this period, *Parade in the Graveyard*, travelling gypsy fortune-tellers, cripples and acrobats with their caravan move through the crosses. The playing cards, the word "Fortune" on the side of the caravan, and the straggling group all mock human aspira-

tions in the face of the inevitable. "There is a sense of confusion in the drawing which the refinements of the watercolour and painting eliminate," Thom explained.

> Positions of figures change and greater rhythm joins each part. It is, however, the addition of colour which transforms the image. Once again Bates' strengths as a colourist are revealed, using tones which are heavily grayed and a series of close complementaries, he makes unworkable colours work. This is achieved partially through his sense of pattern (recurring stripes and polka-dots), partially through careful control of the compositional space and partially, through sheer audacity.[51]

In *Kindergarten* the colour is restrained to a sour combination of yellow and green with black. The children stand as if frozen, the boy with his arms upraised at the window and the girls facing the viewer. In this disturbing work, the sense of forcible confinement and sterility is emphasized by the teacher figure at the desk, a skeleton in motley. While his *A GoGo Girls* is a variation on the earlier *Girls at the Cafe Congo*, his first *Cocktail Party* marked a new source of subject matter. Max enjoyed such occasions, watching the wandering guests, their social restraints slipping; he represented them as "a lonely crowd," with, as Thom wrote, "their faces mask-like, the real face hidden.[52] The composition of **Still Life** of 1965 was unusual, even for Max. On the brown plank kitchen table he placed a bowl of red flowers, a feathery plant in a soft yellow pot, and a bowl of green fruit. Sitting by the table is a strange little figure, a girl with a green bow in her hair. Her red dress echoes the flowers and the yellow of the chair repeats the colour of the flower pot. The dark blue background is framed by patterned drapes. In spite of the disparate collection of objects, even to the shadowed waste paper container under the table, the composition with its superb colour is satisfying.

In this same productive period, Max expressed his puckish wit in a series of ink and wash drawings depicting artists at work. Salvador Dali, dapper in a suit and hat and with his famous moustache, paints a landscape; a fiery and heavily bearded Titian turns away from his raddled model with her elaborate hair and hanging breasts. At his feet is propped up a very modern looking painting of two figures.

Hand upraised, the solemn Ruskin is surrounded by beautifully organized decorative detail, bricks, columns, scrolls and arches. He has laid his book and pen on the head of a statue. *Nicolas Poussin Painting Venus* shows the artist with a dashing hat painting the breast of a heavy-eyed Venus. Her Cupid, perched on her shoulder, has a young man's head on a dwarf body.

Max also painted several landscapes of the Saanich area. He wrote John Turner that the landscape was similar to that painted by the Barbizon school, "but without rivers."[53] As that group had done, Bates painted small, intimate sections of the Saanich fields, meadows and trees. Townshend recalled that

> In 1965, Bates wrote, "I've decided to paint pictures that are simple, direct and complete landscapes"... he may have felt his land-

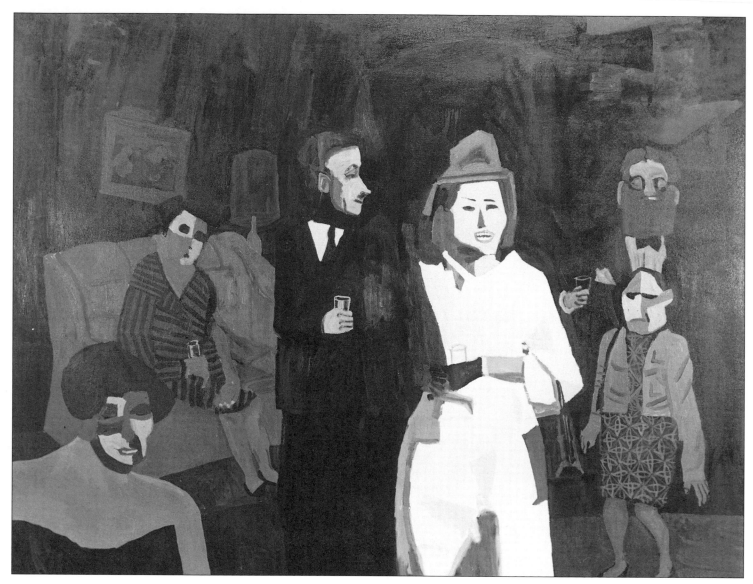

Cocktail Party #1 (1965). Oil on canvas, 106.7 × 152.5 cm. Photo from Maxwell Bates fonds, Special Collections, University of Calgary Libraries. Collection of the Art Gallery of Greater Victoria.

scapes of the last four years lacked "completeness." In an effort to regain this, he returned to his earlier concerns of simplicity and contrasts.[54]

Max achieved the simplicity and directness he wanted in *Landscape near Victoria #2*. The brown field is dominated by a leafy tree which fills half the picture space and on the horizon is a row of trees, green and brown against the bright blue of the sky. *Saanich Inlet* is one of Bates's few landscapes that features a body of water. The green of a tree and the deep brown of a wooden stanchion frame the sparkling water of the inlet with its pier and boats. In the background, the hills rising to the sky provide a unifying contrast to the liveliness of the water scene.

Several of these landscapes were sent to John Turner for a one-man show at Canadian Art Galleries in June of 1965, and Max was pleased with the sales. "A show was an excellent idea," he wrote to Turner. "Perhaps you will have more sales before it is over. I am doing a lot of work for some shows here. Then I shall paint more landscapes, etc., and I want to do a few more Paris street-scenes."[55] As it turned out, this was his last show with Turner, who soon sold the business. On hearing the news Max wrote to his friend:

> It was a shock to me that you are retiring and closing your gallery. You are the only dealer who can sell my work with any regularity. I shall have to depend on selling work to visitors to my studio, which will depend far too much on luck ... you have sold a considerable number of my paintings since you opened your gallery,—and I shall miss that.[56]

Titian Painting a Portrait (1964). Watercolour, 36.2 × 43 cm. Photo from Maxwell Bates fonds, Special Collections, University of Calgary Libraries.

Max's sales continued to be low in eastern Canada, in spite of constant exposure in picture loan collections and such large exhibitions and sales as those sponsored by the National Council of Jewish Women. Doris Pascal, who operated the successful Gallery Pascal in Toronto, had arranged a two-man show for Max and J.N. Hardman. Bates sent sixteen works in ink and wash, but the notice by David Silcox in the *Globe and Mail* was rather dismissive.[57] Doris Pascal wrote of the disappointing sales[58]—only one initially and later two more—and Max's reply was bitter. "This is the pattern for me in Toronto up to now," he wrote. "Perhaps I shall not show there again. I can do better from my studio."[59] The reception for his work in Winnipeg was mixed. He had sent a one-man show of graphics to the Grant Gallery, and at the same time, some of his oils were hanging in the Canadian room of the Winnipeg Art Gallery. The *Winnipeg Free Press* reviewer described him as

> a stylist whose style is increasingly cool and, for all the seeming violence of its color and design, strangely non-committal emotionally ... if only his vigorous designs could be animated by a matching neo-European passion—political commitment, positive obsession with people or nature, a headlong satirical impulse—he would almost surely come into focus as a figure of greatness.[60]

The *Winnipeg Tribune* account was more favourable; it carried the headline, "A mature, honest artist it's a pleasure to see" and was accompanied by two reproductions, *Tavern* and *Schliemann at Troy*. The writer commented on

Bates's "universal appeal" and thought the black and white *Schliemann at Troy* "superbly imaginative."[61]

Max not only painted with intensity and originality in 1965 but was also working on an account of his war experiences, which some years later was published as *A Wilderness of Days*.[62] He also completed an intriguing short story, "The Prisoner of War," which was set in Paris during the Occupation. A young artist, a foreigner caught in the city, takes refuge with his art dealer, who keeps him in an upper room on the condition that he paint forgeries for sale to the occupying troops. The tensions built up by the young man's fear of betrayal, his isolation, and his disgust at what he is doing all serve to intensify his claustrophobic plight.[63]

In a letter to Snow, Max wrote of the pleasure that he and Charlotte took in the spring flowers and how he rose at dawn in order to take Spanish lessons from the television.[64] His morning reflections are hinted at in two of his poems:

THINKING OF PARMENIDES

Sitting in the quiet world of five A.M.:
Watching
Quail with nodding crests, pecking:
Their heads delicate trip hammers.
On my right the extreme beauty of the predawn sky,
Thinking of Parmenides
And the dawn of new things.[65]

WHEN IS THE NEW WASTELAND?

People wonder on the street and on the beach,

While politicians preach and preachers teach
In the assemblages of cretins
Arranging meetings
In Vancouver, and Victoria Before Christ.

The country of the Quail and Pheasant is at
 peace.
Our cat waits for the door to be opened
Like a girl out with a man
Of good manners and bad intentions;
While I sip coffee
And listen to Peggy Lee in the morning.[66]

Max may have been suffering a touch of claustrophobia himself, for their property at Beaver Lake Road was low-lying and surrounded by trees. His desire for the stimulation of change and new views resulted in a move nearer Victoria to Royal Oak Avenue. The house had a "splendid view of Victoria and the Olympic mountains,"[67] a view which Max subsequently painted several times. By October, Max wrote Snow:

> the house is taking shape inside. It looked like the bottom of a woman's purse at first ... the move has disrupted work for the time being! My studio is in the house and good. I want a tile floor like your studio but my affluence is tested now. I have rented the Beaver Lake Rd. house to a friend.

In the same letter he mentioned that he had begun working with a kind of print called 'polygraph.' "One is done, but not printed yet," he wrote.

> A friend here prints by driving her car over it! ... I have a new idea for texture that might go well on a stone. Do you know the papier mâché type sheets newspapers are printed from? A piece of this with some large type printed upside down, across,—diagonally should give a rich texture. I shall get some from the Victoria Press, because I know the Publisher. I shall roll color on and roll on the back to transfer print."[68]

Snow did not pick up on this suggestion, but Max continued to experiment with the sheets.

He was also painting over some of his tachiste works; one example, a northern pine forest scene, *Wilderness*, was reproduced in colour to accompany an article on British Columbia painters in *Vie des Arts*.[69] The writer, Jacques de Rousson, found Bates's work often sarcastic and pitiless, rendered with a dynamism that verges on abstraction. Max's geometrical composition in rich colour, with a golden tree in the foreground, illustrated the writer's statement that "Ce peintre a passé par le cubisme et récemment par l'op art dont il ne garde aujourd'hui que certains effets incorporés discrètement à son réalisme."[70]

Max was able to turn again to lithography when he and Snow were commissioned by David Silcox, Arts Officer of the Canada Council, to create a print each to be given to volunteer adjudicators.[71] Snow completed a still-life, *La Noche*, in an edition of fifty with ten artist's proofs, but Silcox wrote him to say that Bates was having difficulty getting his printed. He suggested that Max visit Calgary at the Council's expense so that Snow could carry out the printing. The invitation was accepted, and Max and Charlotte drove to Calgary. Snow had organized two aspiring young artists, Rob Dempster and Barry Smylie, to help carry the

Corsican Town *(1966). Lithograph, 35.5 × 45.5 cm. Photo by John Dean. Private collection.*

heavy stone up from the cellar. Max remained upstairs and drew on the stone. Once one image was printed, the young men ground the stone, preparing it for the next image to be superimposed on the previous one. Snow did the printing of the several images of *Cirque Medrano* in the evening. Max and Snow also took advantage of the visit to print two other lithographs, *Woman and Still-Life* and *Corsican Town*.

Bates returned to Victoria to the news that several of his paintings had sold from a retrospective exhibition mounted by the Art Gallery of Greater Victoria. In the introduction to the catalogue, the director of the gallery, Colin Graham, praised the artist:

> During the past six years the painting of Maxwell Bates has reached a richly expressive maturity toward which three decades of growth and experiment had been heading. Now fully in control of his painterly means, working easily in several form conventions, and using colour fluently both as an emotional and a decorative factor, he has been able to evolve an astonishing and haunting iconography that is entirely his own. There seems to be nothing like it in the whole range of Canadian art. Sombre and often macabre, yet lit at times by a sardonic humour that is not without compassion, this iconography centres on the human figure, the treatment of which places Bates securely in the expressionist traditions of the twentieth century.[72]

There were seventy-four works in the show—oils, watercolours, drawings, monoprints and lithographs.

"The world of Maxwell Bates is extraordinary," Robin Skelton wrote of the retrospective exhibition. "It is populous with symbolic figures and vivid with theatricality. ... Beggars and Kings are fused together in images whose tattered and mortal complexities have hieratic dignity and comic pathos."[73] Skelton singled out *Night of Nepenthe* for special comment. In this brothel scene, the cream of the women's bare breasts is emphasized by the use of red, brown and a black shading into purple. A black male figure with sad eyes converses in the background, while to the left, against a red background, a musician in evening dress plays his flute. In the foreground is a smiling child dressed in yellow; beside her, on a blue table, sits an angry-looking cat. The motionless, watching cat became a sort of icon and appeared in several paintings of the next few years. The discordant tension in the painting belies its title, which suggested forgetfulness in pleasure, but Skelton found tenderness as well as condemnation in Bates's view of his subjects.

The Canada Council agreed to sponsor a tour through the Maritimes of thirty of the works from the exhibition. Max was pleased to hear from Moncrieff Williamson, now at the Confederation Centre in Charlottetown, that the exhibition was "the most interesting and spectacular exhibition they have had in the new Gallery."[74] Praise came, as well, in the form of a review of the exhibition in *Artscanada* magazine, where George Fry wrote,

> one is reminded strongly of James Ensor, with certain qualities of Francis Bacon and

an influence from Max Beckmann. Yet this is to say nothing of Bates' personal qualities. He is an original: what he has to say is his ... his distortions are not vicious. Bates is a realistic but compassionate man. His work is strong but his sense of pity for human foibles appears in every frame. ... Personal symbols with a literary content are rather démodé. We live in an age of "every canvas a new experience" and "let us not interpret." Nevertheless the recurring themes in Bates' work prompt thought. There is ... the young girl tucked into the bottom of various canvases, gazing directly out at the spectator. She may be a conventional symbol conveniently filling a space; or is she like the candle in Guernica?"[75]

Though Max rarely offered interpretations of his work, he never hesitated to incorporate literary and artistic references in it for his own delight. If the viewer picked them up, so much the better. At the request of the director, Max did write an explanation of *Crucifixion* when it was bought by the Willistead Art Gallery of Windsor, Ontario. "This resulted from a slow but sure development from an image that appeared very often in my work in the fifties, that of the scarecrow," Bates explained.

Perhaps the image first appeared as a simple design image but it became a symbol of the condition of man in this century. A scarecrow is a contemptible figure,—the target of clods of earth and stones thrown by kids. It is a cousin of the clown and flutters at the mercy of the wind. That relates it to puppets and marionettes which I've often used as subjects also. All these are moved by unpredictable outside forces. The crucifixion and the scarecrow became a single image.[76]

When the retrospective was displayed at Memorial University, the reviewer's attention was caught by *Blue Scarecrow*, prompting the comment that:

at all times Bates says more than appears on the surface; the underlying meanings have a certain ambiguity, like symbols in a dream or fantasy, but they are readable.
Blue Scarecrow (which has been bought by the Gallery) rises like a grotesque bird, or a faceless wounded soldier above a city, the stiffly stretched out arms suggest a crucifixion; scarecrow, victim or man triumphant?[77]

The reviewer's description of this piece brings to mind the scene that Max witnessed in Thuringia—the unforgettable image of the injured airman descending on the camp, his bloody arm extended like a wing.

Max continued to turn out powerful, compelling canvases in 1966. "In his large oil, *French Town*, a street scene painted in a subtle range of snuff colours, colours of dried vegetation, his two worlds meet," wrote P.K. Page.

In the background stands a great palpable building—shuttered, chimneyed, occupied. And middle foreground where the eye somehow expects a horse-drawn carriage—a group of men move towards one, striped, camouflaged, verging on illegibility. Not revellers. Not workmen, Cosmic footballers? They fit no known category. Are they perhaps materializing at this very moment by a trick of light or the angle of one's own gaze? And why the miniature nine-starred constellation at their feet?[78]

Beautiful B.C. (1966). Oil on canvas, 90 × 120 cm. Photo from Maxwell Bates fonds, Special Collections, University of Calgary Libraries. Collection of the Vancouver Art Gallery.

One of Max's most notable works, *Beautiful B.C.*, was also executed in 1966.[79] Max drew his inspiration for the painting from the magazine of the same name, and he admitted that his version of *Beautiful B.C.* was meant to be satirical one. His friend Karl Spreitz was the photographer for the magazine, and as Max explained:

> He said if they were to use one of his photographs for the magazine, it had to have perfectly blue sky and everyone had to be smiling and all that. There had to be just a nice little leaf, just in here, and so on and so forth. Everything had to be roses, so to speak. Propaganda. I don't know why I thought of that girl looking through the back of the car window. I don't understand that, really, myself; it baffles me.[80]

There is no "nice little leaf" in Bates's work; rather, a wooden sign forbidding trespassing and the bare sand. The sea and sky are indeed blue, but they are faded in comparison with the paint on the car. There is something obscene about the machine's bulky rear, with its red lights, silver bumper and "Beautiful British Columbia" license plate. The driver faces forward as his companion, her blonde hair swept to the side, looks over her shoulder through the rear window. Her gaze is conspiratorial and her tiger-skin coat emphasizes a predatory aspect.

The critic, Frank Nowosad wrote:

> The painting is at once elegant and illicit, exquisite and humorous, and for the viewer it triggers boundless suggestions, both explicit and paradoxical. Although its impact is immediate, the painting sustains interest—a perpetual quiz and a continuing pleasure.[81]

The impetus for another impressive work, *Babylonian Emissaries*, lay in the visit to Victoria of a Hollywood movie crew. The witty canvas is crowded with figures—sailors with tattooed arms and exotic headgear, the toothy director, beautiful girls, mounted police and the cat, all surrounded by ropes, masts, flags, with the grill of a limousine in the foreground. As Barry Lord described the painting in his book *History of Painting in Canada: Toward a People's Art*:

> It records the arrival of a company of Hollywood movie actors and their director by motor launch to shoot part of a film. And certainly it has a Beckmann look. In Beckmann's manner, Bates has grouped the figures tightly together, contrasting the working crew members at left with the leering director and cosmetic actresses. One starlet wears a dress with a pattern derived from a Mondrian abstract painting, while another is hard to distinguish from the cat sitting in the foreground. Near the centre is a Bentley automobile grill, a most suitable car for the director, and a stars and stripes yachting pennant associated with the origin of these emissaries. Hollywood with Babylon, the ancient capital of decadence in the Old Testament. In the lower right corner he has the mounties wearing Klu Klux Klan hoods to reinforce the suggestions of racism and police state control that the U.S. film makers bring with them. They are admitted to our country by R.C.M.P. inspectors. *Babylonian Emissaries* is consciously anti-imperialist.[82]

Lord points out that the arrival of the film crew was not the only incident fuelling Bates's satire; he was also responding to the take-over of Alberta oil and the dominating influence in Calgary of citizens from the United States.

The ambience of Victoria was clearly to Max's liking, and he and Charlotte were happily settled there. His work of the previous few years, in its variety and intensity, showed that his powers were undiminished by his handi-cap. Towards the end of 1966, Snow wrote to Max to tell him of Roy Stevenson's death in a single car accident driving home from a teaching session in Camrose, Alberta. Max replied in a letter dated "Year's end" 1966: "I was shocked to hear about Roy. It makes the second this year. Earlier in the year Don Buchanan was killed by a car. Both events were very sad for me."[85]

More Productive Years, 1967–72

Canada's Centennial was an occasion for numerous exhibitions celebrating the country's art, the major one being held at Expo '67 in Montreal and organized by Barry Lord, the editor of *Artscanada*.[1] Lord wanted the exhibition, which was hung in the Canadian Government Pavilion, to be "a sample at the very highest level of quality of the most exciting painting being done in Canada today." Bates sent his *Babylonian Emissaries*.[2] The Canadian Society of Graphic Art exhibition celebrated the Centennial at the National Gallery, and Max submitted the lithograph he had just done in Calgary, *Woman and Still Life*.[3] The other print from Calgary, *Corsican Town*, travelled the Western Canada Art Circuit in the show *Western Printmakers*.[4] For the Simon Fraser University Centennial Suite, Max produced *Figures at a Table*,[5] a serigraph of a working man and his attractive companion drinking wine. This work in blue, black and yellow found its way into the collection of the Tate Gallery. On 1 July 1967 the Centennial medal was "conferred on Maxwell Bates in recognition of valuable service to the nation."[6]

In the late summer the Bau-Xi gallery in Vancouver included Max's work in their exhibition of Northwest Drawings. In the catalogue account, the writer drew attention to Bates's drawing *Lunch Hour*,

with its three forlorn figures settled into a state of non-communication ... that relates so well to the general themes and style of the American Expressionists, exhibits a sad restraint that characterizes much of Bates' work. While other Expressionists rant visually about the large injustices that plague society or the passions of the individual, this artist whispers about the day-to-day minutiae that slowly grind men down, that force men to retreat into windowless shells.[7]

The next month Bau-Xi mounted an exhibition of Max's watercolours and prints,[8] announcing the show with a large, spectacular poster in silver with a drawing of two seated workmen. Max was so pleased with it that he sent a copy to Snow.

For an exhibition organized at the University of British Columbia, Bates invited Eric

Metcalfe to show with him, a tremendous boost for a young artist still studying at the University of Victoria. The following tribute to Bates's timelessness appears in Michael Morris's notice of the show:

> Maxwell Bates is one of the few artists of his generation in Western Canada to have maintained the respect and admiration of successive generations of painters. His single-mindedness and ability to grasp and understand "the moment" without allowing it to interfere with his own direction has served as an example to painters like Roy Kiyooka, Ron Bloore, Iain Baxter, and myself. ... His concerns are private, often literary and highly satirical. They deal almost totally with his own experience and condition. He is a documenter, and keeps extensive notebooks, photos and sketches which provide amazing detail and authenticity to all of his work. There are references in Bates' work to the major trends in twentieth century painting; but it would be an oversimplification to approach his painting as expressionism or surrealism. ... Maxwell Bates has absorbed these influences to create an uncompromising personal mythology.[9]

In reviewing the exhibition for *Artscanada*, Richard Simmins wrote:

> Bates is far more than a social satirist and ironic commentator on man as fool and spiritual eunuch. Yet he is far less than he wants to be—an internationalist whose themes have transcended the confines of regionalism.

Simmins found no relief in Bates's work from "his lonely world filled with love/hate experiences. The universe is one of despair, an agony of personality isolation, death and worst of all—futility."[10]

In several of the works following the intense paintings of the mid-sixties, there is little of that "love/hate" or "despair" of which Simmins complained, but rather a lyrical quality, an enjoyment of life. Bates celebrated the Saanich countryside in his landscapes, and one of them, *Near Saanichton*, Ian Thom described as follows:

> Particularly striking is the use of closely toned but distinct greens, salmonberry pink and green-blue. Although unrelated to the natural landscape, the colours have a conviction and a rightness which is absolute. Highly resolved, the painting is a minor masterpiece.[11]

In *Farm People* a colourful, happy family poses for their portrait against the cultivated hill and stand of trees rising into the blue sky. In striking contrast to Bates's prairie families, this smiling, triumphant group clearly enjoys the fruit of their toil. Max painted people on the beach, on the street, and at cocktail parties. He turned frequently to one of his favourite media, ink and watercolour. In *Bacchus* the dignified, stern profile of the god with his upraised hand is set against a patterned background. Vine leaves crown the impressive head, and in the right-hand corner of the work, imitating an ancient inscription, Max has printed "BACCUS." Max's witty painting *Opening—Michael Morris Exhibition, 1968* com-

memorated the occasion at the Douglas Gallery in Vancouver. Bates echoed Morris's striped installations in the print of the central woman's dress. In the background are a native with pigtails and a figure who looks very like Roy Kiyooka, who had been flown in by the gallery for the occasion.[12]

A commercial gallery, Pandora's Box, had at last opened in Victoria and was showing Max's work. With some prompting from Max, the gallery mounted a one-man exhibition of Snow's work, but Max was annoyed at the reviews: "Two reviews of your show have appeared, and I enclose them," he wrote to Snow. "Neither critic is at all authoritative, but they are what we have now. I often deny that you are influenced by me,—and maintain that you have a strong personal style of your own. So I hope you won't be too irritated."[13]

Max's artist friend Nita Forrest soon opened her commercial gallery in Oak Bay, and mounted an exhibition of his watercolours, drawings and prints.[14] "The subtle use of distortion creates people we know," Ina D.D. Uhtoff wrote in her review. "Our next-door neighbors, or the man across the street, the woman in the shoes that appear too small for her or that have heels that are too high; yet his sympathy and tolerance was always evident."[15] Ted Lindberg of the *Victoria Daily Times* interviewed Max at home and spoke of his "Olympian stature in the annals of Canadian art." Of the works in the exhibition, Lindberg wrote:

> Victorians have shied away from them. ...
> They want realism: but not reality. ... He

dearly loves women, perhaps as much as Matisse did, but dwells not so much on their age-old charms as on their vulnerability, their self-delusion and false confidence.[16]

The Canadian Society of Graphic Art honoured Max's achievements with a retrospective of twenty-five of his drawings and prints.[17] Bill Stavdal, a reporter for *Time*, interviewed Max, who stressed his long-held belief that man was helpless in the grip of fate—a perception that he often represented by the use of puppets and scarecrows in his work. He also told Stavdal that he'd "never painted with the idea of selling. Once an artist does that, he's finished," Max continued, "The artist who addresses himself to other people defeats himself. I would like to communicate with other people, but they must come to me—I'm not going to go to them. ... The success kick is something I'm not very keen on, because it makes people distort themselves." He further explained that he liked everybody except "insincere people."[18]

Max had a further chance to air his views in response to a statement by Dr. Alan Gowans, chairman of the Art and Art History Division of the University of Victoria's School of Fine Arts. Gowans had written an article for the *Victoria Daily Times* attacking contemporary art, complaining that there was a gap between the public and the artist and that no work of scholarship had yet explained this lack of understanding. In Gowans's opinion, the framed, easel painting was dead. "Painters found the reality of painting to consist of paint itself," Gowans said, "so that you will end up with ... canvases whose meaning is to be found

in an inner world of the painter's own psyche."
He was scornful of the work of Courbet,
Gauguin and Picasso.[19] The newspaper's
publisher W. A. Irwin, asked Bates to frame a
reply. In it Max insisted that the division
between the artist and his society was far from
being a modern problem. Artists from prehis-
toric times to the modern day drew on their
"inner world." And as Bates concluded, "the
grand old art will be practised until there are

Maxwell Bates and Charlotte Kintzle Bates (1972). Photo from Maxwell Bates fonds,
Special Collections, University of Calgary Libraries.

no longer brushes, burnt sticks or twigs to
make marks."[20]

Early in 1968, Memorial University had
asked Max, now in his sixty-second year, to
accept an honorary doctorate, which he had to
decline because of the rigours of the long
journey.[21] Max and Charlotte were able to
travel to Winnipeg for the opening of his
retrospective there in September. The exhibit
featured thirty-five of his works from 1947
on—oils and ink and wash[22]—and Max pro-
nounced himself "satisfied with it."[23] John
Graham, in *Artscanada*, drew attention to
Bates's ability to handle the quality of light.
"He succeeds in capturing the luminous
shadowless light created by the pre-dawn glow
of the sky," Graham wrote of *Roman Dawn*,
one of Bates's cityscapes. "He conveys com-
pletely, with all its nuances of meaning associ-
ated with it, that ever-recurring, timeless
suspended moment of stillness which antici-
pates the clamorous day."[24] All his life, even in
the prison camp, the dawn and its light evoked
an emotional response in Max.

The next year the exhibition travelled first to
Halifax and then to Calgary, where it was hung
in the spacious, new Dr. Alexander Calhoun
gallery of the Allied Arts Centre. Unable to
attend the opening, Bates asked Snow to give
him an account. Snow replied that it was
"quite a gala affair—full house and most
enthusiastic reception"[25] and listed all of Max's
old friends in attendance, including Calhoun.
In a subsequent letter Snow told Max that
there were several red stickers.[26]

It was a busy year for Bates, and to further
complicate matters, Charlotte and Max moved

to a new home on Lakeview Avenue, overlooking Swan Lake and near Flemming Jorgensen's home. The house had a studio on a level with the main floor. Jorgensen later ventured that these

> were good years for Max: he painted a lot and was in reasonable good health. I enjoyed Max a great deal. Now that I knew him we had many interesting afternoons with good conversation and gossip (he loved it). He also enjoyed naughty jokes and kept telling us the same one for years—and I still missed the punchline.[27]

Herbert Siebner remembers that Max was very fond of the works of George Grosz and Otto Dix, and Siebner could see the influence of these artists in Max's work. Siebner has also given an account of one result of their friendship:

> In 1968 we decided to have an exhibition together in Seattle at the "Otto Seligman" Gallery. We even applied for a grant and after several telephone calls, we each got $150. ... To simplify matters, I packed all our paintings in my V.W. Van (in all about 50 works) in order to avoid trouble at the border. ... I had placed a very crude painting by Max of a scarecrow with a very primitive frame on the outside. The customs officer eating his lunch came curiously inspecting my load. I said they are paintings for an exhibition. So I opened my van and showed him the first painting—he turned around offended and said I spoiled his lunch—so I took off.[28]

The "crude painting" was likely *Scarecrow*, in which "A startled scarecrow watches, impo-

tent, while a rout of hoydens—smashed raspberry mouths, flushed scarlet flesh, skirts hoisted above their crotch—cavort about as though maddened with aphrodisiac."[29] At the opening in Seattle, an Austrian art critic approached Max, saying "You must be the German artist," to which Max shook his head, produced his stick and replied: "No, I was only a prisoner there!"[30]

The Bateses' circle of friends was augmented by Peter and Marian Daglish, who arrived from London, England, where Daglish taught at the Slade and the Chelsea School of Art. Invited to the University of Victoria as a visiting instructor, he had a strong influence on his students, one of whom was Eric Metcalfe. The two became friends, and Daglish acted as best man at Metcalfe's marriage to another young artist, Kate Craig, who remembers the twinkle in Max's eye.[31] Craig, Metcalfe and Morris were younger members of the group which partied on the weekends. Rita Morris remembers one merry occasion when Max, who had had one or two drinks, pursued an attractive young guest with his cane, stomping on the floor and repeating, "I want this beautiful girl. I want this beautiful girl."[32]

Max's broodings at this time were often explicit in their sexual emphasis. He conceived of plug-in games that could be played at home, and one he named "Las Vegas." It involved slot machines and a blonde resembling Marilyn Monroe and would bear the seeds of its own destruction so that the owner would have to buy a later model.[33] He wrote two little poems at this time in which he wryly hints at frustrated attractions:

ALLURE

You stir my guts with a spoon
Is this a strange dish from the moon
That you make?
I should swallow your pearls
One by one,—instead of my pills;
But that is all allure, and no cure.[34]

EYES

To lose oneself in a pair of eyes
That become the universe.
Then one must cross a Bridge of Sighs
Built by mute cries
Of Circe; lost in infinite depth.
What must one do?
I'll tell you: go and dig turnips;
Swat a wasp,—or two.[35]

For most of Max's life his attitude towards women was conventional and inhibited. Brought up in an Edwardian household, segregated with men for a long period in his prime, it was not until his marriage to May that he was able to enjoy a sustained release of his emotional and sexual impulses. He admired and was at ease with such women as Lettie Hill and P.K. Page who shared his interests, but he was more relaxed in the company of men, especially fellow artists. The ferment of feminism made little impact on his view of women, and he seldom saw them beyond their traditional roles. In a note on "The man and the woman as creators of works of art," he wrote, "Women lack the power to see generic lines—to generalize. Women's works not monumental—not conceived as a whole." Women's success in literature could be accounted for because

a narrative can lack synthesis and monumentality, and if it shows psychological insight, observation, interest of plot will superficially seem as fine a creation to the public, critics etc. as a work conceived "in the round." ... The aesthetic elements are more hidden than in e.g. music.

He concluded that "women fail as artists because they can't synthesize sufficiently."[36] He also made a note after reading in Kinsey's report on the sexuality of women that women were less affected by visual stimuli than men. Applying Kinsey's finding to the world of visual art, Max had further support of his explanation of why women had not excelled in the visual arts.[37]

In Victoria, though, his relationships with women became less inhibited and more enjoyable. His disability made it possible for him to admire and respond to feminine charm and dress without fear of reproach or rejection. In many of his paintings, the women are primarily people, members of the flawed human race; in other works, their female characteristics are emphasized. For some critics, such as Richard Simmins, this emphasis is "anti-feminine," "flopping, graceless nudes ... all fat bellies, tits and lips."[38] Others disagreed. Frank Nowosad wrote of how

[Bates] loved the ladies. Wide-eyed, buxom, and fertile, they bloomed throughout his paintings. Also always drawn to vivid colors and bold patterns, Bates would exploit these aspects of women's fashions and fancies to a grand extreme. ... Sometimes the women would bulge disproportionately, becoming viragos and female chauvinists, as threaten-

ing as the mother-in-law in the old Maggie and Jiggs comic strip.[39]

The beautiful girl in **Modern Olympia**, painted in 1969, does bloom. The work is a variation on Manet's famous painting, a variation in which substitutions and additions generate an added excitement. The black maid has been replaced by the enigmatic cat, the bouquet of flowers is in the forefront of the picture; instead of the nineteenth-century courtesan with her soft limbs and creamy skin, Bates has painted a beautiful, vibrant, modern woman, arms outspread, offering herself with a half-smile on her lips. Thom said of her, "she is like Nana, a coquette but a coquette of unimagined complexity."[40] Undoubtedly, Max was remembering his days in Paris when he painted **Odalisque** (1970), in which Mme Palmi, the fortune teller in his story "The Dentist of the Rue Mahomet" appears. "It is a mark of Bates' great skill that this highly improbable mixture of crude drawing, childish pattern and garish colour works so wonderfully," Thom wrote of this work.

> Again and again he violates all the rules, placing bright pink by kelly green, diamonds by stripes and polka dots. ... It is, however, her extraordinary face which commands our attention. The violent slash of the mouth and the mesmerizing eyes which at once lure and repel.[41]

Certainly Mme Palmi haunted Max.

His model for the two versions of *United Empire Loyalist* was Pat Martin-Bates, who came from Loyalist stock. One Christmas, as a present to Max, she sent a note saying, "This entitles the bearer to three sittings."[42] In the paintings that resulted from these sittings, she is wearing a black period dress, her dark eyes alive, and her black hair piled loosely on top of her head. As Thom pointed out, Max made subtle changes in the second version so that "they seem to be different women—one caught in the role, even the time of the Loyalists, the other impatient and barely able to be contained in her role or her sharply cut-out costume."[43]

There were periods in the wintertime when Max found it difficult to "practise the grand old art."[44] "I've been through it so many times," he said, "as long as two or three months and I know it will end and that I'll be just as full of ideas and everything as ever. It doesn't matter to me."[45] In such periods, he read his books and periodicals. He especially enjoyed the modern French novelists and had added Martin Tournelle's *The Art of French Fiction* to his library. He recommended that Snow read Donald Barthelme, whose mockery of the intellectual establishment delighted Max. He often reread his favourite Russian novelists and Proust. These fallow periods were somewhat relieved by the presence of Gisela and Bill Bates, who had moved to Victoria, where Bill took up a career in real estate. Spike, the cat, had succumbed to old age, and his place had been taken by two others, Samson and Delilah.[46] Max wrote a bit wistfully:

> no longer does the grey gull visit us. We moved from that property four years ago. No gull visits us here looking for handouts like pieces of bread. One may yet come but the leitmotif has gone. I could continue to

mention it but that would not sit well with me. An old man I knew years ago said "There is nothing higher than truth" and I believed him.[47]

Max enjoyed eating out, but his taste in food was so conservative that he would order omelettes in Chinese restaurants or send back a lamb dish because it lacked mint sauce. He enjoyed observing other diners and painted several works with a restaurant setting. Dingle House on the Gorge inspired a painting, as did the Cherry Bank Restaurant with its table-cloths of red and white checks. He preferred easily accessible locations, the Garden Terrace in the Empress Hotel and the Snug in Oak Bay. He loved receptions and parties, but Charlotte and Gisela took to protecting him from admirers whose attentions he found tiring or obnoxious. Gisela took him to a fashion show in the ballroom at the Empress, and when he won a prize of a free hair styling, he insisted on going up to the platform to claim it.[48]

Although Max was stubbornly trying to overcome his physical handicap, it became increasingly difficult for him to manage. "Today we crossed to Vancouver on the shaky old dowager, the Queen of Sidney," he wrote. "I shall avoid this ferry because she has no elevator and I climbed about fifty steps. Very tiring. We went to a reception and the opening of Jock Macdonald's retrospective at the Burnaby Art Gallery. It was very pleasant and everything was well done."[49] The effort involved in this journey testified to Max's enduring affection for his old friend. Considering his handicaps, his steady production of work was remarkable. In 1970 he had a one-man show at the Bau-Xi Gallery,[50] and within a few months, another exhibit covering his works from the 50s to the 70s was held at the Upstairs Gallery,[51] both in Edmonton and Winnipeg. The *Winnipeg Free Press* announced the show and Bates's election to full membership in the Royal Canadian Academy.[52] In a later issue John Graham, especially impressed with the cityscapes, reviewed the exhibition at length.[53]

Nita Forrest had moved the Print Gallery to Victoria's Wharf Street, and she opened the new location with a show of sixty of Max's works from the previous two years.[54] The opening became a celebration; Max's fellow artists and friends came, and a report of the event even appeared in a Calgary paper.[55] Max had been working on a series of oils based on the Tarot cards and chose to show eight of the trumps, the Acrobat, High Priestess, Empress, Emperor, Pope, Death, the Devil, the Tower of Despair, and the World.[56] In an interview Max spoke of his fascination with fortune-tellers and cards and explained how the decorative look of the cards on the table got him started on a composition. Though he had a set of French Tarot cards, he did not use them to tell fortunes;[57] however, he did cast horoscopes for his friends as an aid, he said, to understanding them.[58] The Tarot card series did not receive much attention, and eventually Bates painted over some of them. P.K. Page wrote about the Print Gallery exhibition for *Artscanada*:

His world contains landscapes complete with trees, lakes, flowers and rivers; cities with

street lamps, shops, houses; houses with furniture, cutlery, plants, toys, pets—even abstract paintings for the walls! And a cavalcade of people: kings, queens, clowns, children, socialites, politicians, poets, lance-corporals, labourers; characters lumpish and asleep as Beckett's Hamm and Clov; hierophants and magicians evocative and mystifying as the figures of the Major Arcanum.

In his studio, Page was struck by the feeling of tension and energy and impressed by how he called on his knowledge of history, art through the ages, and literature, "as if he were in fact saying, all time is now: all space is here." Of his portrayal of his fellow men she wrote:

> Anyone who has had a vision of what man could become must thereafter see him in his partial evolution as deformed. "Man, poor man, half animal, half angel." Vile only in relation to his possibilities. I believe this to be the essence of Bates' message.[59]

Bates's young friends Eric Metcalfe, Kate Craig and Michael Morris were preparing to move to Vancouver, where they established the Western Front, an influential centre for the new fields of video and performance art. Their departure from the more traditional media did not attract the group of Max's friends who formed "The Limners" under his leadership. Herbert Siebner had suggested the idea to Max, who took it up and became the first president, remaining so until his death. The other founding members were Herbert Siebner, Myfanwy Pavelic, Karl Spreitz, Nita Forrest, Richard Ciccimarra, Elza Mayhew, Robert de Castro

and Robin Skelton. Niki Pavelic became the treasurer and Sylvia Skelton, the secretary.[60] It was a loose organization, a group of friends who wanted to "work together and to bring each other's work to the public in a more effective manner than is possible for an artist working entirely alone." The common element in their work, as Robin Skelton described it, was the significance of "the human content" and they were "opposed to that denigration of humanity which results when men and women are portrayed as lay figures for a pictorial design, or presented as creatures of one mood." The name came from "travelling journeymen painters of the middle ages" and the group's logo was a runic sign meaning "man."[61]

Max thoroughly enjoyed the meetings, which were usually held in the Pavelic home. He would bang with his cane to get attention,[62] and business was dispatched in a most unruly manner. Skelton remembers that with his friends Max was

> at ease and then the mouth would broaden into a grin, the rasping voice comment, and the snorting cackle of his laugh express his enormously affectionate zest for all things curious and absurd. ... Delighting in anarchy, he would, in a sardonic fashion support any suggestion however outrageous to tease and challenge authority.[63]

Myfwany Pavelic painted Max at one of their gatherings, wearing a large black hat[64] borrowed from a guest; under the brim, he looked like a dwarf under a mushroom. Max's self-portrait of 1971 is equally unflattering,

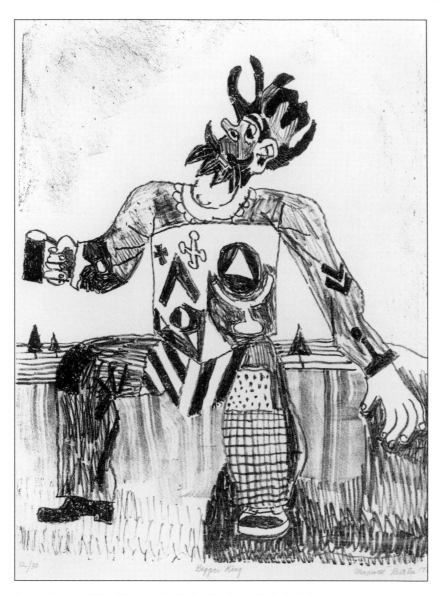

Beggar King (1971). Lithograph, 40.5 × 30.4 cm. Photo by John Dean. Private collection.

devastatingly realistic with all the lines sagging and only the eyes retaining their intensity in an old man's face. He was clearly thinking now of last things, as in his poem titled "Death":

DEATH

There are many bad things about death;
I'm almost sure you'll agree.
It is like being forced to leave
A great play before the end.
Quando—quando—quando
It's so important to know
Quien sabe, mi amigo
When shall I draw my last bath,
Or my last breath.[65]

For some years Max's friends in Calgary had been trying to get an honorary degree for him from the university. After some resistance in the same narrow spirit that rejected his airport mural, the degree Doctor of Laws was conferred on Bates by the University of Calgary at the Spring Convocation of 1971. The supporting statements drew attention to the strong, progressive influence he had on the cultural life in Calgary,[66] to the high regard in which he was held by young artists,[67] and to his unique imagination.[68] When asked his opinion of Calgary's new cityscape by a reporter from the *Calgary Herald*, he said it was too cold and sterile and insisted the buildings needed mosaics and sculpture to give them tone. He commented on the lack of a civic gallery in Calgary, a facility enjoyed by every other major city in western Canada. In answer to a question about modern art, Max said that the public's confusion was understandable, in that

the artists themselves seemed to be confused. "They are wound up in the belief that the artist must be an innovator and do something different from anybody else, and that's no longer possible," Max told the reporter. "He must be an individual, but that doesn't mean he has to start a whole new school of art. In the end, it's the quality that counts."[69]

To celebrate the occasion, several exhibitions of Max's work were held. The Alberta College of Art mounted a show of his work gathered from Calgary collectors.[70] His friend, Margaret Hess, now proprietor of Calgary Galleries, hung his works, as did Canadian Art Galleries, which was operating under new management. Max was welcomed warmly by his old friends in the Calgary art community, and he found time to create two lithographs at Snow's house. Max drew on the stones and Barry Smylie again carried them to the basement for the image to be printed by Snow. In *Fortune Teller* a young woman sits thoughtfully waiting while the fortune teller, with her coarse face and curled hair, studies the cards laid out on the table. *Beggar King* repeats one of his favourite images, the polarities of beggar and king brought together. Thom said of this work: "Recalling earlier images of the same theme this print has a strength of drawing which dazzles us with its sureness. He exists as symbol and yet the raggedy clothing, lopsided hat/crown and bare landscape connect him to the earth."[71]

During 1971 Max embarked on a series of oils, all titled *Reception* and numbered. There is a subtle joke in the difference between *Reception #3* and *#4*: the first is a fashionable gathering, probably at a gallery or a large house; the second reception room is in a brothel. Though Bates denied that the figures in the social gatherings were suggestive of his friends or acquaintances, some, like Skelton, certainly saw themselves in the paintings.[72] Occasionally Max included himself. The scene in the brothel is dominated by the blonde reclining on a chaise longue in her red slip and sexy suspenders. Obviously the star of the establishment, she reads a movie magazine, indifferent to the male visitor and the waiter with his tray. In the background one girl sits in a striped chair, and two others stand on either side of the painting, the canvas vibrating with the reds, greens, yellows and violet.

Max's oils were shown at the Print Gallery[73] in the spring, and in the fall his works were exhibited with the silkscreen prints of Roy Kiyooka.[74] It was a successful exhibition with good sales, but it was the last for the Print Gallery. Nita Forrest closed the gallery shortly afterwards, and in a note to Max she wrote, "If it wasn't for your sales, I don't think there would be a gallery!"[75] The sales of his work were improving, as attested by an interesting arrangement developed with Dr. Joseph Starko in Edmonton. The son of Ukrainian immigrants, Starko was first attracted to Bates's paintings of the prairie farm people and had bought some from Turner.[76] He began to deal directly with Bates, sending him a monthly cheque for works to be painted and delivered when Max thought suitable. At times Starko indicated what type of picture he would like, and Max was considerably intrigued with this arrangement, which continued to 1976.[77]

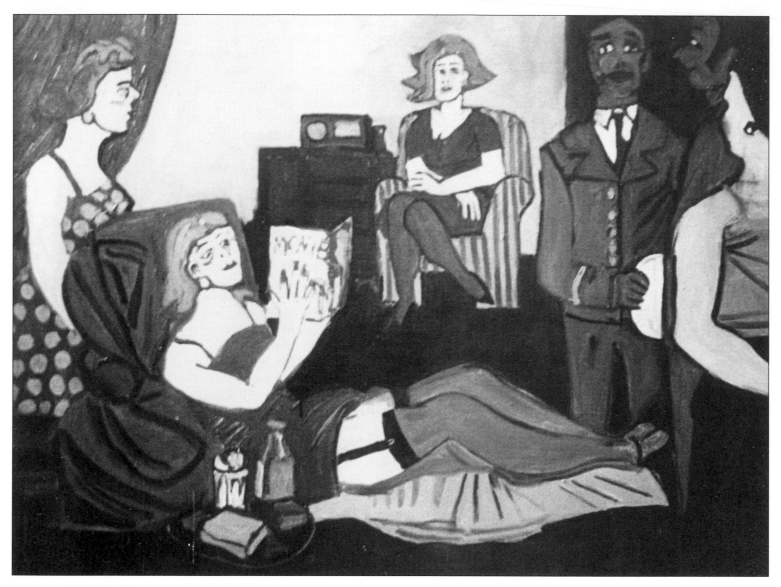

Reception #4 (1971). Oil on canvas, 90 × 120 cm. Photo from Maxwell Bates fonds, Special Collections, University of Calgary Libraries.

Though Charlotte and Max were generally enjoying themselves in Victoria, Max sometimes found life dreary:

DAY FOLLOWS DAY

Day follows unadventurous day
Into the
undifferentiated gray
Miasmus.
Day follows day
Like wasted leaves
Of a ledger thrown away
Unwritten on
But musty damp
And beginning to decay.
Day follows unromantic day
Neither bad
Nor yet good enough to bid them stay[78]

Although he was suffering from giving up smoking,[79] the coming of spring always made Max feel better, and in a letter to Snow congratulating him on his retirement at the end of 1971, Max wrote,

> We are snowed in!!! horrible as it is to admit it. However, it won't last long. ... We are well and I have done a lot of painting in the last year. We had a quiet Christmas and New Year, and are now ready for Spring. Daffodils are sprouting, also crocuses.[80]

Max valued his friends and was stimulated by them. He was sorry to see the Daglishes return to England and gave them a painting (**Untitled**, 1969) to remind them of the parties they had enjoyed. The central figure is a glamorous Nita Forrest, and among the others are Robin Skelton and Betty and Donald Harvey. Max saw his friends frequently:

Flemming Jorgensen and Niki Pavelic played chess with him; Robin Skelton popped in to chat; and Saul Green, who collected his paintings, called for lunch on the occasions when he was in Victoria. A commercial traveller, Green was intensely interested in Canadian art. "Max always wanted to know what was going on in the Art world where I travelled," Green said, "and we used to spend the day together."[81] In addition to the works he had bought, Green commissioned portraits of himself and his wife. Because of his reluctance to paint likenesses, Max struggled with his portrait of Mrs. Green. "In the case of Mrs. Green," he said. "I didn't want to make something that looked absolutely awful because she's quite attractive looking, actually ... and yet I didn't want to make a pretty thing of it. It's an awkward thing. I made several efforts which had to be painted over and wasted before I got what I thought was all right."[82]

Robin Skelton wrote eloquently of what he knew of Max in an article for *The Malahat Review*[83] titled "Maxwell Bates: Experience and reality," which made up most of the issue. It was generously illustrated with examples of Bates's work, and the cover reproduced a charcoal study of Max by Pavelic. Skelton wrote:

> Though his work frequently involves such archetypal figures as the beggar, the king, and the fortune-teller, and all these are painted with an intensity that suggests the presence of a mystery, they do not appear to me to imply more than the queerness of the universe. They are watchers and observers. In their own haggard and sometimes frenzied

fashion, they are attempting to pull aside a curtain, to peer through the surface of things. Their vision however is distorted."[84]

Skelton concluded: "Though his techniques may remind us of expressionism, as they sometimes remind us also ... of Millet, Rouault, Picasso, they are utilized in the service of an individual vision which has made Maxwell Bates one of the most powerful, original, and profound painters of his generation."[85] Max's was one of Pavelic's portraits of all the original members of "The Limners," and the portraits were hung at the group's exhibition at the Art Gallery of Greater Victoria in the spring of 1972.[86]

Final Years in Victoria, 1973-80

The Vancouver Art Gallery exhibition *Maxwell Bates in Retrospect, 1921–1971* opened on 5 January 1973 and hung until the end of the month. Doris Shadbolt, associate director of the gallery, wrote about the preparation of the exhibition. "It seems that few living senior artists are held in such deep and warm respect, both for the sustained contribution he has made over the years to Canadian art and for his humanity."[1] Terry Guernsey, assistant curator, interviewed Bates in preparation for the catalogue. She reminded him that some reviews had stressed his social criticism and even "brutality." Max responded that he did not see his work as depressing, and he was not interested in social criticism. If it was in his work, he said, "it just happens, quite by accident—a by-product, an unintentional thing." Nor was he conscious of the humour in his work, although, he admitted, "sometimes I see a little bit of something that strikes me as amusing. It's not really thought out or planned in any way." When Guernsey then asked him about *Beautiful B.C.*, Max agreed that it was a successful painting which "came about by accident."[2] This "accidental" element may have emerged from his subconscious, but Myfanwy Pavelic saw some of these "accidents" in process—she had watched him at work. He would pause, push the easel away with his cane and look at the painting, then pick up a newspaper cutting or a cigarette carton, anything lying at hand that he could paint into the work for balance or to increase tension. She remembered him painting a beach scene that featured a miserable looking child in pink in the foreground and abruptly adding a red Du Maurier cigarette package to complete the scene.[3]

It must have given Max immense pleasure and satisfaction to see 160 of his works hanging together and spanning fifty years of his life. When Rose Page was shown the catalogue in the nursing home in Victoria she was touched by Max's acknowledgement of her help and encouragement so many years before.[4] The Vancouver Art Gallery had bought the *Secrets of the Grand Hotel*, series and all twenty-five of these brilliant monoprints were now shown together for the first time. Writing in *Artscanada*, Joan Lowndes termed the series a "tour de force in decorative invention and

sustained fantasy." She also found the exhibition "so dense and complex" that it was difficult to know how to approach it. She saw his puppets, clowns and scarecrows as "recharged with fierce emotion" and "Everywhere a raw female aggressiveness born of boredom and despair." She concluded:

> Retrospectives imply a summing up, but it is impossible to sum up Bates. Everything you could say about him would have an exception. What happens, in the end, is a kind of synergy whereby the total impact is greater than the sum of the very different parts.[5]

The exhibition travelled to the Norman Mackenzie Art Gallery in Regina, the Alberta College of Art, and the Saskatoon Gallery and Conservatory Corporation.[6] It was Bates's faces that impressed the reviewer in Saskatoon, "Faces of people lost in the business of ordinary living. ... Faces, turned inside out, intense, speaking urgently from somewhere deep down."[7] In Calgary the exhibition had to be divided in two, with one section at the Alberta College of Art and the other at the Glenbow. As the reviewer pointed out, this situation emphasized the city's need for the civic art gallery that Max had referred to during his last visit to Calgary in 1971.[8]

It was significant that this exhibition did not travel to central Canada. Max's work over the years had been shown most successfully in the West and in galleries in the Atlantic region. In spite of his awards and the approval of such prominent critics as Buchanan, Harper and Lord, his art did not achieve recognition in Toronto and Montreal. Even such energetic gallery owners as Dorothy Cameron and Doris Pascal had been unable to sell his work. Strangely enough, the retrospective was reviewed some five years later in *Vie des Arts* by Alma de Chantal, who noted that Bates's work was not well known in Quebec. She contrasted the serenity and sensitivity of many of his prairie works with the elements of the bizarre, the nightmarish and grotesque which appeared in other works and the "présence de la Mort."[9]

Max expressed his bitterness about this neglect in an interview with P.K. Page[10] in preparation for a live TV phone-in to raise money for the Art Gallery of Greater Victoria. Page decided to do a dry run in case Max became "disconcertingly monosyllabic." She spent the afternoon with him, "discussing his childhood, his family, literature, architecture, painting, his influences, his interest in astrology and much else."[11] This preliminary tape is valuable because most of Max's revelations were not heard on the live broadcast. Fortified by a drink with Alice Munro, Dorothy Livesay and Pat Martin-Bates before the telethon, Max spoke freely, but P.K. said afterwards that she had trouble getting him out of his short pants.[12] During the interview Max said that one year he had sent 100 crates down east, and that in spite of the fact that he had two retrospectives, "it didn't do much good" because "I don't think anybody from the West is taken any notice of down there." He thought the alienation was "truer of eastern and western Canada than east of Suez." He went on to speak of the lack of good critics in Canada, even those who wrote in *Canadian Art*. He had been influenced by the writings of critics such

as Clive Bell and Roger Fry but believed he had never had effective criticism of his own work.[13]

His painting, he said, was hard work. Sometimes he did preliminary sketches and "other times I just slash away at the canvas and that's it. ... Sometimes I never know whether I am finished with a painting or not— but when I'm tired of it, that's it." He said he didn't like landscapes untouched by man, "I like to have a shack or a fence or something— otherwise I don't relate to it." For him, Canada had little history. "It's something that makes it less interesting to me, that's all," he explained. "I'm absolutely fascinated where there's a great deal of history like Paris, Vienna and places like that." When P.K. Page queried him about fear, specifically fear of dying, he said:

> Oh, not now, no. It's just a door you go through at the end of a corridor, that's all. ... It's rather interesting to see if there's something there or not—probably isn't but we'll see. ... I've a vague idea that there might be some sort of meaning but I've also got a suspicion that it isn't so.[14]

Max became heavily involved in preparing for a one-man exhibition in October at the Galerie Allen in Vancouver, sending oils, prints and watercolours. The show was both a financial and artistic success, with prices ranging from $175 to $400. In a letter to Snow, Max said that by the time they had arrived at the opening, half an hour late, twenty-nine oils had been sold. "I am certainly not used to this kind of thing happening,"[15] he wrote. Joan Lowndes was again impressed with the "high drama of Bates' color," writing in her review:

We know how deeply he has been influenced in his emotive use of color by his study with Beckmann and by the many German Expressionist exhibitions which he saw in London before the Second World War. If one stands on the balcony at the Galerie Allen and looks down at the paintings, one gets a marvellous feeling for Bates' special color combinations. Blood red and Prussian blue are characteristic, along with mustard and a certain insistent pink which has the quality of a malignancy. And black of course, used to slash at the figures or outline them heavily. ... Another ploy is to use a range of soft colors— blues, mauves, peppermint greens—as an effective counterpoint to the eerie content.[16]

Subsequent to the Galerie Allen show, Bates gave an interview to the *Victoria Times*. He maintained that though many thought him a satirist, he was a realist, adding: "but really I like paint, and am far more interested in what the paint and the color are doing ... I'm interested in people ... their motivations. Not commentary upon them. But basically, I just like color and paint."[17] He insisted, as he always had, that the viewer must bring to a painting his own resources built up during his life. He was not interested in work which did not have a connection with reality. "In the whole field of art it's hard to find anything very exciting these days," he said. "I'm bored by a lot of these movements, like conceptual art. A man shovels a pile of old car parts into a corner and tells me it's art ... well, I'm just not interested."[18]

Max had written in his journal, "Those artists still playing at 'Hard Edge' and other minimalist apocrypha are necrophiliacs play-

ing with the bodies of dead movements."[19] Previously he had written about his own conception of art:

> About the time I began to think seriously about painting I believed I should be trying to make something beautiful. It seemed axiomatic that beauty was what I should aim at. After receiving fascinating incites [sic] into the motivations of the Modern Movement in painting, it began to be less apparent that beauty was what painters should wish to create. Other aims such as strength, simplicity, intensity, originality began to assume validity. Spontaneity was added to the list, and expressiveness also. In these unruly days, in which so many well-meaning people are confused, it may be good to reconsider beauty.
>
> The artist creates a counter-environment, which allows a more tolerable world to live in. Many great artists, for example, Rembrandt, Rubens surrounded themselves with what they considered beautiful objects which helped create a sympathetic counter-environment. To a degree every artistic person attempts this.[20]

Since Peter Daglish had returned to London, Bates and he had been in prolonged negotiations for a joint show at Canada House and the Canadian Cultural Centre in Paris. Max planned to send drawings and watercolours to be framed there. Daglish designed a witty announcement in bright yellow contrasted with the black of a high relief photograph of the face of each artist. Above the photograph of Bates was written, in French and English, "to be human" and "sagittarius 1906"; and below Daglish was "'she' and other works" and

"taurus 1930."[21] Drawing attention to this difference in the ages of the two served to emphasize Bates's contemporaneity. Daglish's jazzy images of voluptuous women reflected the free-wheeling sixties. With their long eyelashes, exaggerated mouths and painted nails, they represented the sub-culture of London, centred in the bars. By contrast, Max's images were compressed, expressing the inner tension and loneliness of his subjects in an inimical society. The Snows were in London in time to help Daglish hang the exhibition in Canada House. The exhibition was reviewed in *Arts Review*: "Bates' mind seems to be a consistent source and image bank of visual notations gathering explosive ammunition for his lightning sense of portrayal and feeling for people. His works are all highly charged with an almost abandoned use of media." The reviewer noted Daglish's accent on "the theatrically bizarre and the bawdiness of popular motifs ... Red Hot Mommas, ice cream cones, children's building bricks."[22] It was an exhilarating exhibition.

Bates's memories of his London years were further stimulated by a notice in *Arts Review* of an exhibition of the work of Villiers David, his former friend and sponsor. Max wrote him, hoping that he would be able to see the show at Canada House:

> I wonder if you remember the youngish, shy painter you helped in the late thirties. I remember your kindness and your studio ... I still eat rice with a spoon ... my wife and I (and our cat) came to Victoria to live;. ... I have a studio on the ground floor (small but I make do) more exhibitions than I need (I

should welcome some peace,—without three exhibitions at my throat.)[23]

One of the exhibitions to which Max referred was another at Galerie Allen, made up entirely of his recent watercolours and hung for the opening of their new gallery. All thirteen of what Bates called "watercolour ink drawings"[24] were sold. The white bearded *Man* in his green coat, red scarf against a yellow background, gazes speculatively past the viewer. In another work, *Flowers*, the blonde woman in the blue dress waits, impatiently tapping her foot beside a table that holds an opulent bouquet of flowers. Art Perry, the critic, commented on the elements of German expressionism in Bates's work. He related him to Beckmann "in the strong emphasis of expressive black line and flat areas of blatant colour. Mixing both wash and pen line together so that ink feathers through the moist paint, Bates uses the idea of accident to perfection."[25]

Only two oils sold from the non-commercial gallery at Erindale College, University of Toronto. This exhibition of his work was organized by David Blackwood, then artist-in-residence at the college. The announcement drew attention to the fact that this was the first major one-man exhibition in Ontario "by this senior Canadian artist" who was a "major influence on Western Canadian artists."[26] It was perhaps significant that Blackwood, a native of Newfoundland, should choose to organize an exhibition of works by a western painter.

Recognition from eastern Canada also came in the form of an interesting commission from the Art Investment Corporation. Twenty-four of the most prominent Canadian artists were approached for designs for tapestries to be woven in Mexico.[27] Fay Loeb from the Corporation interviewed Max, who readily agreed. He submitted his design, a variation on an oil, *Circus People*, which he had painted in 1969. Two of the figures are clowns in costume, and the third is a handyman smoking a cigarette. Despite limitations in dyeing the yarns, the clowns and their drum gave Max ample opportunity to use his well-defined shapes, his favourite stripes and fantastic headgear. His violet, orange and yellow stand out against the blue wall and green door. After some alterations Max approved the final tapestry, an edition of twenty-five was issued, and the tapestries were displayed in five major museums, including the Glenbow in Calgary.

Considering that Bates was now approaching seventy, his continuing output was impressive. John Snow sent him slides of the foothills thinking Max would be stimulated and his memory refreshed. Max painted several landscapes from them and sent one (***Untitled***, 1975) to the Snows as a present. In it the yellow stubble field is filled with snow, which lies in a mass below the dark hills and lowering sky; a winter scene which Max did not care to see in reality again.

Another, ***Alberta Landscape***, painted earlier, is striking for the tension generated between the man with his snap-brimmed fedora and furtive aspect, thrusting from the lower right corner, and the summer green of the hills, in which he is an alien, urban figure. When he and Charlotte drove with Bill and

Gisela to the Kootenays to see Dorothy Duncan, he took the opportunity to paint *Kootenay Lake*, a piece which Townshend described as "pictorially innovative ... with its unusual cloud feature."[28] In Victoria he painted *Victoria Flower Show*, with two women and one of his child images rising, as they so often did, from the front edge of the picture and gazing with innocent intensity at the viewer. He painted a restaurant, *Chez Pierre*, with copper pots hanging on the wall. As a result of all this activity, he had enough work to send to a one-man exhibition of oils and watercolours at the Upstairs Gallery in Winnipeg. In his review of the show John Graham wrote:

> his attention seems more equally divided between the biting commentary and the compositional aspects of pattern and color. It is as if he felt freed from the need to expose our masquerade as a constant duty, and was able once again to indulge in the celebration of the senses.[29]

Mary Fox, reviewing Max's exhibition of thirty-three oils at the Bau-Xi Gallery early in 1976, tended to agree:

> Looking at his works, the viewer becomes increasingly aware of Bates's love of the medium. Oils can be thick, rich and lustrous, and there is nothing to equal their quality on canvas. Bates organizes space with flat colors and with a complete disregard for perspective. He wants to tell you things, ... about paint and surface and how expressively they can interact.[30]

Max's production was interrupted by their move to Stonehewer Place. The sloping approach to the house at Lakeview had become treacherous for him. As Flemming Jorgensen recalled:

> Once again the gypsy appeared and Max had to move, this time to Oak Bay—the stronghold of the British in Victoria—to Stonehewer Place. Max said he liked the name. The house was very ordinary but perhaps a bit easier for Max to negotiate. In addition, the street was a cul-de-sac and Max could go for short walks. He had a large studio in the basement which I installed for him. I had moved his entire inventory of work—professional movers were not to be trusted in this matter."[31]

Max considered the location more convenient, but in a letter to Snow he complained: "I have been a little upset about several things I have mislaid somehow. If they turn up soon I shall feel better; but one of the worst things about moving is that there are so many things I don't seem to be able to find. This is very disagreeable but inevitable I suppose,—but the problem seems worse this time."[32] He later sent a more cheerful note on the title page of Patricia Godsell's book *Enjoying Canadian Painting*, in which *Interior with Figures* of 1961 was reproduced along with a short accompanying essay.[33]

His friends Pat Martin-Bates and Robin Skelton lived nearby, and Skelton often dropped in to chat or to discuss the publication of Max's prison camp memoirs, which were nearly completed. Skelton wrote of those visits:

In conversation at his house over a drink or two of whisky, he showed the real gentleness and generosity of his nature. There was always a new art book to be rejoiced over or a new painting by a friend or acquaintance to be admired. He did not like to talk of himself. The privileged few could go with him downstairs to his studio and Max would show his latest work without any comment save sometimes a hesitant "I like this one" or "I did that yesterday."[34]

Two of the "privileged" were Peter and Shirley Savage from Calgary, collectors and admirers of Bates's work. They recalled that Max would make outrageous statements and then watch with a quizzical look to gauge the reaction. Though the atmosphere was easy, Shirley Savage felt the penetration of his gaze and thought that "he was seeing what was inside of her outward appearance and really knew what was inside."[35]

Max still enjoyed chess and was a member of the British Columbia Chess Federation.[36] He played frequently with his brother Bill, Flemming Jorgensen and Niki Pavelic. The game inspired his poem *Chess Player*.

CHESS PLAYER

Sitting in my study reading 'Klein'
Glancing at news from Haiti,—
The ton ton Macoute are on the run
All that is fine;
But when I have some tea, will there be a
 bun?

The jet set play with money in the
 Mediterranean sand

There is a film at the Grand
That I should see, but I don't think I shall
On what kind of issue should I stand?

Shall I use the Ruy Lopez or the Benoni?
That is the important question of the day.[37]

In much the same rather aimless mood he tossed off the following:

BRING ME MY SUFIC BOOKS

Bring me my Sufic books,
A candelabra and my false teeth.
Bring me my rouge pot, oaf,
I must go to watch my rooks
At play or working the sky beneath.
Bring me a wilderness and a loaf
And most of all red wine and white
And lovely colours to my sight.
Bring me my Sufic books O Haj
And my unchristian democratic badge.[38]

As Max approached seventy, his friends in Victoria wished to honour him. Colin Graham wrote a tribute to him for *Arts West*, commenting on the "solid organization of his canvases" and his subtle thought processes and expressing the certainty that Max's works "would be permanently relevant contributions to art in Canada."[39] Graham organized a surprise retrospective in his honour at the Greater Victoria Art Gallery. When Max arrived he was rather ungracious and muttered "I hate surprises";[40] his brusque shyness reasserting itself in the face of admiring attention. He was more relaxed for a party organized at the Skelton house, the main rooms of which had been transformed into an art gallery with Max's works gathered from many sources. The

guests came as figures in his paintings: Flemming Jorgensen as a clown, Niki Pavelic as a king with a gold crown, Rita Morris and Elza Mayhew as bag ladies, and Pat Martin-Bates in a veil. Myfanwy Pavelic was almost unrecognizable in a black wig. Max sat in a chair, holding court and accepting presents. The Mayor, Peter Pollen, had consulted with Charlotte about a suitable present; Charlotte said first that Max had everything, but then added, "Maybe an ostrich egg." Pollen brought one to the party and the guests autographed it.[41] "When the party was over and the figures of his imagination were moving away into the night he thanked us in a speech of his usual length," wrote Robin Skelton. "'Thank you,' said Max, it was a good party.' And again, through his muffler as he negotiated the back step, 'Thank you,'"[42]

It was remarkable that Max had reached seventy, considering his physical condition, but Charlotte's devoted care and his own stubborn determination sustained him. Peter Daglish, visiting early in 1977, found Max in good form but thought Charlotte looked very tired.[43] The occasion of Daglish's visit was a joint exhibition of works on paper by Daglish, Bates and Snow to celebrate their twenty-one years of friendship. Peter and Max thought the show would travel fairly widely in Canada, but Max was uncertain about showing in Ontario. "I distrust the east profoundly," he wrote in 1976 to John Snow. "It has never been any good for me." He explained that he could not produce twenty works in time for a show until 1977. He had to prepare ten oils for an exhibition of works by the Limners to be hung in the Shaw-Rimington Gallery in Toronto.[44] In addition he was planning for a show of thirty oils for the Backroom Gallery in Victoria to open in October. He wrote again in the fall to say that the summer had been good and that he had got a lot done. He would have his twenty works ready for the celebration.[45] Snow arranged for the exhibition to open at the University of Calgary, and Daglish designed the invitation.

The Celebration Exhibition—Maxwell Bates, Peter Daglish, John Snow came together under the direction of Brooks Joyner of the University and hung from 7 January to 6 February 1977. In spite of offers to show the exhibition in Victoria, Vancouver and Edmonton, Joyner did not see fit to move on the matter; as a result, to Max's great disappointment, he could not see the exhibition. Max's monoprints with puppets, street scenes, and lost people contrasted with Daglish's rich lino cuts that "zap you with electricity."[46] Snow showed still-lifes, hot Greek beach scenes, and his quiet interiors. Peter Daglish came to Calgary for the opening and then went to lecture at the University of Victoria. Max was delighted to see him and attended his lecture followed by a party at Pat Martin-Bates—"one of the most memorable parties I have been to here," wrote Max. He continued, "Thursday Peter came to see us,—another good time. Then, on Friday, the Harveys, ... had an excellent dinner party for him. All very satisfactory."[47] Daglish wrote that Max was "beaming like a schoolboy and producing lots of monoprints."[48]

Ted Godwin, in Victoria to teach summer school at the university, also remarked on

Max's amazing productivity. "His quiet wit and keen mind I found as present as ever," he wrote, "and his output as an artist as prodigious."[49] Max was not only working on a series of drawings to illustrate his book *A Wilderness of Days* but was preparing for a major show at the Bau-Xi Gallery in Vancouver which would subsequently travel to their other gallery in Toronto, with the same illustrated catalogue accompanying both shows.[50] The *Wonder Woman* of 1977 is a magnificent, aggressive figure from "pop" culture, painted in red, white and blue, with hands on hips and stars on her briefs. Two of the oils, cityscapes, harked back to their trip to Europe, *Church at Nice* and *Brompton Road*. In an account of an interview with Max, Frank Nowosad wrote of these:

> They have appeared sporadically at recent shows, carrying with them an aura of subdued pleasure that reminds one of Oscar Kokoshka's city portraits. ... Watercolors by Bates have a more buoyant feel than the oils which form the bulk of his work, and are also more concerned with humor.

Max said, "There is not a big difference in the way I approach watercolors and oils, but, of course, the results are very different." Nowosad continued: "In recent years the oils have become looser and more impressionistic; the intense black outlining has dispersed and the paint is applied less consistently."[51]

When the show appeared at the Bau-Xi in Toronto, the *Globe and Mail* reviewer found

> The most astonishing aspect of this artist's work is his absolute denial of perspective. He

refuses to allow the viewer any illusionary sense of depth. Everything is brought up to the surface and tensioned there by nothing more than shapes and colors. The most compelling painting in the show, for me, is *Cocktail Party*. It is composed of minor triumphs and one crowning achievement: the vibrancy of yellow light in the dress of the central figure.[52]

Although Max's mind was as keen as ever, Ted Godwin and the Snows all noticed physical changes: an involuntary jerk of the head as though he were trying to look over his shoulder; his mouth more tightly clenched; his stooped back and slow movements. The familiar course of the Bates household was disturbed when Charlotte's mother, now very ill, was brought to Stonehewer Place for her dying months. Max found the constant presence of the hired nurses upsetting.[53] Torn between the care of her mother and her concern for Max, Charlotte became increasingly protective of him and at times—without Max's knowledge—turned away visitors, even old friends.[54] Ted Godwin did manage a visit in the company of Peter Thielsen to discuss the possibility of a major exhibition in 1978 at the Canadian Art Galleries in Calgary. Godwin was distressed at the jerks of Max's head and the grinding motion of his teeth.[55] An entry in Max's journal at that time, one of the last, offered a clue to his thoughts, "I have no more reason to be afraid of death than going to a party where I know no one."[56]

Max's increasing frailty was, to a degree, reflected in some oils of this period. The background areas were more loosely filled in

with thin paint, as though he was in a rush to get the canvas covered. His figures were not as tightly constructed, though in paintings such as *Wonder Woman* or *Woman in Blue* this does not detract from the power of the works. Frank Nowosad commented on this change, noting that Max's paintings from this time "looked hurriedly executed, the paint applied in blunt masses with gritty edges. Form and structure appear to be crumbling." Of *Woman in Blue* he wrote:

> The figure is roughly marked out with an intense cerulean blue, the folds in the blouse delineated by a few swipes of black paint. The manner in which the woman tilts her head and reaches up to her face with a withered arm conveys the impression that perhaps she too has suffered a stroke. The power of the colour and sensation of psychological distress is unsettling. ... It haunts the viewer.[57]

Max was still intensely interested in what was going on in the art world, sharing with Frank Nowosad a new book on the Colombian artist Fernando Botero.[58] He cut out of *Time* an article in which Robert Hughes castigated the vogue for realism in painting:

> The characteristics of the style are extreme deadpan literalness of image, generally repainted from photos with an air brush, immaculate precision of surface, a taste for mechanical subjects such as cars, fire trucks and long expanses of shiny kitchen ware. The average result is almost unimaginably stupid and passive.[59]

Max also kept in his files the full text of Tom Wolfe's "The Painted Word," a scathing indict-

ment of modern art and how dealers promoted it.[60] In October of 1978, Max wrote his own last word on visual art and where it was headed in a "Manifesto: A return to Manet." There he affirmed even more strongly the need for beauty. "I have said (and thought it much more often) that we should return to painting a rose in a glass of water. ... This pleasure in the sense of sight and the feeling we experience as a result of it, [it] is that to which I urge a return." After stating his admiration for the triumphs of modern art, he emphasized the need for study of art history, music, literature, all the arts. "My belief in a movement 'Back to Manet' seems necessary to me to vacate ... the widespread belief that a painter who does not make art history by introducing some entirely new development, is scarcely worthy of our attention. This is rubbish."[61]

The spring of 1978 saw the publication of Bates's prison camp memoirs, *A Wilderness of Days*,[62] a spare, unemotional account whose very restraint increases its intensity. For five years, at the peak of his career, Bates had been shut off from the world, yet there is no bitterness in the account. In his moving final paragraph he explained:

> We had all learned much, perhaps not so much as we would have learned in five years of normal living, but what we had learned could not be learned any other way. Many of us had come to despise things we had valued before, and had learned to value things that we had despised or overlooked. It was up to us whether we lapsed back into the old grooves of hypocrisy, snobbishness and humbug. At least some of us had been freed.[63]

Max produced twenty-six ink drawings to illustrate the book. On the cover is his butterfly in the barbed wire. In his review of the book, Doug Collins, a knowledgeable veteran of the war, commented on the dignity of the account and added that Bates was one of the few who knew that being sent "to the salt mines" was no joke.[64]

In July Max shipped the work for his show at the Canadian Art Galleries, and in his letter to Thielsen he wrote,

> I think it will be a good show. You will be asked about the framed gouaches. These are on discarded newspaper plates which take watercolour and gouache extremely well. I used them because of the interesting textural effect. I know of no other painter who has done this,—so I believe they are a "first."[65]

In a further letter he said that "recent shows have left me without work; so it will take a little time to have anything much on hand."[66] In fact, he had very little left in his studio. The Snows visited Max and Charlotte in August and saw his works on the newspaper plates, as well as two finished suites in ink and wash. From his memories of Rue Pigalle he drew the buildings, the showgirls, and the street characters of the area; and for the nineteen drawings of the ***Classical Suite*** he drew figures of Greek mythology with noble proportions and bearing in rich colours. Max was in the process of giving them titles when the Snows arrived, so they helped with suggestions. Max was eager to discuss with Snow the possibility of a joint show of paper works in the next year, the thirtieth anniversary of their printmaking

collaboration. They agreed on a spring show, and Max offered to design the invitation and arrange with Kyle's Gallery in Victoria for the exhibition.

Max's Calgary exhibition opened at the Canadian Art Galleries in September.[67] The variety of subjects and styles included landscapes, beautiful women, and one more self-portrait, ***Unself Portrait***, in which the barely recognizable Max is painted like a clown over one of his tachiste works. A new ***Beggar King***, mellowed and benign, is also painted over an old canvas. In *Estelle with Fan* and *Party with Violet Dress*, Max emphasized with a fan the diagonal lines of the compositions. In the background of the latter painting is the familiar dark figure of the faintly menacing man, a contrast to the flower like aspect of the beautiful woman. After the preview, people lined up in front of the gallery to buy the piece they wanted, a sight Max would have been gratified to see. In his review Brooks Joyner wrote:

> Bates is, without too much qualification, a product of the tradition of European Modernism. ... Bates has assimilated a larger international experience. These new paintings, with their hard brittle lines, striking vibrant color and mutilated forms, are a summary statement for Bates. He addresses the formal symbolism of his past work and succeeds in maintaining the enigmatic communication, emotions and visual simplicity that have made him a contemporary master, he's still the Master.[68]

Looking forward to the joint show in the spring, Max wrote Snow to tell him that he had

made the poster and was preparing a Chinese series for the exhibition. He also sent him the notice of his fall show at the Backroom Gallery, a witty drawing of a scene in the Garden Terrace of the Empress.[69] Near the end of 1978, Max attended a celebration of an exhibition of Jack Shadbolt's large Indian drawings at Kyle's Gallery. "I believe we were 10–12 painters that evening," Flemming Jorgensen wrote of the dinner in Chinatown.

> Jack Shadbolt and Max were seated at the end of a long table. Shadbolt loomed large next to short Max, Shadbolt doing a lot of talking, Max, saying little. During dinner Max got up and we thought he was about to give a speech but instead, "just have to rest my ass." (It was an all-boys night.) The following morning Max had his second stroke.[70]

The massive stroke cut short all of Max's plans for the coming year, robbing him of his speech and much of his ability to move. He was transferred to the Gorge Road Hospital, but despite the good physiotherapy he received there, his condition did not improve. Charlotte visited him every day, encouraging him, bringing him the chess moves from the newspaper. Bill and Gisela were frequent visitors and sometimes took him out in the car. The Snows went to see him when they came for the opening of the exhibition in March. The care and the concern of his family and friends was not enough. Max was a prisoner again.

For the joint show Max had designed a striking poster featuring a classical head and the thirty years emphasized in numbers and three languages. *The Daily Colonist* came to photograph Snow sorting work at the gallery without his friend. When asked about a number of Max's drawings without titles, Snow replied, "Max's work doesn't need titles."[71] The joint show opened without Max, although he did manage to get to it later, in his wheelchair. His work sold immediately to the crowd of admirers waiting at the door for the opening. "Much of the artist's work stems from his prompting of technical errors—brush smears, blotchy lines—which he tames into sharp quirky images," Nowosad wrote in his review of the show. "What Kyle's show reveals is something of a pinnacle in Bates' freewheeling musings." He contrasted Max's "high riding of spontaneity" with Snow's images, "sublime and free of agitation," and concluded that the work of the two artists "provides a satisfying balance."[72]

Bates was moved from the Gorge Hospital to the Mt. Tolmie Hospital, a long-term care institution. While he was there, the news came that he was to be awarded the Order of Canada. Charlotte and Gisela went to Ottawa to receive the award.[73] Max also heard from Xisa Huang that his work was to be included in the Fifth Dalhousie Exhibition of Drawing. For the unusual catalogue, each artist had been asked for a statement, and Max's statement was his poem, "Behold the Flowers."[74]

John Snow saw Max one more time in 1980 and remembers that in spite of Max's condition, there was no awkwardness between them, only affection. Bates died in September as the result of a choking seizure. The Snows received the news of his death when they were in New York; their son, John Vance Snow, who had known Max since he was a child, sat during the night writing his tribute.

In Memorium

MAXWELL BATES
1906–1980

The wire is sliced at last.

Dust and space, which brought
lesser spirits to their knees,
ran in his veins as hard as
1930's western grunts
when farmers got the question,
"How's the crop?"

The prophet, chronicler of Place Pigalle short fortunes,
cotton housedressed women,
survivors
beggar kings
asked for nothing,
leered at charity,
roared at tenderness
like the wind which blew
ten thousand dreams to nothing.

Beggar himself, proud as Nehemiah,
cried destruction to a world of carnivals,
sat Sibylline with the Barman,
eyes like Checkpoint Charlie searchlights,
waiting.

The man liked cocktail parties, sat in sidelines,
laid pallet traps for unwary souls,
caught innocents for self-examination,
lured social Hansels to be fattened
for his multicoloured pies.
When I was five, I thought him a goblin king,
lurking in shadows, ready to pounce.
Troll lord, when I was five.
At ten, the hunchback for his own cathedral.

The man had wire in his soul,
arteries of hatred,
a life supply of hemlock-flavoured truth.
He and the Barman liked each other, sort of.

When he died, the Hansels rushed
to pluck the painted candies from his house,
forgetting the stone centres,

inlaid with mirrors.

The Barman poured out the old man's
last straight-up drink
and didn't forget the barbed wire swizzle stick
either.[75]

Epilogue

Max's ashes lie under a plaque in the Royal Oak Cemetery in Victoria. Public tributes appeared in the Victoria,[1] Vancouver[2] and Calgary[3] newspapers and one was broadcast over the CBC. The accounts placed him among the great in Canadian art:

> He was one of Canada's finest figurative painters, with a vision as personal as any we have had.[4]

Art Perry in the Vancouver *Province* examined that personal vision:

> "Bates' art was never a pretty playground. The beauty and surface appearance of things meant nothing in his search for basic answers to our consciousness rather than our contentment. ... Current styles or contrivances were no way to reach these truths. In using a naive and instinctive line in his art, Bates freed himself from layering the truth of what he saw with art games. The only games seen in Bates's art are the games we all play with our lives. ... Bates's gift to us all was his ability to see beyond the surface and to value the precious truths and honesties when we find them amid the soulless options offered by life at every corner."[5]

The photograph accompanying the article showed Max in his last days, eyes like stones under low brows, mouth grimly shut: in the hospital, he had said to Bill, "They let you die slowly here."[6]

Jack Shadbolt's tribute in *Artscanada* was more personal, emphasizing Bates's remarkable influence on others. Shadbolt found Max exemplary of a special kind of artist:

> In the first place it has to do with their creative talents which are so convincing as to attract to them a following: but it is definitely more than that. It would seem to be a kind of total, unquestioning self-belief in the occupation of art with which they are concerned and which consumes their entire life without residue. They burn clean. In a way it is a conviction born of natural innocence however sophisticated they may appear to be. Yet beyond that, and possibly because of it, they have a moral strength which enables them to live above adversity.

Of Bates's style, Shadbolt wrote, "He had a kind of unvarnished, awkwardly angular actuality of form, never prettied up, which was yet so psychologically telling in its summariz-

Coming Attractions and *A House Full of Women*, and since then have matched others up with whatever suitable books came along.[24]

Both books are collections of short stories, and on the first the press used the lithograph, *Figures at a Table*, which Max had done for the Simon Fraser exhibition of 1968; for the second, by Elizabeth Brewster, they picked *Cocktail Party #3*. From 1983 to 1986 Oberon Press published six books in hard and soft cover with Max's work on them.[25] For the cover of *Lives of the Saints* by Nino Ricci, winner of the 1990 Governor-General's Award,[26] Cormorant Press chose Bates's 1967 watercolour *Scarecrow*, the painting which ruined the customs officer's lunch when Max and Herbert Siebner were crossing the United States border.

Towards the end of the 1980s, prints made by Bates and Snow were again on exhibit in joint shows. An account of their pioneering explorations in lithography appeared in *Printmaking in Alberta, 1945–1985* by Bente Roed Cochran.[27] Canadian Art Galleries showed the early prints from the fifties and sixties, when the artists experimented together on the limestone slabs and press. Nancy Tousley wrote of this exhibition: "Watching Bates and Snow converse, seeing them work in concert and apart, influencing each other and going their separate ways, is a pleasure. It's also a dialogue that contributed a significant chapter to the history of Alberta art."[28] The prints of Bates and Snow were joined by those of Barry Smylie in a travelling exhibition, Friends and Mentors: Maxwell Bates, Barry Smylie and John Snow, mounted by the Muttart Art Gallery, Calgary.[29] Smylie had expanded on his early experience with the presses through study at Sir George Williams University in Montreal. The exhibition was designed to illuminate the printmaking process and show the varied results produced on the same presses. As curator Richard L. White wrote, "Friends and Mentors is an exhibition about the common artistic discoveries of three gifted Alberta lithographers ... a testament to their success in establishing lithography as an integral part of Alberta's visual arts."[30]

The Snows had advertised in British periodicals, hoping to trace some of the work Bates had done while in England. The only echo from that past was a clipping from the *Eastbourne Herald* reporting an exhibition at the Towner Art Gallery which celebrated the achievements of Lucy Wertheim, Bates's redoubtable patron during his years in England. The account detailed her success in introducing modern British art to the public and characterized her as "one of the most determined and charismatic figures of the gallery scene in the 1930s."[31] The Snows took further action when, concerned that Bates's records and papers might be lost, they asked Charlotte's permission to gather them up and deposit them in the Special Collections at the MacKimmie Library of the University of Calgary. Charlotte was still living in Stonehewer Place with round-the-clock helpers, and with Charlotte's supervision, working every day for a week, the Snows packed eight boxes which were shipped to the University in Calgary.

These records, together with those of the Canadian Architectural Archives, were used when Bates's architectural achievements were recognized in an exhibition at the Nickle Arts Museum, University of Calgary in 1992. The Architecture of Maxwell Bates[32] was researched and arranged by a group of students—Christine J. Fraser, Cammie McAtee, Mace Mortimer and Brendan Tomlins—under the direction of Professor Geoffrey Simmins, art historian. Bates's drawings and plans were exceptionally well-mounted and provided the first examination of this aspect of Bates's career, part of his life which had been interrupted by war and terminated by his illness. The students' essays[33] in the catalogue explored various facets of his work, suggested possible architectural influences, and traced his movement towards architectural modernism. In an extensive review of the exhibition, Nancy Tousley drew attention to the fact that

> Bates did his Calgary churches during the 1950s, stripping Gothic Revival architecture of its fussier details and giving his work a clean, updated look that is still resonant with ecclesiastical tradition. St. Mary's, the largest and most important of his commissions, is dramatically proportioned and almost austere in its modern simplicity.[34]

Max Bates's home and studio remained much as he had left it, and after a severe stroke hospitalized Charlotte, the house was empty. When she died in September of 1991, it appeared that everything had been left to her brother, E. Kintzle, a resident of the United States. Charlotte had previously indicated that she wished the bulk of Bates's remaining work to be held at the Art Gallery of Greater Victoria, which had already benefitted from her donations. The gallery intended to create a centre for the study of Max's work, and to that end, they had already catalogued the contents of the studio.[35] They had also made available for sale a video about Bates and his work, *Art on Video: Maxwell Bates*.[36] However, with seeming disregard for Max's achievements or the aspirations of the gallery, and to the dismay of Max's friends and admirers, Kintzle directed that everything be sold at auction. Nicholas Tuele, curator of the Art Gallery of Greater Victoria, termed it "an unmitigated disaster."[37] At the crowded auction held on 9 June 1992, the gallery managed to procure some of the works, along with Bates's easel with its unfinished painting and other furniture from the studio.[38] Prices were high,[39] not only for Bates's work but for the paintings, ceramics and sculpture which he had collected. A further auction of the artist's prints was held on 1 September 1992, and that completed the dispersal of Bates's works.

There is no doubt of Max Bates's importance to art in western Canada. Over the years several writers have commented on the lack of attention paid to him in central Canada. Christopher Varley, curator of the exhibition Winnipeg West: Painting and Sculpture in Western Canada, 1945–1970, reproduced two of Bates's works in the catalogue and wrote of him as "tough and uncompromising, yet fundamentally generous. ... Bates' importance to western Canada still appears to be poorly understood, in part because so many of his

paintings were so bad or derivative."[40] David Burnett and Marilyn Schiff, discussing his work in *Contemporary Canadian Art*, wrote:

> Artistic activity in the Calgary he left in 1931 and the city to which he returned in 1946 was severely restricted in both quality and quantity. With few exceptions the art being made was an amateur version of landscape and still-life subjects. From the start, Bates broke this pattern. ... In his own work he sought an approach which was singular and imaginative; he produced paintings of raw expressive strength, sometimes explosive, sometimes derivative, sometimes bad, but never dull.[41]

Though Bates drew on many sources for his work—his own capacity for observation, his background in architecture and art, his study of modern art, his extensive reading—he was able to weld them together and stamp them with his personal vision. In his search he explored the work of poets and novelists and the literature of mysticism, philosophy and astrology; in his art and architecture, he employed powerful and ancient symbols to express the unknown or the inexpressible. As he painted the familiar and the commonplace, wooden tables, flowers, buildings, workmen, people in cafés or at cocktail parties, prairie farms or Saanich countryside, he hoped to awaken in the viewer unfamiliar and fresh perceptions. What many thought was satiric commentary or cynicism in his depiction of people, others saw as a clear-sighted, compassionate, even a loving view of humanity. In his own life he showed dedication to his art, stubborn courage, kindness and humour.

Max's eidetic gift and penetrating perceptions enabled him to achieve his aim of directness, simplicity and intensity. What his inner and outward eye saw, his skill ensured that the energy in the work continues to pulse. Much of that energy came from Bates's reliance on the Hegelian triad, the resolution of opposites to a new harmony. Even as a child he had been aware of the polarities of living beauty and death, and in his maturity he was open to both. His notes are full of what he saw as the necessity in art to bring together opposites in a momentary and sharp resolution. He wrote:

> The artist moves in a forest of intimations of how opposites may be resolved, polarities apprehended, the abyss between their terms, absurdities understood. A work of art therefore is an answer we are badly in need of—we should say a masterpiece, not merely a work of art. The answer is on the side of cooperation, integration, togetherness as opposed to isolation and chaos. The answer is moral. It is the religious statement of affirmation.[42]

Notes

Unless otherwise indicated, the journals, notes, correspondence, unpublished manuscripts, and miscellaneous papers of Maxwell Bates are all held in the Maxwell Bates fonds, Special Collections Division, MacKimmie Library, University of Calgary.

Notes to Chapter 1

1. Ian M. Thom, *Maxwell Bates: A Retrospective: Une Rétrospective* (Victoria: Art Gallery of Greater Victoria, 1982), 7.

2. William Bates, Interview, 20 March 1988.

3. Bryan P. Melnyk, *Calgary Builds: The Emergence of an Urban Landscape, 1905–1914* (Alberta Culture: Canadian Plains Research Centre, 1985), 21.

4. Ibid., 32.

5. Ibid.

6. Ibid., 138.

7. Patricia Jasen, *An Introduction to the Architecture of William Stanley Bates* (Alberta Historical Research Foundation, 1987), 5.

8. Ibid., 59.

9. Ibid.

10. Ibid., 70.

11. P.K. Page, "Max and my mother: A memoir," *Border Crossings* 7 (October 1988), 74.

12. M. Bates in a taped interview with P.K. Page, 1973. Copy in possession of J.H. and K. Snow. Edited transcript, "The self-contained castle," *Border Crossings* 7 (October 1988), 77–79.

13. M. Bates, "Biographical notes."

14. M. Bates, Interview, P.K. Page.

15. Ibid.

16. J.H. Snow, Interview, 10 May 1986.

17. P.K. Page, "Max and my mother," 74.

18. P.K. Page, Interview, 9 October 1986.

19. M. Bates, Notes.

20. Ibid.

21. M. Bates, Interview, P.K. Page.

22. M. Bates, Notes.

23. M. Bates in the edited transcript of a taped interview with Terry Guernsey in *Maxwell Bates in Retrospect 1921–1971* (Vancouver: Vancouver Art Gallery, 1973), 18.

24. M. Bates, "Biographical notes."

25. Ibid.

26. M. Bates, *Vermicelli*. Unpublished manuscript.

27. M. Bates in an unedited taped interview with Terry Guernsey, November 1972. Copy in J.H. Snow Papers.

28. Glen MacDougall, Interview, 4 January 1988.

29. P.K. Page, Interview, 31 May 1988.

30. William Bates, Interview, 20 March 1988.

31. Della Scott Foster, Interview, 4 June 1988.

32. M. Bates, "Biographical notes."

33. M. Bates, Interview, P.K. Page.

34. P.K. Page, Interview, 9 October 1986.

35. M. Bates, Interview, P.K. Page.

36. P.K. Page, "Max and my mother," 76.

37. P.K. Page, "Maxwell Bates, The Print Gallery, Victoria, February–March 1970," *Artscanada* 27 (April 1970), 62.

38. M. Bates, Interview, P.K. Page.

39. M. Bates, "Biographical notes."

40. P.K. Page, Interview, 9 October 1986.

41. M. Bates, Interview, P.K. Page.

42. P.K. Page, "Max and my mother," 74.

43. M. Bates, "Waking in the Morning," *Far-Away Flags* (Vancouver: Seymour Press, 1964), 1.

44. M. Bates, "Sky Flowers." Unpublished play.

45. M. Bates, "The Kite," *Far-Away Flags*, 2.

46. P.K. Page, "Max and my mother," 76.

47. Nancy Townshend, *Maxwell Bates: Landscapes/Paysages 1948–1978* (Medicine Hat, Alberta: Medicine Hat Museum and Art Gallery, 1982), 9.

48. M. Bates, Interview, P.K. Page.

49. Robin Skelton, "Maxwell Bates: Experience and reality," *The*

Malahat Review 20 (October 1971), 58.

50. M. Bates, "Biographical notes."

51. M. Bates, "The painter, W.L.S.: A memoir," Unpublished manuscript.

52. Ibid.

53. Ibid.

54. J. Russell Harper, *Painting in Canada: A History* (Toronto: University of Toronto Press, 1966), 346.

55. M. Bates, "The painter, W.L.S."

56. M. Bates, Interview, P.K. Page.
57. M. Bates, "Biographical notes."

58. M. Bates, "The painter, W.L.S."

59. I.M. Thom, 6.

60. M. Bates, "The painter, W.L.S."

61. Ibid.

62. M. Bates, Interview, P.K. Page.

63. M. Bates, "The painter, W.L.S."

64. Ibid.

65. Helen Collinson, "Lars Haukaness: Artist and instructor," *Alberta History* 32 (Autumn 1984), 13.

66. M. Bates, "The painter, W.L.S."

67. Ibid.

68. D. Foster, Interview, 4 June 1988.

69. M. Bates, "The painter, W.L.S."

70. N. Townshend, 11.

71. M. Bates, "The painter, W.L.S."

72. Ibid.

73. "Profiles: M. Bates," *Highlights* 6 (June 1952), 7.

74. J.H. Snow, Interview, 10 May 1986.

75. *Modern Paintings in the Catalog of the Helen Birch Bartlett Memorial* (Chicago: Art Institute of Chicago, 1926), 2.

76. M. Bates, Notes.

77. *Modern Paintings*, 3.

78. M. Bates, "Night Mutter," *Far-Away Flags*, 4.

79. Eileen Learoyd, "Artist Maxwell Bates—A man of blunt honesty," *Daily Colonist* (Victoria, B.C.), 8 September 1963.

80. M. Bates, "Foreword." Unpublished manuscript.

81. M. Bates, "October Evening," *Far-Away Flags*, 6.

82. R. Skelton, "Maxwell Bates," 60.

83. M. Bates, "Bricks and Leaves," *Far-Away Flags*, 3.

84. I.M. Thom, 6.

85. Patricia Jasen, "One who stayed: Career of architect William Stanley Bates," *Society for the Study of Architecture in Canada Bulletin* (March 1988), 8.

86. P. Jasen, "One who stayed," 140.

87. M. Bates, Interview (unedited), T. Guernsey.

88. John H. Cook, Interview, 15 September 1988.

89. Roger Boulet, *A.C. Leighton: A Retrospective Exhibition* (Edmonton: Edmonton Art Gallery, 1981), 14.

90. M. Bates, Notes.

91. R. Boulet, *A.C. Leighton*, 14.

92. M. Bates, Notes.

93. M. Bates in a taped interview with Frank Nowosad, 1977. Copy of the tape in the possession of J.H. and K. Snow.

94. M. Bates, National Gallery of Canada, Artists' Information Form, 1959.

95. E. Learoyd, "Artist Maxwell Bates."

96. Ibid.

97. R. Skelton, "Maxwell Bates," 61.

98. M. Bates, Notes.

99. M. Bates, Notebook of sales.

Notes to Chapter 2

1. Eileen Learoyd, "Artist Maxwell Bates—A man of blunt honesty," *Victoria Daily Colonist*, 8 September 1963.

2. Ibid.

3. M. Bates, *Vermicelli*. Unpublished manuscript.

4. M. Bates, "Biographical notes."

5. M. Bates, "Sounds."

6. M. Bates in a taped interview with Bill Stavdal, 1968. Transcription in Papers.

7. M. Bates, Notes.

8. *Three Painters and Three Sculptors* (London: Bloomsbury Gallery, 1931).

9. M. Bates, "Biographical notes."

10. M. Bates, Notebook of sales.

11. Lucy Wertheim, *Adventure in Art* (London: Nicholson and Watson, 1947).

12. Ibid., 47.

13. Ibid., ix.

14. M. Bates, *Vermicelli*.

15. M. Bates, Notebook of sales.

16. L. Wertheim, 10.

17. Maria Tippett, *Emily Carr: A Biography* (Markham, Ontario: Penguin Books, 1982), 95.

18. L. Wertheim, 50.

19. Ibid., 51.

20. M. Bates, "On naïve painting," *Phoebus Calling* (Spring 1934), 20–23.

21. Ibid., 20.

22. Ibid., 21.

23. Ibid., 22.

24. Ian M. Thom, *Maxwell Bates: A Retrospective: Une Rétrospective* (Victoria: Art Gallery of Greater Victoria, 1982), 8.

25. M. Bates, "Biographical notes."

26. M. Bates, in a taped interview with P.K. Page, 1973. Copy of tape in possession of J.H. and K. Snow.

27. M. Bates, "Biographical notes."

28. M. Bates, "Street Music," *Far-Away Flags* (Victoria: Seymour Press, 1964), 8.

29. M. Bates, Notes.

30. M. Bates, Interview, P.K. Page.

31. M. Bates, "Journey to a Little Beyond the World," *Far-Away Flags*, 10.

32. P.K. Page, "Max and my mother: A memoir," *Border Crossings* 7 (October 1988), 76.

33. Herbert Read, *Paul Nash* (Harmondsworth, England: Penguin, 1944), 10.

34. Ibid., 13–14.

35. Robert Hughes, "English art in the twentieth century," *Nothing If Not Critical: Selected Essays on Art and Artists* (New York: Knopf, 1990), 178–79.

36. Robin Skelton, "Maxwell Bates: Experience and reality," *The Malahat Review* 20 (October 1971), 63.

37. Cynthia Bates Aikenhead, Interview, 4 May 1988.

38. Royal Institute of British Architects, Files.

39. Ibid.

40. William Bates, Interview, 8 May 1987.

41. George White, Interview, 15 October 1988.

42. M. Bates, "Biographical notes."

43. Ibid.

44. M. Bates, Notebook of sales.

45. M. Bates, "Beach," *Far-Away Flags*, 13.

46. M. Bates, Notebook of sales.

47. Brinsley Ford, Interview, 8 October 1988.

48. Ibid.

49. M. Bates, Notebook of sales.

50. B. Ford, Interview.

51. M. Bates, Notebook of sales.

52. B. Ford, Interview.

53. Ibid.

54. J.H. Snow, Interview, 8 October 1988.

55. B. Ford, Interview.

56. Ibid.

57. Ibid.

58. M. Bates, "Biographical notes."

59. I.M. Thom, *Maxwell Bates*, 7.

60. M. Bates, "Evening of an Actress," *Far-Away Flags*, 22.

61. Quoted in Richard Cork, "Desperate Defiance," *Listener*, 27 November 1986, 20.

62. Ibid.

63. Ibid.

64. Ibid.

65. Joyce Zemans, *Jock Macdonald: The Inner Landscape: A Retrospective Exhibition* (Toronto: Art Gallery of Ontario, 1981), 109.

66. R. Skelton, "Maxwell Bates," 81.

67. R. Cork, "Desperate Defiance."

68. M. Bates, Prison journal.

69. *Surrealism in Canadian Painting* (London, Ontario: London Public Museum and Art Gallery, 1964).

70. M. Bates, Notes.

71. M. Bates, "Song of the Earth," *Far-Away Flags*, 18.

72. M. Bates, National Gallery of Canada, Artists' Information Form, 1959.

73. *Paintings by Maxwell Bates* (London: Wertheim Gallery, 1937).

74. M. Bates, Artists' Information Form.

75. M. Bates, "Biographical notes."

76. M. Bates, *Vermicelli*.

77. M. Bates, "Chronicles of a Forgotten House," in *Vermicelli*.

78. M. Bates, *Vermicelli*.

79. R. Skelton, "Maxwell Bates," 64.

80. M. Bates, "The Dentist of the Rue Mahomet," in *Vermicelli*.

81. Ibid.

82. M. Bates, Artists' Information Form.

83. M. Bates, "Biographical notes."

84. *Paintings by Maxwell Bates* (London: Wertheim Gallery, 1937). Bates frequently cited the date of his London one-man exhibition as 1938. The notice in the library of the Victoria and Albert Museum gives the date as 25 November 1937.

85. M. Bates, Artists' Information Form.

86. "Former Albertan's painting in Academy," *Calgary Albertan*, 13 May 1939.

87. From the evidence of the poem "Paris 1938," it would seem that Bates made a second trip to Paris.

88. M. Bates, "Paris 1938," *Far-Away Flags*, 36.

89. Doris Schmidt, "Biography," in *Max Beckmann: A Retrospective*, eds. Carla Schultz-Hoffmann and Judith D. Weiss (St. Louis: St. Louis Art Museum/Prestel-Verlag, Munich/W.W. Norton, New York and London, 1984), 461.

90. "Modern German art—till now," *Studio* (September 1938), 160.

91. Ibid.

92. Stephan Lackner, "Max Beckmann: Memories of a friendship," *Arts Yearbook* 4 (1961), 123.

93. Ibid.

94. Jane D. Burke, "An introduction to the self-portraits," *Max Beckmann: A Retrospective*, 57.

95. "Catalogue: Paintings," *Max Beckmann: A Retrospective*, 264.

96. Ibid., 258.

97. Sheldon Cheney, *Expressionism in Art*, rev. ed. (New York: Tudor Publishing, 1948), 93.

98. S. Lackner, "Max Beckmann," 121.

99. L. Wertheim, 85–6.

100. Ibid.

101. Andrew Bogle, Letter to R. L. Harpham, 14 October 1988. J.H. Snow Papers.

102. L. Wertheim, Letter to M. Bates, 31 May 1959.

103. M. Bates, "Biographical notes."

104. M. Bates, Artists' Information Form.

105. R. Skelton, "Maxwell Bates," 82.

106. M. Bates, "Biographical notes."

107. R. Skelton, "Maxwell Bates," 83.

108. Ibid.

Notes to Chapter 3

1. Maxwell Bates, *A Wilderness of Days* (Victoria: Sono Nis Press, 1978).

2. M. Bates, Prison notebook.

3. Leo Keys, Interview, 21 October 1988.

4. Eileen Learoyd, "Artist Maxwell Bates: A man of blunt honesty," *Victoria Daily Colonist*, 8 September 1963.

5. M. Bates, *Wilderness*, 12.

6. Ibid., 15.

7. Ibid., 12.

8. M. Bates, "Before the Deluge," *Far-Away Flags*, 44.

9. M. Bates, *Wilderness*, 19.

10. Ibid., 19.

11. Ibid., 21.

12. Ibid., 22.

13. Ibid., 23.

14. Ibid.

15. Ibid., 32.

16. Ibid., 33.

17. Ibid., 36.

18. Robert.MacDonald, Interview, 15 October 1988.

19. M. Bates, *Wilderness*, 36.

20. Ibid., 37.

21. R. MacDonald, Interview.

22. Ibid.

23. M. Bates, *Wilderness*, 39.

24. R. MacDonald, Interview.

25. M. Bates, *Wilderness*, 41.

26. Ibid., 42.

27. Ibid., 40.

28. Ian M. Thom, *Maxwell Bates: A Retrospective: Une Rétrospective* (Victoria: Art Gallery of Greater Victoria, 1982), 9.

29. M. Bates, *Wilderness*, 45.

30. George White, Interview, 10 October 1988.

31. W.B. Payne, Letter to Charlotte Bates, 23 February 1988.

32. M. Bates, *Wilderness*, 48.

33. Ibid., 47.

34. Ibid., 51.

35. Ibid.

36. R. MacDonald, Interview.

37. M. Bates, *Wilderness*, 48.

38. Ibid., 63.

39. Ibid., 49.

40. Ibid., 59.

41. Ibid., 50.

42. Ibid., 49.

43. R. MacDonald, Interview.

44. M. Bates, *Wilderness*, 58.

45. R. MacDonald, Interview.

46. *Prisoner of War* (London: 3.6). Copy in Papers.

47. R. MacDonald, Interview.

48. M. Bates, *Wilderness*, 51.

49. G. White, Interview.

50. M. Bates, *Wilderness*, 84.

51. R. MacDonald, Interview.

52. Ibid.

53. Leo Keys, Interview, 16 October 1988.

54. R. MacDonald, Interview.

55. L. Keys, Interview.

56. R. MacDonald, Interview.

57. Ibid.

58. Ibid.

59. G. White, Interview.

60. R. MacDonald, Letter to author, 24 April 1988.

61. Margaret Perkins Hess, Interview, 26 March 1989.

62. G. White, Interview.

63. R. MacDonald, Interview.

64. Gisela Bates, Letter to author, 20 August 1990.

65. M. Bates, *Wilderness*, 86.

66. L. Keys, Interview.

67. G. White, Interview.

68. *Encyclopedia of World War Two* (New York: Simon and Schuster 1978), 279.

69. M. Bates, *Wilderness*, 85.

70. G. White, Interview.

71. M. Bates, Prison notebook.

72. Ibid.

73. Ibid.

74. G. White, Interview.

75. M. Bates, Prison notebook.

76. M. Bates, "On the Little Side," *Far-Away Flags*, 43.

77. M. Bates, Prison notebook.

78. Ibid.

79. Ibid.

80. M. Bates, "Behold the Flowers," *Far-Away Flags*, 40.

81. M. Bates, Prison notebook.

82. Ibid.

83. Ibid.

84. "Calgary artist moved old masters in war," *Calgary Albertan*, 29 March 1956.

85. L. Keys, Interview.

86. M. Bates, *Wilderness*, 65.

87. Ibid., 70.

88. Ibid., 69.

89. Ibid., 71.

90. Ibid., 74.

91. Ibid.

92. K. MacDonald, Interview.

93. M. Bates, "Barbed Wire," *Far-Away Flags*, 42.

94. *Encyclopedia*, 163.

95. L. Keys, Interview.

96. M. Bates, *Wilderness*, 90.

97. Ibid., 98.

98. L. Keys, Interview.

99. R. MacDonald, Interview.

100. M. Bates, *Wilderness*, 112.

101. Ibid., 111.

102. Ibid., 95.

103. Ibid., 108.

104. Ibid., 117.

105. Ibid., 121.

106. Ibid., 122.

107. Ibid., 106.

108. Ibid., 130.

109. Ibid., 132.

110. Ibid., 133.

111. Ibid.

112. M. Bates, *Wilderness*, 133.

113. R. MacDonald, Interview.

114. "Export License" (London: Board of Trade, 1945).

115. William Bates, Interview, 20 March 1988.

116. Robin Skelton, "Maxwell Bates: Experience and reality," *The Malahat Review* 20 (October 1971), 86.

117. G. White, Interview.

Notes to Chapter 4

1. William Bates, Interview, 17 October 1986.

2. W. Mason, *Prisoners of War: Official History of New Zealand in the Second World War, 1939–45* (Wellington: War History Branch, Dept. of Internal Affairs, 1954). Copy in Papers.

3. M. Bates, "Calgary," *Far-Away Flags*, 49.

4. Glen MacDougall, Interview, 14 January 1988.

5. Files, Royal Institute of British Architects, London.

6. *William Stanley Bates, Index of Buildings* (Calgary: Glenbow-Alberta Institute, n.d.).

7. A.F. Key, "The Calgary Arts Centre," *Canadian Art* (May 1947), 122.

8. Janet Mitchell, Interview, 30 October 1989.

9. Joyce Zemans, *Jock Macdonald: The Inner Landscape: A Retrospective Exhibition* (Toronto: Art Gallery of Ontario, 1981), 15.

10. Ibid., 42.

11. Grace Turner, Interview, 20 July 1986.

12. J. Zemans, *Jock Macdonald*, 49.

13. Margaret Perkins Hess, Interview, 2 April 1989.

14. J. Zemans, *Jock Macdonald*, 115–16.

15. Ibid., 120.

16. Illingworth H. Kerr, Interview, 16 July 1986.

17. M. Bates, Notes.

18. Ted Godwin, Interview, 16 July 1986.

19. J. Zemans, 130.

20. Ibid., 132.

21. M. Bates, Notes.

22. James W.G. Macdonald, "Heralding a new group," *Canadian Art* 5 (1947), 35–36.

23. John D. Turner, *Sunfield Painter: The Reminiscences of John Davenall Turner* (Edmonton: University of Alberta Press, 1982), 110.

24. Grace Turner, Interview.

25. *Exhibition of Paintings by Maxwell Bates, 25 January–1 February 1947* (Calgary: Canadian Art Galleries, 1947).

26. W. Bates, Interview, 8 May 1987.

27. "Chicken Inn letters flocking in," *Sunday Magazine, Calgary Herald*, 28 January 1990, 13.

28. Frank Palmer, Interview, 12 November 1986.

29. G. MacDougall, Interview.

30. I.H. Kerr, Interview.

31. "War experiences add to background: Maxwell Bates exhibition at the Art Gallery," *Vancouver Daily Province*, 7 May 1947.

32. Mildred V. Thornton, "Bates' exhibition draws interest at Art Gallery," *Vancouver Sun*, 6 May 1947.

33. G. MacDougall, Interview.

34. M. Bates, "To a Lady Never Met," *Far-Away Flags*, 48.

35. M. Bates, "Woman," *Far-Away Flags*, 48.

36. Ian M. Thom, *Maxwell Bates: A Retrospective: Une Rétrospective* (Victoria: Art Gallery of Greater Victoria, 1982), 12.

37. Ibid.

38. I.H. Kerr, Unpublished statement, December 1988. J.H. Snow Papers.

39. Ibid.

40. M. Bates, "Graphic Arts in Alberta," *Highlights* 2 (March 1948), 3.

41. I. Kerr. Unpublished statement.

42. F. Palmer, Interview.

43. J. Mitchell, Interview.

44. J.H. Snow, Interview, 4 June 1988.

45. I. Kerr, Interview.

46. M. Bates, "Children's art classes. Paper. Calgary Provincial Institute of Technology and Art, 1947.

47. Ibid.

48. I. Kerr, Interview, 30 November 1988.

49. Kathleen Perry, Interview, 12 November 1986.

50. T. Godwin, Interview.

51. Roy Kiyooka, Interview, 15 July 1988.

52. M. Bates in an unedited taped interview with Terry Guernsey, November 1972. Transcript in files of the Vancouver Art Gallery.

53. I. Kerr, Interview, 16 July 1986.

54. J.S., "28 oils and watercolours by Calgary artist," *Saskatoon Star-Phoenix*, 1 October 1947.

55. J. Macdonald, "Heralding a new group," 35.

56. G.H. Tyler, Letter to M. Bates, 22 February 1948.

57. J.S., "Calgary group of artists," *Saskatoon Star-Phoenix*, 11 September 1948.

58. J.H. Snow, Interview, 4 October 1986.

59. I. Kerr, Interview.

60. I.M. Thom, *Maxwell Bates*, 12.

61. M. Bates, "Some problems of the environment," *Highlights* 2 (December 1948), 2–3.

62. *Illingworth Kerr; Fifty Years a Painter* (Edmonton: Edmonton Art Gallery, 1963).

63. M. Bates, "Prairie from a Train Window," *Far-Away Flags*, 51.

64. J.H. Snow, Interview.

65. M. Bates, Notes.

66. M. Bates in a taped interview with P.K. Page, 1973. Copy of tape in possession of J.H. and K. Snow. Edited transcript, "The self-contained castle," in *Border Crossings* 7 (October 1988), 77–79.

67. I. Kerr, Interview, 30 November 1988.

68. Tom Baines, Interview, 24 April 1990.

69. *Maxwell Bates in Retrospect 1921–1971* (Vancouver: Vancouver Art Gallery, 1972), 31.

70. M. Bates, Letter to the Editor, *Atlantic Monthly*, 24 December 1948.

71. M. Bates, "Art and snobbery," *Highlights* 3 (March 1949), 2–3.

72. M. Bates, Notes.

73. M. Bates, "Art and snobbery."

74. Bente R. Cochran, *Printmaking in Alberta, 1945–1985* (Edmonton: University of Alberta Press, 1989), 17.

75. I.M. Thom, *Maxwell Bates*, 12.

76. *William Stanley Bates, Index of Buildings* (Calgary: Files of the Glenbow-Alberta Institute, n.d.).

77. G. MacDougall, Interview.

78. W. Bates, Interview, 10 March 1989.

79. M. Bates, "Plans for work."

80. Ibid.

Notes to Chapter 5

1. Doris Schmidt, "Biography," *Max Beckmann: A Retrospective*, eds. Carla Schultz-Hoffmann and Judith C. Weiss (St. Louis: St. Louis Art Museum/Prestel Verlag, Munich/W.W. Norton, New York and London, 1984), 461.

2. Ibid.

3. Grace Turner, Interview, 20 July 1986.

4. M. Bates, Notebook of sales.

5. Edwina McCaffary Mair, Interview, 15 February 1989.

6. Daisy Benbow, Interview, 14 March 1988.

7. "Mrs. Maxwell Bates, prominent nurse, dies," *Calgary Herald*, 3 June 1952.

8. Helen Knight, Interview, 15 February 1989.

9. "Mrs. Maxwell Bates."

10. J.H. Snow, Interview, 10 March 1988.

11. George White, Interview, 10 October 1988.

12. John Aikenhead, Interview, 15 June 1990.

13. Robin Skelton, "Maxwell Bates: Experience and reality," *The Malahat Review* 20 (October 1971), 87.

14. Frank Palmer, Interview, 12 November 1986.

15. Walter Barker, "Beckmann as teacher; An extension of his art," *Max Beckmann: Retrospective*, 177.

16. Ibid., 177–78.

17. Ibid.

18. M. Bates, Prison notebook.

19. R. Skelton, "Maxwell Bates," 87.

20. Ibid.

21. Sarah O'Brien-Gwohig, "Beckmann and the city," *Max Beckmann: A Retrospective*, 92.

22. Ibid.

23. Ibid., 105.

24. Peter Selz, "The years in America," *Max Beckmann: A Retrospective*, 166.

25. Stephan Lackner, "Max Beckmann: Memories of a friendship," *Arts Yearbook* 4 (1961), 123.

26. Carla Schultz-Hoffmann, "Bars, fetters and masks: The problem of constraint in the work of Max Beckmann," *Max Beckmann: A Retrospective*, 18.

27. P. Selz, "The Years," 166.

28. S. Lackner, "Max Beckmann," 123.

29. Peter Beckmann, "Beckmann's path to freedom," *Max Beckmann: A Retrospective*, 11.

30. M. Bates, Notes.

31. P. Beckmann, 11.

32. Illingworth Kerr, Interview, 16 July 1986.

33. M. Bates in an unedited taped interview with Terry Guernsey, November 1972.

34. M. Bates in a taped interview with P.K. Page, 1973. Copy of tape in the possession of J.H. and K. Snow.

35. M. Bates, Interview, T. Guernsey.

36. Ibid.

37. Illingworth Kerr, "Maxwell Bates, dramatist," *Canadian Art* 13 (Summer 1956), 326.

38. M. Bates, Notes.

39. Ibid.

40. Ibid.

41. J.W.G. Macdonald, Letter to M. Bates, 23 April 1950. Collection of McCord Museum.

42. J. Russell Harper, *Painting in Canada: A History*, 2nd ed. (Toronto: University of Toronto Press, 1977), 345.

43. Ibid., 346.

44. Tom Joyce, Interview, 15 May 1987.

45. Helen Knight, Interview, 15 February 1989.

46. Ted Godwin, Interview, 16 July 1986.

47. Glen MacDougall, Interview, 14 January 1988.

48. I. Kerr, "Maxwell Bates, dramatist," 324.

49. Janet Mitchell, Interview, 5 June 1988.

50. William Bates, Interview, 8 May 1987.

51. Allan Mogridge, Interview, 15 November 1989.

52. M. Bates, "Restlessness in modern architecture." Unpublished manuscript.

53. Ian M. Thom, "Maxwell Bates," *Visual Arts Newsletter* 5 (Winter 1983), 3.

54. I. Kerr, Interview, 30 November 1988.

55. I. Kerr, "Maxwell Bates, dramatist," 326.

56. M. Bates, Notes.

57. Margaret Perkins Hess, Interview, 2 April 1989.

58. Art Gallery of Ontario, Letter to M. Bates, 8 December 1952.

59. Nancy Townshend, *Maxwell Bates: Landscapes/Paysages 1948–1978* (Medicine Hat, Alberta: Medicine Hat Museum and Art Gallery, 1982), 15.

60. F. Palmer, Interview.

61. M. Bates, Notes.

62. Ibid.

63. J.H. Snow, Interview, 4 May 1988.

64. *Greg Arnold: Painting, Constructions* (Calgary: Triangle Gallery, 1989).

65. "Calgary art hung," *Calgary Albertan*, 24 October 1941.

66. Robert Ayre, "Western painting comes to Montreal," *Canadian Art* 9 (Christmas 1951), 58.

67. J. Macdonald, Letter to M. Bates, 17 March 1951.

68. Paul Duval, *Canadian Drawings*

and Prints (Toronto: Burns and MacEachern, 1952), 82.

69. Paul Duval, *Canadian Water Colour Painting* (Toronto: Burns and MacEachern, 1954), 80.

70. Kathleen Perry, Interview, 12 November 1986.

71. M. Bates, "The Tiger," *Far-Away Flags*, 51.

72. "Mrs. Maxwell Bates."

73. M. Bates, "Neon City," *Far-Away Flags*, 53.

74. M. Bates, "Pain," *Far-Away Flags*, 54.

75. Roy Kiyooka, Interview, 15 July 1988.

76. Azelie Clark, Interview, 10 May 1988.

77. William Bates, Interview, 17 October 1986.

78. Dushan Bresky, "Stronger civic pride advocated by artists," *Calgary Herald*, 26 May 1953.

79. I. Kerr, "Maxwell Bates, dramatist," 326.

80. M. Bates, "Intimations," *Far-Away Flags*, 55.

81. M. Bates, "Vision," *Far-Away Flags*, 55.

82. M.P. Hess, Interview, 28 March 1989.

83. J. Mitchell, Interview, 30 October 1989.

84. M. Bates, "The existential direction in painting." Unpublished manuscript.

85. Joyce Zemans, *Jock Macdonald: The Inner Landscape: A Retrospective Exhibition* (Toronto: Art Gallery of Ontario, 1981), 163.

86. Charlotte Bates, Interview, 7 October 1986.

87. W. Bates, Interview.

88. C. Bates, Interview.

89. M. Bates, "The flight from meaning in painting," *Canadian Art* 11 (Winter 1954), 59–61.

90. Ibid., 61.

91. M. Bates, "Talent," *Far-Away Flags*, 56.

92. Kenneth Sturdy, Interview, 12 November 1986.

93. Ibid.

94. "Cathedral in the West," *Canadian Catholic Institutions* (November/December 1960), 36.

95. G. White, Interview.

96. M. Bates, Interview, P.K. Page.

Notes to Chapter 6

1. M. Bates, *Vermicelli*. Unpublished manuscript.

2. M. Bates in a taped interview with P.K. Page, 1973. Copy of the tape in the possession of J.H. and K. Snow.

3. M. Bates, *Vermicelli*.

4. M. Bates. Notes.

5. Ibid.

6. Bente R. Cochran, *Printmaking in Alberta, 1945–1985* (Edmonton: University of Alberta Press, 1989), 139.

7. Elizabeth Kilbourn, "18 printmakers," *Canadian Art* 18 (March/April 1961), 100–13.

8. Ibid., 112.

9. M. Bates, "Method of Painting."

10. M. Bates, Notes.

11. M. Bates, Notebook of sales.

12. *First Biennial Exhibition of Canadian Painting* (Ottawa: National Gallery of Canada, 1955). Papers.

13. *Jubilee Exhibition of Alberta Painting* (Calgary: Allied Arts Centre, 1955). Papers.

14. M. Bates, "Some reflections on art in Alberta," *Canadian Art* 13 (Autumn 1955), 185.

15. Ibid., 187.

16. Nancy Townshend, *Maxwell Bates: Landscapes/Paysages* (Medicine Hat: Medicine Hat Museum and Art Gallery, 1982), 21.

17. Ibid.

18. Ibid., 24–25.

19. M. Bates, Notes.

20. Peter Daglish, Statement. J.H. Snow Papers.

21. Joyce Zemans, *Jock Macdonald: The Inner Landscape: A Retrospective Exhibition* (Toronto: Art Gallery of Ontario, 1981), 171.

22. Iain Baxter, Interview, 20 February 1987.

23. Ibid.

24. Illingworth Kerr, "Maxwell Bates, dramatist," *Canadian Art* 13 (Summer 1965), 324.

25. M. Bates, Notes.

26. Ibid.

27. George Swinton, "Art show judge hits back. Do you want postcards?" *Winnipeg Tribune*, 8 November 1955.

28. G. Swinton, "The Winnipeg show," *Winnipeg Tribune*, 2 November 1955.

29. G. Swinton, "Art show judge hits back."

30. Ibid.

31. "Nauseous blobs spark gallery row," *Winnipeg Free Press*, 7 November 1955.

32. G. Swinton, "The Winnipeg show's new look," *Winnipeg Tribune*, 8 November 1955.

33. Joe Gelmon, "Confused by art?— Don't be too practical," *Winnipeg Free Press*, 28 October 1955.

34. M. Bates, "Beautiful sunsets makes artist's job too easy," *Saskatoon Star-Phoenix*, 5 November 1955.

35. "Art squabble judge shows his paintings," *Winnipeg Tribune*, 11 January 1956.

36. G. Swinton, "Richards and Bates: Calgary painter and Winnipeg sculptor: Two sturdy independents," *Winnipeg Tribune*, 13 January 1956.

37. "Art authorities to serve as jury," *Regina Leader-Post*, 6 January 1956.

38. *Saskatchewan Art Exhibition* (Regina: Saskatchewan Arts Board, 1956).

39. M. Bates, "Modern primitive art." Unpublished manuscript.

40. M. Bates, Letter to the Honourable Secretary, Alberta Association of Architects, 31 December 1955.

41. M. Bates, Notes.

42. Ibid.

43. M. Bates, Plans, Snyder House.

44. "Confusion seen in art circles," *The Albertan*, 3 February 1956.

45. I. Kerr, "Maxwell Bates, dramatist," *Canadian Art* 13 (Summer 1956), 324–27.

46. M. Bates, "Foreword."

47. M. Bates, "Note on the Question of Value in Painting."

48. Ibid.

49. M. Bates, Notes.

50. Ibid.

51. Ibid.

52. Ibid.

53. *Maxwell Bates Paintings* (Toronto: Greenwich Gallery, 1956). J.H. Snow Papers.

54. Pearl McArthy, "Maxwell Bates," *Globe and Mail*, 22, 29 September 1956.

55. J.W.G. Macdonald, Letter to M. Bates, 10 September 1959. Collection of McCord Museum.

56. *Weekend Magazine*, 7.13 (1957).

57. Nancy Wallace, Letter to J.H. Snow, 14 September 1956. J.H. Snow Papers.

58. Nancy Tousley, "Lithographers' collaboration a joy to view," *Calgary Herald*, 4 December 1988.

59. I. Kerr, "Maxwell Bates, dramatist," 325.

60. M. Bates, Notes.

61. "Cathedral in the West," *Canadian Catholic Institutions* (November/December 1960), 37.

62. M. Bates, Notes.

63. J.H. Snow, Interview, 15 March 1989.

64. "Cathedral in the West," 37.

65. J.H. Snow, Interview.

66. Frank Palmer, Interview, 12 November 1986.

67. J.H. Snow, Interview, 10 April 1989.

68. Luke Lindoe, Letter to author, 5 February 1989.

69. Ian M. Thom, *Maxwell Bates: A Retrospective: Une Rétrospective* (Victoria: Art Gallery of Greater Victoria, 1982), 17–18.

Notes to Chapter 7

1. M. Bates, "Divided we fall," *Highlights* (Summer 1957), 7–8.

2. M. Bates in a taped interview with Bill Stavdal, December 1968. Transcript in Papers.

3. Ian M. Thom, *Maxwell Bates: A Retrospective: Une Rétrospective* (Victoria: Art Gallery of Greater Victoria, 1973), 18.

4. M. Bates, Interview, Bill Stavdal.

5. Philip T. Clark, Letter to M. Bates, 18 February 1957.

6. Nancy Townshend, *Maxwell Bates: Landscapes/Paysages* (Medicine Hat, Alberta: Medicine Hat Museum and Art Gallery, 1982), 83.

7. Robert Ayre, "Spring exhibit has 102 oils," *Montreal Star*, 5 April 1957.

8. Robert Ayre, "Calgary painters exhibit," *Montreal Star*, 23 February 1957.

9. R. de Repentigny, "Variety in the Calgary painters," *La Presse*, 2 March 1957.

10. "Oeuvre d'un pionnier de l'art dans l'ouest," *La Presse*, 18 February 1957.

11. Earle Birney, "Poets and painters: Rivals or partners," *Canadian Art* 14 (Summer 1957), 148–50.

12. M. Bates, Letter to the Editor, *Canadian Art*, 19 August 1957.

13. Joyce Zemans, *Jock Macdonald: The Inner Landscape: A Retrospective Exhibition* (Toronto: Art Gallery of Ontario, 1981), 186.

14. Ibid., 187.

15. Ibid., 188.

16. M. Bates, "Jock Macdonald, painter-explorer," *Canadian Art* 14 (Summer 1957), 151–54.

17. M. Bates, Notes.

18. J. Zemans, *Jock Macdonald*, 192.

19. M. Bates, "Journal, 1957–1977."

20. Ibid., 1.

21. Ibid., 2.

22. Ibid., 4.

23. Ibid., 6.

24. Ibid.

25. Ibid., 2.

26. Ibid., 7.

27. Ibid., 10.

28. Ibid., 9.

29. Nancy Tousley, "Sculpture highlights Gothic gem," *Calgary Herald*, 9 June 1985.

30. "Cathedral in the West," *Canadian Catholic Institutions* (November/December 1960), 37.

31. M. Bates, "Journal, 1957–1977," 16.

32. I.M. Thom, *Maxwell Bates*, 42.

33. "Cathedral in the West," 38.

34. Stephanie White, "Bates' delicate St. Mary's Cathedral is one of the classic jewels of the city," *Calgary Herald*, 7 July 1979.

35. Ibid.

36. W.S. Goulding, "The symbol building," *Journal of the Royal Architectural Institute*, 35 (November 1958), 409.

37. J.H. Snow Papers.

38. Bente R. Cochran, *Printmaking in Alberta 1945–1985* (Edmonton: University of Alberta Press, 1989), 3.

39. *Graphics by Bates and Snow* (Vancouver: New Design Gallery, 1957).

40. "Calgary artists go on display," *Vancouver Province*, 7 December 1957.

41. M. Bates in the edited transcript of a taped interview with Terry Guernsey in *Maxwell Bates in Retrospect 1921–1971* (Vancouver: Vancouver Art Gallery, 1973), 24.

42. *Graphics by Bates and Snow* (Regina: Norman Mackenzie Art Gallery, 1958). J.H. Snow Papers.

43. J.H. Snow, Interview, 5 January 1986.

44. *Fifth International Biennial of Contemporary Color Lithography* (Cincinnati: Art Gallery, 1958). J.H. Snow Papers.

45. G. Loranger, Letter to M. Bates, 23 June 1959.

46. *Canadian Artists Series 1: Bates/Humphrey* (Ottawa: National Gallery of Canada, 1958).

47. Ibid.

48. *Brandon Daily Standard*, 9 January 1959.

49. M. Bates, Notes.

50. M. Bates, "Journal of Travel."

51. Ibid.

52. Ibid.

53. M. Bates, "Sketchbook." Private collection.

54. Ibid.

55. M. Bates, "Journal of Travel."

56. Ibid.

57. Ibid.

58. Ibid.

59. M. Bates, "Some impressions of art in Europe," *Highlights* (Autumn 1959), 8.

60. Ibid., 9.

61. M. Bates, "Journal of Travel."

62. D. Bair, *Samuel Beckett: A Biography* (New York: Harcourt, Brace, Jovanovitch, 1978), 490.

63. M. Bates, "Journal of Travel."

64. Ibid.

65. Ibid.

66. M. Bates, "Some impressions."

67. M. Bates, "Journal of Travel."

68. M. Bates, "Journal of Travel (on the Continent)," 2.

69. Ibid., 3.

70. M. Bates, Sketchbook.

71. M. Bates, "Journal of Travel," 8.

72. Ibid.

73. Ibid., 11.

74. Ibid., 36.

75. M. Bates, "Some impressions," 8.

76. M. Bates, "Journal of Travel," 5.

77. M. Bates, "Some impressions," 8.

78. Ibid., 22.

79. Ibid.

80. M. Bates, "Some impressions," 9.

81. M. Bates, "Journal of Travel."

82. M. Bates, Postcard to J. Snow, 8 December 1958. J.H. Snow Papers.

83. M. Bates, "Journal of Travel," 41.

84. Ibid., 32.

85. Ibid., 9.

86. Ibid., 35.

87. Ibid.

88. Ibid., 31.

89. Ibid., 43.

90. M. Bates, *Vermicelli*. Unpublished manuscript.

91. M. Bates, "Some impressions," 9.

92. M. Bates, "Journal of Travel," 48.

93. M. Bates, "Some impressions," 9.

94. Ibid.

95. M. Bates, "Journal of Travel," 50.

96. Ibid., 50.

97. Ibid., 50.

98. Ibid., 60.

99. M. Bates, "Some impressions," 9.

100. M. Bates, "Journal of Travel."

101. Ibid.

102. M. Bates, "Some impressions," 9.

103. M. Bates, "Journal of Travel."

104. Ibid.

105. Ibid.

106. Ibid.

107. Ibid.

108. Ibid.

109. Ibid.

110. M. Bates, "Some impressions," 10.

111. M. Bates, "Sketchbook." Private collection.

112. E. Vulliamy, "Massacio Unveiled," *Manchester Guardian*, 5 April 1990.

113. M. Bates, "Journal of Travel."

114. Ibid.

115. Ibid.

116. Ibid.

117. M. Bates, "Some impressions," 10.

118. M. Bates, "Journal of Travel."

119. Ibid.

120. M. Bates, "Some impressions," 10.

121. M. Bates, "Journal of Travel."

122. Ibid.

123. M. Bates, "Sketchbook."

124. M. Bates, "Journal of Travel."

125. Ibid.

126. M. Bates, "Excursion to Corsica," *Highlights* (Spring 1961), 10–11.

127. M. Bates, "Journal of Travel."

128. M. Bates, "Excursion," 13.

129. M. Bates, "Journal of Travel."

130. Ibid.

131. M. Bates, "Some impressions," 8.

132. Ibid.

133. Ibid., 7.

134. M. Bates, "Journal of Travel," 123.

Notes to Chapter 8

1. Illingworth Kerr, "Maxwell Bates exhibits here," *Calgary Herald*, 13 April 1959.

2. "City artists exhibit work at centre," *Calgary Herald*, 22 October 1959.

3. M. Bates, Notes.

4. Ian M. Thom, *Maxwell Bates: A Retrospective: Une Rétrospective* (Victoria: Art Gallery of Greater Victoria, 1982), 18.

5. M. Bates, Letter to Lucy Wertheim, 9 May 1956.

6. Lucy Wertheim, Letter to M. Bates, 31 May 1959.

7. M. Bates, "Journal, 1957–1977."

8. Ibid.

9. "City artists."

10. Christine J. Fraser, "The Liverpool Competition," *The Architecture of Maxwell Bates* (Calgary: Nickle Arts Museum, University of Calgary, 1992), 24.

11. Ibid.

12. Ibid.

13. Ibid.

14. M. Bates, "Some impressions of art in Europe," *Highlights* (Autumn 1959), 9.

15. C.J. Fraser, "The Liverpool Competition," 25.

16. "Service of Dedication," St. Martin's Anglican Church, Calgary, Alberta, November 1960.

17. Ibid.

18. Peter Savage, Interview, 27 April 1988.

19. Stephanie White, "Church shows

artist's hand at architecture," *Calgary Herald*, 1 November 1980.

20. Ibid.

21. Ibid.

22. "Service of Dedication."

23. M. Bates, "Journal."

24. M. Bates, "Some Impressions," 10.

25. M. Bates, "The Existential Direction in Painting." Unpublished manuscript.

26. M. Bates, Notes.

27. Ibid.

28. Ibid.

29. M. Bates, "The Existential Direction."

30. M. Bates, "Visual art and photography," *Canadian Art* 17 (March 1960), 83.

31. Ibid.

32. Ibid.

33. Ronald Spickett, Letter to the author, 10 May 1989.

34. M. Bates, "Ronald Spickett: Symbols of the real," *Canadian Art* 17 (July 1960), 225.

35. Ibid.

36. Donald Buchanan, "Canadian graphic art abroad," *Canadian Art* 16 (Summer 1959), 198–99.

37. M. Bates, List of exhibitions. J. H. Snow Papers.

38. Nancy Townshend, *Maxwell Bates: Landscapes/Paysages, 1948–1978* (Medicine Hat: Medicine Hat Museum and Art Gallery, 1982), 85.

39. Ibid.

40. Ibid.

41. M. Bates, List of exhibitions. J. H. Snow Papers.

42. Ibid.

43. M. Bates, "Journal."

44. Ibid.

45. Ibid.

46. Steve Kiss, Interview, 11 March 1989.

47. M. Bates in a taped interview with Frank Nowosad, 8 May 1977. Copy of the tape in the possession of J.H. Snow and K. Snow.

48. M. Bates, Notes.

49. *Winnipeg Show* (Winnipeg: Winnipeg Art Gallery, 1957).

50. M. Bates, "Journal."

51. Ibid.

52. "Paintings reflect world of reality," *Regina Leader-Post*, 1 December 1960.

53. Ted Godwin, Interview, 16 July 1986.

54. M. Bates in the edited transcript of a taped interview with Terry Guernsey in *Maxwell Bates in Retrospect 1921–1971* (Vancouver: Vancouver Art Gallery, 1973), 13.

55. M. Bates, Notes.

56. *Canadian Group of Painters* (Toronto: Art Gallery of Ontario, 1959). J.H. Snow Papers.

57. M. Bates, Notebook of sales.

58. M. Bates, "Journal," 33.

59. J.W.G. Macdonald, Letter to M. Bates, 19 September 1959. Copy of letter in McCord Museum, Montreal, Quebec.

60. J.W.G. Macdonald, Letter to M. Bates, 15 November 1959.

61. J.W.G. Macdonald, Letter to M. Bates, 17 February 1960.

62. Joyce Zemans, *Jock Macdonald: The Inner Landscape: A Retrospective Exhibition* (Toronto: Art Gallery of Ontario, 1981), 238.

63. Ibid.

64. *Prints and Drawings: John Snow, Roloff Beny, Maxwell Bates* (Toronto: Here and Now Gallery, 1960).

65. *Western Artists* (Toronto: Here and Now Gallery, 1960).

66. R.L. Bloore, *Maxwell Bates Retrospective Exhibition* (Regina: Norman Mackenzie Art Gallery, 1960).

67. Vic Wilczur, "Calgary artist's work a display," *Regina Leader-Post*, 3 November 1960.

68. Roy Kiyooka, "Preface," *Maxwell Bates Retrospective.*

69. R. L. Bloore, "Introduction," *Maxwell Bates Retrospective.*

70. R.L. Bloore, "Maxwell Bates retrospective exhibition at Regina," *Canadian Art* 18 (March/April 1961), 123–24.

71. J. Russell Harper, *Painting in Canada: A History*, 2nd ed. (Toronto: University of Toronto Press, 1977), 352.

72. Ibid.

73. T. Godwin, Interview, 5 July 1987.

74. T. Godwin, Interview, 10 April 1987.

75. M. Bates, "Constructivism." Unpublished article.

76. M. Bates, "Journal."

Notes to Chapter 9

1. Elizabeth Kilbourn, "18 printmakers," *Canadian Art* 18 (1961), 324–27.

2. M. Bates, "Technique of ink paintings done in 1961." Unpublished manuscript.

3. M. Bates, "Journal, 1957–1977," 42.

4. Ibid., 51.

5. Astrid Twardowski, "Maxwell Bates exhibit well worth attending," *Calgary Albertan*, 24 June 1961.

6. *Canadian Group of Painters' Exhibition* (Vancouver: Vancouver Art Gallery, 1961).

7. Ian M. Thom, *Maxwell Bates: A Retrospective: Une Rétrospective* (Victoria: Art Gallery of Greater Victoria, 1982), 20.

8. Nancy Townshend, *Maxwell Bates: Landscapes/Paysages* (Medicine Hat: Museum and Art Gallery, 1982), 25.

9. M. Bates, "Journal," 52.

10. Robert Ayre, "Plus ça change at the RCA," *Montreal Star*, 18 November 1961.

11. Peter Daglish, Letter to M. Bates, November, 1961.

12. M. Bates, Notice to Members, Alberta Society of Artists.

13. Astrid Twardowski, "Alberta artists '61 features," *Calgary Albertan*, 4 September 1961.

14. Dorothy Cameron, Letter to Maxwell Bates, 5 June 1961.

15. Terry Guernsey, *Maxwell Bates in Retrospect 1921–1971* (Vancouver: Vancouver Art Gallery, 1973), 31.

16. M. Bates, "A private eye looks at a western." Unpublished manuscript.

17. M. Bates, Letter to Paul Arthur, 10 May 1962.

18. M. Bates, Notes.

19. M. Bates, Letter to Paul Arthur.

20. Clement Greenberg, "Clement Greenberg's view of art on the prairies," *Canadian Art* 20 (March/April 1963), 90–107.

21. M. Bates, "The tough dollar: How the creative artist makes a living." Unpublished manuscript.

22. Eric Metcalfe, Interview, 16 March 1988.

23. *Bates: New Paintings* (Toronto: Here and Now Gallery, 1962).

24. Dorothy Cameron, Letter to M. Bates, 3 February 1962.

25. M. Bates, Letter to D. Cameron, 8 May 1962.

26. D. Cameron, Letter to M. Bates, 16 May 1962.

27. M. Bates, "Life Work," *Far-Away Flags* (Victoria: Seymour Press, 1964), 57.

28. Leonore Crawford, "Festival art exhibit spotlights nine painters from the prairies," *London Evening Free Press*, 7 July 1962.

29. Charlotte Bates, Interview, 18 October 1986.

30. M. Bates, Letter to J.H. Snow, 6 July 1962. J.H. Snow Papers.

31. M. Bates, Letter to J. Turner, 26 July 1962. John Davenall Turner Papers.

32. M. Bates, Letter to J. Turner, 11 August 1962. J.D. Turner Papers.

33. A. Twardowski, "Around the galleries," *Calgary Albertan*, 4 October 1962.

34. Joyce Zemans, "Maxwell Bates at the Canadian Art Galleries, Calgary," *Canadian Art* 19 (November/December 1962), 395.

35. N. Townshend, *Maxwell Bates*, 27.

36. Ibid., 29.

37. M. Bates, Letter to J. Turner, 10 August 1962. J.D. Turner Papers.

38. C. Greenberg, "View of art," 101.

39. M. Bates, Letter to J.H. Snow, 8 October 1960. J.H. Snow Papers.

40. M. Bates, "Critic," *Far-Away Flags*, 57.

41. M. Bates, "An International Conference of the Arts," *Far-Away Flags*, 58.

42. M. Bates in a taped interview with P.K. Page, 1973. Copy in possession of J.H. and K. Snow.

43. Virginia Lewis Harrop, Interview, 24 March 1988.

44. Arthur Corry, "Academician comes to city," *Victoria Daily Times*, 29 September 1962.

45. Colin Graham, Interview, 24 March 1988.

46. Donald Harvey, Interview, 30 May 1988.

47. Roy Kiyooka, Interview, 15 July 1988.

48. Rita Morris, Interview, 21 March 1988.

49. Michael Morris, Letter to author, 28 July 1988.

50. Flemming Jorgensen, Letter to author, 15 September 1988.

51. M. Bates, Notes.

52. Ada Severson, Interview, 24 March 1988.

53. I.M. Thom, 20.

54. M. Bates, Letter to J.H. Snow, 21 May 1963. J.H. Snow Papers.

55. Richard Ciccimarra, "Fullest possible range in a small print show," *Victoria Daily Times*, 11 May 1963.

56. M. Bates, Letter to J. Turner, 27 March 1963.

57. Vancouver Art Gallery *Bulletin* (February/March, 1964).

58. *Canada on Canvas* (Stratford: Shakespearean Festival, 1963).

59. Vancouver Art Gallery *Bulletin* 31 (1963).

60. M. Bates, "Fort Street's thunderbird mural is a turkey," *Victoria Daily Times*, 8 June 1963.

61. M. Bates, Notes.

62. J.R. Matheson, *Canada's Flag* (Belleville: Miha Publishing, 1986), 61.

63. M. Bates, Notes.

64. M. Bates, Notes.

65. Ibid.

66. Ibid.

67. M. Bates in the edited transcript of a taped interview with Terry Guernsey, *Maxwell Bates in Retrospect 1921–1971* (Vancouver: Vancouver Art Gallery, 1973), 24.

68. M. Bates, Notes.

69. *A.R.C.A. Maxwell Bates Paintings* (Victoria: Ego Interiors, 1963).

70. Ted Gaskell, "Nothing unusual about a two-way artist," *Victoria Daily Colonist*, 24 November 1963.

71. Moncrieff Williamson, "Wide range, complex talents characterize Maxwell Bates," *Victoria Daily Times*, 23 November 1963.

72. Eileen Learoyd, "Artist Maxwell Bates—A man of blunt honesty," *Victoria Daily Colonist*, 8 September 1963.

73. *The Limners* (Victoria: Pharos Press, 1975).

74. Herbert Siebner, Letter to author, 20 July 1988.

Notes to Chapter 10

1. Maxwell Bates, *Far-Away Flags* (Vancouver: Seymour Press, 1964).

2. M. Bates, *Secrets of the Grand Hotel* (Vancouver: Vancouver Art Gallery, 1972).

3. Roy Kiyooka, Interview, 15 July 1988.

4. M. Bates in the edited transcript of a taped interview with Terry Guernsey, *Maxwell Bates in Retrospect 1921–1971* (Vancouver: Vancouver Art Gallery, 1972), 18.

5. M. Bates, Notes.

6. M. Bates in edited interview (Guernsey, 18).

7. M. Bates, Notes.

8. M. Bates in edited interview (Guernsey, 20).

9. *Secrets of the Grand Hotel* (Vancouver: Vancouver Art Gallery, Education Department).

10. Ian M. Thom, *Maxwell Bates: A Retrospective: Une Rétrospective*

(Victoria: Art Gallery of Greater Victoria, 1982), 26.

11. M. Bates, "God Bless the Queen of Aquitaine."

12. *Surrealism in Canadian Painting* (London, Ontario: London Public Library and Art Museum, 1964).

13. M. Bates, *Vermicelli*.

14. M. Bates, Letter to J.H. Snow, 13 April 1963. J.H. Snow Papers.

15. M. Bates, *Vermicelli*.

16. Ibid.

17. Ibid.

18. Ibid.

19. Ibid.

20. Ibid.

21. Ibid.

22. M. Bates, Letter to J.D. Turner, 20 January 1964. J.D. Turner Papers.

23. J.R. Harper, Letter to M. Bates, 23 December 1963.

24. J.R. Harper, Letter to M. Bates, 7 February 1964.

25. J.R. Harper, Letter to M. Bates, 21 March 1964.

26. J.R. Harper, *Painting in Canada: A History* (Toronto: University of Toronto Press, 1966), 406.

27. M. Bates, Letter to J.H. Snow, 10 January 1964. J.H. Snow Papers.

28. J.H. Snow, Letter to M. Bates, 1 February 1964.

29. M. Bates, Letter to J.H. Snow, 22 January 1964. J.H. Snow Papers.

30. Vancouver Art Gallery *Bulletin* 31 (1964).

31. M. Bates, *Vermicelli*.

32. Ted Godwin, Interview, 12 November 1986.

33. W.A. Irwin, Letter to M. Bates, 12 December 1968.

34. P.K. Page, "Max and my mother: A memoir," *Border Crossings* 7 (1988), 76.

35. Pat Martin-Bates, Interview, 30 May 1988.

36. "Artist to stage show for university students," *Victoria Daily Colonist*, 14 January 1964.

37. M. Bates, Interview, 21 May 1971.

38. Myfanwy Spencer Pavelic, Interview, 27 March 1987.

39. P.K. Page, "Max and my mother," 76.

40. Eric Metcalfe, Interview, 16 March 1988.

41. Rita Morris, Interview, 28 May 1988.

42. Donald Harvey, Interview, 30 May 1988.

43. P. Martin-Bates, Interview.

44. Colin Graham, "Maxwell Bates," *Arts West* 1 (1976), 26.

45. I.M. Thom, *Maxwell Bates*, 49.

46. David Thompson, "Gallery exhibition draws high praise," *Calgary Herald*, 15 October 1964.

47. "Maxwell Bates' latest works not everyone's idea of art," *Vernon Daily News*, 13 March 1964.

48. Robin Skelton, "Canadian group show is a mixed bag," *Victoria Daily Times*, 20 March 1965.

49. I.M. Thom, *Maxwell Bates*, 28.

50. Ibid.

51. Ibid.

52. Ibid., 93.

53. M. Bates, Letter to J.D. Turner, 21 October 1964. J.D. Turner Papers.

54. Nancy Townshend, *Maxwell Bates: Landscapes/Paysages* (Medicine Hat: Medicine Hat Museum and Art Gallery, 1982), 27.

55. M. Bates, Letter to J.D. Turner, 8 June 1965. J.D. Turner Papers.

56. M. Bates, Letter to J.D. Turner, 29 June 1965. J.D. Turner Papers.

57. David Silcox, [Notice of exhibition] *Globe and Mail*, 6 March 1965.

58. Doris Pascal, Letter to M. Bates, 29 March 1965.

59. M. Bates, Letter to Doris Pascal, 4 April 1965.

60. Ken Winters, "Inexpressive expressionist," *Winnipeg Free Press*, 28 April 1965.

61. Jan Kamienski, "A mature, honest artist it's a pleasure to see," *Winnipeg Tribune*, 24 April 1965.

62. M. Bates, *A Wilderness of Days* (Victoria: Sono Nis, 1978).

63. M. Bates, "The Prisoner of War," in *Vermicelli*.

64. M. Bates, Letter to J.H. Snow, 17 February 1965. J.H. Snow Papers.

65. M. Bates, "Thinking of Parmenides."

66. M. Bates, "When is the New Wasteland?"

67. Flemming Jorgensen, Letter to author, 17 September 1988.

68. M. Bates, Letter to J.H. Snow, 16 October 1965. J.H. Snow Papers.

69. Jacques de Rousson, "Les peintres de la Colombie Britannique et leur environnement," *Vie des arts* 44 (Automne 1966), 76.

70. Ibid.

71. David Silcox, Letter to J.H. Snow, 22 June 1966.

72. *Maxwell Bates Retrospective* (Victoria: Art Gallery of Greater Victoria, 1966).

73. R. Skelton, "Greatness seen in Bates' paintings," *Victoria Daily Times*, 8 October 1966.

74. M. Bates, Letter to J.H. Snow, 14 November 1966. J.H. Snow Papers.

75. George Fry, "Maxwell Bates Retrospective," *Artscanada* 24 (February 1967); Suppl. 4.

76. M. Bates, Letter to Kenneth Saltmarche, 4 October 1966.

77. Rae Perlin, "MUN Gallery a gogo," *Evening Telegram* (St. John's, Newfoundland), 10 March 1967.

78. P.K. Page, "Maxwell Bates, The Print Gallery, Victoria, February–March 1970," *Artscanada* 27 (1970), 62.

79. *Maxwell Bates in Retrospect, 1921–1971*, 20.

80. M. Bates in edited interview (Guernsey, 23).

81. Frank Nowosad, "I don't pretend to be anywhere near the avant-garde: Notes on Maxwell Bates," *Monday Magazine* (24–30 October 1977).

82. Barry Lord, *History of Painting in Canada: Toward a People's Art* (Toronto: NC Press, 1974), 221.

83. M. Bates, Letter to J.H. Snow, "Year's end" 1966. J.H. Snow Papers.

Notes to Chapter 11

1. Barry Lord, *Painting in Canada Today* (Montreal: Canadian Government Pavilion, 1967).

2. Ibid.

3. J.H. Snow Papers.

4. *Western Printmakers* (Vancouver: Western Canada Art Circuit, 1967).

5. List of holdings, Canada Council Art Bank.

6. Notice of Award.

7. *Northwest Drawings* (Vancouver: Bau-Xi Gallery, 1967).

8. *Maxwell Bates* (Vancouver: Bau-Xi Gallery, 1967).

9. Michael Morris, *Maxwell Bates and Eric Metcalfe* (Vancouver: University of British Columbia, 1967).

10. Richard Simmins, "Maxwell Bates and Eric Metcalfe," *Artscanada* 24 (1967), 4.

11. Ian M. Thom, *Maxwell Bates: A Retrospective: Une Rétrospective* (Victoria: Art Gallery of Greater Victoria, 1982), 33.

12. M. Bates, Letter to J.H. Snow, 4 October 1968. J.H. Snow Papers.

13. M. Bates, Letter to J.H. Snow, 18 February 1968. J.H. Snow Papers.

14. *Maxwell Bates: Watercolours and Drawings* (Victoria: Print Gallery, 1968).

15. Ina D.D. Uhtoff, "Artist shows our town on sympathetic satire," *Victoria Colonist*, 15 December 1968.

16. Ted Lindberg, "Max Bates' reality sandwiches," *Victoria Daily Times*, 7 December 1968.

17. Bente R. Cochran, *Printmaking in Alberta 1945–1985* (Edmonton: University of Alberta Press, 1989), 58.

18. M. Bates in a taped interview with Bill Stavdal (1968). Transcript in M. Bates Papers.

19. M. Bates, Letter to W. A. Irwin, 16 January 1968.

20. M. Bates, "Victoria painter takes issue with Dr. Gowans' art thesis," *Victoria Daily Times*, 20 January 1968.

21. M. Bates, Letter to Peter Bell, February 1968.

22. *Maxwell Bates* (Winnipeg: Winnipeg Art Gallery, 1968).

23. M. Bates, Letter to J.H. Snow, 17 March 1969.

24. John Graham, "Maxwell Bates," *Artscanada* 25 (1968), 72–73.

25. J.H. Snow, Letter to M. Bates, April 1969.

26. J.H. Snow, Letter to M. Bates, 20 April 1969.

27. Flemming Jorgensen, Letter to author, 17 September 1988.

28. Herbert Siebner, Letter to author, 23 July 1988.

29. Joan Lowndes, "Maxwell Bates in Retrospect, 1921–1971," *Artscanada* 30 (May 1973), 61.

30. H. Siebner, Letter to author, 23 July 1988.

31. Kate Craig, Interview, 16 March 1988.

32. Rita Morris, Interview, 28 May 1988.

33. M. Bates, Notes.

34. M. Bates, "Allure," Notes.

35. M. Bates, "Eyes," Notes.

36. M. Bates, "The man and woman as creators of works of art," Notes.

37. M. Bates, Notes.

38. R. Simmins, 115.

39. Frank Nowosad, "The prairie artist who looked at life bleakly," *Vancouver Sun*, 13 October 1982.

40. I.M. Thom, *Maxwell Bates*, 33.

41. Ibid., 34.

42. Pat Martin-Bates, Interview, 30 May 1988.

43. I.M. Thom, *Maxwell Bates*, 34.

44. Gisela Bates, Interview, 17 October 1986.

45. M. Bates in a taped interview with P.K. Page, 1973. Copy of tape in possession of J.H. and K. Snow.

46. John Vance Snow, Interview, 5 March 1987.

47. M. Bates, Notes.

48. G. Bates, Interview, 7 October 1986.

49. M. Bates, "Journal, 1957–1977."

50. *Maxwell Bates* (Vancouver: Bau-Xi Gallery, 1970).

51. *Maxwell Bates* (Edmonton: Upstairs Gallery, 1970).

52. John Graham, "Bates' work displayed," *Winnipeg Free Press*, 11 April 1970.

53. J. Graham, "Today's poet prophet," *Winnipeg Free Press*, 21 April 1970.

54. B. Stavdal, "They must come to me," *Victoria Daily Colonist*, 17 February 1970.

55. Eva Reid, "Eavesdrop with Eva," *Calgary Albertan*, 9 March 1970.

56. Nita Forrest, Interview, 29 May 1988.

57. M. Bates in the edited transcript of an interview with Terry Guernsey in *Maxwell Bates in Retrospect, 1921–1971* (Vancouver: Vancouver Art Gallery, 1973), 14.

58. M. Bates, Interview, P.K. Page, 1973.

59. P.K. Page, "Maxwell Bates, The Print Gallery, Victoria, February–March 1970," *Artscanada* 27 (April 1970), 62.

60. *The Limners* (Victoria: Pharos Press, 1981).

61. Ibid.

62. Myfanwy Pavelic, Interview, 27 March 1987.

63. Robin Skelton, "Max at seventy," *Visual Arts Newsletter* 5 (Winter 1983), 3.

64. M. Pavelic.

65. M. Bates, "Death," Notes.

66. J.H. Snow, Honorary Degree Nomination for Maxwell Bates; Supporting Statement. University of Calgary, 28 August 1967.

67. Michael Morris, Honorary Degree Nomination for Maxwell Bates; Supporting Statement. University of Calgary, 24 November 1967.

68. Illingworth Kerr, Honorary Degree Nomination for Maxwell Bates; Supporting Statement. University of Calgary, 28 November 1967.

69. Bill Musselwhite, "Former city artist comes home to honors," *Calgary Herald*, 21 May 1971.

70. Ouida Touche, "Works of Maxwell Bates' hang vividly in your memory," *Calgary Herald*, 22 May 1971.

71. I.M. Thom, 34.

72. Robin Skelton, "Max at seventy," *Visual Arts News Letter* 1 (Winter 1983), 3.

73. *Maxwell Bates at the Print Gallery* (Victoria: Print Gallery, 1971).

74. *Selected Works of Maxwell Bates and Silk Screen Prints of Roy Kiyooka* (Victoria: Print Gallery, 1971).

75. N. Forrest, Letter to M. Bates, 3 August 1971.

76. Joseph Starko, Letter to J.D. Turner, 12 April 1970.

77. M. Bates, Notebook of sales.

78. M. Bates, "Day follows day."

79. M. Bates, Letter to J.H. Snow, 28 July 1971. J.H. Snow Papers.

80. M. Bates, Letter to J.H. Snow, 18 January 1972. J.H. Snow Papers.

81. Saul Green, Letter to author, 6 March 1990.

82. M. Bates in edited interview (Guernsey, 14).

83. R. Skelton, "Maxwell Bates: Experience and reality," *The Malahat Review* 20 (October 1971), 94.

84. Ibid., 97.

85. Ibid.

86. Bill Thomas, "Limners Group 'just artists'," *Victoria Daily Colonist*, 13 April 1972.

Notes to Chapter 12

1. Doris Shadbolt in *Maxwell Bates in Retrospect, 1921–1971* (Vancouver: Vancouver Art Gallery, 1973), 1.

2. Maxwell Bates in an edited interview with Terry Guernsey, *Maxwell Bates in Retrospect*, 20, 23.

3. Myfanwy Pavelic, Interview, 27 March 1987.

4. P.K. Page, letter to M. Bates, January 1973.

5. Joan Lowndes, "Maxwell Bates in retrospect, 1921–1971," *Artscanada* 30 (May 1973), 60, 62.

6. *Maxwell Bates in Retrospect*, 1.

7. Ingrid Jaffe, "Faces intense and urgent thoughts," *Saskatoon Star-Phoenix*, 13 June 1973.

8. Carol Hogg, "Diversity makes exhibit outstanding," *Calgary Herald*, 23 February 1973.

9. Alma de Chantal, "Maxwell Bates," *Vie des Arts* 22 (Été 1977), 48–49.

10. M. Bates in a taped interview with P.K. Page, 1973. Copy of the tape in the possession of J.H. and K. Snow.

11. P.K. Page, "The self-contained castle: Maxwell Bates and P.K. Page in conversation," *Border Crossings* 7 (Fall 1988), 77.

12. Pat Martin-Bates, Interview, 30 May 1988.

13. M. Bates, Interview, P.K. Page.

14. Ibid.

15. M. Bates, Letter to J.H. Snow, 24 October 1973. J.H. Snow Papers.

16. Joan Lowndes, "Bates is back, with joy and bitterness," *Vancouver Sun*, 22 October 1973.

17. Jeremy Boultbee, "Maxwell Bates: 'I just like color and paint'," *Victoria Times*, 17 November 1973.

18. Ibid.

19. M. Bates, "Journal, 1957–1977."

20. Ibid.

21. *Maxwell Bates and Peter Daglish* (London: Canada House, 1974).

22. Dennis Bowlen, "Maxwell Bates and Peter Daglish," *Arts Review* (28 June 1974), 15.

23. M. Bates, Letter to Villiers David, 13 May 1974.

24. Art Perry, "Recent watercolours by Maxwell Bates in Galerie Allen," *Vancouver Province*, 23 September 1974.

25. Ibid.

26. *Maxwell Bates* (University of Toronto, 1974).

27. Fay Loeb, Letter to author, 26 August 1987.

28. Nancy Townshend, *Maxwell Bates: Landscapes/Paysages 1948–1978* (Medicine Hat: Medicine Hat Museum and Art Gallery, 1982), 27.

29. John Graham, "Bates' vigorous, dynamic shorthand," *Winnipeg Free Press*, 10 October 1975.

30. Mary Fox, "Maxwell Bates more taken with painting than subjects," *Vancouver Sun*, 19 March 1976.

31. Flemming Jorgensen, Letter to author, 18 May 1988.

32. M. Bates, Letter to J.H. Snow, 13 April 1976. J.H. Snow Papers.

33. Patricia Godsell, *Enjoying Canadian Painting* (Don Mills, Ontario: General Publishing, 1976), 223.

34. Robin Skelton, "Max at seventy," *Visual Arts Newsletter* 5 (Winter 1983), 3.

35. Peter and Shirley Savage, Interview, 2 April 1988.

36. Notice of meeting.

37. M. Bates, "Chess Player."

38. M. Bates, "Bring Me My Sufic Books."

39. Colin Graham, "Maxwell Bates," *Arts West* 1 (1976), 25–27.

40. C. Graham, Interview, 24 March 1988.

41. R. Skelton, Interview, 21 March 1988.

42. R. Skelton, "Max at seventy."

43. Peter Daglish, Letter to J.H. Snow, 13 January 1977. J.H. Snow Papers.

44. M. Bates, Letter to J.H. Snow, 16 February 1976. J.H. Snow Papers.

45. M. Bates, Letter to J.H. Snow, 11 September 1976. J.H. Snow Papers.

46. Don Mabie, "Miss Truly Amazing and friends," *Calgary Albertan*, 27 January 1977.

47. M. Bates, Letter to J.H. Snow, January 1977. J.H. Snow Papers.

48. P. Daglish, Letter to J.H. Snow, 13 January 1977. J.H. Snow Papers.

49. Ted Godwin, "Maxwell Bates," *Arts West* 3 (September/October 1978), 38.

50. *Maxwell Bates* (Vancouver and Toronto: Bau-Xi Gallery, 1977).

51. Frank Nowosad, "I don't pretend to be anywhere near the avant-garde," *Monday Magazine* (24–30 October 1977).

52. "Bates and Freifeld," *Globe and Mail*, 12 November 1977.

53. William Bates, Interview, 20 March 1988.

54. Pat Martin-Bates, Interview, 30 May 1988.

55. Ted Godwin, Interview, 16 July 1986.

56. M. Bates, "Journal, 1957–1977," 14 January 1977.

57. Frank Nowosad, "The enigmatic Maxwell Bates," *Monday Magazine* (1–7 October 1982).

58. Frank Nowosad, "I don't pretend."

59. Robert Hughes, "The realist as corn god," *Time* (31 January 1972), 36–41.

60. Tom Wolfe, "The painted word," *Harper's* 50 (April 1975), 57–90.

61. M. Bates, "Manifesto: A return to Manet."

62. M. Bates, *A Wilderness of Days* (Victoria: Sono Nis Press, 1978).

63. Ibid., 133.

64. Doug Collins, "And so to the salt mines," *Vancouver Sun*, 7 April 1978.

65. M. Bates, Letter to Peter Thielsen, 27 July 1978.

66. M. Bates, Letter to Peter Thielsen, 7 December 1978.

67. Brooks Joyner, "Bates' show proves he is still the master," *Calgary Albertan*, 1 October 1978.

68. Ibid.

69. M. Bates, Letter to J.H. Snow, 9 October 1978. J.H. Snow Papers.

70. F. Jorgensen, Letter to author, 18 May 1988.

71. Jim Gibson, "Show celebrates long friendship," *Victoria Daily Colonist*, 4 March 1979.

72. Frank Nowosad, "The metamorphosis of Maxwell," *Monday Magazine* (16–22 March 1979).

73. "City artists honored," *Victoria Times*, 28 June 1980.

74. Xisa Huang, Letter to Maxwell Bates, 16 April 1980.

75. John Vance Snow, "In Memoriam; Maxwell Bates 1906–1980," *The Malahat Review* 62 (July 1982) 202–03

Notes to Epilogue

1. "World of art loses one of its greatest," *Victoria Times-Colonist*, 17 September 1980.

2. Art Perry, "Maxwell Bates," *Vancouver Province Magazine*, 2 November 1980.

3. Nancy Tousley, "Modernist Alberta painter dies after illness," *Calgary Herald*, 24 September 1980.

4. Russell Keziere, "In Memoriam," *Canadian Broadcasting Corporation*, 26 October 1980. Transcript of radio broadcast.

5. Art Perry, "Maxwell Bates."

6. William Bates, Interview, 17 October 1986.

7. Jack Shadbolt, "Maxwell Bates (1906–1980)," *Artscanada* 37 (December 1980/January 1981), 2.

8. "Maxwell Bates," *Visual Arts Newsletter* 5 (Winter 1983), 3–5.

9. P.K. Page, Interview, 19 October 1986.

10. David Silcox, Tribute, Canadian Conference of the Arts, 1981.

11. Robin Skelton, "Max at Seventy," *Visual Arts Newsletter* 5 (Winter 1983), 3.

12. "Max Bates Secrets of the Grand Hotel on view at the Vancouver Art Gallery," *Vancouver Art Gallery Press Release*, 3 April 1981.

13. Ian M. Thom, *Maxwell Bates: A Retrospective: Une Rétrospective* (Victoria: Art Gallery of Greater Victoria, 1982).

14. Nancy Townshend, *Maxwell Bates: Landscapes/Paysages 1948–1978* (Medicine Hat: Medicine Hat Museum and Art Gallery, 1982).

15. *Maxwell Bates: A Retrospective: Une Rétrospective.*

16. Frank Nowosad, "The prairie artist who looked at life bleakly," *Vancouver Sun*, 13 October 1982.

17. Nancy Tousley, "Alberta artist gets royal treatment in retrospective," *Calgary Herald*, 13 November 1982.

18. "Maxwell Bates: Art Gallery of Greater Victoria, September 9–October 17," *Artscanada* 39 (November 1982), 3.

19. Art Perry, "The genius of Bates," *The Province*, 19 September 1983.

20. Art Perry, "Bates assaults human existence," *The Province*, 9 September, 1982.

21. N. Townshend, *Maxwell Bates: Landscapes/Paysages.*

22. Maxwell Bates, "Jock Macdonald, painter-explorer," *Artscanada* 38 (March 1982), 79–81.

23. Maxwell Bates, "Visual art and photography," *Artscanada* 38 (March 1982), 89.

24. Nicholas Macklem, Letter to author, 12 November 1987.

25. Books published by Oberon Press using works by Maxwell Bates on the cover: *14th St. N.Y.C.*, 1954 on cover of *The Master of Strappado* by Negovan Rajic; translated by David Lobdell, 1984. *Bathers*, 1966 on cover of *Coming Attractions, 4* by Dayv James-French, Lesley Krueger and Rohinton Mistry, 1986. *Cocktail Party #3*, 167 on cover of *A House Full of Women* by Elizabeth Brewster, 1985. *Figures at a Table* 1968 on cover of *Coming Attractions: Stories by Sharon Butala, Bonnie Burnard and Sharon Sparling* 1983. *Fortune Teller* 1974 on cover of *Wise-ears* by Nancy Bauer, 1985. *Cocktail Party* 1975 on cover of *Raspberry Vinegar* by Joan Fern Shaw, 1985.

26. Nino Ricci, *Lives of the Saints* (Dunvegan, Ontario: Cormorant Books, 1990).

27. Bente R. Cochran, *Printmaking in Alberta, 1945–1985* (Edmonton: University of Alberta Press, 1989), 54–58.

28. N. Tousley, "Lithographers' collaboration a joy to view," *Calgary Herald*, 4 December 1988.

29. Richard L. White, *Friends and Mentors: Maxwell Bates, Barry Smylie and John Snow* (Calgary: Muttart Art Gallery, 1989).

30. Richard White, *Friends and Mentors*, 2.

31. "Gallery tribute," *Eastbourne Herald*, 18 April 1992.

32. C.D. McAtee, C.J. Fraser, M.H. Mortimer, and B.E. Tomlins, *The Architecture of Maxwell Bates* (Calgary: Nickle Arts Museum, University of Calgary, 1992).

33. C.D. McAtee, "The artist as architect," 7–17; B.E. Tomlins, "Building with ideals: Saint Mary's Cathedral," 18–22; C.J. Fraser, "The Liverpool competition," 23–26.

34. Nancy Tousley, "In search of an artist's double life," *Calgary Herald*, 8 August 1992.

35. Robert Amos, "Going. Going … the great Bates estate," *Victoria Times-Colonist*, 6 June 1992.

36. *Art on Video: Maxwell Bates* (Victoria: Art Gallery of Greater Victoria, 1990).

37. Robert Amos, "Going, Going."

38. Robert Amos, "Bates auction was a great party with lots of bargains," *Victoria Times-Colonist*, 13 June 1992.

39. Jody Paterson, "Bates prices soar at packed auction," *Victoria Times-Colonist*, 11 June 1992.

40. Christopher Varley, "Winnipeg West: The post war development of art in western Canada," in A.W. Rasporitch, *The Making of the Modern West: Western Canada Since 1945* (Calgary: University of Calgary Press, 1984), 217–31.

41. David Burnett and Marilyn Schiff, *Contemporary Canadian Art* (Edmonton: Hurtig, 1983), 125.

42. Maxwell Bates, Notes.

Selected Sources

PRIMARY SOURCES: MAXWELL BATES

Journals, notes, correspondence and miscellaneous papers of Maxwell Bates. Maxwell Bates fonds. Special Collections Division, MacKimmie Library, University of Calgary.

Letters to John H. Snow. J.H. Snow Papers. In possession of J.H. and K. Snow.
Letters to John Davenall Turner. J.D. Turner Papers. In possession of Grace Turner.

Maxwell Bates in a taped interview with Bill Stavdal (1968). Transcript in Maxwell Bates Papers.
Maxwell Bates in a taped interview with Terry Guernsey (1972). Transcript in collections of Vancouver Art Gallery. Edited version published in *Maxwell Bates in Retrospect 1921–1971* (Vancouver: Vancouver Art Gallery, 1973): 3–28.
Maxwell Bates in a taped interview with P.K. Page (1973). Copy of tape in possession of J.H. and K. Snow. Edited version published in "The self-contained castle." *Border Crossings* 7 (Fall 1988): 77–79.
Maxwell Bates in a taped interview with Frank Nowosad (1977). Copy of tape in possession of J.H. and K. Snow.

"On naïve painting." *Phoebus Calling* (Spring 1934):20–23.
"Children's art classes." Unpublished article. (Calgary: Provincial Institute of Technology and Art, 1947).

"Graphic art in Alberta." *Highlights* 2 (March 1948):3.
"Behold the flowers." *Canadian Poetry* 11 (June 1948):9–10.
"Some problems of the environment." *Highlights* 2 (December 1948):2–3.
"Art and snobbery." *Highlights* 3 (March 1949):2–3.
"Government and the arts." *Highlights* 3 (September 1949):1–2.
"Note on the quality of our exhibitions." *Highlights* 4 (September 1950):1–2.
"By what criteria can one decide whether any picture is good or bad?" *Highlights* 4 (June 1951):1.
"The Canadian Society of Graphic Arts." *Highlights* 5 (March 1952):21.
"The Calgary Allied Arts Council." *Royal Architectural Institute of Canada Journal* 30 (February 1953):47.
"The flight from meaning in painting." *Canadian Art* 11 (Winter 1954):59–61.
"Some reflections on art in Alberta." *Canadian Art* 13 (Autumn 1955):183–87.
"Jock Macdonald, painter-explorer." *Canadian Art* 14 (Summer 1957):151–54.
"Divided we fall." *Highlights* (Summer 1957):7–8.
"Some impressions of art in Europe, Winter 1958–59." *Highlights* (Autumn 1959):7–10.
National Gallery of Canada, Artists' Information Form, 1959.
"Visual art and photography." *Canadian Art* 17 (March 1960):76–83.

"Ronald Spickett: Symbols of the real." *Canadian Art* 17 (July 1960):224–26.
"Excursion to Corsica." *Highlights* (Spring 1961):9–13.
"Fort Street's thunderbird mural is a turkey." *Victoria Daily Times*, 8 June 1963.
Far-Away Flags (Victoria: Seymour Press, 1964).
"Victoria painter takes issue with Dr. Gowans' art thesis." *Victoria Daily Times*, 20 January 1968.
A Wilderness of Days (Victoria: Sono Nis Press, 1978).

BOOKS, PAMPHLETS, CATALOGUES, TRIBUTES, VIDEO

Art on Video: Maxwell Bates. Victoria: Art Gallery of Greater Victoria, 1990.
Bair, D. *Samuel Beckett: A Biography*. New York: Harcourt, Brace, Jovanovitch, 1978.
Bates: New Paintings. (Exhibition catalogue). Toronto: Here and Now Gallery, 1962.
Bloore, R.L. *Maxwell Bates Retrospective Exhibition*. (Exhibition catalogue). Regina: Norman Mackenzie Art Gallery, 1960.
Boulet, Roger. *A.C. Leighton: A Retrospective Exhibition*. (Exhibition catalogue). Edmonton: Edmonton Art Gallery, 1981.
Burnett, David and Schiff, Marilyn. *Contemporary Canadian Art*. Edmonton: Hurtig/Art Gallery of Ontario, 1983.
Canadian Artists: Series 1: Bates/Humphrey. (Exhibition catalogue). Ottawa: National Gallery of Canada, 1958.

Canadian Group of Painters. (Exhibition catalogue). Toronto: Art Gallery of Ontario, 1959.

Cheney, Sheldon. *Expressionism in Art*. Rev. ed. New York: Tudor Publishing, 1948.

Cochran, Bente R. *Printmaking in Alberta, 1945–1985*. Edmonton: University of Alberta Press, 1989.

Duval, Paul. *Canadian Drawings and Prints*. Toronto: Burns and MacEachern, 1952.

——. *Canadian Water Colour Painting*. Toronto: Burns and MacEachern, 1954.

Evans, M. *Frances Hodgkins*. Harmondsworth, England: Penguin Books, 1948.

Fifth International Biennial of Contemporary Colour Lithography. (Exhibition catalogue). Cincinnati: Art Gallery, 1958.

Godsell, Patricia. *Enjoying Canadian Painting*. Don Mills, Ontario: General Publishing, 1976.

Graphics by Bates and Snow. (Exhibition catalogue). Vancouver: New Design Gallery, 1957.

Graphics by Bates and Snow. (Exhibition catalogue). Regina: Norman Mackenzie Art Gallery, 1958.

Guernsey, Terry. *Maxwell Bates in Retrospect, 1921–1971*. (Exhibition catalogue). Vancouver: Vancouver Art Gallery, 1973.

Harper, J. Russell. *Painting in Canada: A History*. Toronto: University of Toronto Press, 1966.

Harper, J. Russell. *Painting in Canada: A History*. 2nd ed. Toronto: University of Toronto Press, 1977.

Hughes, Robert. *Nothing If Not Critical: Selected Essays on Art and Artists*. New York: Knopf, 1990.

Illingworth Kerr: Fifty Years a Painter. (Exhibition catalogue). Edmonton: Edmonton Art Gallery, 1963.

Jasen, Patricia. *An Introduction to the Architecture of William Stanley Bates*. Calgary: Alberta Historical Research Foundation, 1987.

Keziere, Russell. "'In Memoriam' Max Bates." Radio broadcast, Canadian Broadcasting Corporation, 26 October 1980.

Lewis, Wyndham. *Letters of Wyndham Lewis*. Edited by W.K. Rose. London: Methuen, 1962.

The Limners. Victoria: Pharos Press, 1975.

The Limners. Victoria: Pharos Press, 1981.

Lohnes, Donna and Nicholson, Barbara. *Alexander Calhoun*. Calgary: Calgary Public Library, 1987.

Lord, Barry. *A History of Painting in Canada: Toward a People's Art*. Toronto: NC Press, 1974.

Matheson, J.R. *Canada's Flag*. Belleville: Miha Publishing, 1986.

Maxwell Bates. (Exhibition catalogue). Winnipeg: Winnipeg Art Gallery, 1968.

Maxwell Bates. (Exhibition catalogue). Toronto: University of Toronto, 1974.

Maxwell Bates. (Exhibition catalogue). Vancouver/Toronto: Bau-Xi Gallery, 1970.

Maxwell Bates. (Exhibition catalogue). Edmonton: Upstairs Gallery, 1970.

Maxwell Bates. (Exhibition catalogue). Vancouver/Toronto: Bau-Xi Gallery, 1977.

Maxwell Bates: A Retrospective Exhibition. (Exhibition catalogue). Victoria: Art Gallery of Greater Victoria, 1966.

Maxwell Bates at the Print Gallery. (Exhibition catalogue). Victoria: Print Gallery, 1971.

Maxwell Bates: Watercolours and Drawings. (Exhibition catalogue). Victoria: Print Gallery, 1968.

McAtee, C.D.; Fraser, C.J.; Mortimer, M.H.; and Tomlins, B.E. *The Architecture of Maxwell Bates*. (Exhibition catalogue). Calgary: Nickle Arts Museum, 1992.

McInnes, Graham. *Canadian Art*. Toronto: Macmillan, 1950.

Melnyk, Bryan P. *Calgary Builds: The Emergence of an Urban Landscape, 1905–1914*. Regina: University of Regina, Canadian Plains Research Centre, 1985.

Modern Paintings in the Catalog of the Helen Birch Bartlett Memorial. (Exhibition catalogue). Chicago: Art Institute of Chicago, 1926.

Morris, Jerrold. *100 Years of Canadian Painting*. Agincourt, Ontario: Methuen, 1980.

Morris, Michael. *Maxwell Bates and Eric Metcalfe*. (Exhibition catalogue). Vancouver: University of British Columbia, 1967.

Northwest Drawings and Prints. (Exhibition catalogue). Vancouver: Bau-Xi Gallery, 1967.

Nowosad, Frank. *Ciccimarra: A Biography*. Ann Arbor, Michigan: Fuller Technical Publishing, 1988.

Rasporich, A.W. *The Making of the Modern West: Western Canada Since 1945*. Calgary: University of Calgary Press, 1984.

Read, Herbert. *Paul Nash*. Harmondsworth, England: Penguin Books, 1944.

Reid, Dennis. *Concise History of Canadian Painting*. 2nd ed. Toronto: Oxford University Press, 1988.

Schultz-Hoffman, Carla and Weiss, Judith C., eds. *Max Beckmann: A Retrospective*. St. Louis: St. Louis Art Museum/Prestel-Verlag, Munich/W.W. Norton, New York and London, 1984.

Selected Works of Maxwell Bates and Silk Screen Prints of Roy Kiyooka. (Exhibition catalogue). Victoria: Print Gallery, 1971.

Selz, Peter. *German Expressionist Painting*. Berkeley, California: University of California Press, 1957.

Service of Dedication. Calgary: St. Martin's Anglican Church, 1960.

Silcox, David. "Maxwell Bates." Presentation to the Canadian Conference of the Arts, 1981. Ottawa: Canadian Conference of the Arts, 1981.

Skelton, Robin. *Memoirs of a Literary Blockhead*. Toronto: Macmillan, 1988.

Surrealism in Canadian Painting. (Exhibition catalogue). London, Ontario: London Public Museum and Art Gallery, 1964.

Thom, Ian M. *Maxwell Bates: A Retrospective: Une Rétrospective*. (Exhibition catalogue). Victoria: Art Gallery of Greater Victoria, 1982.

Three Painters and Three Sculptors. London: Bloomsbury Gallery, 1931.

Tippett, Maria. *Emily Carr: A Biography*. Markham, Ontario: Penguin Books, 1982.

Townshend, Nancy. *Maxwell Bates: Landscapes/Paysages, 1948–1978*. (Exhibition catalogue). Medicine Hat: Medicine Hat Museum and Art Gallery, 1982.

Turner, John Davenall. *Sunfield Painter: The Reminiscences of John Davenall Turner*. Edmonton: University of Alberta Press, 1982.

Varley, Christopher. *Winnipeg West: Painting and Sculpture in Western Canada, 1945–1970.* Edmonton: Edmonton Art Gallery, 1983.

Wertheim, Lucy. *Adventure in Art.* London: Nicholson and Watson, 1947.

Western Printmakers. (Exhibition catalogue). Vancouver: Western Canada Art Circuit, 1967.

White, Richard L. *Friends and Mentors: Maxwell Bates, Barry Smylie and John Snow.* (Exhibition catalogue). Calgary: Muttart Art Gallery, 1989.

William Stanley Bates, Index of Buildings. Calgary: Glenbow-Alberta Institute, n.d.

Zemans, Joyce. *Jock Macdonald: The Inner Landscape: A Retrospective Exhibition.* (Exhibition catalogue). Toronto: Art Gallery of Ontario, 1981.

PERIODICALS

Anonymous listed in order of date of publication:

"Exhibitions London." *Studio* 115 (March 1938):155–56.

"Modern German art till now." *Studio* 116 (September 1938):160–61.

"Former Calgarian's painting in academy." *Calgary Albertan,* 13 May 1939.

"War experiences add to background: Maxwell Bates exhibition at the Art Gallery." *Vancouver Daily Province,* 7 May 1947.

"Prairie scenery is a challenge." *Winnipeg Tribune,* 28 October 1955.

"Nauseous blobs spark gallery row." *Winnipeg Free Press,* 7 November 1955.

"Art authorities to serve as jury," *Regina Leader-Post,* 6 January 1956.

"Art squabble judge shows his paintings." *Winnipeg Tribune,* 11 January 1956.

"Confusion seen in art circles." *Calgary Albertan,* 1 February 1956.

"Calgary artist moved old masters in war." *Calgary Albertan,* 29 March 1956.

"Oeuvre d'un pionnier de l'art dans l'ouest," *La Presse,* 18 February 1951.

"Pour cinq jours encore l'île." *La Presse* [Montreal], 2 March 1957.

"Calgary artists go on display." *Vancouver Province,* 7 December 1957.

"City artists exhibit work at centre." *Calgary Herald,* 22 October 1959.

"Calgary artist's work on display." *Regina Leader-Post,* 30 November 1960.

"Paintings reflect world of reality." *Regina Leader-Post,* 1 December 1960.

"Cathedral in the west." *Canadian Catholic Institutions,* November–December 1960.

"Artist to stage show for university students." *Victoria Daily Colonist,* 14 January 1964.

"Maxwell Bates' works on view." *Calgary Albertan,* 17 June 1961.

"City painter displays art at exhibition." *Calgary Herald,* 17 June 1961.

"Maxwell Bates' latest work not everyone's idea of art." *Vernon Daily News,* 13 March 1964.

"Works of Calgary artist on display." *Calgary Albertan,* 24 February 1973.

"Bates and Freifeld." *Globe and Mail,* 12 November 1977.

"Eight artists of British Columbia." *Malahat Review* 45 (1978):65–72.

"City artist honored." *Victoria Times,* 28 June 1980.

"World of art loses one of its greatest." *Victoria Times-Colonist,* 16 September 1980.

"Maxwell Bates." *Visual Arts Newsletter* [Alberta Dept. of Culture and Multiculturalism] 2 (Fall 1980).

"Maxwell Bates: Art Gallery of Greater Victoria, September 9 to October 17, 1982." *Artscanada* 39 (November 1982): 3.

"Maxwell Bates." *Visual Arts Newsletter* [Alberta Dept. of Culture and Multiculturalism] 5 (Winter 1983).

"Gallery tribute." *Eastbourne Herald* [Eastbourne, England], 18 April 1992.

Amos, Robert. "Going, going ... the great Bates estate." *Victoria Times-Colonist,* 6 June 1992.

———. "Bates auction was a great party with lots of bargains." *Victoria Times-Colonist,* 13 June 1992.

Ayre, Robert. "Western painting comes to Montreal." *Canadian Art* 9:2 (Christmas, 1951):58.

———. "Calgary painters exhibit." *Montreal Star,* 23 February 1957.

———. "Spring exhibit has 102 oils." *Montreal Star,* 5 April 1957.

———. "Plus ça change at the RCA" *Montreal Star,* 18 November 1961.

Bell, Andrew. "Canadian painters in water colour—A Silver Jubilee exhibition." *Canadian Art* 8 (Spring 1951):94–98.

Birney, Earle. "Poets and painters: Rivals or partners." *Canadian Art* 14 (Summer 1957):148–50.

Bloore, R.L. "Maxwell Bates retrospective exhibition." *Canadian Art* 18 (March/April 1961):123–24.

Boultbee, Jeremy. "Maxwell Bates: 'I just like color and paint ...'" *Victoria Times,* 17 November 1973.

Bowlen, Dennis. "Maxwell Bates and Peter Daglish." *Arts Reviews* 16 (June 1974):15.

Bresky, Dushan. "Artist who once slaved in German salt mines now painting in city." *Calgary Herald,* 23 January 1953.

———. "Stronger civic pride advocated by artists." *Calgary Herald,* 26 May 1953.

Buchanan, Donald W. "Canadian graphic art abroad." *Canadian Art* 16 (Summer 1959):198–99.

Chantal, Alma de. "Maxwell Bates." *Vie des Arts* 22 (Été 1977):48–49.

Ciccimarra, R. "Quality, not quantity characterizes the jury show." *Victoria Daily Times,* 27 April 1963.

———. "Fullest possible range in small print show." *Victoria Daily Times,* 11 May 1963.

Collins, Doug. "And so to the salt mines." *Vancouver Sun,* 7 April 1978.

Collinson, Helen. "Lars Haukaness: Artist instructor." *Alberta History* (Autumn 1984):11–20.

Cork, Richard. "Desperate defiance." *BBC Listener,* 27 November 1986.

Corry, Arthur. "Academician comes to city." *Victoria Daily Times,* 29 September 1962.

Crawford, Leonore. "Festival art exhibit spotlights nine painters from the prairies." *London Evening Free Press* [London, Ontario], 7 July 1962.

Dufour, Pat. "Newest collection of Bates creates stir of excitement." *Victoria Daily Times,* 21 February 1970.

Fox, Mary. "Maxwell Bates more taken with painting than subjects." *Vancouver Sun,* 19 March 1976.

Fry, G. "Maxwell Bates retrospective." *Artscanada* 24 (February 1967): Supp. 4.

Gaskell, Ted. "Nothing unusual about a two-way artist." *Victoria Daily Colonist*, 24 November 1963.

Gelmon, Joe. "Confused by art?—Don't be too practical." *Winnipeg Free Press*, 28 October 1955.

Gibson, Jim. "Show celebrates long friendship." *Victoria Daily Colonist*, 4 March 1979.

Glyde, H.G. "Community art in Alberta." *Canadian Art* 5 (Autumn 1947): 30–34.

Goldring, Douglas. "Artists and pictures." *Studio* 108 (July–December 1934): 98.

Gould, Ed. "'Spilled milk' included architecture, art careers." *The Victorian*, 15 August 1973.

Goulding, W.S. "The symbol building." *Journal of the Royal Architectural Institute of Canada* 35 (November 1958): 408–14.

Graham, Colin. "Maxwell Bates." *Arts West* 1:4 (1976): 25–27.

Graham, John W. "Paintings show man in despair." *Winnipeg Free Press*, 9 October 1968.

——. "Maxwell Bates." *Artscanada* 15 (December 1968): 72–73.

——. "Bates' work displayed." *Winnipeg Free Press*, 11 April 1970.

——. "Today's poet-prophet." *Winnipeg Free Press*, 21 April 1970.

——. "Bates produces sensitive work." *Winnipeg Free Press*, 28 November 1972.

——. "Bates's vigorous, dynamic shorthand." *Winnipeg Free Press*, 10 October 1975.

Greenberg, Clement. "Clement Greenberg's view of art on the prairies." *Canadian Art* 20 (March/April 1963): 90–107.

Harvey, Don. "The man for the reply." *Victoria Daily Times*, 22 January 1968.

Hogg, Carol. "Diversity makes exhibit outstanding." *Calgary Herald*, 23 February 1973.

Howarth, Glenn. "A cluster of our best." *Victoria Daily Times*, 22 April 1972.

Hudson, Andrew. "Maxwell Bates at the Canadian Art Galleries." *Canadian Art* 19 (November/December 1962): 395.

Hughes, Robert. "The realist as corn god." *Time* (31 January 1972): 36–41.

J.S. "28 oils and watercolours by Calgary artist." *Saskatoon Star-Phoenix*, 1 October 1947.

——. "Calgary Group of Artists." Saskatoon Star-Phoenix, 11 September 1948.

Jaffe, Ingrid. "Faces, intense and urgent thoughts." *Saskatoon Star-Phoenix*, 9 June 1973.

Jasen, Patricia. "One who stayed: career of architect William Stanley Bates." *Society for the Study of Architecture in Canada Bulletin* (March 1988): 15–19.

Joyner, Brooks. "Bates show proves he's still the master." *Calgary Albertan*, 1 October 1978.

Kamienski, Jan. "A mature, honest artist it's a pleasure to see." *Winnipeg Tribune*, 24 April 1965.

Kerr, Illingworth. "Maxwell Bates exhibits here." *Calgary Herald*, 13 April 1959.

——. "Maxwell Bates, dramatist." *Canadian Art* 13 (Summer 1965): 324–27.

Key, A.F. "The Calgary Art Centre." *Canadian Art* 4 (May 1947): 122.

Kilbourn, Elizabeth. "18 print-makers." *Canadian Art* 18:72 (March/April 1961): 100–13.

Lackner, Stephan. "Max Beckmann: Memories of a friendship." *Arts Yearbook* 4 (1961): 120–34.

Learoyd, Eileen. "Artist Maxwell Bates—A man of blunt honesty." *Victoria Daily Colonist*, 8 September 1963.

Lindberg, Ted. "Max Bates' reality sandwiches." *Victoria Daily Times*, 7 December 1968.

Lowndes, Joan. "Maxwell Bates in retrospect 1921–1971." *Artscanada* 30 (May 1973): 59–63.

——. "Maxwell Bates collection steeped in memories of European tradition." *Vancouver Sun*, 19 January 1973.

——. "Bates is back, with joy and bitterness." *Vancouver Sun*, 22 October 1973.

Mabie, Don. "Miss Truly Amazing and friends." *Calgary Albertan*, 27 January 1977.

Macdonald, James W.G. "Heralding a new group." *Canadian Art* 5 (Autumn 1947): 35–36.

McArthy, Pearl. "Maxwell Bates." *Globe and Mail*, 22 September 1956.

McLean, Helen. "Doctorate goes to Calgary artist." *Calgary Albertan*, 22 May 1971.

Musselwhite, Bill. "Former city artist comes home to honors." *Calgary Herald*, 21 May 1971.

Neesham, Robin. "Bates departs from usual artistic style." *Calgary Herald*, 15 August 1963.

Nowosad, Frank. "'I don't pretend to be anywhere near the avant-garde.'" *Monday Magazine*, 24–30 October 1977.

——. "The metamorphosis of Maxwell." *Monday Magazine*, 16–22 March 1979.

——. "The enigmatic Maxwell Bates." *Monday Magazine*, 1–7 October 1982.

——. "The prairie artist who looked at life bleakly." *Vancouver Sun*, 13 October 1982.

Page, P.K. "Maxwell Bates, the Print Gallery, Victoria, February–March 1970." *Artscanada* 27 (April 1970): 62.

——. "Max and my mother: A memoir." *Border Crossings* 7 (October 1988): 74–76.

——. "The self-contained castle: Maxwell Bates and P.K. Page in conversation." *Border Crossings* 7 (October 1988): 77–79.

Paterson, Jody. "Bates prices soar at packed auction." *Victoria Times-Colonist*, 11 June 1992.

Perkin, Rae. "MUN gallery a go-go." *St. John's Evening Telegram*, 10 March 1967.

Perry, Art. "Recent watercolours by Maxwell Bates in Galerie Allen." *Vancouver Province*, 23 September 1974.

——. "Maxwell Bates." *Vanguard* 8 (May 1979): 23–25.

——. "Maxwell Bates." *Vancouver Province Magazine*, 2 November 1980.

——. "Images of the inner I." *Vancouver Province Magazine*, 26 April 1981.

——. "Bates assaults human existence." *Vancouver Province Magazine*, 9 September 1982.

——. "The genius of Bates." *Vancouver Province Magazine*, 19 September 1983.

Peterson, Kevin. "Writers and words." *Calgary Herald*, 6 May 1978.

Reid, Eva. "Eavesdrop with Eva." *Calgary Albertan*, 9 March 1970.

Repentigny, R. de. "Variety in the Calgary painters." *La Presse* [Montreal], 2 March 1957.

Rice, Gordon. "Bates feels place, time." *Victoria Daily Times*, 21 February 1970.

——. "Own kind of beauty." *Victoria Daily Times*, 28 February 1970.

——. "Max Bates' unique contribution." *Victoria Daily Times*, 20 February 1971.

Rousson, Jacques de. "Les peintres de la Colombie britannique et leur environnement." *Vie des Arts* 44 (Automne 1966):76–84.

Scott, Andrew. "Maxwell Bates, master of Canadian expressionism." *Performance* (12–25 November 1977):5.

Shadbolt, Jack. "Maxwell Bates (1906–1980)." *Artscanada* 37 (December 1980/January 1981):2.

Silcox, David. [Notice of exhibition.] *Globe and Mail*, 6 March 1965.

Simmins, Richard. "Maxwell Bates and Eric Metcalfe." *Artscanada* 24 (December 1967):4.

Skelton, Robin. "Canadian group show is a mixed bag." *Victoria Daily Times*, 20 March 1965.

——. "Satire, lyricism in Bates' reflective drawings." *Victoria Daily Times*, 22 January 1966.

——. "Greatness seen in Bates' paintings." *Victoria Daily Times*, 8 October 1966.

——. "Max at seventy." *Visual Arts Newsletter* [Alberta Dept. of Culture and Multiculturalism] 5 (Winter 1983):3.

——. "Maxwell Bates: Experience and reality." *The Malahat Review* 20 (October 1971):57–97.

Snow, John Vance. "In memoriam: Maxwell Bates, 1906–1980." *The Malahat Review* 62 (July 1982):202–03.

Stavdal, Bill. "They must come to me." *Victoria Daily Colonist*, 17 February 1970.

Swinton, George. "The Winnipeg show." *Winnipeg Tribune*, 2 November 1955.

——. "The Winnipeg show's new look." *Winnipeg Tribune*, 2 November 1955.

——. "Art show judge hits back. 'Do you want postcards?'" *Winnipeg Tribune*, 8 November 1955.

——. "Richards and Bates: Calgary painter and Winnipeg sculptor: two sturdy independents." *Winnipeg Tribune*, 13 January 1956.

——. "Painting in Canada." *Queens' Quarterly* 62 (Winter 1956):539–52.

Thomas, Bill. "Limners group 'just artists.'" *Victoria Daily Colonist*, 13 April 1972.

Thompson, David. "Gallery exhibition draws high praise." *Calgary Herald*, 15 October 1964.

Thornton, Mildred Valley. "Bates' exhibition draws interest at art gallery." *Vancouver Sun*, 6 May 1947.

——. "Edmonton artists show at gallery." *Vancouver Sun*, 17 April 1948.

Touche, Ouida. "Art works of Maxwell Bates' hang vividly in your memory." *Calgary Herald*, 22 May 1971.

Tousley, Nancy. "Modernist Alberta painter Maxwell Bates dies after illness." *Calgary Herald*, 24 September 1980.

——. "Maxwell Bates (1906–1980), modernist Alberta painter." *Artswest* 5 (November/December 1980):11.

——. "European modernism suffuses show by prairie artists." *Calgary Herald*, 29 August 1981.

——. "Alberta artist gets royal treatment in retrospective." *Calgary Herald*, 13 November 1982.

——. "Bates' landscapes shine in graceful exhibition." *Calgary Herald*, 5 February 1983.

——. "Sculpture highlights Gothic gem." *Calgary Herald*, 9 June 1985.

——. "Lithographers' collaboration a joy to view." *Calgary Herald*, 4 December 1988.

——. "In search of an artist's double life." *Calgary Herald*, 8 August 1992.

Twardowski, Astrid. "Maxwell Bates exhibit well worth attending." *Calgary Albertan*, 24 June 1961.

——. "Alberta artists 61 features." *Calgary Albertan*, 4 September 1961.

——. "One-man show opens gallery." *Calgary Albertan*, 8 September 1962.

——. "Around the galleries." *Calgary Albertan*, 4 October 1962.

Uhtoff, Ina D.D. "Bates' work to have impact here." *Victoria Daily Colonist*, 17 November 1962.

——. "Maxwell Bates' work offers fresh impact." *Victoria Daily Colonist*, 8 September 1963.

——. "This should not be missed." *Victoria Daily Colonist*, 5 May 1963.

——. "Bates exhibition full of interest." *Victoria Daily Colonist*, 3 May 1964.

——. "Bates shows Canadian life." *Victoria Daily Colonist*, 6 October 1966.

——. "Artist shows our town on sympathetic satire." *Victoria Daily Colonist*, 15 December 1968.

Vulliamy, E. "Masaccio unveiled." *Manchester Guardian*, 5 April 1990.

White, Stephanie. "Architecture Calgary: Bates' delicate St. Mary's Cathedral is one of the classic jewels of the city." *Calgary Herald*, 7 July 1979.

——. "Church shows artist's hand at architecture." *Calgary Herald*, 1 November 1980.

Wilczur, Vic. "Calgary artist's work a display." *Regina Leader-Post*, 3 November 1960.

Williamson, Moncrieff. "Wide range, complex talents characterize Maxwell Bates." *Victoria Daily Times*, 23 November 1963.

Wilson, R. York. "From Ontario's eastern border to the Rockies." *Journal of the Royal Architectural Institute of Canada* 28 (November 1951):370–75.

Winters, Ken. "Inexpressive expressionist." *Winnipeg Free Press*, 28 April 1965.

Wood, Rosemary. "Local paintings to be exhibited in Montreal." *Calgary Herald*, 2 February 1957.

Young, Ira. "Art in Alberta." *Journal of Royal Architectural Institute of Canada* 30 (February 1953):51–53.

Zemans, Joyce. "Maxwell Bates at the Canadian Art Galleries, Calgary." *Canadian Art* 19 (November/December 1962):395.

Exhibitions

ONE-MAN

1934 Manchester, Wertheim Gallery
1937 London, Wertheim Gallery
1947 Calgary, Canadian Art Galleries
Vancouver, Vancouver Art Gallery
Saskatoon, Saskatoon Art Centre
1948 Calgary, Canadian Art Galleries
1950 Kingston, Queen's University
1952 Calgary, Canadian Art Galleries
Calgary, Calgary Allied Arts Centre
1956 Winnipeg, University of Manitoba
Art School
1956 Toronto, Greenwich Gallery
1959 Calgary, Calgary Allied Arts Centre
Calgary, Provincial Institute of
Technology
Calgary, Canadian Art Galleries
1960 Regina, Norman Mackenzie Art Gallery
(retrospective)
1961 Calgary, Calgary Allied Arts Centre
1962 Toronto, Here and Now Gallery
Victoria, Art Gallery of Greater Victoria
Calgary, Canadian Art Galleries
1963 Victoria, Ego Interiors
1964 Vancouver, Bau-Xi Gallery
Victoria, University of Victoria
1965 Calgary, Canadian Art Galleries
Winnipeg, Grant Gallery
1966 Victoria, Art Gallery of Greater Victoria
(retrospective)
1967 Vancouver, Bau-Xi Gallery
Vancouver, University of British
Columbia Fine Arts Gallery

1968 Vancouver, Bau-Xi Gallery
Victoria, Print Gallery
Winnipeg, Upstairs Gallery
Winnipeg, Winnipeg Art Gallery
(retrospective)
Calgary, Allied Arts Centre
1969 Vancouver, Bau-Xi Gallery
Victoria, Print Gallery
Oshawa, Annual Exhibition CSGA
(retrospective)
St. John's, Memorial University
1970 Vancouver, Bau-Xi Gallery
Winnipeg, Upstairs Gallery
Edmonton, Upstairs Gallery
Victoria, Print Gallery
1971 Calgary, Alberta College of Art
Calgary, Canadian Art Galleries
Calgary, Calgary Galleries
Victoria, Print Gallery (two exhibitions)
1972 Winnipeg, Upstairs Gallery
Edmonton, Upstairs Gallery
Vancouver, Vancouver Art Gallery
(retrospective)
1973 Vancouver, Galerie Allen
1974 Vancouver, Galerie Allen
Toronto, Erindale College, University of
Toronto.
1975 Vancouver, Vancouver Art Gallery
(extension exhibition)
Winnipeg, Upstairs Gallery
Edmonton, Upstairs Gallery
1976 Vancouver, Bau-Xi Gallery
Victoria, Art Gallery of Greater Victoria
(retrospective)

1977 Vancouver, Bau-Xi Gallery
Victoria, Backroom Gallery
Toronto, Bau-Xi Gallery
1978 Victoria, Backroom Gallery
Calgary, Canadian Art Galleries
1979 Calgary, Sundance Gallery
1981 Vancouver, Vancouver Art Gallery
1982 Victoria, Art Gallery of Greater Victoria
(retrospective)
Medicine Hat, Medicine Hat Museum
and Art Gallery
Vancouver, Bau-Xi Gallery
1992 Calgary, Nickle Arts Museum

TWO- AND THREE-MAN

1956 Winnipeg, Winnipeg Art Gallery
(with Cecil Richards)
1957 Vancouver, New Design Gallery
(with John Snow)
1958 Ottawa, National Gallery of Canada
(Canadian Artists Series 1: Bates/
Humphrey)
1960 Victoria, Art Gallery of Greater Victoria
(with John Snow)
Toronto, Here and Now Gallery
(with John Snow and Roloff Beny)
1964 Vancouver, New Design Gallery
(with John Snow)
1965 Toronto, Gallery Pascal
(with J.N. Hardman)
1967 Vancouver, Art Gallery of the University
of British Columbia (with Eric
Metcalfe)

1969 Seattle, Seligmann Gallery
 (with Herbert Siebner)
1971 Victoria, Print Gallery (with Roy
 Kiyooka)
1974 London, Canada House Gallery
 (with Peter Daglish)
 Paris, Canadian Cultural Centre
 (with Peter Daglish)
1977 Calgary, University of Calgary
 (with Peter Daglish and John Snow)
1979 Victoria, Kyle's Gallery (with John
 Snow)
1988 Calgary, Canadian Art Galleries
 (with John Snow)
1989 Calgary, Muttart Gallery (with John
 Snow and Barry Smylie)

GROUP

1928 Calgary, Calgary Art Club
1930 Ottawa, National Gallery of Canada,
 Exhibition of Canadian Painting
 New York, Opportunity Gallery
 New York Laurel Gallery
1932 London, Bloomsbury Gallery, *Three
 Painters and Three Sculptors*
1932–39 London, *The Twenties Group*
1936–39 London, Storran Gallery
1937 London, Artists' International
 Association Exhibition
1939 London, Royal Academy
1947 Vancouver, Vancouver Art Gallery,
 Calgary Group
 Canadian Society of Graphic Art
 (and in subsequent years)
1948 Indiana University, *Summer Exhibition*
1949 Calgary, Calgary Allied Arts Centre,
 Western Canadian Painters
 Western Canadian Art Circuit,
 Western Scene

1950 New York, Laurel Gallery,
 Directions for 1950
1951 Montreal, Dominion Gallery,
 Western Canadian Artists
 Canadian Society of Painters in
 Watercolour (and in subsequent
 years)
1953 Ottawa, National Gallery of Canada,
 Canadian Painting
 Winnipeg, Winnipeg Art Gallery,
 *Progressive Painters of Western
 Canada*
1955 Ottawa, National Gallery of Canada,
 First Canadian Biennial (and in
 subsequent years)
 Calgary, *Golden Jubilee Exhibition*
1956 *Canadian Group of Painters*
 (and in subsequent years)
 Regina and Montreal, *Four Calgary
 Painters*
1957 Montreal, *Montreal Spring Show*
 (and in subsequent years)
 Winnipeg, *Winnipeg Show*
 (and in subsequent years)
1958 Cincinnati, *First International Biennial
 of Color Lithography*
 Philadelphia, Philadelphia Print Club
1959 *Canadian Watercolours and Graphics
 Today* (American Federation of Arts)
1960 Chicago, *New Directions in Printmaking*
 Tokyo, Second International Biennial
 Exhibition of Prints
 Mexico City and Guadalajara, *Canadian
 Paintings and Graphics*
 Toronto, Here and Now Gallery
1963 London (Ontario), *Master Canadian
 Painters and Sculptors*
1964 London (Ontario), *Surrealism in
 Canadian Painting*

1967 Vancouver, Bau-Xi Gallery
 (and in subsequent years)
 Montreal, Canadian Government
 Pavilion, *Painting in Canada*
 Annual RCA Exhibitions
 (and in subsequent years)
 Vancouver, *Western Printmakers*
1968 Winnipeg, Winnipeg Art Gallery,
 *Directions in Western Canada
 Printmaking*
1972 Victoria, *The Limners*
1976 Toronto, *Tapestries*
 Toronto, *The Limners*
1980 Halifax, Dalhousie Drawing Exhibition
1983 Edmonton, Edmonton Art Gallery,
 Winnipeg West
1986 Calgary, Founders of the Alberta
 College of Art
1989 Calgary, Triangle Gallery,
 Christmas Cards
1992 Edmonton, Edmonton Art Gallery,
 Alberta Society of Artists–Sixty Years

Represented in:

National Gallery of Canada;
Canada Council Art Bank;
Department of External Affairs;
Art Gallery of Ontario;
Alberta Art Foundation;
Tate Gallery, London, England;
Wertheim Collection, England;
Auckland City Art Gallery, New Zealand;
Art Gallery of Greater Victoria;
Vancouver Art Gallery;
Glenbow Museum and Art Gallery;
 and many other art galleries, corporate }
 and private collections.

Chronology

1906	Born 14 December, Calgary, Alberta.
1912	Visited England with his family.
1924	Began work in William Stanley Bates's architectural firm.
1926–27	Attended art classes at Provincial Institute of Technology and Art under Lars Haukaness.
1926	Became member of the Calgary Art Club.
1928	Visited Vancouver and Victoria with Leroy Stevenson. Expelled from Calgary Art Club.
1929	Visited Chicago with Leroy Stevenson.
1931	Went to London, England.
1932–36	Member of the "Twenties Group."
1934	Began work in the firm of J. Harold Gibbons, Architect.
1936–38	Travelled to Belgium, Channel Islands, Paris.
1939	Joined British Territorial Army.
1940	Assigned to British Expeditionary Force, France.
1941	Captured by Germans; prisoner of war in Thuringia.
1942	Granted registration as an architect in the United Kingdom.
1945	Freed by United States forces and returned to England.
1946	Returned to Calgary to work in his father's firm.
1947	Member, Canadian Society of Graphic Art and Alberta Society of Artists.
1948–49	Instructor, evening classes in life drawing and children's classes, Provincial Institute of Technology and Art.

1949	Married May Watson. Studied in New York under Max Beckmann and Abraham Rattner at the Brooklyn Museum Art School.
1950	Returned to Calgary to work with architect A.W. Hodges.
1951	Registered as an architect in Alberta. Received an honorary award from the Royal Architectural Institute of Canada (MRAIC). Became member of the Canadian Society of Painters in Watercolour.
1952	Death of May Watson Bates. Elected Vice-President, Alberta Society of Artists.
1953	With John H. Snow, acquired lithograph presses and began experimenting in the medium.
1954	Married Charlotte Kintzle.
1954–57	Worked on St. Mary's Cathedral, Calgary.
1955	Co-juror of *Winnipeg Exhibition*, Winnipeg Art Gallery.
1956	Travelled to Toronto for his exhibition at the Greenwich Gallery. Appointed to the National Committee of the International Society of the Plastic Arts.
1957	Travelled with John H. Snow to Vancouver for show of their lithographs at New Design Gallery. Elected to the Canadian Group of Painters.
1958–59	Travelled extensively in Europe.
1960	Travelled to Regina for his retrospective at the Norman Mackenzie Art Gallery. Became fellow of the International Institute of Arts and Letters.

1961	Suffered first stroke. Became Associate of the Royal Canadian Academy (ARCA).
1962	Moved to Victoria, B.C. Made Honorary Member, Alberta Society of Architects.
1964	Published *Far-Away Flags*. Travelled to Vancouver with John H. Snow for exhibition of their paintings at New Design Gallery.
1966	Returned to Calgary for the printing of lithograph commissioned by the Canada Council.
1967	Awarded the Centennial Medal.
1968	Travelled to Winnipeg for his retrospective at the Winnipeg Art Gallery.
1969	Travelled to Seattle for an exhibition with Herbert Siebner at Seligmann Gallery.
1970	Travelled to Vancouver for an exhibition of the work of Jock Macdonald.
1971	Travelled to Calgary to receive LL.D. from the University of Calgary. Became member of the Royal Canadian Academy (RCA). Formed The Limners group in Victoria.
1973	Travelled to Vancouver for his retrospective at the Vancouver Art Gallery.
1978	Published *A Wilderness of Days*. Suffered second stroke.
1980	Order of Canada, C.M. Died 14 September, Victoria, B.C.

Index to Bates's Works

Subject Index

Maxwell Bates

COLOUR PLATES

Washerwoman (ca. 1927). Oil on board, 20×24 cm. Photo by John Dean. Private collection.

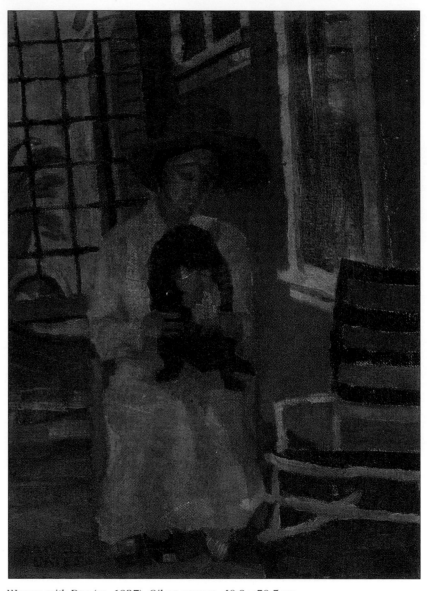

Woman with Dog (ca. 1927). Oil on canvas, 40.9 × 30.5 cm.
Photo courtesy of the Auckland City Art Gallery.
Collection, the Auckland City Art Gallery. Donated by Lucy Wertheim.

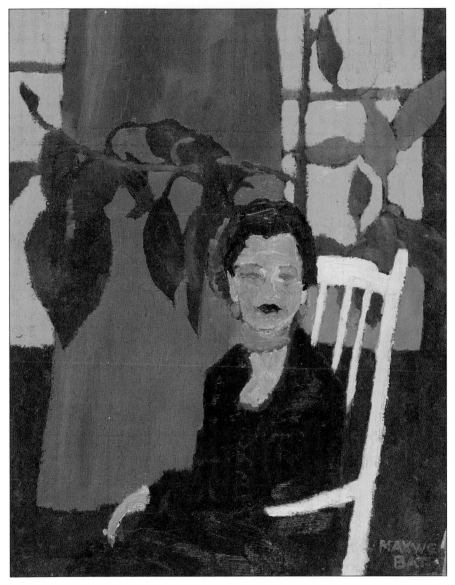

Untitled (portrait of Marion Thomasson Bates, 1929). Oil on board, 35 × 27.5 cm.
Photo courtesy of Destrubé Photography, Victoria. Private collection.

Prairie Woman (1947). Oil on paper mounted on board, 65.7 × 50.3 cm.
Photo by Trevor Mills. Courtesy of the Art Gallery of Greater Victoria. Private collection.

250

Prairie Life (1947). Oil on canvas, 51.7 × 71.2 cm. Photo by John Dean. Collection of Dr. George Prieur.

251

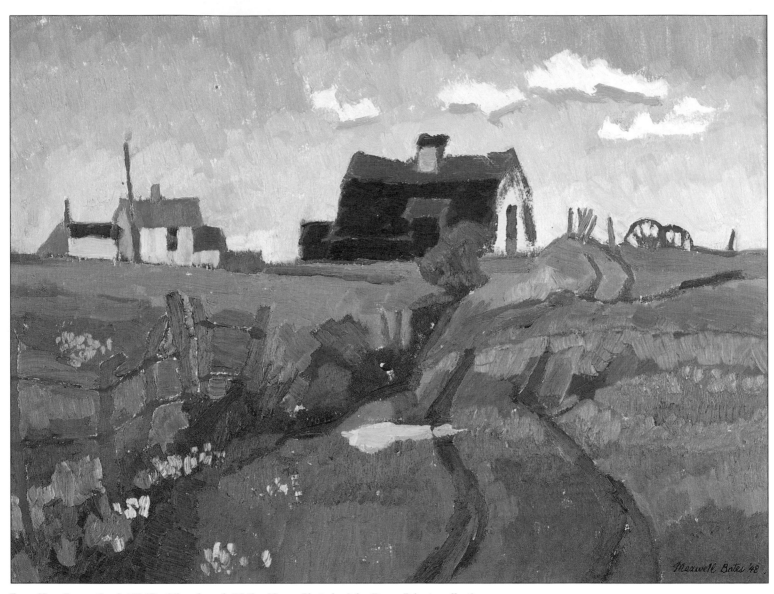

Farm Near Bragg Creek (1948). Oil on board, 30.5 × 40 cm. Photo by John Dean. Private collection.

252

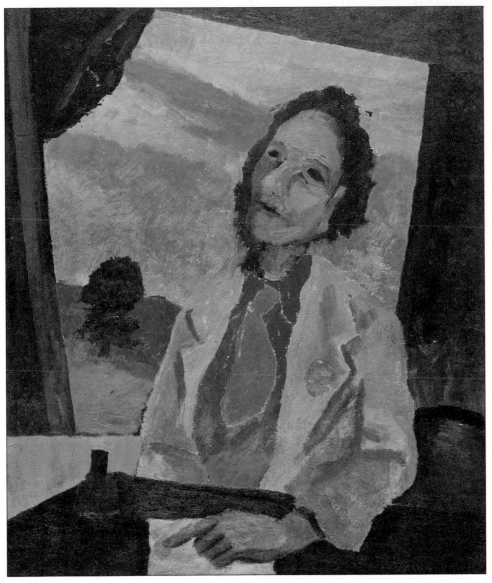

Poet (1948). Oil on board, 40 × 30.5 cm. Photo by John Dean. Private collection.

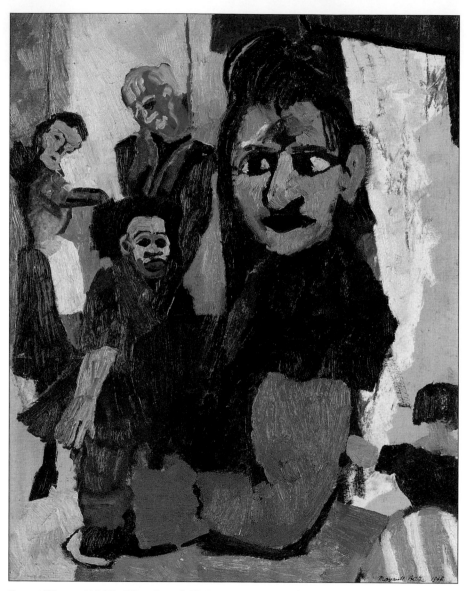

Puppet Woman (1948). Oil on board, 50.7 × 40.7 cm.
Photo by John Dean. Private collection.

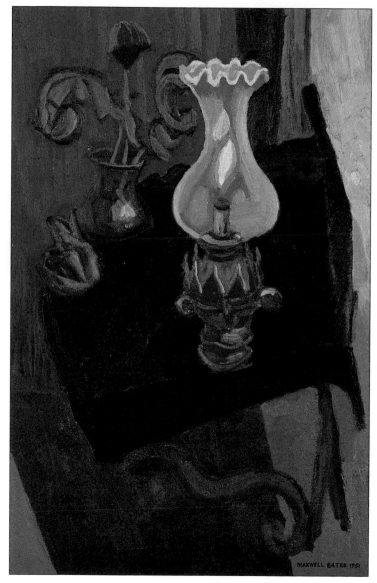

Untitled (still life with lamp, 1951). Oil on canvas, 56 × 35 cm.
Photo by John Dean. Private collection.

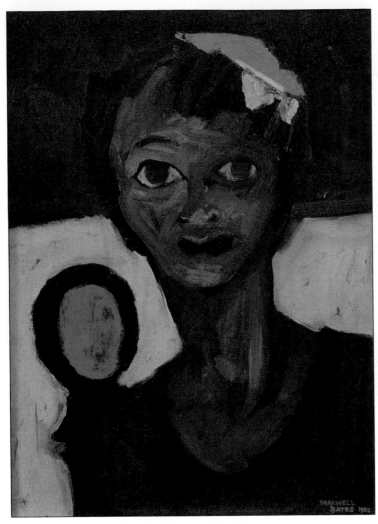

Head of a Woman (1952). Oil on board, 60 × 45 cm.
Photo by John Dean. Private collection.

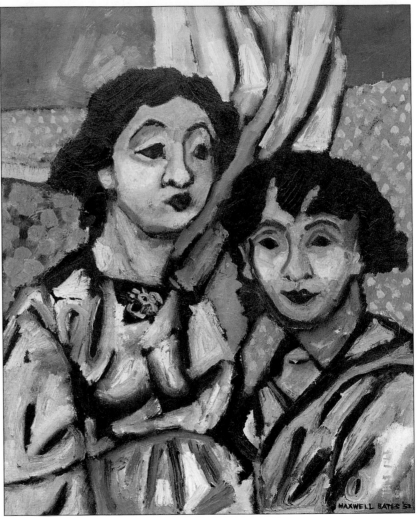

Two Women (1953). Oil on canvas, 60.9 × 50.8 cm.
Photo by John Dean. Private collection.

256

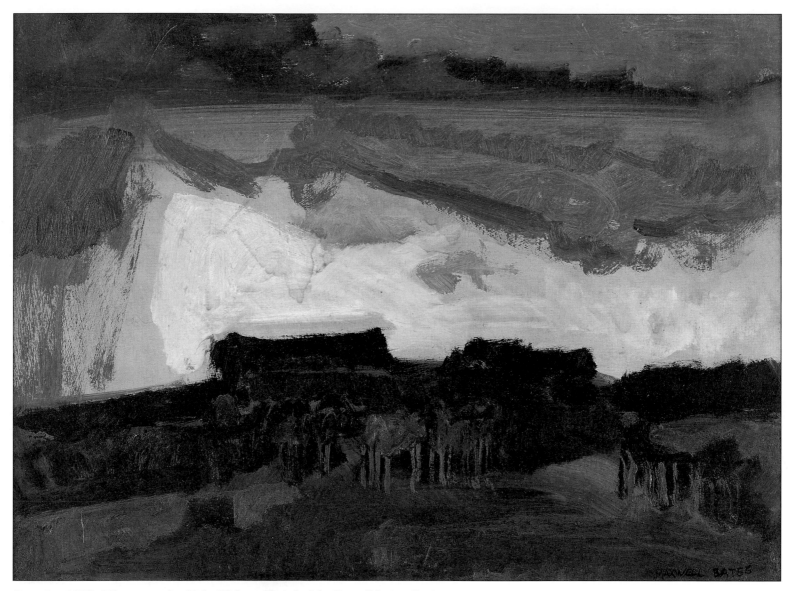

Storm (ca. 1955). Oil on masonite, 60.6 × 76.2 cm. Photo by John Dean. Private collection.

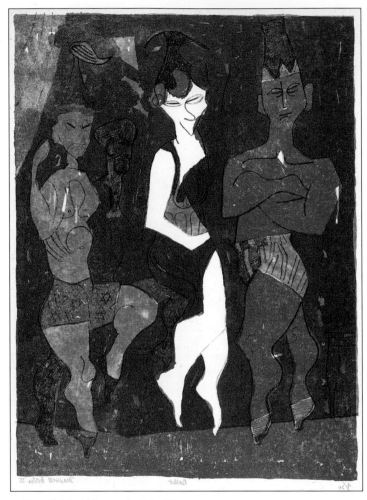

Ballet (1955). Lithograph, 35×26 cm.
Photo by John Dean. Private collection.

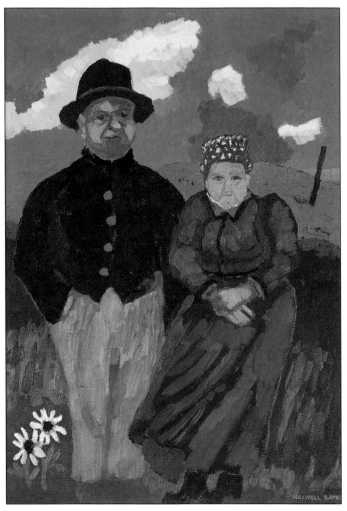

Prairie Settlers (ca. 1955). Oil on canvas, 65×55 cm.
Photo by John Dean. Private collection.

258

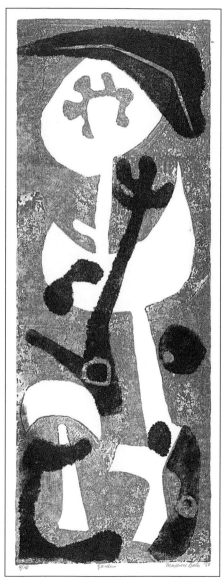

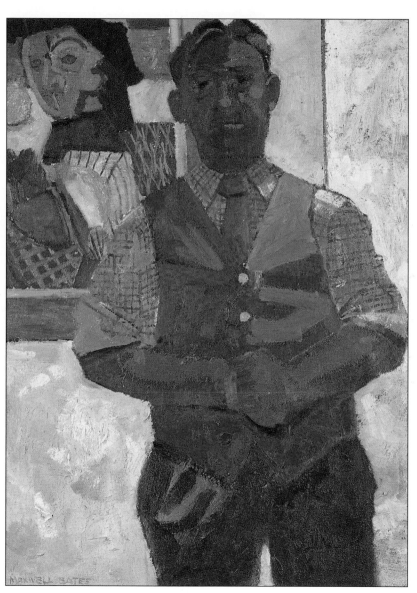

Garden (1956). Lithograph, 42 × 15 cm.
Photo by John Dean. Private collection.

Self Portrait (ca. 1956). Oil on canvas, 71 × 52.5 cm.
Photo by John Dean. Private collection.

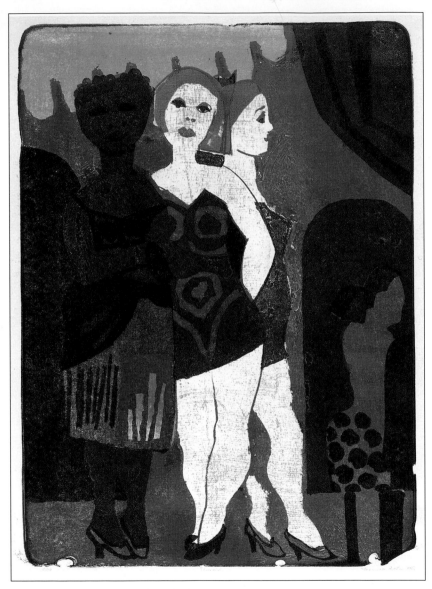

Showgirls (1957). Lithograph, 66 × 50.8 cm.
Photo by John Dean. Private collection.

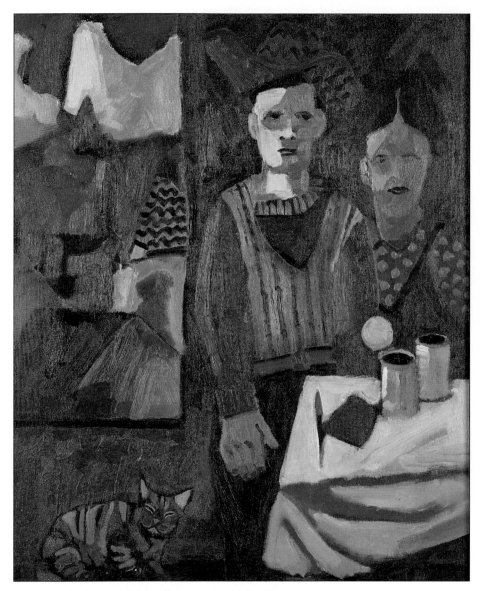

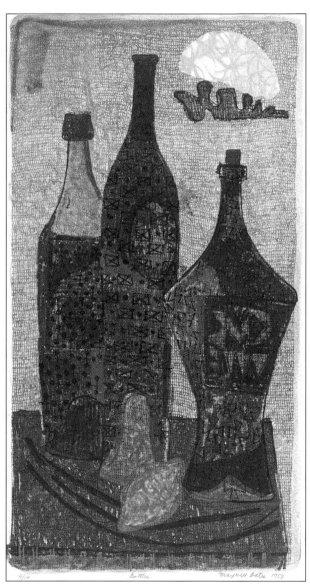

Interior with Figures (1957). Oil on canvas, 86.7 × 71.4 cm.
Photo by John Dean. Private collection.

Bottles (1958). Lithograph, 43 × 22 cm.
Photo by John Dean. Private collection.

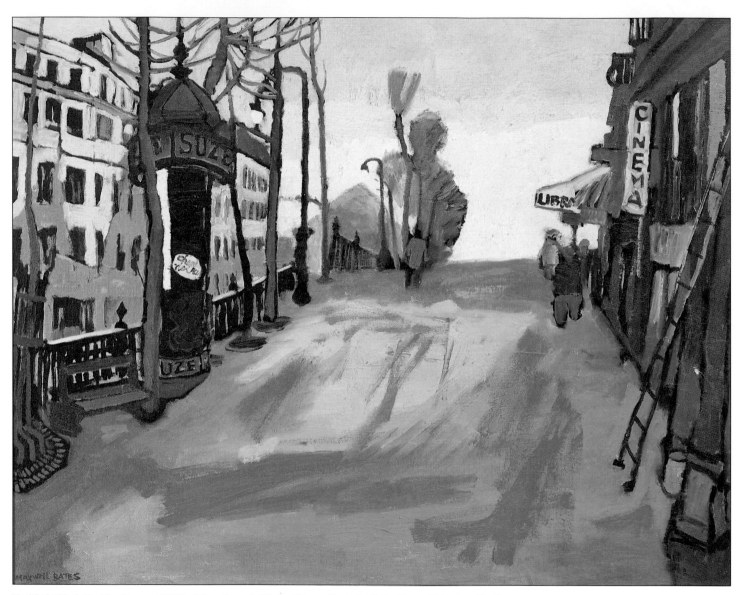

Untitled (Blvd. St. Martin, ca. 1959). Oil on board, 60.9 × 76 cm. Photo by John Dean. Private collection.

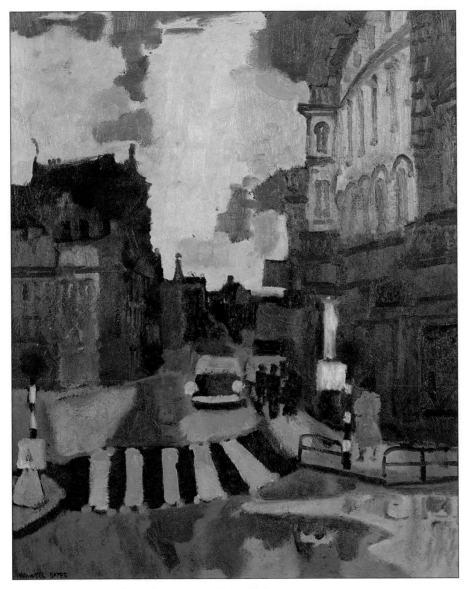

South Kensington (1959). Oil on canvas, 76.2 × 60.9 cm.
Photo by John Dean. Private collection.

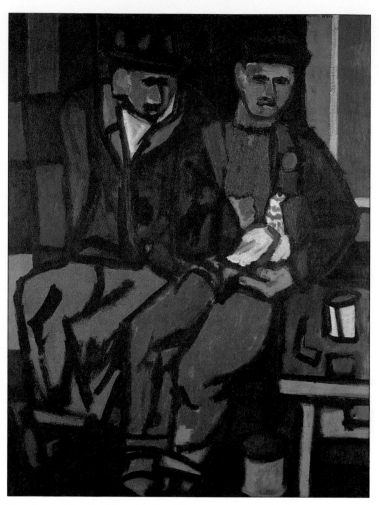

Green Forest (ca. 1960). Oil on board, 120 × 90 cm.
Photo by J. Jardine. Collection of Dr. and Mrs. Murray Isman.

Two Men with a Bird (ca. 1960). Oil on canvas, 120 × 90 cm.
Photo by John Dean. Private collection.

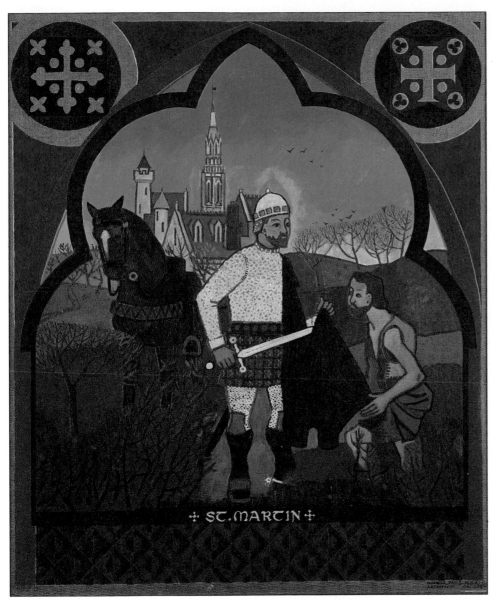

St. Martin of Tours (1960). Oil on board, 76 × 65 cm. Photo by John Dean.
Courtesy of St. Martin's Anglican Church, Calgary.

265

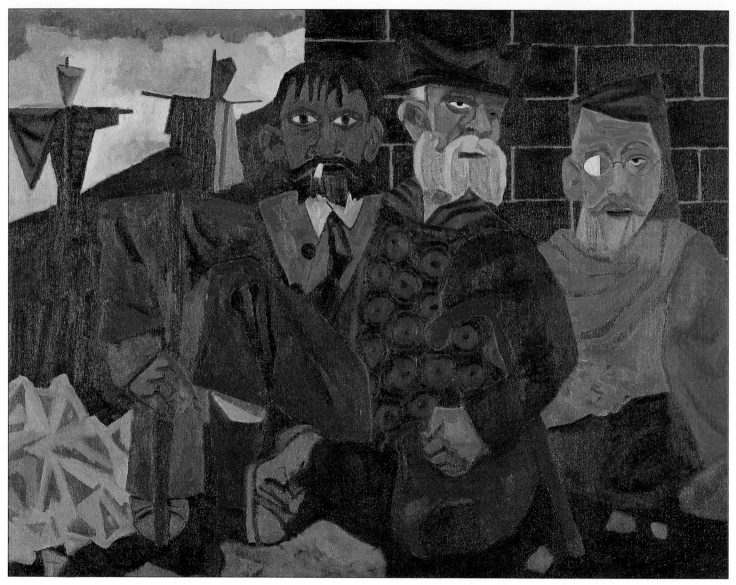

Beggars and Scarecrows (1961). Oil on canvas, 76.3 × 91.4 cm. Photo courtesy of the Calgary Allied Arts Foundation. Collection of the City of Calgary.

Mountains—Vancouver Island (1962). Oil on canvas, 49.6 × 59.8 cm.
Photo by Trevor Mills. Courtesy of the Art Gallery of Greater Victoria.
Collection of the Nickle Art Museum, Calgary.

Landscape Near Victoria (1962). Oil on board, 30 × 40 cm.
Photo by John Dean. Private collection.

Beggar King (1963). Oil on masonite, 88.3 × 59.2 cm. Photo by Trevor Mills. Courtesy of the Art Gallery of Greater Victoria. Private collection.

Duchess of Aquitaine (1964). Watercolour gouache, 37.9 × 45.7 cm.
Photo by Trevor Mills. Courtesy of the Art Gallery of Greater Victoria. Private collection.

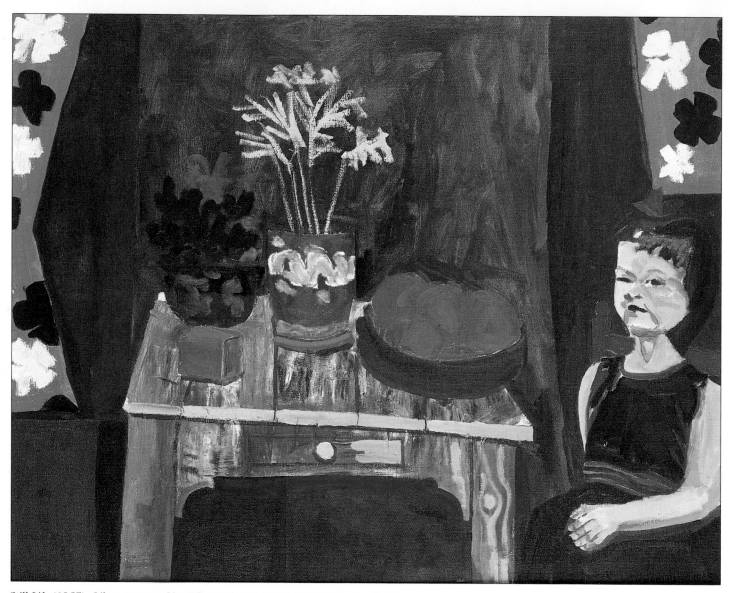

Still Life (1965). Oil on canvas, 60 × 75 cm. Photo by John Dean. Private collection.

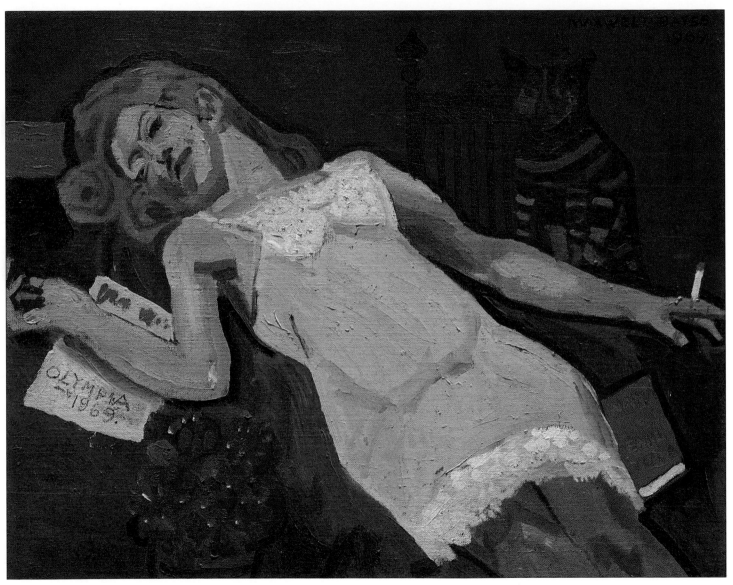

Modern Olympia (1969). Oil on canvas, 40.2 × 50.5 cm. Photo by Trevor Mills. Courtesy of the Art Gallery of Greater Victoria. Private collection.

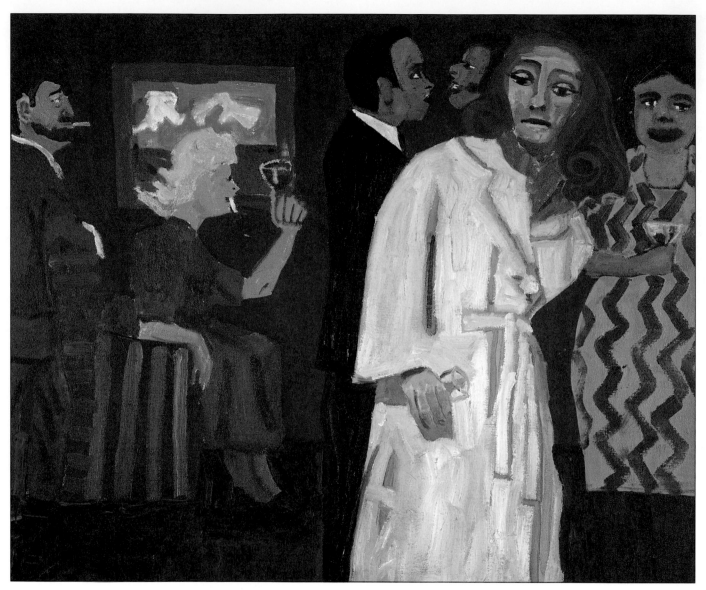

Untitled (cocktail party, 1969). Oil on canvas, 50 × 60 cm. Photo courtesy of Peter Daglish. Collection of Mr. and Mrs. Peter Daglish.

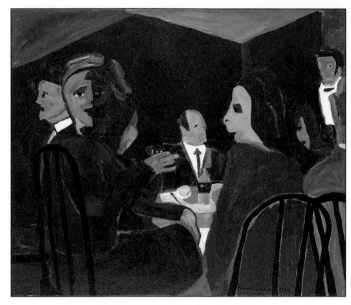

Restaurant (1969). Oil on canvas, 75 × 90 cm.
Photo by J. Jardine. Collection of Mr. and Mrs. Michael Isman.

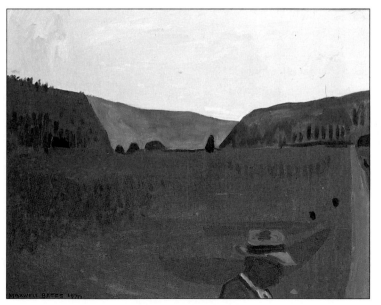

Alberta Landscape (1970). Oil on canvas, 66 × 81.3 cm.
Photo by John Dean. Private collection.

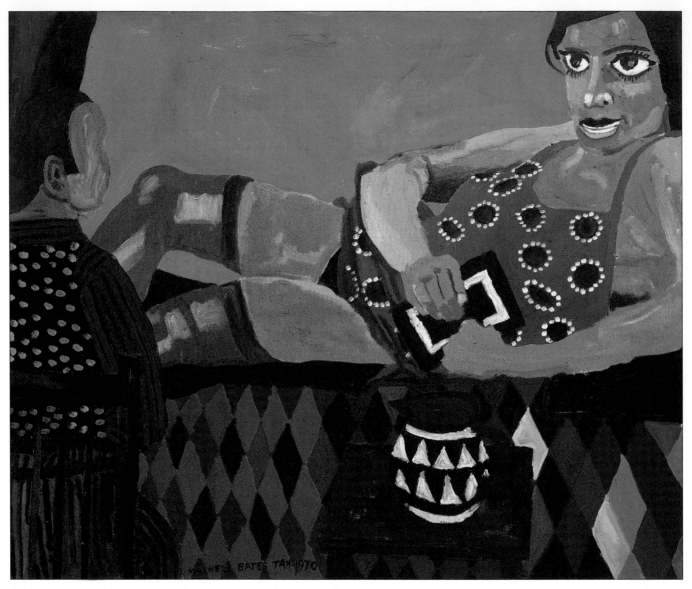

Odalisque (1970). Oil on canvas, 76 ×81.5 cm. Photo by Trevor Mills. Courtesy of the Art Gallery of Greater Victoria. Private collection.

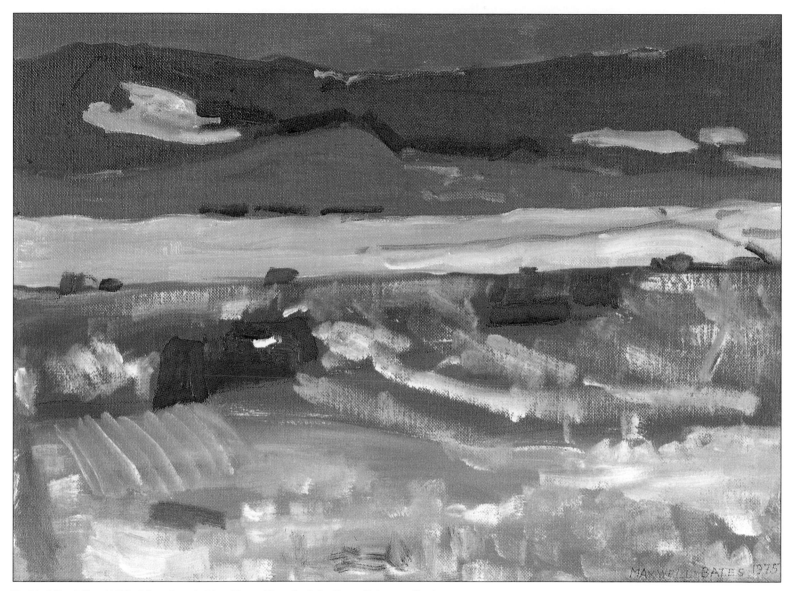

Untitled (foothills, 1975). Oil on board, 30×40 cm. Photo by John Dean. Private collection.

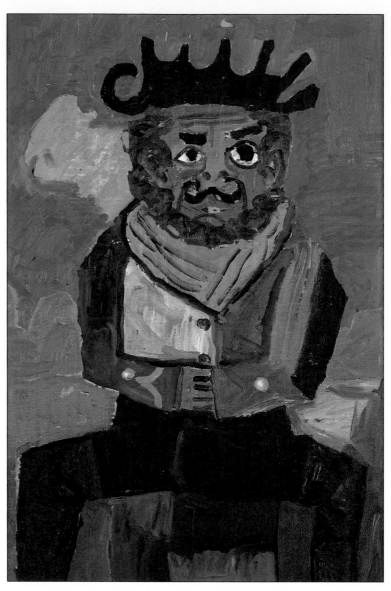

Beggar King (1978). Oil on board, 90 × 61 cm.
Photo by John Dean. Private collection.

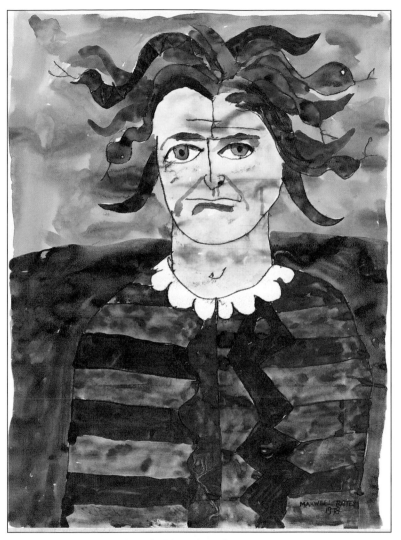

Medusa (1978). Ink and wash, 60 × 45 cm sheet.
Photo by John Dean. Private collection.

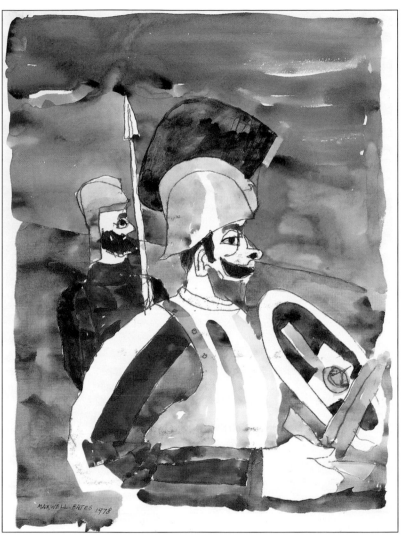

Soldiers (1978). Ink and wash, 60 × 45 cm sheet.
Photo by John Dean. Private collection.

277

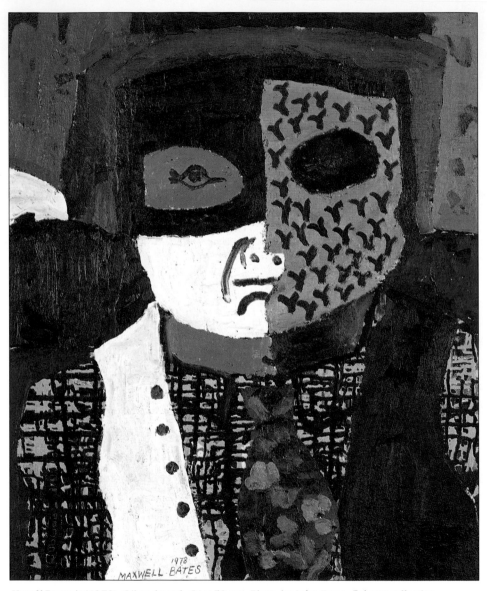

Unself Portrait (1978). Oil on board, 61 ×50 cm. Photo by John Dean. Private collection.